Mapping

DAVID GREENHOOD

Illustrations by Ralph Graeter

Revised with the assistance of Gerard L. Alexander

Phoenix Science Series

THE UNIVERSITY OF CHICAGO PRESS

Chicago and London

This book is also available in a clothbound edition from

THE UNIVERSITY OF CHICAGO PRESS

Previous editions, under the title *Down to Earth: Mapping for Everybody,*
published by Holiday House, New York. © 1944, 1951, by David Greenhood.

Library of Congress Catalog Card Number: 63-20905

THE UNIVERSITY OF CHICAGO, CHICAGO & LONDON
The University of Toronto Press, Toronto 5, Canada

Mapping

To the honor of

HANS OTTO STORM

1895–1941

Engineer • Writer • Humanist

Acknowledgments

The earlier editions of this book were published by Holiday House, New York. To the founders of that firm—Mr. Vernon A. Ives, Mr. Theodore A. P. Johnson, and Miss Helen Gentry—I am indebted for the suggestion of writing an easy, pleasure-bent explanation of mapping. I continue to think with warm appreciation of their sponsorship and of their loyal help in the preparation of the manuscript.

There are others without whom I would not have had the hardihood to go through with the attempt even though maps had been a favorite interest of mine since boyhood. It seems that geography is one of the sciences in which the experts are always hospitable to the layman with his enthusiasm for participation. Probably this tolerance exists because the seasoned professional likes to repeat for himself the marvels of glimpsing for the first time those fundamentals which have become workaday matters to him. It may be, too, that those laymen who are deriving enough pleasure from their avocation to regard it earnestly can become of some use to the full-timers. I hope so. That would serve to pay some of my debt for the authoritative counsel, information, materials, and good wishes given to me.

The following helped me with the earlier editions:
Captain K. T. Adams, The Coast and Geodetic Survey;
Mr. Paul J. Alexander, The Army Map Service;
Mr. Samuel Whittmore Boggs, Division of Geography and Cartography, Department of State;
Mr. Frank C. Bryan, The Howe Memorial Press;
Rear Admiral Leo Otis Colbert, The Coast and Geodetic Survey;
Mr. Harold Faye, Cartographer;
Mr. F. C. Gallen, The Coast and Geodetic Survey;
Mr. Earl G. Harrington, The General Land Office;
Mr. Richard Edes Harrison, Cartographer;
Mr. G. S. Hume, The Canadian Department of Mines and Technical Surveys;
Mr. O. M. Miller, The American Geographical Society;
Mr. F. H. Peters, The Hydrographic and Map Service;

ACKNOWLEDGMENTS

Mr. J. W. Pumpelly, The Map Information Office, The Geological Survey;
Mr. J. L. Rannie, Canadian Department of Mines and Technical Surveys;
Mr. J. Wreford Watson, Canadian Department of Mines and Technical Surveys.

I was aided in the preparation of the present edition by
Mr. Louis P. Ade, The Army Map Service;
Dr. Brian J. L. Berry, Department of Geography, University of Chicago.
Mr. Frederick J. Doyle, American Society of Photogrammetry;
Miss Wilma B. Fairchild, *The Geographical Review;*
Dr. Lincoln LaPaz, Division of Astronomy, University of New Mexico;
Dr. N. L. Nicholson, Canadian Department of Mines and Technical Surveys;
Mr. C. E. Palmer, American Society of Photogrammetry;
Mr. Charles E. Sharp, Civil Engineer;
Mr. Albert A. Stanley, The Coast and Geodetic Survey;
Dr. Waldo R. Tobler, Department of Geography, University of Michigan.

And for helping me with the earlier and the present editions, I wish to thank
Mr. Gerard L. Alexander, Map Division, New York Public Library;
Mr. J. O. Kilmartin, The Map Information Office, The Geological Survey.

The credit for whatever is commendable in this book I share with those named above and with many others. The blame for defects will be wholly my own.

DAVID GREENHOOD

SANTA FE, NEW MEXICO

Introduction

. . . that master tool, geography's perfection, the map.—RICHARD U. LIGHT.

This book has been written to be read rather than studied. It is a book for the amateur, designed to give him an understanding and appreciation of maps, whether his interest be as user, maker, or collector.

The aim is not to supplant the few excellent textbooks on cartography for students who are ready to enter into the rigorous training necessary in becoming professional but rather to lead toward a quickened and deepened receptivity for what those books offer.

As an informal approach to maps, the order here is not one made in accordance with a logical classification of the various elements of the subject; instead it is made to parallel the experience of confronting a map and viewing it with more and more insight. The progression is from familiar aspects, through contingent matters, to the grand concepts that fortify the working principles.

Most readers, perhaps, will begin with the first section—on interpreting and applying maps. But it is not essential to follow a step-by-step procedure from the first chapter to the last. If you wish to set about making and collecting maps at once, you will find the second part of this book as accessible as the main entrance at the opening chapter. If you come to an unfamiliar point, the Index will locate the needed explanation.

All the explanations that include any calculations use only simple arithmetic and a minimum even of that. But if you've been blessed with a mathematical mind, you'll discern implications, for mathematics should never cease to be respected as the innermost support of surveying and mapping.

The prodigious automational devices that now and then come out, one superseding the other, are also respectfully omitted. Any written account of them would be either so thin as to be vague or so densely detailed as to be confusing, unless you could see them in operation for considerable periods. This is true also of the complicated processes of reproducing maps, even without automation. Besides, printing is entirely another kind of craft, with fundamental principles and subtleties categorically different from those which will engage quite a lot of our attention here.

Everybody who likes maps and broods over them has sought to account for their appeal. Probably the most frequent explanation is the one that the sea dog Marlow, in Joseph Conrad's *Heart of Darkness*, makes when trying to tell what may have originally motivated his difficult voyages:

> Now when I was a little chap I had a passion for maps. I would look for hours at South America, or Africa, or Australia, and lose myself in all the glories of exploration. At that time there were many blank spaces on the earth, and when I saw one that looked particularly inviting on a map (but they all look that) I would put my finger on it and say, When I grow up I will go there . . .

That is, a map seems to say to you, don't

just stand there—and it's your imagination that does something.

> But thou at home, without tide or gale,
> Canst in thy map securely sail,
> Seeing those painted countries, and so guess
> By those fine shades their substances;
> And, from thy compass taking small advice
> Buy'st travel at the lowest price.

Robert Herrick wrote this in an age of lively exploring and vivacious mapping. Although he was an armchair voyager he loved his English countryside, and he and his countrymen did not just sit there—that countryside is one of the most beautiful and most beautifully mapped in the world.

Shut in one cold, rainy day in Scotland, a young man and a boy amused themselves by painting pictures—that is, the boy painted pictures. The young man, more boylike than his companion, drew a map of an island, one which he had never heard of or seen. But the longer he looked at it, the more real it became. Its story unfolded in his mind—*Treasure Island!* Stevenson's first novel was inspired by a map.

Many of the most inventive novelists draw maps while writing, so that they may keep before them the whole scene of the action and make their fiction as credible as history to the reader. In fact, the story "plot" is essentially a map idea. Navigators speak of "plotting" their bearings or courses on their charts.

A map need not be fanciful to stimulate our imagination. The most matter-of-fact maps, accurate down to the microscopic fraction of an inch, often do more for true map-musers than some of the pictorial maps with their sentimental overstatement and whimsical prettiness.

In contemplating maps, whether already made or about to be made, the imagination is a vital activity. And it leads to practical action. A map-musing Marlow must eventually do something to fill in those blank spaces. Thus maps breed more maps. For no map is ever quite complete, and instead of trying to be the map to end all other maps, an honest one that is performing its certain service well deliberately leaves need for further maps to use. There is also as much to understand about what a given map won't do as about what it does. Much of this further performance we may first imagine before we decide we need it; but in any event, once the need is apparent, our imagination as well as our reason must go to work solving the consequent problems.

The idea of such a thing as a map is at once one of the most primitive and the most civilized of human feats. It is both a yen and a conception, like such other old but ever new ideas as music and dance, myth and fiction, image and depiction, thought and symbol.

Every map is a tacit "as if" or, as children say, "Play like—" or "Pretend." This is absolutely necessary because the exact duplication of a place or area is obviously futile. Yet many people who are otherwise literate can't read maps simply because they expect such duplication; they just won't "play." They are like people who can't, or won't, read a story unless they can be assured that it is "true," that it "really happened." Such people can't, or refuse to, understand that the truth itself is one thing and the process of *showing* it is necessarily something else. Or, less abstractly, let's say it's the difference between the fact of a river, which is if anything wet, and the wriggly line that symbolizes it on a map and has got to be dry. A map must therefore be a simile or metaphor if it is to tell us what we need to know. A map has as much right to be *figurative* as spoken or written language has; it too is language.

Actually, there are often many truths in a place or an area right before our eyes, and yet we're not aware of those truths (or features, or facts) until a depiction or a symbol or

even a diagram *shows* them to us. That is one reason why we need maps not only of far-away places we've never seen but of the very regions we live in. Just as in the days of Sophocles and, centuries later, of Shakespeare people enjoyed the great plays all the more because they already knew the stories and wished to realize them anew for further satisfactions, maps have most to tell to people who already know some geography.

Map-making is almost as irrepressible in us as making gestures to bring out the full meaning of what we have to say. People who might back away from reading a map or diagram will lean forward to draw one for you rather than let you go away unimpressed. Restaurant owners have to tolerate the figuring and mapping done on their napkins and tablecloths by customers explaining various journeys, land-use projects, military strategies, etc.

The curious fact is that the word "map" itself comes from the word that the Romans used for napkin. And they got this word, *mappa,* from Carthage (today, Tunis), where it meant "signal cloth." The word "chart," like the word "card," goes back to the Greek word *chartos,* which meant "leaf of paper."

Probably because of the technical applications associated with the term "chart," the science of making maps—from surveying to drawing—has come to be called *cartography* (chartography).

And because of their instructive aspect, charts and maps impress people as being authoritative. Somewhat as mere print does. In spite (or because) of the dread too many people feel in trying to read them, maps can have a mighty influence. A map-maker once put down the name of the wrong explorer as being the one after whom a vast region was to be named. The name stuck, even after the cartographer himself and the public must have recognized the mistake. That region was the

New World and the name was America! (History makes maps, and they in turn make history.)

This power of maps is quickly seized upon by propagandists for swaying and often misleading the public. The wily demagogue in the pretense of doing something "educational," or of showing "scientific proof," will issue falsified maps, or maps with alluring devices for deception, or maps that may be correct for a certain period or a special purpose but which in his hands are just as dangerous as an altered crossroads sign.

Maps are supposed to give information, but they can also put up an argument. This argument will appear so convincing that only another map can successfully refute it. The "our-side" areas can be played up in attractive colors and in central positions, while the "other-side" areas can be made to look dreary, insignificant, or like looming menaces. With small print or with illegible lines, maps can suppress certain features while having other features boldly obvious and thus emphasize particular facts or relations so much out of proportion that they are no longer the truth. Frederick the Great had some maps of Silesia printed with uncorrected mistakes, so as to mislead his enemies. Sometimes the "scientific" detail will be laid on so thick that the layman, unable to read the map, will think that it must be somehow accurate beyond his ken, though it's mostly fake.

"Maps confuse me" then becomes a legitimate complaint against them. Badly made maps, whether because of bad intentions or of bad work, *are* confusing. (And so are ugly maps.) But people afflicted with cartophobia hold within themselves the usual sources of confusion.

One of these, as already mentioned, is the unwillingness to put the imagination to work by giving it play: reluctance to proceed on a supposition or to invite the hypothetical. Con-

fusion and diffidence arise mostly, though, from not knowing the first thing about how to look at a map.

The first thing is most natural and simple: seeing the map as whole. This is how we ordinarily first see a person (infinitely more complicated than any map) or a sculpture or a mountain or a spread of country viewed from a mountain top. This was the first and only view of the land of Gilead the Lord let Moses have at the end of an arduous career much concerned with geography, and that overall view had to suffice. "I have caused thee to see it with thine eyes, but thou shalt not go over thither."° It was a *comprehensive* view: "all the land of Gilead, unto Dan," which could well be the title of it as a map. And weary old Moses, who probably had never seen a map, must have comprehended the terrain as such.

The first look at a map is a similar overview, a prospect entire. Once we have that, we can confidently permit ourselves to look into its parts.

This prime relationship of any part to a whole is a profound as well as simple concept in making and using maps. The total meaning of anything is always simpler and more easily retainable than the multitude of smaller meanings that constitute it. It should be the first and the last one to note. This total meaning gives us the continuous clue to the parts, just as the thread of Ariadne helped Theseus through the complications of the labyrinth.

It actually simplifies the parts for us. By the way in which it holds those parts together as a plan on paper it also holds them together as an idea in our minds. This "holding together" is an integrating framework, the first characteristic about the map as a whole of which we advantageously take note, and this integrating framework is therefore the subject of the first chapter in this book.

° Deut. 34:4.

There is gratification in knowing that each part is related to the whole and that it is also responsible to the whole. If it isn't, it's virtually lost; consequently, so are we. We can't map any part of the earth's surface truly and safely without depending upon a reference to the whole sphere. The very making of a map begins with the integrating framework. Not only that, but the details too, a cartographer draws into the map by beginning with the larger ones and proceeding to the smaller and smaller. That's what a reader's eyes will do if he will but let them without interference from map fright.

There is an important reassurance in realizing the definite connection between one's own back yard on the surface of the earth and the position of our planet in the vastness of space. If you wish to locate for sure the point where you stand, you'll have to refer to those glittering far-off points, the stars. And when you do, you'll naturally ask to have some kind of integrating framework for them too. It's the only way of being sure not to get lost in the infinite extent of space.

This connection between local pinpoints and cosmic points is one of the majestic relationships recognized by science. Considering how much the mere idea of a map encompasses, maps are probably more *unconfusing* than anything else put down on paper. A map should be regarded as an antidote to panic, not an occasion for it. In the midst of storm, battle, and political turmoil, the map is a spot of calm and reason.

Terrestrial maps show more than just the earth itself. Our back yard is a vast area to a caterpillar as he toils over hills and through the weed jungles. In his entire lifetime as a crawler he will never see more than a small portion of this realm. He can have no idea of it as a whole. No mind for maps. And there is more to a map than a bird's eyes can view. For any given area many different kinds of

maps are possible. There are soil maps, tree maps, and maps of the migrations of birds. Maps can give not only a horizontal aspect of the earth, its surface, but also a vertical one, its heights and depths that tell its story. Maps show time as well as space, history as well as geography. They must show weather, past and future, to guide the plow and the propeller. They must show, not only the works of people—cities, canals, bridges, dams, transmission lines—for which the technical term used by cartographers is "culture," but also the laws and thoughts.° A political map—districted according to the voting behavior of various sections of the public—tells the politician what to expect and the public how to beware. Another kind of map shows the businessman the buying habits here and there, and the consumer the business methods. There are maps that guide public health, charting the occurrence of diseases, accidents, and different types of human excellence. There is no walk of life without a guide in the form of some kind of map.

The famous poetic equation that John Keats made for beauty and truth when he brooded over a Grecian urn is also effectual in the fine maps. In some of the plainest—those without ornamentation, glamorous coloring, fantastic

° See "A Map of the World's Law," by John H. Wigmore, in the *Geographical Review*, Vol. 19, 1929, pp. 114–20.

symbols, or antiquarian associations—there can be beauty. The beauty of truth. It is similar to the kind of truth that is beautiful in a musical composition. You will perceive it at once, also, if you know and enjoy mathematics. If you can't understand math, though, you can no less quickly respond to the ways in which a good map has confronted the complexities of nature and idea, and resolved them so as to form a necessary design. A design whose whole duty is to signify. What it signifies cannot be told in any other way. The map is unique among the modes of human expression.

It is a tool for geography, astronomy, and the many other studies and activities prompted by the momentous little adverb, "where." As the invention of tools is epochal in human history, the invention of the map, which is probably the first intellectual tool, is preeminent in human development.

The use of flight and light, electronics, and of surpassingly productive mechanical mathematicians in the making of today's maps is putting into the hands of both the advanced scientist and the first-grade child cartography better than any dreamed of before.

As maps become less strange to us they grow more wonderful. So we take them into our homes to make ourselves more at home in the universe.

ABBREVIATIONS

A.M.S.—Army Map Service

A.G.S.—American Geographical Society

B.L.M.—Bureau of Land Management

FM—Field Manual, Department
of the Army

N.G.S.—National Geographic Society

PL—Price List, Superintendent of Documents, Government Printing Office

RF—Representative Fraction, or Natural Scale

TM—Technical Manual, Department
of the Army

U.S.C.G.S.—United States Coast and
Geodetic Survey

U.S.G.S.—United States Geological
Survey

U.S.N.H.O.—United States Navy,
Hydrographic Office

Contents

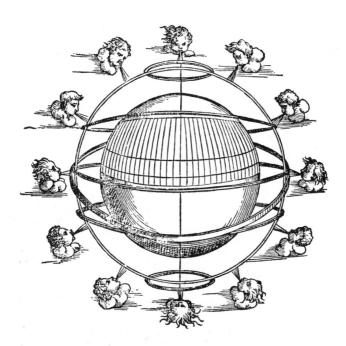

Armillary, or skeleton, celestial sphere containing terrestrial sphere,
a zone of which is embraced by the grid of Ptolemy's Conic Projection.
From an edition of his Cosmography, *printed at Venice, 1562,*
and reproduced by courtesy of the Rare Book
Division of the New York Public Library.

Part I
Getting the Most
out of Maps

I. How to Find Places:
COORDINATES

MAPPING MIGHT well be called "The Science of Whereabouts."

A basic principle of this science is to take note of recognizable things. The simplest application of this principle is the use of landmarks. We use landmarks every day, in all our goings from one place to another, even within our houses and even in the dark.

Airpilots use landmarks—and some of their charts help them do so—in contact flying. Sea pilots watch for familiar or remarkable features on coastways.

At night there are beacons. When fog obscures the visual features of certain water routes, there are horns and bells whose tones the pilot can recognize as belonging to definitely located buoys and stations. And sometimes in the absence of these the pilot, especially in bays or inland waters, can ascertain his whereabouts by definite smells: a gasworks here, a chocolate factory there, etc. A good dog on the scent uses this principle of location, and that speaks well for it.

But the application of a principle can be frequently useful and yet not wholly scientific. Science means *knowing*. Landmarks, familiar features, and oddities in shape do not enable us to know enough about the location of a point anywhere. In order to know exactly where a place is we must have a way of knowing its position in space. This space may be the depth of the cosmos or the surface of the earth. It may also be the surface of a sheet of paper.

Finding the exact location of Rome on a map is not merely a matter of looking for a boot-shaped land and pointing to a place halfway up the shin. And Wake Island! Just where shall we look for *it*? No familiar land forms to go by, either on the map or on the broad Pacific. . . . For that matter, how would we know our exact position in our own back yard? Just where are we standing in this yard? We may notice that the yard is framed by a fence. Why not refer to this frame? If lines were drawn from the second post of the back fence and the third post of the side fence, they would cross just where we are standing.

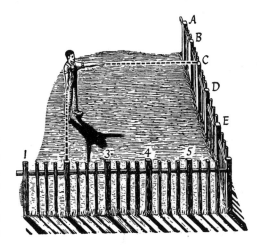

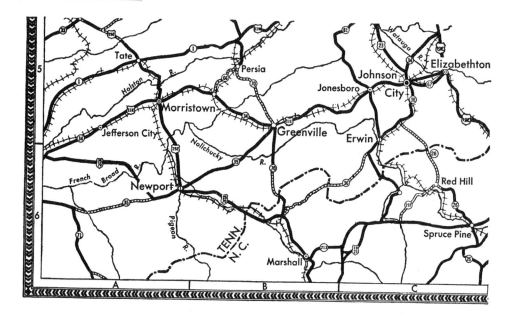

And that, essentially, is an application of our basic principle! What we did was make of that fence what scientists call a "frame of reference." Whenever they wish to find out where and what a thing is—to explore, or "isolate" and "investigate" it—they start out from a framework. They set it up so that they can have something definite to refer to, like the No. 2 and No. C posts in our fence.

There are several methods of using this reference-frame principle for maps. A map-user should know them all. They are easier to learn than they appear to be.

One of these methods you no doubt know already and have often used when consulting city maps, road maps, and atlases. The "fence" or reference frame is the frame of the map. The "posts" are guide-marks: numbers on two facing sides, letters on the other two facing sides of the map. Along with this is an index of the names of places to be found on the map.°

° Corner of a highway map, with original guide marks altered and certain deletions. Courtesy of Department of Highways, Commonwealth of Virginia.

Suppose we wish to find Greenville. We look it up in the index, where we are given the terse reference, "B-5." But it's all we need: in less time than it takes to tell how, we locate Greenville where a line from B crosses a line from 5.

An easy, handy method. Even when a map already has a more geographical system of guide-marks in it, we often like having this index method added for quick reference.

Its limitation is that if you change the size of a map, or the shape, or shift the focus, you can't use the same guide-marks. Different publishers for different good reasons print these marks differently on their different maps. Thus, if anyone should ask where Inaccessible Island is, *exactly*, the answer "3-F" would not tell him anything unless he happened to have the map this reference was especially made for. These are merely printer-made guide-marks *added* to a map. The surveyors who measured the ground and the draftsmen who drew the map did not use these marks and most probably did not even have them in mind.

Some cities have their street-name system

4

made up of numbers and letters. Numbered streets may run in one direction, and lettered streets in the cross direction. To locate "Fourth and D Streets" is easy, whether you are looking for it on paper or on pavement. You can't help thinking of the guide-marks as being in the ground itself. Not just in the frame, but in the picture. These streets usually are surveyor-made guide-marks.

Or take another town layout: the thoroughfares going east-and-west called avenues and those going north-and-south called streets. That, too, is a town which is its own map.

Maps of either of these towns can have any size, shape, or emphasis; but the guide-marks remain the same for all the maps.

RECTANGULAR COORDINATES

Perhaps you have noticed that crisscross reference-lines resemble a gridiron. So the soldier very graphically calls them GRIDS.

Note how the grid lines are numbered. The lower left-hand (or southwest) corner is the ORIGIN and from there the numbers read to the right, or eastward. And also from there they read up, or northward. The soldierly way

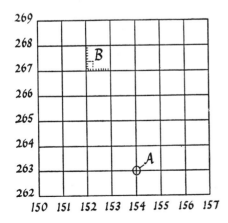

to read grid maps is in just this order: first to the right, then up. So he memorizes the phrase, "Read right-up."

Where's point A? First, reading right, 154. Then, reading up, 263. Point A is at 154–263.

Suppose we have to give the location of a place that's not spang on an intersection, such as point B, which is in the vicinity of 152–267. All we do is tick off ten smaller divisions on two sides of the small rectangle there. Then we can correctly say that the location is three ticks east of line 152 and four north of 267. Or more tersely: 152.3–267.4.

These ticks may stand for feet, yards, or meters—or longer units. Ten, of course, is useful because the tenths fractions and the decimals are easy to make, state, and understand.

The beauty of using these orderly lines to find and fix places is that the lines *coordinate* so well on the job. A horizontal line coordinates with a vertical line, the way two persons would in trying to catch a rabbit by cornering it. Map experts call these lines COORDINATES.

In the grid system, the horizontal grid line, going from west to east, is called the x coordinate. The vertical, going from south to north, is the y coordinate.

Because the lines cross to make rectangles, surveyors speak of them also as rectangular coordinates.

This is but the simplest form of a grid system. Grids have other aspects and vary in form to serve certain uses and users.° Some of these aspects and variations will appear later as we deal further with the structure of maps.

For the present, let's take stock of the terms that have been piling up. Guide-marks. Reference lines. Synonyms, yes, but the second term implies not only guidance *toward;* it also

° For detailed explanations of military grids, see the latest publications by the Department of the Army, such as *Map Reading* (FM 21–26) and the Field Manuals and Technical Manuals dealing specifically with grid systems.

implies *back*. Take the word apart: *re* = "back" and *fer* = "bearing." To bear back to something, from a frame of *refer*ence (or from anything else that pertains) is a way of understanding any whereabouts. It's one of those things that are so obvious that we forget we ever knew them, and so we must be reminded. The concept of *reference*—bearing back—is a useful one to keep in the front of our minds throughout our acquaintanceship with mapping.

Cartographers use another synonym: *index.* Like the index of a book, index lines indicate specific details inside a map. In making maps, experts try to get all the indexes they can, and in reading maps the rest of us had better look for as many as we can. The more important the map, the more accurately must its reference lines and index lines and index points coordinate. They themselves must be particularly accurate. When they are so accurate that we can have complete faith in them, they merit the name of *FIDUCIAL.* Fiducial points or marks are what mappers must first establish in order to be sure of proceeding wisely a bit further.

BUT THE WORLD IS ROUND: SPHERICAL COORDINATES

If the whole world were flat, like our back yard, this scheme of rectangular coordinates would serve all map purposes. But with a globular world we have to develop a set of coordinates which fit it just as snugly and precisely as a grid fits a flat, rectangular surface.

A rectangle has four sides to act as a reference frame to mark off from. But what has a globe? It begins nowhere and ends nowhere.

But it moves. The earth turns on its axis. It has poles. They are definite points. Just as the center of a circle is a definite point from which

you can measure, lay out, divide, and locate places within a circle, so the poles are definite points for measuring and locating everything and anything on the surface of the earth.

Midway between the poles we imagine a line like a belt around the middle of a fat man. Equator is just the right name for it: it *equates* the globe in north and south halves.

Poles and Equator. That is all we need for a frame of reference to build up as neat a system of coordinates as anybody could ask for.

The Equator is the largest of a series of circles like the circles on a target. And the Pole (North or South) is the bull's-eye. The biggest circle is numbered 0 and the bull's-eye 90.

These circles are parallel to each other; so they are called *PARALLELS.*

What they do is show how far anything is from the earth's base line, the Equator. North or south. If, for instance, you find an island

on the third line south and that parallel is numbered 30, then the position of that island is 30 S. That, strictly speaking, is its *LATITUDE*. That's all latitude means: how far north or south of the Equator.

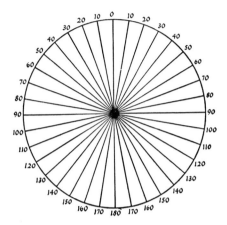

know the distance before or behind them by the lines that *cross* their path on the map-grid.

If you are flying along a certain parallel, it would be your *path* but not your distance marker. The meridians which cross your path would mark how far you've gone *longitudinally*. East or west.

If you are flying along a certain meridian, it would be your *path* but not your distance marker. The parallels which cross your path would mark how far you've gone *latitudinally*. North or south.

If you are at the North or the South Pole, the meridians radiate outward from your position, the same as if you were standing at the center of a circle. In the Arctic or the Antarctic Circle, the radiuses are meridians. They are *polar coordinates*, for you can measure a distance outward on any of them to locate any point around you, inches or thousands of miles away.

In the same way as the rectangular grid coordinates have the symbols x and y for the east-west and the north-south lines, respectively, the coordinates of the spherical graticule° have the Greek letters ϕ (phi) for latitude and λ (lambda) for longitude. If you have any difficulty remembering which of these symbols stands for one or the other, perhaps the nonsense word "phlatitude" will be of some help.

Look now at the other set of lines. They are semi-circles which swing from pole to pole. They mark off the globe much as the section-lines do on a melon or on a peeled orange. These lines are *MERIDIANS*. If you call one of them the zero meridian, you can count left or right, west or east, from it to see how far around the melon or the world a spot is. That's its *LONGITUDE*. That's all longitude means: how far east or west of the zero meridian.

The latitude and longitude lines are a terrestrial system much like our own town system of avenues and streets.

If you are flying northward or southward, you count the *parallels* which cross your path. Latitude.

If you are flying eastward or westward, you count the *meridians* which cross your path. Longitude.

Just as a football player on his grid knows his distance from a goal by the yard-lines which *cross* his run, so the traveler and map-user

° This is the term adopted by the A.M.S. for "any organized framework of latitude and longitude used for maps." *Map Intelligence*. (2d ed.; A.M.S. Training Aid 6, 1954), p. 57.

BUT WHY DEGREES?

Take this conversation:
"How much string do you want?"
"Oh, I can use about five feet."
And this:
"How much pie do you want?"
"I can eat about a quarter of it."

Here are two different ideas of measurement. The first is so many units: feet. The other is so much of a whole: a fraction. That's what a degree is, a fraction of a circle.

If we know the fraction of a circle of pie or of the world, we can readily know how much there is to the rest of the circle. Also, that fraction, say, ¼th, would be the same fraction for every circle, no matter what its size. So with a degree: it is 1/360th of every circle in creation, from the tiniest wheel in the tiniest wristwatch to the largest orbit in the heavens.

On our round world, regardless of how good a mile-count we might keep, we must know *what fraction of* the earth circle we are distant from the zero lines in order to have a definite idea of our location.

But why *360* degrees?

One of the favorite amusements of the ancients was watching the many-ringed circus in the heavens. They noticed things went round and round. The moon came around and disappeared about every 30 days. They called that moon-round a month ("moonth"). If they began counting those "moonths," as they naturally might, in spring, they found it took 12 "moonths" of waiting from the first bird-peep or star place of one spring to the first such of the next spring. They called that a year—a round of 12 times 30, or 360. And as naturally as they divided the circle of the year into 360 *days* they divided every possible other circle under the sun (and above it, too) into *degrees.*

By counting these divisions we can tell the size of an arc. Or of an angle. For what is an angle but a couple of radiuses of the same cir-

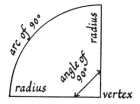

cle? (Don't balk at this bit of geometry. *Geo* means "earth," and *metry* means "measuring.")

Let's see how these degrees work.

Opposite is a picture ° of the earth with a chunk cut out of it from the North Pole to the Equator. The spot we are locating is Sydney, Canada. Notice the (local) parallel passing through it. A line drawn from that parallel to the center of the globe makes an angle of 46° with a line drawn from the center of the earth to the Equator. That is the *angular distance* of Sydney from the Equator, 46° North. That is its latitude. As simple as that. Whenever you think latitude, think of an angle like this, and you'll have the right idea.

The latitude angle gapes north and south.

Look again at the illustration. Note the meridian passing through Greenwich. Note also the meridian passing through Sydney. These two meridians mark the sides of the cut-out portion. These two sides form at the axis of the earth an angle of 60°.

Therefore, we say that the Sydney meridian is an angular distance of 60° from the Greenwich meridian. Sydney is 60° west of Greenwich. That is the longitude of Sydney: 60° W.

The longitude angle gapes east and west.

THE PRIME MERIDIAN

The right name for the zero meridian or longitude 0° line is the *PRIME MERIDIAN.* Unlike the Equator, there is no *earthly* reason why the Prime Meridian should be where it is rather than some other place. The Equator is where it is, because it is halfway between the

° After the Department of the Army.

poles and nobody can change the poles. No-body can shift the Equator so that he will have the prime parallel run through his capital city

But the Dutch city of Amsterdam has passing through it a Prime Meridian that is 4° 35′ east of the Greenwich meridian. Here are

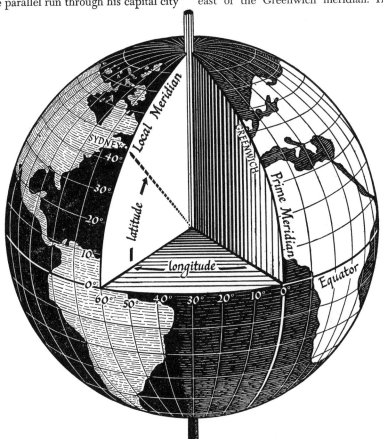

and thus give prestige to his nation. It is not an arbitrary line.

But the Prime Meridian is. It can be any-where that a world power has a mind to put it. Spain has had it pass through Madrid. And when her explorers sailed westward they reck-oned longitude from the Madrid meridian. You can't blame them: they wanted to know how far they were from home, and that was their home meridian.

The Prime Meridian used by Americans is one that passes through Greenwich, England.

some other Prime Meridians you may see on foreign maps:

Location	Longitude Angle (East of Greenwich)	
Athens	23°	42′
Brussels	4°	22′
Copenhagen	12°	34′
Istanbul	28°	59′
Lisbon	99°	11′
Moscow	37°	34′
Oslo	10°	43′
Paris	2°	20′
Peking	116°	288′
Rome	12°	27′
Stockholm	18°	18′
Tokyo	139°	44′

COORDINATES

The Greenwich meridian is the most generally accepted one. Look closely at this meridian where it cuts through southeast of London, in a part called Greenwich. If you were flying on that meridian and descended there you would come to a hill. On it is a famous observatory directed by the Admiralty, primarily for the advance of navigation. Here for years scientific workers have made observations of help to navigators and map-makers; and now in modern times they flash sea news, star news, and globe news around the world and across the poles for the benefit of all who have the serious responsibility of knowing their meridians. No wonder, then, that Greenwich has become a kind of home-plate for seamen and airmen, the navigation capital of the world. Globe-girdlers riding the waves and the clouds have become used to counting *from* Greenwich by counting *upon* it. They imagine a line passing through it, and the line as soon as they use it becomes real. The Prime Meridian.

From the sky the ancients got their cue for measuring the circle. They got from the same overhead source the idea of a globe.

Thus, the first spherical maps were star maps. The old-timers pointed their plows and their prows at a certain star to make sure they were going right. And so do we new-timers—with our airplane noses. To this day we use that star map. It has poles connected by meridians and, crossing them, an equator with parallels. In fact, the trick is to imagine the earth in the center of this celestial sphere in the same way as you can imagine yourself in the center of the earth globe.

Living within this imaginary sky-cage, the ancients would say when the sun reached its highest point in the daily swing across the heavens, "medius dies." Middle of the day. People kept on saying "medius dies" for so many generations that the phrase got worn and re-shaped into the word *meridian*.

A meridian, therefore, is a noon line. Our common abbreviations A.M. and P.M. refer to this line: *Ante,* meaning "before" meridian; *Post,* meaning "after" meridian.

When the sun stands high on the Greenwich meridian we can think of a great shining zero. Greenwich's longitude. The observatory flashes its time signal to timekeepers, navigators, earth-measurers, and all around the world. "Noon here!" it seems to say. "Where are you?"

At that very moment, in the Antarctic, some airmen doing exploration hear that signal. They are so far south that the sun is in the north for them. But it is also noon there. And by this they know they are on the same meridian as Greenwich. Longitude 0°.

Notice again on your globe or world map how the meridians are numbered off from the Prime Meridian. They are usually counted by 15's. This is why: the earth takes 24 hours to complete a turn of 360 degrees, through a day and a night. Divide 360 (degrees) by 24 (hours) and you get 15. That's how many degrees the sun goes across the sky in an hour. Those meridians on your map are spaced, therefore, to represent one hour's turning of the earth toward or away from the sun. Toward or away from noon.

Stand on this turning earth of ours and watch the sun for 4 minutes; in that space of time it will "move" in the sky 1 degree toward your local meridian or away from it.

All this sky-measuring is earth-measuring too. Finding your longitude is merely a matter of comparing noons with Greenwich. You are just as long a distance from Greenwich as your noon is long a time from the Greenwich noon.

If your noon comes before the Greenwich noon, you are east of Greenwich. For instance, the sun is on your meridian (12 noon) and you hear Greenwich radio 10 A.M. Then you are two hours before, or 30° east, of Greenwich. The earth must turn two more hours before

the sun will shine on the Greenwich meridian.

If your noon is after the Greenwich noon, you are west of Greenwich. Suppose the sun is at high noon on your meridian (12 noon to you) and your chronometer, set to Greenwich time, says 6 P.M. That means the earth has been turning six hours since the noon at Greenwich, and 6 times 15 is 90. That's your longitude west of Greenwich, 90° west longitude.

And if it's noon to you when it's midnight at Greenwich, you are clear on the opposite side of the world at long 180°.

Thus time and space are partners. Maps are a combination of time-lines and space-lines.

Whether you go east or go west from 0° those meridians are marked off with a higher figure until they reach the 180th. The 180th is the greatest longitude. It is the farthest you can get away from the Prime Meridian. And that is halfway round the world. Half of 360. It is just as far east of zero as it is west of it. When you get to that line you are both east and west at the same time! When mariners cross that line in the mid-Pacific, they say only 180°, and let it go at that: no need to say east or west. There is only one 180° line on the map. Incidentally, that hill in Greenwich is just 180 ft. high.

THE EARTH AS A CLOCKFACE

The 180th meridian is not only halfway, but also a *half day* around the world from Greenwich. For the earth turns through one half a day in 180°, which is a half circle.

When the day is at high noon at long. 0° it is at midnight at long. 180°.

Just as wherever on earth the sun is at the meridian, morning ceases and afternoon begins, so wherever on earth midnight comes, the "old" day dies and a new day is born. This happens at long. 180°, same as anywhere else.

But long. 180° has a unique distinction. It is the International Date Line. Exactly what

that means, and why, is easy to make out, once we see what happens.

Let's watch midnight and noon take a complete, 24-hr. turn upon the face of the earth. The *clock* face of the earth. For if we can imagine ourselves far above the North Pole, the earth from that view is but a disk, and with the imaginary midnight-noon indicator across it, it is also a dial.

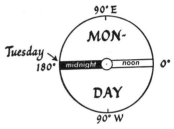

Noon at Greenwich, 0°, and midnight at the Date Line, 180°. As midnight strikes, the day there changes from Monday to Tuesday.

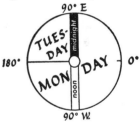

Tuesday, which begins at the Date Line, is now 6 hrs. old, and is a fourth of the way around the world. As the midnight line passes the 90° meridian, Tuesday "arrives" there. Monday gets "smaller."

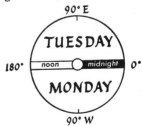

The midnight line arrives at Greenwich, and Monday there becomes Tuesday. Tuesday is

now 12 hrs. old, has gone halfway round the world and has lived half its lifetime. It is noon now at the Date Line, Tuesday on one side of it and Monday, the "old day," on the other side of it. Meanwhile Monday gets smaller smaller—

and smaller—

until it is no more.

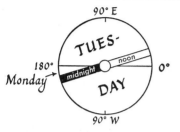

For Wednesday is born at midnight on the Date Line, and it begins to take in the world,

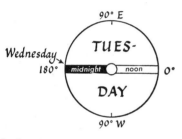

hour by hour, while Tuesday, now the old day, gets smaller and smaller, as did Monday.

Thus it takes a map to tell of time. The difference between today and tomorrow is something on the map as well as on the clock.

As we've seen, the new day's scope begins at the 180th meridian and extends clockwise to as far as the midnight line has gone. So, there are always two days going on on the earth at the same time. And the 180th meridian divides the new day from the old day. That's why it's called the Date Line.

If you cross it going toward Asia, or Australia, on Monday noon, say, you sail into Tuesday. Turn around and come back and you'll go from Tuesday back into Monday. No matter

what the hour of the day might be, the old day is on one side, the new day on the other.

That's true also of the midnight line, but the midnight line *moves* around the earth, stretching the new day along with it and squeezing the old day out against the International Date Line, which stays put.°

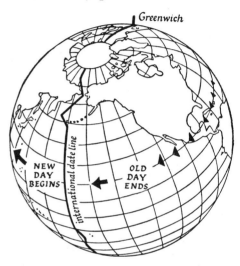

That line is kinked a little here and there, so that certain places can enjoy the same day of the week as the rest of a nation does.

The entire terrestrial clockface is divided into 24 hours, or *time zones* of 15° each.

The central meridian of each of these zones is a time meridian. In conterminous U.S. the time meridians are: longs. W. 75°, 90°, 105°, and 120°.

The boundaries of the standard time zones in the U. S. have jogs for somewhat the same reasons as the International Date Line: local allegiances, interests, and working schedules. Some of these jogs are made to enable the **transcontinental tourist to change his watch-time at a railroad point instead of at the geographical meridian marking the zone's bound-**

° Illustration made for the *New York Times* by the Pictograph Corporation.

ary, which likely as not crosses the track at no special place.

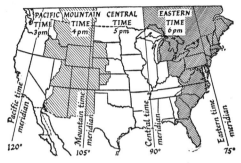

Standard time zones in the United States

DETERMINING LATITUDE AND LONGITUDE

If parallels and meridians are imaginary lines on the earth's surface, how can we know for certain where they are? That something imaginary may be also precise seems a self-contradiction. Yet it is so.

Men worked out a way to find the latitude of a place many centuries before they could do equally well with longitude. In the old-time maps, the latitudes are often fairly correct but it's their longitudes you cannot trust.

You don't have to do any traveling to measure your latitude: you can stay in one place and let the heavenly bodies travel for you. And by measuring how high they are in the sky you can by certain other astronomical computations tell how many degrees you are north or south of the Equator. Each noon the sun appears a little higher or lower on the meridian line, according to where you are on earth on a definite day of the year.

Exactly what do we mean when we say one star is "higher in the sky" than another?

The height of a heavenly object above the horizon line is its *ALTITUDE*. You can't meas-ure that in feet but you can in degrees. It's simply a matter of how many degrees in the angle at your eye if one line goes from your eye to the horizon point (on the same level with you) and the other line goes to the sun or star. Navigators have an angle-sighting device, called the sextant, with which they find the altitude of the sun at high noon. "Shooting the sun." They check this angle with some astronomical tables in their nautical almanac for that year. These tables show just how far north or south of the Equator a place is if at noon of a certain day the sun is a certain number of degrees above the horizon.

In the northern hemisphere the altitude of the North Star above your back yard is your latitude! At the North Pole, lat. 90°, this star's altitude is 90°—right above your head. But at the Equator its altitude is zero, and that's zero latitude. Thus if you can rig up a large enough protractor to sight the angle of the North Star, and find that to be, say, 38°—that's also your latitude. (Roughly, of course, since that star is *not quite* at the celestial pole.)

Finding longitude is really simpler, but without a good timekeeper it's just about impossible. For you can tell how many degrees you are from your base meridian only by knowing exactly what the time is there when the sun is at high noon on your local meridian.

Without good timekeepers and ships that make good time, the east-west going once held more uncertainty for people than the north-south voyages, which were short, as from England to Italy. So along with dreadful monsters and falling-off places, the idea that the world was *longer* east-and-west than north-and-south took hold.

Not until 38 years after Columbus made his "long" voyage did anyone even point out that a navigator could use time as a factor in finding longitude. For no one dreamed that a timepiece could be made which could be set at a prime meridian and trusted to keep accurate

13

time for weeks at sea, in all kinds of weather and changes of temperature. And not until around 1735 was there actually such a chronometer. The inventor and maker of it was John Harrison, an English carpenter who had taught himself the sciences. His chronometers kept good time within 3 seconds a day, after weeks at sea.

Further correcting of world longitude determinations, however, had to await another invention, the radio.

Maps are first made in the sky. There is star work and sun work in them. The very word *consider* meant, originally, to observe the stars. You really have to "hitch your wagon to a star" if you wish to get anywhere.

A GRAND NETWORK

If you are on the high seas far from any landmark, your latitude and longitude are the best answer to the question, "Where am I?" Or if you wish to guide a plane, flying blind or above clouds with no visible marks to go by, you must know the latitude and longitude of the points of your departure and destination. The rest is heading accordingly and staying on the course. That may be on a radio beam or a combination of star beams as well as on certain compass lines. All these beams and lines are but these map-coordinates acting in electrical, astronomical, or magnetic roles.

So what we have is a reliable set of coordinates for locating any and every place on this great old ball. Wherever a certain numbered parallel crosses a certain numbered meridian that's where a certain place is; nowhere else.

These lines cross in a regular network. If they were printed only one degree apart on an ordinary sized globe the lines would come so close together they would smother the countries from your sight. That is why only every 5th, 10th, 15th, or 20th degree is shown.

But on the huge earth-globe, a net of lines only 1° apart would be far too open a mesh for practical use. Some spaces would be as large as 69 miles each way. And in navigation or avigation a craft's position must be precise to the fraction of a mile.

For that reason we divide the degree—by 60. Each of these 60ths is a minute. (Symbol: ′) Not a clock-minute of course: "minute" also means "little." Even this little is not small enough for scientific locating. We must divide the degree a second time, and each of these divisions is a second. (Symbol: ″) A second is a 60th of a minute.

That makes a network of so small a mesh with which to cover the earth that no place can slip through. For even the second can be broken down into decimals. For instance, the Washington Monument with its square base of 55 ft. 1½ in. is located at lat. 38° 53′ 21.681″ N, long. 77° 02′ 07.955″ W. That's getting things down pretty fine.

This is where the geodetic engineer comes in. Before anybody can divide a sheet of paper into reference lines to make a map, on which to put the exact location of a place, he must know the exact location of that place with reference to certain lines that divide up the earth itself. Geodesy means literally "earth-division." The geodetic engineers are not only earth dividers but world integrators, for their network of survey lines ties the humblest village in with the grand world scheme.

Their regular work takes in applied astronomy, oceanography, seismology, terrestrial magnetism, gravitational physics, and *the figure of the earth.*

You come across that last phrase again and again among these men who do the actual groundwork for maps. It has not been easy, figuring out the earth's figure. Spinning at the rate of 1,000 m.p.h., at the Equator, the earth naturally bulges a little there—from sheer centrifugal force—and flattens a little at the poles.

This makes the diameter through the Equator almost 27 mi. greater than that through the poles. We haven't a perfect sphere to do our geodetic surveying on. On a 30-in. globe this difference in diameters would be only 0.10 in. Still, a tenth of an inch is not invisible on a map. And in actual survey lines of any extent it amounts to hitting or missing something.

Not only does the Equatorial circumference differ from the meridional circumference, but all the intervening ones differ also. In former times, these differences did not count for much in practical matters. Today they do. The calculations necessary for such up-from-earth affairs as supersonic aeronautics, space vehicle re-entry plottings, long-arc guided missiles, and precisely orbited satellites often require the utmost accuracy in earth measurements. It is easier to read the most complicated map than to read the roundness of this planet.

The earth's curvature is much greater than most people realize. Although it is only 0.7 ft. in the first level mile, it is 2.7 ft. in the second mile of level distance, and mapping surveyors must sight considerable distances through their instruments. For instance, on the clearest day, a person 6 ft. tall, standing at water level and gazing across a 6-mi. bay, cannot see

detic service to make basic surveys for maps. The United States Coast and Geodetic Survey goes all over the states and possessions nailing down a network of map coordinates.

Triangulation mark

Perhaps, while tramping through the fields or snooping about town you have come upon one of these "nails." The head of each is a bronze disk about 3½ in. in diameter, and it is likely to be securely fastened in a rock outcrop, or a concrete monument. At the bottom of this monument, which goes 4 ft. down in the ground, is another bronze disk exactly the same as the one above, so that if the top one is stolen or effaced, the bottom will still mark this geographically strategic spot.

This spot is a "monumented survey station." If the mark has a triangle in the center, there

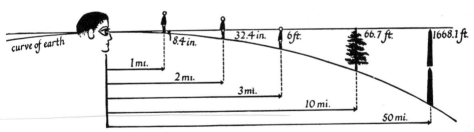

Departure of earth's curve from true level ("sight line" without refraction)

another of the same height on the opposite shore because the earth's curve interrupts the sight line. At 50 mi. the earth's curvature makes a difference of 1668.1 ft.!

All progressive countries maintain a geo-

is likely to be within 100 yds., in different directions, two other similar bronze marks but with arrows on them pointing to this station. These are reference marks. To give you an idea of geodetic scrupulousness: the distance of

these reference marks from the station mark must be recorded to the thousandth of a foot!

The U. S. C. G. S. inscribes these standard marks in several different ways (see p. 236) according to whether they show direction, position, elevation, etc. Those marked with a triangle are either traverse or triangulation stations.*

A station is a point at which to base a set of measurements in a survey. In order to get these measurements right, a surveyor at one station should be able to see signals at two or more others. But in flat, wooded country this is not always possible. So the surveyor *traverses* the country with a series of lines. He measures the length of each of these as he goes over them, and the angle of each corner or bend as he comes to it; hence the name *TRAVERSE*. Because of the many unavoidable errors and no good visible means of checking up the work this isn't the best survey method, although at times the best has to be made of it.

To make more stations more intervisible, a U.S.C.G.S. signalman, Jasper S. Bilby, invented a portable steel observation tower—actually, a giant tripod—extensible up to 129 ft. It is a double tower. The inner one, being the tripod, holds the sensitive sighting instrument, the theodolite, but does not vibrate at the movements of the surveyors, who stand on the entirely separate, outer tower. As many as 12 of these towers will be on the job at one time, two going up at the new stations ahead while two are going down at the rear of the survey. In heavily wooded mountain sections, surveyors sometimes lop off the top of the tallest tree, using the stump for an instrument support, while for an observer's platform they build

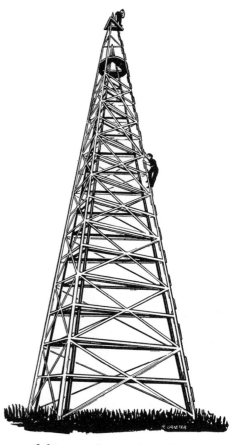

* The U. S. Geological Survey also has established station marks throughout the vast regions which it has mapped. The U. S. G. S. and the U. S. C. G. S. have cooperated with one another, as have nearly all workers in a field too wide for rivalry.

around this a crow's nest, often felling a nearby tree or two and leaning it into this for a brace. These towers have been 200 ft. high.

When mapping country in which you are able to see your reference points that well, you can use the highly accurate *triangulation* method of surveying. This utilizes the simple geometrical principle that if you know one side and two angles of a triangle you can tell what the rest of the triangle measures. That line which you know the length of is your *BASE LINE*. But when you have figured the other sides of the triangle, you can use one of them as a base line for the next triangle, and in that way go clear across the continent!

These triangles do not show on the finished map, but they are at work there just the same, truing up the position of every point that does show. They *control* the accuracy of all horizontal measurements of a country, and so this function is spoken of by surveyors as the *HORIZONTAL CONTROL* underlying a map. There must be also a vertical control to establish elevations for a map which shows mountains and valleys, but the national horizontal-control net takes the country as if it were smooth all over and had the curvature of a sea-level surface—as on your globe.

Many familiar objects figure in the control system that the Coast and Geodetic surveyors establish for the entire nation, if they stand out prominently. Church towers, radio towers, water tanks, and navigation lights become landmarks, *literally*. They are located with the utmost precision by and for the triangulation in order to build up the total precision of the control.

The framework of a map is not like the frame of a picture but like the skeleton of a body; it's structural. It forms from references to points within itself as well as to points without.

There are tens of thousands of geodetically determined station marks prudently distributed through the conterminous part of the United States. In most of this the U.S.C.G.S. has maintained a policy of providing a triangulation station for about every 50 sq. mi. If you realize that the sides of such an area might be only 5 by 10 mi., you can see how close together the stations can be—about one every 7½ mi.

Of course, such spacing must vary with the regional needs. In vast unsettled sections of the West, 1 station for about every 15 mi. is usually sufficient. But along main highways, the Survey has a policy of providing stations every 4 or 5 mi. It prescribes the spacing of 3 to 4 mi. in rural areas of highly valuable acreage, and 1 and 2 mi. in metropolitan areas.

SUPER-ACCURACY

The closer together the points and lines of a survey are, the greater is the likely accuracy. Only in recent decades has there been much achievement in this. No farther back than the 1920's, the spacing in this net was mostly in terms of hundreds of miles.

Surveyors and engineers recognize certain standards of accuracy. The ratings result from the question: In how many units is there allowable only 1 unit, or "part," wrong? Thus, in a triangulation rated as "first-order" there would be only 1 inaccuracy in as many as 25,000 units. Second-order accuracy would allow discrepancies on the basis of 1 part in 10,000; third, 1 in 5,000. You can see the logic of this way of figuring when you think of how many more times "correcter" the first must be than the second and the third. First-order is called "higher" (in accuracy) than second-order.

Usually, the two lower orders of accuracy are tolerable for subsidiary surveys of comparatively small areas. Thus, if a mistake occurs within a third-order frame, it can be checked or controlled so as not to spread into the next better frame and finally, with accumulated damaging power, throw the entire grand framework out of kilter.

Sometimes there is a call for an exceptionally high order of accuracy, particularly in triangulating a comparatively small area. A memorable example is the special job the U.S.C.G.S. did in 1960 in the vicinity of Cape Canaveral, a work field about 90 mi. long and about 45 mi. wide. The Air Force was planning to test an electronic missile-tracking device. The precision method of checking on its operation in the sky was to photograph it in flight against the background of stars. Nine ballistic cameras shooting simultaneously had to be situated at definite points. This called for accurately determined triangulation sta-

tions. The Air Force asked for an accuracy of 1:400,000. Thanks to the use of Bilby towers, geodetic surveying instruments, know-how, and scientific conscience, the Survey delivered an accuracy of better than 1:1,000,-000! With characteristic modesty, the Survey's Chief Mathematician, who reported the achievement to the public, gave much of the

Mt. Shasta to Mt. St. Helena, which joins all the surveys for maps of the Pacific Coast to all those of the Atlantic Coast. The eastern surveys were carried westward along the 39th parallel for this wedding. By means of heliographs and telescopes on both mountain-peak stations, the surveyors saw and exchanged signals over the 192 mi. distance.

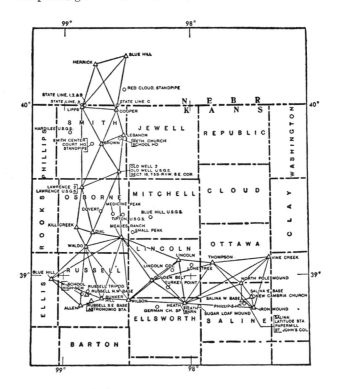

credit to the favorable surveying conditions in Florida, then concluded philosophically: "The ultimate accuracy was not, as it never is, reached."°

Because of the earth's curvature, triangulation affords the only sure way of running a line straight for a very long distance.

In northern California there is a line from

More impressive than all this is the part played by Meades Ranch, in Osborne County, Kansas.° Here in a large pasture is a concrete block with a bronze station disk on which is a cross mark. At the point where the two small lines intersect begins the mapping not only of all the United States but the whole continent of North America! It is the initial station for reckoning the latitude and longitude of one

° A Singular Geodetic Survey, by L. G. Simmons, U.S.C.G.S. Technical Bulletin No. 13, 1960.

° Map courtesy of U.S.C.G.S.

sixth of the world's land surface. Its own position is:

lat. N. 39° 13′ 26.686″
long. W. 98° 32′ 30.506″.

These figures mark the spot where the transcontinental arc of triangulation crosses the long pole-to-pole, international meridian, and the entire coherent network is pinned down.

A definite "pin-down" like this, which surveyors establish as a basis for doing their reckoning of other positions and measurements, is a *DATUM*. (From the Latin word, *dare,* "to give.") It is a "given." To determine a datum takes science, but to establish one takes harmony.

Such a cooperative arrangement among nations (Canada, Mexico, and the United States) on a single tie line, or "geodetic datum," was never before seen. It was effected in 1913, just before the First World War, and it continues, as sound as ever. This center pin at Meades Ranch is called by mapping engineers "the North American Datum of 1927," because in that year all the stations were checked and trued-in with that point of origin.

India with its great triangulation has served as a Meades Ranch for a far-flung network of coordinated mapping to include Asia, Europe, Australia, and the Philippines. This project has been called "the geodetic Eden for half the world's maps."

The U.S. Army Corps of Engineers and its Army Map Service engage in extensive geodetic and cartographic projects in many parts of the world. The 7,000 mi. intercontinental arc of triangulation, running northward from South Africa and through Europe to the Arctic, is an example of military mapping that is also one of the great feats of modern survey. And as an example of accuracy, an Army Engineer unit on a task in the desert country of Libya worked a line 1,073 mi. long, in the form of a rectangle. When the job was finished the end of this line was within 43 mm., or 1.677 in., of the starting point!

"One great advantage of geographic coordinates," says the U.S.C.G.S., "is that they constitute a universal system for the whole world and any point located in this system is definitely related to any other point in the system." The humblest, most retired farm can have its corner in on this grand deal with the poles and the Equator just the same as a county can have its lines, and a state its boundaries, unimpeachably established by it. If you wish to locate your back yard accurately on this planet, simply measure from an official triangulation station mark. (It is yours as much as anybody else's.) There can be only one point on the face of the earth where a certain parallel and a certain meridian cross, and the station mark you may have stumbled upon is that point. Once your patch of ground is thus located and officially recorded in true map terms, come hurricane or high water, nothing can sweep it away. Though every fence and corner peg be scattered and nearby stations obliterated, there will remain still other stations as staunch witnesses for you, and your place will be reestablished exactly where it was before.

An explanation of how you can do a bit of practical triangulation yourself can be found in chapter 8. At least imagine yourself doing it and add more zest to your understanding of maps.

The trick of triangulation is an ancient one, but like the game of chess it invites the kind of interest that makes it seem new again nearly every time you play it. The "opponent's" challenges are not only roundness and variations in roundness but also gravity and variations in gravity, so that what you might think is a true plumb line is really not plumb true but misses the center of the earth and the zenith of the sky by enough to skew an extensive system of controls. There is not al-

ways intervisibility between points to make a good base line. Often when these points are intervisible, the intervening terrain refracts the sunlight rays—kinks the sight lines so that the sighted points are off true. There is necessity sometimes for establishing very long base lines.

In professional and official surveying, as compared with the essentially similar triangulation that you can well be contented to do in a limited fashion yourself, the requirements for speed, accuracy, and all-around efficiency demand the most ingenious apparatus. The Bilby tower, for sighting long distances between stations, is but one example. There are also such instruments as the Tellurometer and the Geodimeter. (Both names meaning in their source languages, "earth measure.") Both are easily portable, electronic devices for use between intervisible points. The Tellurometer, using sound, is a two-way radio telephone system which operates between a master unit and a remote unit. The Geodimeter measures distances by timing a light beam's round trip between the sending instrument and the reflector.

Artificial satellites, some with near-earth orbits and some with relatively distant orbits, are an immense help to geodetic surveyors. Ballistic cameras with precise shutters stand at their carefully chosen stations and make a continuous record of the overpassing satellite.

Dr. Hellmut Schmid of the Ballistic Research Laboratories in Maryland developed this system. A U.S.C.G.S. engineer, in explaining it to his colleagues when it was quite new, said,

Satellites are tracked against a background of stars whose identity and positions are accurately known. The apparent path of the satellite from each camera station will be defined on a photographic plate by point images closely spaced across the plate, appropriately coded to facilitate image identification. The end result from each photographic plate will be the apparent right-ascension and declination of each satellite image

with corresponding exposure time known to better than 1 millisecond of true time.[*]

Consider what this manner of survey means: a globe-encircling line that defines extremely tiny elements of measure. It's getting some 25,000 mi. down to a gnat's heel! It can span not mere swamps but whole oceans. It can connect remote little islands with the geodetic datums of the huge continents. It means that the earth measurers have attained to superaccuracy. Base lines several hundred miles long can be accurate to one part in a million. Through an improved network, surveyors can connect a point on the Atlantic coast with one on the Pacific within an accuracy of something like 10 or 15 ft.

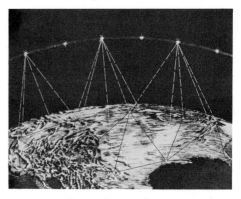

How a satellite and several cameras at carefully chosen sites establish a transcontinental arc of triangulation †

To embrace the entire earth, however, with such accurate networks requires international cooperation. To produce the mapping coordinates takes thorough and widespread coordination. The A.M.S., for instance, has worked with the mapping institutes of 47 different na-

[*] *The Utilization of Artificial Satellites by the Coast and Geodetic Survey* by Lt. Commander Eugene A. Taylor. The Society of American Military Engineers. Washington, D.C., 1962. [The coordinates "right ascension" and "declination" are explained later in this chapter.]

† Courtesy of U.S.C.G.S.

tions. In the spring of 1962, Rear Admiral Arnold H. Karo, Director of the U.S.C.G.S., spoke before a conference of the National Academy of Sciences, and concluded by saying:

I am convinced that as men exchange scientific data to increase their knowledge of the earth, they will at the same time develop a better understanding of their respective ways of life. The next decade offers unusual opportunities to this science. Geodesists should seize upon these opportunities, make the most of them, and, in a great internationally coordinated effort, together forge—in a geodetic sense—one world.

CORRELATING GRID WITH GRATICULE

However glad we are to have spherical coordinates right with the world, in a graticule, we must use rectangular coordinates when we map small parts of it. These are the parts in which we do our car and tractor driving, our hiking, city-planning, and the property-line staking for our homes.

It is simple to start at a point of origin and run x and y coordinates out and up from it at a right angle. But it is not so simple to make a good-sized grid, say, for such an area as a state or county, or a metropolis, and have those coordinates coordinate with the ϕ and λ coordinates of the globular earth. Yes, that triangulation station mark that was explained a while back will serve as a perfect peg for that grid, but this peg is not enough to give us a precise mathematical idea of the relationship between all the constantly straight lines on a flat (plane) surface and the ever bending latitude and longitude lines on an irregularly curved surface.

In 1933, George F. Syme, who was a North Carolina highway engineer, asked the U.S.C.G.S. to suggest a method for making such a grid system to cover his entire state. Dr. Oscar S. Adams, at that time the U.S.C.G.S. Senior Mathematician, worked

out a scheme of grid systems that could be fitted to the size and shape of each of the states. This work has become famous among American surveyors and cartographers as "The State Plane-Coordinate Systems." It should be better known among statesmen and political scientists also, for it is probably the most definite and efficacious linkage of locality, region, nation, and world since man first worked out a concept of territory.

The establishment of systems for correlating straight-line coordinates of the place with the curved-line ones of the earth saves lawsuits, settles land squabbles, and corrects mistakes inherent in the old methods of parceling out and mapping those areas.

Formerly, each piece of ground had its individual survey points, and often the original surveyor was the only one who knew what these were. Instead of a geographical reference point, the surveyor would take a certain hilltop, a rock, or even a tree as a basic marker for a farm, or a river as a dividing line between two counties or states. Time laughs at such marks; it pushes them around and finally obliterates them. Some states were found to have their boundaries from ¼ mi. to ¾ mi. away from where Congress had intended them to be. Surveyors had done very neat mapping jobs for local areas, but these separately devised maps did not always coordinate with maps of adjoining areas.

But now, with the State Plane-Coordinate Systems, surveys of small areas can have a permanent correct relation to the precision surveys and maps of the entire country, and all the local surveys can be connected, one with another. This goes not only for a town, but for any block in the town, and any lot in a city block. City planning and mapping are a geodetic job, too. Not many people know it, but there is (or ought to be!) an underground survey of their town, locating subways, tunnels, water pipes, gas mains, electric conduits, sewers, drains, and buried creeks.

All that a city engineer (or any field surveyor) need do now is to get from the U.S. Government Printing Office, for a remarkably small price, the tables that the U.S.C.G.S. has computed for his state. The pamphlet containing one set of tables may say in its foreword: "The tables in this publication contain the plane coordinates for 2½-minute intersections of meridians and parallels within the limits of the State." The pamphlet containing the other set* of tables may say in its foreword: "The tables in this publication are to be used for the conversion of geographic positions to plane coordinates or plane coordinates to geographic positions."

New Jersey has the honor of being the first state to legalize (in its laws of 1935) the definition of boundaries of public and private property by the use of the state plane-coordinate system that was thus "custom made" for it. The legislatures of several other states have followed suit in giving official approval to land surveys recorded by means of the systems the U.S.C.G.S. has provided.

On all the U.S.G.S. quadrangle maps, except those dated some years back, there are just outside the map border the ticks that indicate the grid of the plane-coordinate system adapted to the state of which the map represents a part. These ticks mark off certain distances in feet. If you draw straight lines between corresponding ticks at opposite sides of the map, you will complete that grid.

RESPECT THE MARK

When the government men finish the elaborate task of placing a station mark they go away and leave it entirely to you and me. Every good citizen feels something stabilizing within himself when he stands beside one of these almost unprotected marks: for each is a

* In Chapter 6, the reason for a set besides the one with intersection tables will appear.

symbol of his country's trust in him as a part-owner.

Illiterate people have dug under marks for buried treasure; careless people have shoved them aside while putting through roads or other construction work; and vandals have stolen them—all not realizing that they were pulling up the holding-peg of their own property. And, of course, the slow movements of the earth's surface sometimes shift these stout little monuments. There are so many of them that the government bureaus have no funds to patrol them. Local engineers, therefore, knowing how fortunate they are to have a high-precision mapping point near their work, do the patrolling themselves. With their own hard labor and at their own expense, they will volunteer to restore or relocate a disturbed station—quietly cooperating with their government's survey bureau step by step, to the thousandth of an inch.

When informing a survey bureau about the suspected disturbance of a control station, take a rubbing of the mark by laying a piece of paper over it and rubbing a pencil or crayon back and forth on the paper to make the lettering come through. Mail this rubbing along with your report.

Often buried under leaves or the debris of the last storm, and passed unnoticed by the hurrying wayfarer who owes his very road and perhaps destination to them, these marks are reminders of the grueling toil, the unglorified intrepidity, and the many painful computations that are hidden within a map.

"LAND-OFFICE" MAPS

The Bureau of Land Management was formerly the General Land Office, the oldest Federal surveying and mapping bureau. Jefferson drew up the original proposal for it in 1784.

At first, Uncle Sam tried to make money out of his unsettled territory by subdividing it and

getting into the real estate business. Then he found he'd prosper more if he just gave the land away to hardy homesteaders. They would go out into the wildest frontiers and develop the country. That was the time he did the proverbial "land-office business." This land-grant policy opened the West and didn't stop until it had spread asphalt from coast to coast.

The momentous Taylor grazing act of 1934 changed this policy to one of land conservation and improvement of the lands that had not been transferred to private ownership and that now still belong to the public domain. These are largely the mountains and the deserts, now held in trust for future generations: 477 million acres of timber and mineral resources for industry, of grassland and woodland for livestock and wildlife, and of natural beauty for recreation. This irreplaceable heritage, which reaches as far south as the Gulf and north as the Arctic, is now called the "national land reserve."[*]

But people still speak of "the Land Office," still meaning the one nearest their home as often as they mean the one in Washington. And the basic work of this venerable office is still today, as it has always been, the land's survey.

Because the great breadth of western land was frontier and because the spirit of the young nation expected that if this land was to be made available to citizen ownership, it should be subdivided beforehand and as fairly as possible, the surveying and mapping had to be done in terms of rectangular coordinates.

These "square deal" lines can agree both with the poet who says, "Something there is that doesn't like a wall," and with his neighbor who replies, "Good fences make good neighbours."[†]

An engineering chief in the B.L.M. has made this impressive observation:

Fly across the heartland of the United States today and you will see below a vast checkerboard, with fields and roads and cities laid out in a precise north-south, east-west arrangement. Practically the only features that don't run by the compass are the ridges and valleys and streams. . . . Today we are the one nation in the world with a land pattern based on a system of surveys making available to the people a precise, easily described method of choosing their desired share of the land surface. . . .[‡]

He went on to remind us that essentially the same system of survey conceived by Jefferson continued to function in Alaska "to mark the boundaries of our last frontier."

This kind of survey is primarily what is known as CADASTRAL, which means determining and laying out the boundaries of a parcel of land so that its individual ownership is defined. It may not always make the next-field neighbor a good neighbor, but it has made a nation of good ones.

The American government has measured large areas, "with baselines providing reference points from which private surveyors can make subdivisions and accurate descriptions."

The great coordinates are broken down into several subordinates. All of these minor kinds are easy to keep in mind if you begin with the largest coordinates.

Each goodly portion of the vast public domain is a single "great survey," and so it takes unto itself as much as it can use of one parallel of latitude and one meridian of longitude. The initial point of the survey is where these two basic reference lines cross. This must be determined astronomically: a star-true point.

The parallel is the BASE LINE, and the meridian is the PRINCIPAL MERIDIAN.

[*] After President Kennedy's phrase uttered in 1961, when he referred to these lands as a "vital national reserve."

[†] From "Mending Wall" from *Complete Poems of Robert Frost.* Copyright 1930, 1939 by Holt, Rinehart and Winston, Inc. Reprinted by permission of Holt, Rinehart and Winston, Inc.

[‡] Remington, C. E. "Surveying our Public Lands," in *Our Public Lands,* April 1962, p. 18.

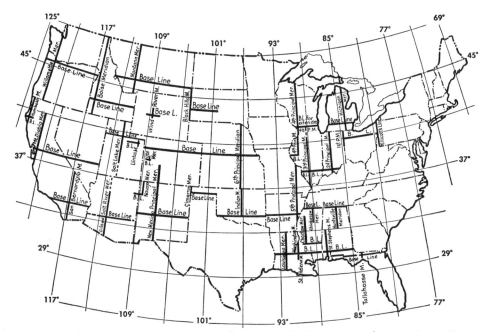

Principal Meridians and Base Lines of the great public-land surveys.† See table, p. 278

There are 31 pairs or sets of these standard lines in the U.S. proper, and three in Alaska.

It would be more practical to have numbered all of these, but somehow we love local color as much as we do precision; so the "Sixth Principal Meridian" is the last with any arithmetic in its name, and the others are "The Black Hills Principal Meridian," "The Choctaw Principal Meridian," and so on.

These are the public-land states: Alabama, Alaska, Arizona, Arkansas, California, Colorado, Florida, Idaho, Illinois, Indiana, Iowa, Kansas, Louisiana, Michigan, Minnesota, Mississippi, Missouri, Montana, Nebraska, Nevada, New Mexico, North Dakota, Ohio, Oklahoma, Oregon, South Dakota, Utah, Washington, Wisconsin, Wyoming. In 1850, the Federal government bought from Texas 75 million acres, and these too are public lands.*

* A good map to have is "United States: Showing Principal Meridians, Base Lines and Areas Governed Thereby" prepared by the U.S.G.S. for the B.L.M.

There were 19 states (including the Thirteen Original) which were not in the public-land systems.‡ These states, except Texas, were all in the East and South. The public-land states begin with Ohio, which rightly calls itself "the pioneer state of our public domain." Its west boundary is the First Principal Meridian.

Using these base lines and meridians, the map arranges rows of blocks, called *TOWN-SHIPS*. These are each 6 mi. square. They are numbered by rows, very much like bricks. An east-west row, like a layer of bricks, is a *TIER*. Tiers are counted from the base line. But instead of saying "Tier One, Tier Two," etc., we

† After B.L.M.

‡ These for the most part used the "metes-and-bounds" system of land survey. Each parcel of land had its well-defined starting point and its boundaries described smugly just for itself, without being tied to any system of base lines—a property-island, so to speak, in the midst of the land. Today, though, the State Plane-Rectangular Coordinate Systems cover these states, and they are among the best surveyed in the Union.

say "Township." For instance, a township in the second tier north of the base line will be named, "Township No. 2 North," or abbreviated as: "T. 2 N." Similarly for tiers south of the base line: "T. 1 S.," "T. 2 S.," and so on, to as far north or south as that particular great survey goes. (Illustration on next page.)

Townships are numbered also according to which column they are in. A column of townships is called a *RANGE*. Ranges take their numbers east or west of the principal meridian. A township in the third range east of a principal meridian is: "R. 3 E."

Now, if we put these two devices of location together, the township in the second tier north of the base line and in the third range east of the principal meridian is: "T. 2 N., R. 3 E."

That's all very nice in itself, but counting,

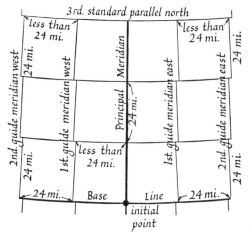

How public land is divided into 24-mi. blocks (lettering omitted on 1st and 2nd standard parallels north)

say, about 19 tiers and 23 ranges to locate a township is not easy, either for the eye on paper or for the instrument on country. We need auxiliary lines to guide us.

This brings in our next group of coordinates. These are lines which somewhat repeat the base-line parallels and principal meridians; so

they take their numbers according to which side of the base line or principal meridian they lie along. For instance, the first parallel north of the base line will be "First Standard Parallel North," and the first meridian west of a principal will be "First Guide Meridian West."

Usually they are spaced 4 townships apart, that is, 24 mi.

Because of the earth's curvature the tiers must curve too. This scarcely shows on maps. But what happens to the ranges does show. You will recall that true geographical meridians converge at the two poles. That would mean a narrowing of townships as they go northward, and they wouldn't all then be 6 mi. square. To prevent this, the guide meridians take a little jog at each standard parallel, then start northward anew the same distance apart as they were at the previous standard parallel. This is what gives the Land-Office map the appearance of jarred masonry.

In a way this map "looks like one a feller made hisself." Just as a man at the beginning of a job will do it one way, then pick up a new trick and do it another way, so this homespun nation and map of ours began at Ohio using one style of making land lines, then along about Kansas, worked in another, and farther on another. This map reflects the peculiar orerinesses of particular regions. Some states do not entirely conform to the general scheme, and if yours is one of them, you can best detect the deviations in the special Land-Office maps of your individual state or of your township. It may require the friendliness of an engineer to explain to you some of the bizarre complications of your local customs in staking off land and "getting on the map."

In some of the earlier surveys, the standard parallels, instead of being the regular 24 mi. (4 Tps.) apart were 30 mi. and even 36 mi. apart. To correct this, the later mappers put in an intermediate line and gave it a local name, such as, "Deerfield Correction Line," or "Second Auxiliary Standard Parallel

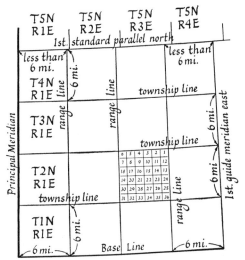

*A 24-mi. block of townships, with T2N, R3E
subdivided into sections*

South." So don't be thrown off by these oddly named parallels; they are in every respect like a regular standard parallel. They're simply parallels with a different past, that's all.

The same explanation goes for those repeaters of the guide meridians sporting such names as "Lost Creek Guide Meridian," or "Ninth Auxiliary Guide Meridian, West."

Now let's take a township by itself—just about the most famous four-sided thing in America. It originally comprised the whole system of public-land surveying. Essentially, the township today is the same as that which Jefferson figured out. Though not to be confused with that venerable *political* division, the New England township, this *geographical* division has in many places become similar to it—a primary unit of local government. Uncle Sam has divided up over 2¼ million square miles of public domain into these 6-mi. blocks.

At each mile along the 6-mi. sides of a township, a line cuts across, so that we have a checkerboard of 36 squares, each a mile square.

These squares are *SECTIONS*. Sections take their numbers 1 to 36, beginning at the north-

east corner of the township, and going across it from side to side, back and forth, much after the manner of plowing.

Here then, in T. 2 N., R. 3 E., let's choose section 16, or "Sec. 16."

Each section may be subdivided into "quarter sections." These are sometimes spoken of as "corners," *e.g.* "Northwest Corner of Section 16" or "NW¼ of Sec. 16."

A quarter section may be further subdivided into "quarter-quarters." And these into lots.

However let's take nothing less than the Southeast quarter of the Northwest quarter, Section 16, Township 2 North, Range 3 East. The abbreviation, or Land-Office code for this is: SE¼ of the NW¼ of Sec. 16, T. 2 N., R 3 E.

In the U.S. public-land surveys the word "corner" means the point at which two or more surveyed lines intersect. At such a point, the B.L.M. places a permanent mark, just as the other official surveys place marks at critical points, but the B.L.M. calls the marker of a corner a *monument*. Usually this is a metal post sunk deep into the ground and capped with an inscription plate which, whatever may be stamped upon it, means: "Cursed be he that removeth his neighbor's landmark. And all the people shall say, Amen."°

There used to be a continual argument going on among engineers as to who invented the rectangular system of surveying. The honor has been claimed for eight or ten different surveyors, including George Washington. Finally, W. A. Truesdale, an engineer speaking before a society of engineers, gave what seems to be the right solution. "No man in particular was the originator," he said. "It was the result of growth and development founded on the principles of self-government, formulated into a law after long and acrimonious sectional controversy, and put into practice because necessity required it."

He was thinking of the American style. The

° Deut. 27:17.

26

rectangular-survey grid itself goes back to ancient times.° Some of the surveys made at the time of Christ were accurate in themselves, but they were smugly local or regional affairs. They had little or no connection with neighboring areas nor any relation to the earth as a whole.

B.L.M. gives 1713 as the date for the first "regular use of rectangular system of surveys in New England." Townships, 6 mi. square were "surveyed beyond settled frontier for future expansion."†

"The Geographer's Line" was the first public-land line to be surveyed by the U.S. government. A standard parallel going westward from the Ohio-Pennsylvania line, it was the north boundary of the "Old Seven Ranges," the first ranges in the public-land system. It was run by Thomas Hutchinson in 1785, who was virtually the first to be placed in charge of the actual survey work of the Land Office, and who bore the official title "Chief Geographer of the United States," later changed to Surveyor-General. What might be offered as a stock epitaph for the mighty but typically modest mapper was said in Hutchinson's obituary in the Gazette of the United States: "He has measured much earth, but a small space now contains him."

"Ellicott's Line" was the first reference meridian made in the great public-lands survey. It is the east boundary of Ohio (long. 80° 20″) and was run in 1786 by Andrew Ellicott, who helped run the western part of Mason and Dixon's Line and surveyed for and published the first map of Washington, D.C.

Right-angled political boundaries, such as those of Colorado and Wyoming, are peculiarly American, originating in the rectangular-survey system of public lands and appear

° See the delightful and scholarly article, "Centuriato: The Roman Rectangular Land Survey," by George Kish, in *Surveying and Mapping*, June 1962.

† *Historical Highlights of Public Land Management*. Bureau of Land Management, Washington, 1962, p. 5.

elsewhere in the world only in newer countries which have followed the American example.

Surveyors say, "A map is condensed history." This is especially true of the maps the B.L.M. and its predecessor have made during more than a century and a half for a land-loving public. But this historical flavor does not hold these land-managing surveyors back from using the most modern means: helicopters, aerial photography, and exceedingly precise electronic equipment. It ties its surveys to the new triangulation systems in cooperation with the U.S.C.G.S. In many of the topographic maps that the U.S.G.S. has produced you can see the township lines of the Land Office.

COORDINATES
IN THE SKY

The "wide open spaces" of a broad land are hardly more mappable than celestial space. The earth sphere is a solid little model of the celestial sphere. But there are some interesting differences which are important to recognize in reading and enjoying star maps.

In the great encompassing globe of the sky, the meridians have the same role as that of the longitude circles on an earth globe. But in astronomy we do not have east-longitude and west-longitude, as we do in geography. It is only on the surface of the earth, or with reference to that surface, that the geographer's *east* and *west* are very useful as directions. The terrestrial sphere is a body and we live *outside* it. But we and our standpoint are *within* the celestial sphere. On the earth the Equator is an imaginary line crossing the ground at our feet; in space it is a great circle we imagine in the sky above our heads.

This difference leads to other differences. When an astronomer uses longitude-like coordinates that he has measured off at distances along his celestial Equator, he has two names

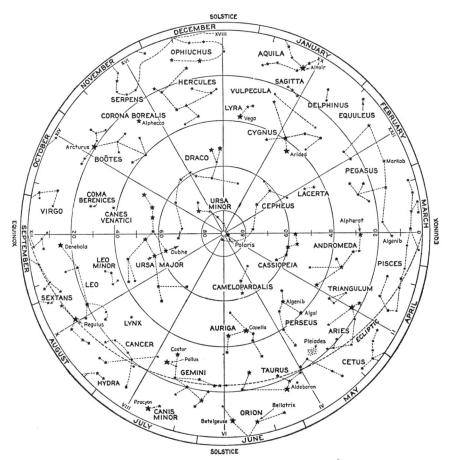

*Star map of the northern celestial hemisphere**

for these coordinates. If the coordinate is one measured toward the "east" he calls it *right ascension*. (An explanation of why he uses these words "right" and "ascension" would make a somewhat complicated digression; so let's simply take his term for it.) If the coordinate is one measured toward the "west" he calls it the *hour-angle*.

If you could watch the sun against the "background" of stars for a whole year, you would see that the sun seems to keep moving across that background, and always in a cer-

tain direction. What we mean by "east" is that direction, astronomically. And what we mean by "west" is the direction in which the sun seems to move across the sky in the course of a day.

It is on the *annual* apparent motion of the sun that the astronomer figures right ascension. He figures hour angle on the *daily* apparent solar motion.

* By permission. Based on material in *Webster's New International Dictionary*, Second Edition, copyright, 1934, 1939, by G. & C. Merriam Co.

But he measures both of these from the same point on the celestial Equator. This point is the "equinox" you see at "March" on the star map shown here. (The spring equinox is explained in the next chapter.) Through this point and through the north and south celestial poles passes a circle that the astronomer calls the *equinoctial colure*. It is analogous to the geographer's prime meridian.

Here, though, is another difference. The geographer, you will remember, measures his longitudes halfway around the earth globe, to 180°. The astronomer measures all the way around the celestial sphere to 360°. He does so whether he is measuring by right ascension or by hour-angle.

Often, however, instead of giving the right ascension or the hour-angle of a star in degrees, he measures these coordinates in terms of hours, minutes, and seconds. He lays off perpendicular to the celestial Equator 24 equally spaced "longitudinal" lines, or *hour circles*.

The astronomer in his mapping not only uses clock language for some of his coordinates, he also has what is actually a clock in the sky. You can easily visualize it by supposing that from a point on the axis of the celestial sphere you were to look toward the north celestial pole, and then made a kind of pole-centered map of what you saw. The Big Dipper, the Little Dipper, and the other circumpolar constellations would be the central content of that map, and the successive hour-circles radiating from the celestial pole would be the coordinates. Also, this map would be like the face of a 24-hour clock, for these coordinates would intersect the circular boundary of the map and be like the marks on the rim of the dial. These points on the sky clock are numbered from 1^h to 24^h, and the latter of course coincides with 0^h.

Time, we might say, is "of the essence" of the star map. The apparent motion of the stars and sun gives us our time measurements, and these time measurements give us our space measurements—and these space measurements enable us to know where to look for certain stars, so as to "locate" them on map!

You are now perhaps wondering about the other coordinate, the one that corresponds to latitude. This is a much simpler affair than the timewise coordinate. As on the terrestrial sphere, this is a measurement of distance (or angle, or arc) away from the Equator. The astronomer's name for it is *declination* (Latin, "turning away"). Declination is expressed in degrees, minutes, and seconds.

Bear in mind the difference between a star's altitude and its declination. The altitude of a star or planet or the sun or a meteor is its height above your horizon. It's an affair of how high in *your* sky, and is quite uniquely a local slant on that object.

But a star's declination is its circlewise distance from the celestial Equator—just how much of an arc it is away from a point on the Equator of the heavens.

And if you wish to have some idea of where such a point might be in the sky, look for the top star of Orion's belt—Mintaka. It's on the celestial Equator. Imagine a line straight from Mintaka to the center of the earth. That line would pass through *our* Equator too.

2. The Versatile Plane:
GREAT CIRCLES

SCIENCE AND imagination. It takes both to make good maps. Map-makers like to imagine an immense slab. It is so immense that it reaches out in all directions as far as they wish. And it is so thin it slits clean through the earth.

Here you see it slicing the world in half at the Equator.

on equator
(latitudinal)

But it slices through at the meridians too. In fact, anywhere at all.

Simple as this slab is, it is the basis of some of the grandest scientific conceptions. If you visualize it now, just as it is here, you will have what is perhaps *the* fundamental conception of map-making. It will keep things clear for you.

Scientifically, it is spoken of as a "plane." That is a word you will come across often from now on. Plane of this and plane of that. "On the plane of the Equator." Yet all it means is this slab passing through the earth. Named for this function, it is a *secant* ("cutting") plane.

Now, see how quickly this conception enables you to understand something which might

otherwise have seemed very abstruse. In order to understand maps we should know some-

meridional
(longitudinal)

thing about circles of the sphere. We look up, as we should, the term in Webster. This is what we find:

circle of the sphere. A circle upon the surface of the sphere, specifically of the earth or of the heavens, called a *great circle* when its plane passes through the center of the sphere; in all other cases, a *small circle.*

oblique

This definition is easy to understand now that we know that "its plane" is simply one of our globe-cutting slabs.

We can see these *GREAT CIRCLES* in all

the figures except one, and in that one the plane does not cut through the globe's center; so it marks just a "small circle."

latitudinal

From now on we are going to be concerned mostly with great circles. And they are *great*. They are the most important circles in the whole world, the most up-to-date, the busiest, and most glorious.

Every great circle is the greatest possible circle on the globe.

Every great circle is the circumference.

Every great circle cuts the globe into equal halves, as the Equator does.

The Equator is a great circle.

The meridians form great circles.

The meridians cross the Equator at right angles, because their planes cross the Equator's plane at right angles. (They also cross the small-circle planes of the latitude parallels at right angles.)

All other great circles cross the meridians and the Equator at other than right angles.

A satellite's path around the earth is elliptical but the imaginary line it "traces" on the earth's surface is a great circle. If another imaginary line were shot out from the center of the earth, passed straight through that great circle, and kept going, it would hit the satellite's orbit. In other words, the orbit, the earth-trace of the satellite, and the center of the earth are all in the same plane.

There can be an infinite number of great circles on the globe. This is a very fortunate fact, for it means that we can travel on a great circle from any place to any other place on earth.

Why should we wish to?

THE SHORTEST DISTANCE

The shortest distance between any two points on the globe is on a great circle! It seems astonishing the first time one hears this. "What! Shortest . . . great . . . ?" we think. The two things seem contradictory.

Look at your globe.

Pick out a point on that great circle, the Equator. Now, if you wish to go to any other point on the Equator, what are you going to do: get off that line? The only way you could "cut across" would be to go through the earth itself! Common sense tells you to stay on that line. It's the shortest distance.

Get on a meridian. At 90° W., say, at Memphis, Tenn. What's the shortest distance to the North Pole? That meridian, of course. That long curve is the shortest way *on earth*. You can't possibly shorten that curve.

Nobody can evade the roundness of the earth. We cannot move across the surface of the earth in any direction but that we travel on an arc.

Just as the shortest distance between two points on a flat surface is a straight line, so on a globular surface the arc of a great circle is a direct line between two points. Look at the arc and chord at the top of the opposite page:

The chord is the shortest distance *through* the earth. The arc is the shortest distance *on* the earth. Straight lines are sometimes called "right lines." Likewise great circles are technically called "orthodromes" (*ortho:* "straight" or "right" + *dromos:* "running"—in Greek).

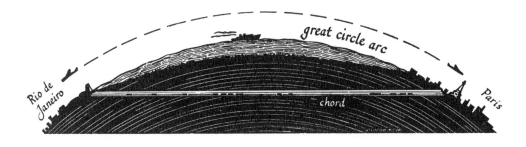

You can see the directness of great circles merely by examining those printed on your globe as meridians, the Equator, and the Ecliptic (if your globe happens to have one). These lines do not waver or weave. This directness is true of all possible great circles, not merely those printed on the globe. It is just as true for the great-circle arc between Kansas City and Zanzibar as for that between Greenwich and the Gold Coast town of Accra.

True as this is of *all* great circles—and very obvious, once you take a good look,—it is not true of any small circle. A small circle on the globe does not afford the shortest distance between two points. And this at first is not so obvious. When we look at one of the small circles printed on a globe that small circle seems at first to be the most direct line between any two points on it. For example, take the small circle representing lat. 30° N. It connects New Orleans and Suez. But don't be deceived. The seeming directness of this neat, plain arc does not show the shortest distance between the two places. You need only pull taut a piece of string or rubber band between New Orleans and Suez on your globe to make out the shortline flight. This new line will be another arc, one with less bend in it. An arc of a larger circle.

Odd, isn't it, that a great-circle arc between two points should be shorter than a small-circle arc between them? But remember it's *on the globe,* not on a flat. Going on a small circle between two ports we must still curve as much

as the earth does, and so we only *add* the small circle's distance.

Another revealing experiment is to draw a straight line on a piece of tracing paper, then to lay the paper on the globe so that the line connects any two cities. Very simple: a straight line is the shortest distance between two points, and here we have it connecting two cities. But just try to make that straight line fit along a small circle, like that of a parallel of latitude! No go.

And if we hanker after still more clarification of why this happens all we need to do is to come back to our keen plane: imagine it slicing through the center of our globe so that it cuts a line between New Orleans and Suez, or any two other points on a small circle of latitude. Here again the difference shows up. The two cities and the great-circle arc are all on the same plane with each other. The small circle swings off this plane. Indeed, the plane which cuts through the globe makes the true *short cut* between any two places it touches.

Note something else: where this short cut occurs. *North* of the Suez-New Orleans latitude line. The same thing would happen anywhere else north of the Equator. In the northern hemisphere, the great circles always cut north of the small circles which represent parallels of latitude. In the southern hemisphere, just the opposite. There all great circles cut *south* of all latitude lines. Easy to see: just picture our plane slicing through the globe.

In fact we don't need to see it in our mind's

eye. We can take an actual plane, and make a great-circle indicator out of it. Only, instead of having it cut our globe, we can have our globe come through it. This plane is a piece of stiff cardboard into which we cut a round hole a bit greater than the diameter of your globe, so that the cardboard will just fit all over the globe without tightness.* Wherever on the globe this plane sits it makes a great circle. It connects any two points by the line of shortest distance. Of all the connections you can make between the two points, only one can be a great circle. And that you now have at hand.

With this great-circle indicator you can get a good idea of the shortest routes between certain world ports.

These great-circle tracks are very recent in the long history of travel. Until mariners realized the world's roundness the idea couldn't have occurred to them. And even after Magellan circumnavigated the world (on anything but a great circle!) they had no way of finding that shortest path until science developed for them the means of determining longitude at sea. Also, as long as winds controlled the course of a ship such a path was hard to follow. And a day saved out of a windjammer month doesn't mean so much as does a day saved out of a Diesel-engine week, an hour out of a jet plane day, or a minute out of an experimental satellite hour.

With your great-circle indicator you can turn up some surprising facts. The shortest dis-

* In order to enjoy the best show your globe can give you, free it from its shackles, as described in chapter 9.

tance, for instance, from New York City to Chungking, China, is not across the Pacific at all. It's almost across the North Pole. Same as the hop between Buenos Aires and Manila —across the South Pole. For want of sense to put a piece of cardboard to their globes people used to figure, for instance, that Hawaii is between the U.S. and Japan. It isn't. By the shortest route—air—the Aleutian Islands are.

People kept on thinking ocean distances when they were capable of doing air distance. Americans were so accustomed to embarking at an Atlantic seaport for "the grand tour" to Europe that they were astonished to learn that some of our west-coast cities are as near Europe as are some of our east-coast cities. (For example, compare the great-circle arc between Charleston, S. C., and Moscow with that between Seattle, Wash., and Moscow. Just about the same length!) People's map-notions hadn't yet caught up with their daily lives.

Geography is not "old stuff." Like history, it's now in the making. It's news. But like other good things maps have their faddists, who don't seem to realize that it is one thing to be conversant with maps and something else again to make them or steer by them. So with the achievement of practical aviation, there sprang up a crop of excited great-circle enthusiasts who raised lusty landlubber shouts from their ground stations that all other forms of navigation were now obsolescent. Certain types of maps, they said, were ready to be junked. As a matter of fact, it would be unwise to discard any scientific map ever made. And believe it or not, some of the most modern aviation maps employ some of the oldest cartographical principles. Another stern fact is that the long way round is still very often, and likely to continue to be for some time, the shortest way home. At least the *easiest*. As will be shown in Chapter 6, the longer course is easier to plot on a certain kind of map, and easier to follow than a great-circle course. What we

have to thank aviation for is not so much that it has increased the importance of great circles but that it has decreased the meaning of great distances. We no longer dread remoteness nor can we take refuge in it. Geographically, there isn't any left.

We had got into such a habit of ship-map thinking that we cut ourselves off from the rest of the world. We kept on using our coordinates as lines of separation instead of as the means of location. We used them to divide mankind into smug sections instead of to divide days into workable hours. We got into the habit of thinking that there was a natural western hemisphere and a natural eastern hemisphere.

But air travel has proved that if you still think in terms of hemispheres you may as well go back to a flat world and its antique maps, with a falling-off place and mythical monsters. Communications (radio waves and, whenever feasible, air vehicles) now take to great circles like everybody's business. And everybody's business it truly is.

For these circles swing freely this way and that, crisscrossing all our time lines, and season lines, and climate lines at any and every angle. Round the world every which way they go, binding the world into a whole.

HORIZONS

The word *plane* enjoys a close kinship with the words *plain, explain,* and *plan.* Not only in ancestry but also in service. If an extent of country appears leveled out flat enough to resemble a plane, we call it a plain. To ex*plain* any matter, or to make an ex*plan*ation of it, is to lay it out "flat" enough to make it plain. That's what our versatile plane does. It enables us to reduce the spherical world to a plan. And a plan is the underlying principle of a map. Making world maps is largely an affair of reducing spherical geometry to plane geometry.

Now let's view another useful application of planes to globe. Let's place the imaginary slab so that we get a practical idea of this or that *horizon.*

The earth's surface, especially at sea or on the Great Plains, seems quite flat, from where we stand, and on out to the very skyline. We call that the horizon, as did the Greeks, who meant by it also as we still do the boundary or limits. When we look out to those utter visual limits, our line of sight is, as we say, *horizontal.*

plane of horizon

Exactly what is that? The earth is curved and horizontal lines are straight. But straight in respect to what? How can we know the difference between a plane that slopes and one that is "absolutely horizontal"? For what is that?

It is simply a plane touching the globe at right angles to a line going from the point of contact into the center point of the earth. That is the whole matter. Yet it is a very useful concept. It will time and again help you out in your endeavor to understand maps or the sciences which maps serve, such as astronomy, geophysics, etc.

Geometers and cartographers call this merely-contacting plane a *tangent plane* (from the Latin word *tangens:* "touching").

We can vary our expression of the concept, and each variation has some richness of suggestion. For instance, we can say that a horizontal line is at right angles to a line from zenith to nadir.

Another consideration is that each horizon plane—yours say, where you are now—is unique. It's the only one that can be at that point. There is nowhere else on earth another horizon plane exactly like it, with exactly the same skyline. Move ever so little and you change your horizon. What is horizontal at one point of the earth is, strictly speaking, not horizontal at another point.

In a poem fraught with meaning for the philosophic user of maps, William Empson says:

"Each tangent plain touches one top of earth,
Each point in one direction ends the world."°

We can be sure he intends more than an idle pun when he spells *plane* "plain"!

If we wished to draw a line that would be horizontal wherever it went on earth that line would be another curve just like the earth's, with the same center as the earth has. But it would not be a plane. Seen from a height, the terrestrial horizon dips below the true horizontal plane, and then the plane of the horizon is no longer tangent but secant.

We can get "new" horizons in two ways. One is by being on the move.

"For my purpose holds to sail beyond the sunset," Tennyson had Ulysses say.

The other way is to extend our horizon by observing from a higher point. The higher we go the larger our horizon circle. On the earth this is a small circle, because of the physical limitations of altitude and vision. But on maps, as you will see in Chapter 6, this horizon circle can be a great circle, the Equator. It is the maximum horizon. Viewed as a plane, it is really a disk—as the full moon or a planet is at its great distance from our eyes.

° Quoted by permission of the author from "The World's End," *Collected Poems*, London, 1956.

SEASON MARKERS

The concept of the versatile plane is a wonderful help for showing us the space-business that brings about the four seasons. This phenomenon has a surprising lot to do with mapping. The Frigid, Temperate, and Torrid Zone boundaries on a map are actually season lines and not merely indications of local climate.

Imagine a plane with the sun in the center. The plane cuts through the center of the sun and also through the center of our planet. This secant plane is the *plane of the earth's orbit*.

Now imagine the earth's axis neatly vertical to this plane—which of course it most certainly is not! If it were, the sunny side of the earth would always reach from pole to pole throughout the round trip we complete annually on this orbit. In fact the orbit plane then would cut through the earth sphere right smack on the Equator. Our days and nights would always be of equal length. All around the year we'd have but one season, if you could call it that.

But the earth's axis is not at right angles to its orbit plane; the axis is off the perpendicular by an angle of about 23½°. That's no small bias. It's a slant that makes all the difference between summer and winter.

So the plane of our planet's orbit cuts

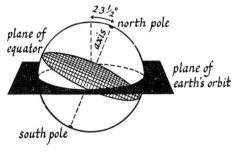

Relation of equatorial and orbital planes

through the earth at that angle: 23° 27′, to be exact. Perhaps you have puzzled over the tilted circle that crosses the Equator on your globe. This great circle, oblique to the Equator, is the line of the orbital "cut." It is called *the ecliptic*. And so the astronomer says "the plane of the ecliptic" which is the same thing as the plane of the earth's orbit, but a neater expression. Cartographers prefer it, too.

on this path, throughout their lives, remembering and telling to each succeeding generation the heavenly doings they had observed. Among these doings were the eclipses of the sun and moon, every one of which took place only when the moon was in or close to this narrow lane of stars. What more natural name for it than ecliptic!

Let's now get back to the plane in which

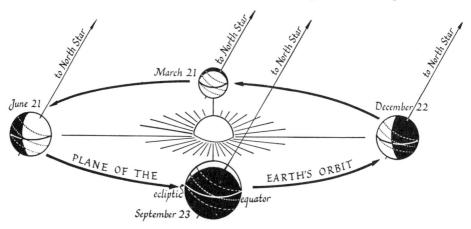

Earth in the plane of its orbit

What does this term "ecliptic" have to do with eclipses? If you keep a daily watch of the sun against the back spread of stars all around the year, as was suggested in the previous chapter, you will notice that its apparent path is pretty definite. To be sure, the stars disappear in daylight, but if you are up early enough, you'll notice a certain group of stars rising before the sun. They will be in about that same relative position in "back of" the sun all day, though you can't see them. Next month another group of stars will follow the previous set. And so on, through the year. If you keep watching the night sky through the year, a time will come when you can see these, formerly pre-dawn, sets of stars in a great arc across the sky. This arc is the sun's apparent path. The ancients kept their eye

this path lies, the plane of the ecliptic. When we observe the night sky along this plane we can mark that path across the sky; the celestial ecliptic, a line on star maps. And when we observe the day sky along this plane, we can see why the sun's daily path is longer and its noon altitude higher at one part of the year than at another.

It's all due to the earth's "attitude." Instead of rotating with its axis squarely vertical to its orbit, it keeps leaning at an angle of 23½°— practically always pointing its two poles in the same two heavenward directions, no matter at which part of its orbit it happens to be.

Leaning that much, the earth has the North Pole turned *toward* the sun when the earth is at one end of the orbit; and when it is at the other end, it has the North Pole turned

away from the sun. When the earth has the North Pole faced toward the sun, the sun's rays reach 23½° beyond the Pole. Summer. No night. But when the earth gets to the other end of the orbit, the sunlight fails to reach the Pole by the same amount, 23½°. The long night, months long. Winter. At the South Pole the sun will now be shining day and night, reaching 23½° beyond that pole, and giving summer to the Antarctic.

For that reason, the Arctic Circle and the Antarctic Circle are each 23½° from the Poles.

At the earth's midriff, the story is somewhat different. This part of the globe every day the year round faces the sun broadside. It's not a matter of sun or no sun but of where and when the sun beats down hottest. That depends upon whether the point on the earth meets the sun rays squarely—"head on." But where the earth's surface curves away from that spot, the rays skid on the curve, because they strike aslant, like a pitched ball arriving foul upon the curved surface of a bat. The impact is not so great. Nor on the earth are light and heat quite so intense as where it catches the sun's rays squarely.

When the earth is at the end of the orbit where it presents as much as it can of the northern hemisphere toward the sun, the hot spot reaches the latitude of 23½° north of the Equator. That hot-spot burns an imaginary circle there which we call a *TROPIC*—from the Greek *trope*, "a turn." That happens on June 21. The noon of that day is the highest of all high noons of the year. At this tropic, the noon is the highest of all places on earth for that day. The midday sun is directly overhead, at zenith. A line from the sun would cut the horizon plane squarely, at a 90° angle, and go straight through the absolute center of the earth. For understanding maps, this fact is most important, because a 90° line is always useful in measuring. This particular one is virtually a celestial plumb line.

The same thing happens six months later, on December 22, in the southern hemisphere, the hot-spot making a circle 23½° south of the Equator.

These tropics are as far north or south as the hot-spot goes, but it touches every latitude in between these two lines at one time or another during the year. That is why this belt (about 3,230 mi. wide) is called the torrid zone. Only in the torrid zone, and nowhere outside, is there ever a midday in the year when the sun hits you right on the top of your head.

This happens twice a year. At the Equator it occurs about March 21 and again about September 22. These spring and autumn occurrences are called, respectively, the vernal and autumn *equinoxes* ("equal nights").

At that time neither pole is presented to the sun more than the other; for then the axis of the earth (if you're looking at it from the sun) slants from left to right instead of from the far side to the near side, or from the near to the far side. At the equinoxes, everything is equal on earth as regards the solar power-house—fifty-fifty. 12 hrs. day, 12 hrs. night, from pole to pole. The most perfectly balanced symmetrical days of the year. If every day were like that we'd all be dead.

At these two half-and-half times the earth is halfway between the other two marks on its orbit. The other two marks are the *solstices*. In the northern hemisphere, the summer solstice is on June 21, and we have the longest day and the shortest night of the year on about that date; the winter solstice, with the shortest day and the longest night, occurs about December 21. In the southern hemisphere, vice versa.

It's this traveling on the Ecliptic that makes the seasons and puts things into circulation.

The ancients divided the heavens into 12 departments, naming each after some animal, as if the sky were a zoo. In fact they called it that—"the zodiac" (*zoo*diac, really). Two of

the animals so honored were the crab and the goat, or as they were called, *cancer* and *capricorn*. The crab's department took in that end of the orbit where the northern hemisphere catches its summer. Hence the northern hot line is the "Tropic of Cancer." And conversely, the southern hot line is the "Tropic of Capricorn."

The ecliptic line reaches diagonally across the Torrid Zone, from one tropic line to the other. The zodiac band is 16° wide—8° on either side of the ecliptic line.

Also spanning the Torrid Zone, on some globes, you will find an 8-shaped device called an *ANALEMMA*. This is for showing two things. The particular latitude in the torrid zone when the sun is directly overhead on one certain day or other. And, secondly, it shows what is called the "equation of time." That is,

the difference between time as we might on a particular day take it from the position of the sun and time as we must average it upon our clocks. In days before the radio, the analemma (which means also "sun dial") was useful for correcting clocks.

It is still useful in reading sun dials and in working out certain subtle matters of navigation. In some books of astronomy you will find, usually under the title, "the equation of time," instructions for applying the analemma. In *The Journal of Geography* for March, 1941, there is a fairly easy explanation by the cartographer Erwin Raisz.

For an interestingly written and fuller account of this planet on its rounds, see *Sun, Earth, Time and Man* by Lucia C. Harrison, published by Rand-McNally Company, Chicago, 1960.

3. This Little Means that Much: DISTANCE

<<<<<<<<<<<<<<<<<<<<<<<<<<<<<<<<<<<<<<<<<<<<<<<<<<<<<<<<<<<>>

... nothing can remain immense if it can be measured, ... every survey brings together distant parts and therefore establishes closeness where distance ruled before. Thus the maps and navigation charts of the early stages of the modern age anticipated the technical inventions through which all eartly space has become small and close at hand. Prior to the shrinkage of space and the abolition of distance through railroads, steamships, and airplanes, there is the infinitely greater and more effective shrinkage which comes about through the surveying capacity of the human mind, whose use of numbers, symbols, and models can condense and scale earthly physical distance down to the size of the human body's natural sense and understanding. Before we knew how to circle the earth, how to circumscribe the sphere of human habitation in days and hours, we had brought the globe into our living rooms to be touched by our hands and swirled before our eyes.—Hannah Arendt, *The Human Condition* (Chicago: University of Chicago Press, 1958), Chap. 35, pp. 250–51.

THE FIRST MAN who actually measured the earth was a poet. The very idea of any man going out and taking the girth of the planet he lives on (and sometimes gets lost on) is in itself poetic. Wherever did he get the notion it could even be done? And just how did he do it? Didn't it take a lot of apparatus, higher mathematics, and celestial engineering? Here if anywhere scientific curiosity mixes with poetic wonderment and they become the same thing.

The immense feat was done almost single-handed, with less arithmetic and bending over and walking from here to there than most of us do in estimating the length of a new carpet for a hall stairway or some wire netting for a back-yard hencoop. The entire apparatus consisted of three things: the sun, an upright stick, and a deep well 500 mi. away. A feat so neat and amazing that every map-lover will enjoy knowing it. Just as everybody who uses the sky should know how Franklin found that lightning is electricity, so everybody who uses the ground should know how Eratosthenes found the circumference of the earth.

He was a meddling, tinkering-around sort of fellow, like many another poet. Shelley, for example, in his youth experimented with electricity to cure chilblains. But this Greek was the right meddler in the right place at the right time for a job on world scale. He was in Alexandria, a boom-town only 55 years less young than himself. It was the home port of most

sailors and the best navigators of the age. Caravans from the depths of Africa and the reaches of Asia met at this hub. He was getting first-hand geographical information from every other man he saw on the street. Besides, Alexandria had the best-stocked library and museum in the world, and Eratosthenes was the head librarian. Few scientific experimenters until modern times have had nearly so good a set-up.

Luck—that is, events in the universe—furnished him with three good tips. They had to do with a little town named Syene which was

—just about due south of Alexandria

—just about 500 mi. from Alexandria

—just about smack on the Tropic of Cancer.

The first tip meant that here he had a meridian to do his measuring on. (A meridian is part of a great circle, and a great circle is the circumference of the earth.)

The second tip meant that here he had a yardstick for measuring with—500 mi. long. Surveyors and travelers going back and forth between the two places had made a fairly reliable computation of that distance: 5000 stadia (500 mi.). This distance, he knew, must be the exact length of an arc of the circumference of the world. But how many degrees in that arc? What part of 360 was it? That was what he had to find out.

The third tip was the spectacular one: it involved both the sun and the earth, and we might say that the earth fairly *posed* for Eratosthenes so that he could measure her. For the Tropic of Cancer is the line farthest north on the earth where she meets the sun's rays squarely and gets them coming straight down. This happens once a year, at the summer solstice, at the highest of all possible high noons. Syene seemed to be very near to that line.

On the 21st (or 22nd) of June, Eratosthenes noticed the sun at Syene was so straight overhead that it completely lighted up a deep well. If that well but continued to the center of the earth the shaft would be a sunlit radius, without a shadow. Not the least shadow was cast by any post or wall. But he was sure that this very moment in Alexandria, north of here, the posts and walls were all casting shadows. Everything vertical *there* had to meet the sun's rays at an angle. The curve of the earth made this difference between anything vertical here and anything vertical there.

Enough difference to measure! Next year come summer solstice, by the gods, he'd measure the angle of that shadow at Alexandria!

While he waited for that crucial hour to come around again he thought of this bit of schoolboy geometry:

Parallel lines crossing a straight line make corresponding angles. And corresponding angles are equal.

Now, say angle o is the sun's angle at Alexandria. The sun rays crossing the post there make that angle. Then angle c—get this!—angle c is at the center of the earth! Because—well, look at the drawing opposite.

This meant that if he knew how many degrees in angle c he'd know how many degrees were in that 500-mi. arc between the two towns. So he set up at Alexandria a pole which was so plumb vertical that he could almost say it was a continuation of an earth-radius sticking above the ground. And he waited the longest year of his life for the longest day in the year, when the sun would be plumb vertical

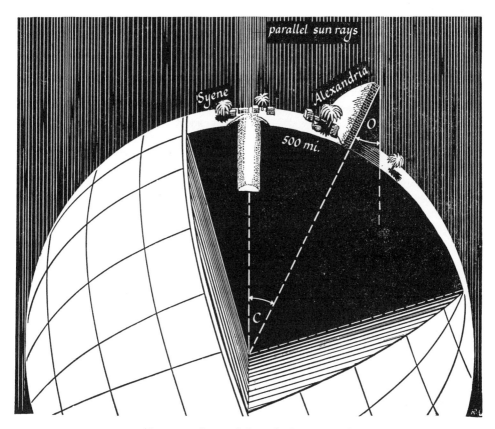

Measuring the earth by a shadow of a wall

at Syene, 500 mi. away. When that day and hour came he had at the top of that pole an angle which was the same as the angle he was after at the center of the earth.

It was 7.2°.

There are 360° around the circle of the earth. And 7.2 is 1/50th of 360. So 50 × 500 mi. is 25,000 mi.—the circumference of the earth!!!

Eratosthenes hit it pretty close. Some authorities say that he measured the angle as 7½° or 1/48th of a circle. This would have made his figure 24,000 mi. The essential reasons for any error were that Syene (called Aswan today) is not quite due south of Alexandria, as you may see on a map, but a bit to the east. Also, the tropic is actually a number of miles farther south than Syene, and so 500 was too small a number of miles to multiply by the angular distance.

This was some 200 years B.C. Later geographers' estimates were 18,000 mi. Ptolemy, about 400 years later, also liked that lesser figure better, and what *he* said remained the last word in geography for the next dozen centuries or more. Even Columbus believed the circumference of the earth to be only 18,000 mi. We wonder would he ever have set out westward had he known the truer figure!

Modern computations put the meridional circumference (which was the one Eratosthenes measured) at 24,860 mi. In 1866, Col. A. R. Clarke, an English geodesist, computed the dimensions of the earth as a spheroid. He got things down so fine that "Clarke's Reference Spheroid of 1866" is now famous among mapping engineers.*

The feat of Eratosthenes was a fundamental contribution to map-making and science. It showed that investigating is better than guessing. It showed a way to tell the difference between two latitudes. In fact, Eratosthenes virtually originated the parallel-meridian system of coordinates, which others (Hipparchus, Marinus of Tyre, and Ptolemy) later improved. By providing us with the measure of the earth as a whole, Eratosthenes enabled us to follow the great mapping principle of working from the whole to the part.

Still another result of this world-measuring feat was that it suggested the simple but fruitful principle: "this little means that much." This is the essence of what map-makers mean by SCALE.

SCALE

We have looked into coordinates and seen how they divide the world into convenient sections for locating points. Scales enable us to measure the distance between points.

Give a good map-muser an inch and he knows how to take a mile. He never ceases to enjoy the plain but curious fact that an inch of paper can be the equivalent of a mile (63,-360 inches!) of world.

He muses over another thing: measurement. Just what is measurement? "Here I am in my back yard," he thinks, "and I have nothing to measure it with. Then I look at my feet. Big as

they are, they're still smaller than the back yard. Besides, they're mine, and I know them: carry them around with me all the time. So if I put one foot before the other I can find out how many times bigger my back yard is than my foot." Then it dawns upon him what he has done. He has made his foot a unit. And measurement is simply counting the number of units in anything.

"Yes, but when it comes to scale," he reflects, "measuring is a sort of double talk. When I measure my back yard I apply the unit (my foot) directly to the ground, but when I use a scale I measure two things at the same time: the map and the world."

What's that map of his but also a unit? Like his foot. A map is not only a picture of the world; it is also a measure of the world.

We can't make a "life-size" picture of the world. Even a "life-size" picture of our back yard is a big order. But we can make a reduced-size picture or plan of it, and do so to scale without thinking of inches or meters. "Scale: 1 thumb to the foot." The plan would be in true proportion to the back yard. The ratio would be: Thumb is to Foot as Plan is to Back Yard.

That is the essential idea of scale.

"Inches-to-the-mile" is the most familiar kind of scale. The moment we see it we know that "inches" refers to *map* and "mile" refers to *world*.

The most familiar, yes, but not the most simple, nor convenient kind of scale. It is rapidly going out of style, now that the technical-minded person is having more and more to say.

For one thing, "inches-to-the-mile" is a mixture of words: one unit is to the map, as another unit is to the world. Going from one map to another you will read, "Scale: 10 miles to the inch," and then, "10 inches to the mile."

It *does* sound like double talk, although it makes sense after some brain-twisting.

There is a kind of scale which does not com-

* There are other precise figures of the earth, obtained before and after this, notably Hayford's, of 1909.

pel you to think in terms of so-many puppy-dogs equaling so-many wildcats.

Take a good draftsman working to scale: he may be making a model of an airplane or a plan of it. Either thing, he can tell you right off and very simply the relation of the model to the real thing. "I'm working in a scale of 1/50th," he says, and both you and he know at once what he is talking about. When he thinks scale he thinks fraction, and a simple one. The plan is 1/50th the size of the plane. Any dimension, any distance from one point to another on the model is 1/50th of the corresponding thing on the ship.

A good map is a scale model of the world, or of some part of the world. For instance, a map of your town may be drawn to a scale of 1/10,000. The map would be 1/10,000th the size of the town.

That *fraction* would *represent* on the map the actual *distances* between points within your town, and do so just as the shapes on the map represent the actual features of the town. So, if anybody asks what's the scale of this map you simply give him this representative fraction: 1/10,000. And that's all. No mixture of words and figures,

REPRESENTATIVE FRACTION. That's the name of this kind of scale. Abbreviation: RF. One of the most important abbrevations in the mapper's jargon. It is sometimes called "natural scale," "fractional scale," and "proportional scale."

On U.S.G.S. (United States Geological Survey) topographical maps the RF is usually printed the way we write fractions, with a straight line separating the numerator from the denominator, thus: $\frac{1}{62500}$.
A frequent way of writing an RF is: 1:62,500. This is in the form of ratio, as if to say, "1 to 62,500." But it means the same as the fraction form.

The numerator is always 1, and represents

Map. And the denominator is always greater, because it represents *Ground.*

RF uses the same unit for the map as for the ground. That unit can be anything you choose: inches or match-sticks. Suppose you have before you a map with an RF of 1:100,000. There are two places, Herschel Park and Franya Hill, just an inch apart on the map. This means they are 100,000 in. apart on the ground. Nothing else. It's that simple! To Eugene measures 2¼ in. That's, say, the length of 1 match. This means if you laid 100,000 of these matches end to end on the ground they would reach from Herschel Park to Eugene!

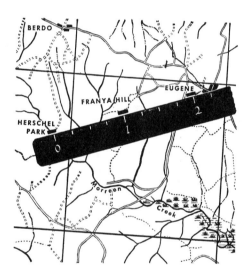

Nobody's going to do that. But this shows that here we have a universally applicable scale system, good for any kind of measure: inches, centimeters, digits, abdats, verchoks, zolls, pouces, geerahs, condyloses, or boos. Good in any country, the same meaning in every language.

All you need to do to get the distance between any two points on the map is to multiply by the denominator of the RF. The measure-

ment between two points is 2¼ in. Our RF denominator is 100,000. So

$$2\frac{1}{4} \times 100{,}000 = 225{,}000 \text{ in.}$$

Actually, the RF system is as simple as multiplying 1 by any number. For its principle is that *any measurement on the map stands for a definite number of times that measurement's own length on the ground.*

There is still another kind of scale. It is the handmaiden of the other two, and is something to look at. It is known as

GRAPHIC SCALE

This is like a small ruler printed in the margin of the map. But the divisions are not like those on a ruler, for they do not mean inches, centimeters, or lengths actually on the ruler. Instead, these divisions are marked to represent some definite distance on the ground.

A graphic scale of miles indicates so many miles, or fractions of a mile.

A graphic scale of yards does the same with yards. Likewise, a kilometer scale. Frequently, maps of small regions will give all three graphic scales. Maps of regions too big to think of in terms of yards, give either the mile or kilometer scale or both.

Ordinarily, graphic scales begin at 0, but some have an extension to the left of the zero. This is a convenience for any one who must figure out small distances which are fractions of the unit.

scale 1:62500

A common mistake people make with graphic scales is to apply a ruler to them "to see how many inches to the mile." They find that the ruler-marks and the scale-marks do not coincide, and they conclude that either their

ruler or the map is wrong. For instance, in a scale of 1:62,500, the division which indicates 1 mi. is not 1 in. but 1.01 in. But that hundredth of an inch is the difference between a RF of 1:62,500 and one of 1:63,360 (or an inch to the mile).

Graphic scales are every bit as simple as they look if you don't complicate them by applying other kinds of measure to them. Just apply a straight-edged strip of plain paper. It casts no shadow as a ruler's edge does over fine print.

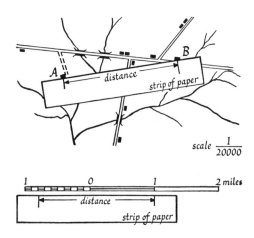

$$scale \ \frac{1}{20000}$$

Suppose you wish to measure the distance between two towns A and B. Lay the paper strip on the map ° along the distance between the two points and make marks ("ticks") on the strip where the edge touches these points. Then bring to the graphic scale and measure.

To measure distance along a crooked road or winding river, there are two good methods:

Take a strip of paper and put a tick mark on its edge to go with A on the map. Beyond A, where the first bend in the road occurs is -1. Bring the edge of the strip to that, to mark off distance A-1, and mark a tick accordingly on the strip. Now turn the strip as if point -1 were

° Courtesy of the Department of the Army.

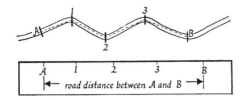

Graphic scale from a map of 1595

a pivot until the edge of the strip comes up to the next bend in the road, or point -2. Tick it. Continue this turn-and-tick business until you finish the road, and then bring the result to the graphic scale.

The other method is with a piece of tracing paper. Draw a straight line down the center. This line corresponds to the edge of the strip in the previous method. At one end of this line mark a point to kiss A with. Lay the paper on the map so that this line is on the road and tick-A is on point-A. Now tick "-1" with pencil point, and using this as a pivot, turn sheet until the line lies on course 1-2. Then tick "-2". And so on.

Realistic note: if the road is level this measurement should be fairly accurate, if not to a gnat's heel at least to a good-sized elephant's, or maybe two. But if the road dips or wriggles through rolling or jagged country, the distance may be greater than you have figured it, as you will find if you try to walk it. So expect it, and add a considerable "+" to your approximate estimate. On most auto maps the broken distances are indicated along the principal roads.

A pair of dividers is also a means of measuring distances with reference to a graphic scale.

SCALES WON'T ALWAYS TELL

On maps showing but a few hundred miles each way, you can depend on the furnished scale to apply equally well all over. But if the area is that of a continent, an ocean, a hemisphere, or of the whole world, no single scale can be equally reliable in every portion of the map. It may be right in one portion but wrong in another. The greater the area the less likely is the scale to be a good overall measurer.

Generally, however, you can trust the scale to apply truly on a world map or hemisphere if you limit your measuring with it to within 10° of the center of the map. And in maps of small countries or of states, you can depend upon scales not making more than a 2% error along important roads (if fairly straight) or between important cities. For important points are usually survey points. And if you know which are the survey points in a given U.S.G.S. or U.S.C.G.S. sheet you can rely upon the scale being accurate between those points.

The paper itself of a map may shrink or stretch as much as 1% (¼ in. in 25 in.) because of dryness or humidity.

Some departures from scale must occur in showing certain natural or cultural features, such as ponds, railroad tracks, important buildings, bridges, etc., by conventional symbols. These symbols are really pictures, and we must have them large enough to recognize. Thus, by a certain map's scale, a forest ranger station would be over 400 ft. high from doorstep to top of flagpole! Railroad tracks 80 ft. wide! Nobody would think of applying the scale to these features, except perhaps to a pond or the width of a river. A pond only a few hundred yards or so across if put to scale

might be an almost imperceptible dot on a map; yet because it is a good landmark for pilotage it must be large enough on the chart to see. And we, seeking a good lake to do a little sailing, might think from the scale it was several miles across—unless we knew charts.

In one curious respect, though, this disparity in scale comes in very handy for accurate distance reckoning on U. S. Aeronautical Charts. On these the railroad tracks appear as heavy black lines, but the crossties are at 5-mi. intervals! On the lighter black lines, for electric trolley railways, the crossties show 2½-mi. distances.

The chief reason for using a large sheet of paper for but a small part of the country is to enable the scale to be more telling. Obviously, we have maps on comparatively small sheets for the mere convenience of carrying them around, keeping them handy, and storing them safely. It isn't physically impossible to paste maximum-sized sheets of paper together to make one enormous map. Theoretically, and in actual mathematics, that's just what good mapping of a very large area tries to do. A good modern map of a small piece of country is not —as formerly—just a separate map, an isolated thing; it is part of a larger map just as the place itself is part of a larger region. Great mapmaking projects keep the *total map* in mind so that although the individual sheets wouldn't, or couldn't, physically be fitted and pasted together they will nevertheless have a continuity that adds up the component parts into a virtual whole. The U.S.G.S. topographical sheets are in various scales to suit the particular regions; yet they can all be envisioned in the one scale of 1:63,360, and if the sheets were assembled into the one big map that each map is a virtual part of, this map of the U.S. would cover about an acre. At 1:31,680 (2 in. to the mile) the distance across the map from coast to coast would be 500 ft.

WHAT'S LARGE ABOUT A LARGE-SCALE MAP?

Or small about a small-scale map?
The *scale* of course!

Scale is whatever you see fit to use as a measure, and it is large or small in relation to the thing you are measuring. In a telephone booth a man's foot will seem to him a pretty large scale to measure with. But let him try to measure the Sahara with his foot and the scale will become extremely small.

That's the whole difference between large scale and small scale. Let's see how it applies to maps.

Here is a large scale:

= 1 mile

It uses 2 in. to show 1. mi.

Here is a somewhat smaller scale:

= 1 mile

It uses only 1 in. to show a mile. But still it would be a large scale compared to one which used 1/16 in. for a mile. This is so small that we cannot well draw it in terms of a single mile. When a scale becomes so small that we must speak of fractions of an inch, we change the wording and the graphic line so we can have a whole inch to deal with. So instead of saying "1/16 in. to the mile" we say "16 mi. to the inch."

Or: = 16 miles

A still smaller scale would be 1/80 in. for a mile, or better expressed: "80 mi. to the inch."

Notice that the greater the number of miles the smaller it divides our scale-inch—or other unit.

"Other" unit because we might be using a representative fraction. For instance, 1 in. for 1 mi. There are 63,360 in. in a mile. So we have:

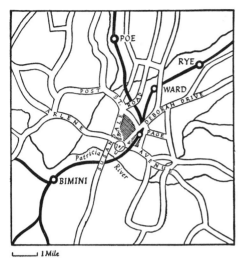

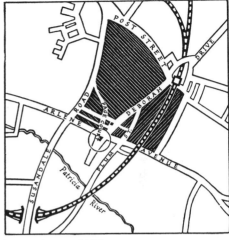

Small scale RF 1:190,080. Only ⅓rd inch to the mile. Extent of region shown: 9 mi.

Medium scale RF 1:63,360. 1 full inch to the mile. Extent of region shown: 3 mi.

RF 1:63,360 (LARGE SCALE)

But if we use 1 in. for 80 mi. we'd express it:

RF 1:5,000,000 (SMALL SCALE)

Notice again how in the smaller scale there is one number which gets greater. Again, this only means that our scale unit—be it an inch or a toothpick—is divided smaller. As that right-hand figure of an RF gets larger the scale gets smaller. Nothing surprising or upside-down about this: that right-hand figure represents the *ground*. And we know that as the ground gets large our measuring unit becomes relatively small.

There is another practical way of looking at this. In a large-scale map we can have a large amount of paper space to show a comparatively small amount of country. We can make topographical features *larger*, and clearer. It is like taking a close-up with a camera: you can't get in quite so much ground, but you get larger detail. Larger scale means larger detail.

On the other hand, if you squeeze the whole world into one small book-page your scale and detail must necessarily be small.

Large scale RF 1:21,120. 3 full inches to the mile. Extent of region shown: 1 mi.

(In the upper maps apply the graphic scale, and see area covered on them by lower map)

Put a magnifying glass upon a small-scale map and just as you magnify its detail you enlarge its scale; to the same mathematical extent.

Large scale means LARGE DETAIL

Small scale means SMALL DETAIL

"Big frog in a little pond." Large scale
"Little fellow in a wide, wide world." Small scale.

or,　　RF 1:10,000　　　Large scale

　　　　RF 1:10,000,000　Small scale

If a cartographer increases the size of a map so as to increase the scale, he may or he may not increase the amount of space for its content. A wall map of Europe may be so large that it will contain small political subdivisions—such as the departments of France —most of the minor streams, most of the small towns, etc. Even though these details will be drawn to scale in this large-scale map, they will probably have to be so small that you will have to stand as close to the map to read it as you are to this page. On the other hand, he may draw a map for a school room or lecture hall to be read at distances of many feet. Such a map will not have much content. Only large features, such as mountain ranges and main rivers will be shown. The very letters of the names will have to be so big that they will occupy the space used by the detail in the other map.

The way in which a map is to be used determines its character as much as does its subject. That is why its subject is not enough for its title. Its use and scale and subject are all necessary parts of its full name.

A MAP IS KNOWN BY ITS SCALE

Scale is so important in maps that it is a key to their classification. If you are buying a map without first seeing it, you can judge its usefulness to you beforehand by knowing its scale. Knowing its scale, you know almost what *kind* of map it will be.

Maps of a scale of 1:1,000,000 and smaller are usually *atlas maps*. In them you will find a general view of the earth's surface, shapes of continents, boundaries of countries, major mountain ranges, the greater deserts, important cities, harbors, principal rivers, railroads, and trans-oceanic courses.

You can usually associate *topographic maps* with scales of from 1:1,000,000 to 1:10,000. In this larger scale a more detailed and scientifically drawn representation of the region is possible for military and civil purposes. It is often large enough to admit creeks, forests, ponds, hills, lowlands, trails, ranger stations, mines, and even springs where you and your burro may stop for a drink.

Scales of 1:10,000 and larger generally mean the *cadastral map* or *plan* (as, for example, the Township Plat), which shows property or real estate divisions. These depict cultural features: houses, windmills, and other data that assessors, registrars, fire-wardens, policemen, growing boys, and other officials need to know. Tax maps, insurance maps, and landscape architect's plans sometimes use an inch for only 50 ft.—an RF of 1 to 600!

Maps are sometimes nicknamed for their scale. There is the "Millionth Map" of Hispanic America, produced by the American Geographical Society. Some people, uninitiated in these mysteries of scale, might take that name to signify that this scientific society has issued a million maps. But the name means that the map has a scale with the RF of 1:1,000,000. Or 15.78 mi. to 1 in. Some people say, "The one-to-a-million-map." Others, "The million map."

This map of over a hundred sheets is part of perhaps the most noble map-making project in all history: "The International Map of the World." The various nations of the world have cooperated to make this map on a uniform scale of 1:1,000,000.

We can just as neatly nickname maps in the inch-to-miles language. For instance, a "Three-inch Map" is one on a scale of 3 in. to a mile. Large scale. When the scale is so small that it splits up the inch, say, into a tenth, the map is named after the miles. For example, the "Ten-mile Map," means one that is 10 mi. to the inch. The British use this terseness more than do the Americans, but if the English system of measurement continues in American mapping why not use English scale-language?

Put a tape-measure around the Equator. If the circumference for your globe is 38 in. those 38 in. mean 25,000 mi. around the earth itself. Then what does 1 in. on your globe mean? Well, 1/38th of 25,000, which is 658. So the scale of the globe is 658 mi. to the inch.

To change this to an RF, multiply it by 63,-360, the number of inches in a mile.

This is, of course, rough figuring, to get round numbers. Actually, your globe might measure 37.6992 in., if it has a 12-in. diameter. And the equatorial circumference of the earth is 24,902 mi. But unless you enjoy finical figuring there is little point in doing it for distance-measuring on globes of such small scale as this. The easier, round-number way is more practicable on small globes. Another handy round number for rough figuring is 250 million —the radius of the earth in inches!

CONVERTING SCALES

Nothing better gives you the feeling of holding the world in your hand than to be calm and competent in handling scales. No one can claim to have skill in map-reading unless he can suit the given scale of a map to his own requirements. A map may have one kind of scale while you would prefer to use another.

Many of us are so used to the English scale that for all the logic of the Representative Fraction we look at an RF and say, "But how many miles is that to the inch?"

Making such a conversion involves simple arithmetic. Remember that there are 63,360 in. in a mile.

If the RF is, say, 1:10,000, how many times does that go into 63,360? About 6¼. Then your map is on a scale of 6¼ in. to the mile.

If the RF number is higher than 63,360, switch it so that you will still be dividing the greater by the lesser number. For instance: RF 1:1,000,000. What's that in plain English miles per inch? This time, then, let 63,360 do the dividing. It goes into 1,000,000 how many times? 15.78. And that's how many miles-to-the-inch your "million map" is.

However, we can save much of this figuring if we list the RF scales most generally used, and have them converted ahead of time. In the Appendix you will find such a table.

Making a graphic scale consists merely of dividing a line properly. If you know how many miles to an inch, nothing could be easier. But often you have to choose between an even inch or an even number of miles. For example, you may have a map in a scale of 0.8 mi. to the even inch. Perhaps you would prefer having the scale in terms of an even mile. Good reason for it, too: easier to figure the number of miles distance in case you are using graphic scale. Easier to mark off 1¼ in. on a line and call it an even mile:

_____| 1 mile

The figuring: If 1 in. means 0.8 mi., ⅛ in. means 0.1 mi. Then 10/8 or 1¼ in. means 1 mi.

Sometimes in making a graphic scale we have to divide a line into a number of parts which we can't easily take off an ordinary ruler.

Suppose we have to draft a graphic scale for a map which requires that we divide a section of a line into 5 parts, and that section is 1$\frac{7}{16}$ in. long. How can we divide 1 $^7/_{16}$ by 5 without a lot of finical figuring? Easy. It's an old geometrical trick of drawing parallel lines by sliding a triangle on a base line.

Here goes: Line *AB* is a section of our graph-

ic scale. It is $1\frac{7}{8}$ in. long and must be divided into 5 parts. First draw construction-line *AX* at a convenient angle. (Quickest way: put triangle on *AB* and use the slanting edge as a ruler.) Next measure off on *AX* 5 convenient sections. Here, ⅜-in. sections go well. Then connect point 5 with *B* at end of *AB*.

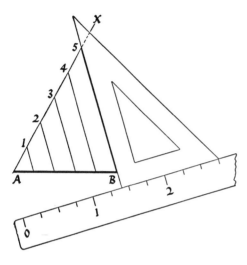

Now, we're ready to draw the parallel lines which will cut *AB* into 5 equal sections. With triangle on line *5B*, place ruler against base of triangle. Then slide the triangle along the ruler to draw section-line *4*, then *3*, and so on. Easier than holding this ruler is to draw a base line. Slide triangle along that.

After making the divisional ticks on your line to be divided, erase the construction lines, and you will have a graphic scale of neat fifths.

Suppose that some barbarian has torn the scale statement off your map. If you happen to know or can find out what the distance is between any two important places on that map, the rest is easy. Measure the number of inches those two places are apart. Then relate that figure to the miles-distance between them.

For example, the distance between two towns is 3½ mi. On your map you measure the

space between them and find it is 7 in. Well, 7 divided by 3½ is 2. So the scale is 2 in. to the mile. Or RF 1:31,680.

MILES-PER-DEGREE

We have measured the globe in terms of degrees, and we have measured it in terms of miles. But how many miles are there in a degree?

That depends upon where you are doing the measuring. An east-west degree along the Equator is 69.172 mi. long. But along the 89th parallel an east-west degree is only 1.211 mi. long.

The reason for this difference becomes obvious with one glance at the globe. The parallel circles of latitude get smaller as we go from the Equator to the poles.

Distance around world at Equator is 24,902 mi.
Distance around world at lat. 89° 30′ is 218 mi.

If the circles get smaller, then the arcs into which they are divided become shorter.

Most globes and world maps show the meridians 15° apart. They cut the Equator, therefore, at equal distances of 1,040 mi. But in the latitude of New York they are only 784 mi. apart.

As 15° is the distance the sun appears to pass across the sky in 1 hr., there is the same proportional difference in time as in miles. At the Equator you must go about 17 mi. to make a difference of 1 min. in true local time, while at New York only 13 mi. will do the trick.

Extensive countries are often mapped in a uniform large scale, covering many sheets. Each sheet will show say, 1° by 1° of country, but not all the sheets will be the same size. Sheets showing southern parts of the U. S. are bigger maps than those of the same series showing northern parts, though the scale be the same for them all, and though they all

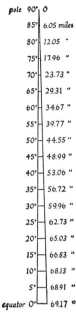

pole 90°	0
85°	6.05 miles
80°	12.05 "
75°	17.96 "
70°	23.73 "
65°	29.31 "
60°	34.67 "
55°	39.77 "
50°	44.55 "
45°	48.99 "
40°	53.06 "
35°	56.72 "
30°	59.96 "
25°	62.73 "
20°	65.03 "
15°	66.83 "
10°	68.13 "
5°	68.91 "
equator 0°	69.17 "

How the number of miles in an east-west degree increases

be the same number of degrees or minutes "square"! U.S.G.S. topographical quadrangles, for example, vary in size from 17½ x 12 in. to 17½ x 15 in., depending upon the latitude.

Knowing how to handle the lengths of terrestrial arcs, whether of parallel or meridian, is a map-reading skill easy to acquire and always interesting to apply.

The north-south degrees have but a slight variation. But the earth is not perfectly round, don't forget. The equatorial great circle is 42 mi. longer than any meridional great circle. That makes little, but still *some*, difference in miles-per-degree. A degree along the Equator is ¾ mi. longer than the first north-south degree. But it is ¼ mi. *shorter* than the last north-south degree! Glance at these figures:

Any degree on Equator, 69.172 mi.
Lat. 0° to lat. 1°, 68.703 mi.
Lat. 89° to lat. 90°, 69.407 mi.

Slight as these differences may appear, they matter in high-precision mapping. Geodetic surveyors have to take them into account, and when they have done so with any great-circle distance they call it a "geodetic line." Fit for an accurate map.

However, for nearly all ordinary map-reading purposes we can say that roughly a degree on any great circle of the earth is 69 mi. long. That is a handy figure to keep in mind, especially when measuring north-and-south distances along the meridians. If you know the circumference of your globe you can measure *any* great circle distance, though, by use of this figure and a piece of string. On a globe with a circumference of 25 in., say, you measure a great-circle distance of 5 in. between two places. 5 is 1/5 of 25. And 1/5 of 360 degrees is 72 degrees. Then 72 × 69 is 4,968 mi., the distance between the two places.

In this air age we are going to do more and more great-circle thinking. Great circles are, above all, air-paths. They are the shortest distances between ourselves and our neighbors, the quickest way to call on them. If we call across by radio, our voice takes to the great-circle distances, too.

So, it may have already occurred to you while reading this that if this system of degrees is so good for measuring this round earth, why don't we have some kind of standard measure which is a combination of miles *and* degrees? Why have an arbitrary statute mile of 5,280 ft.? Why not have a mile which is a definite part of a degree? You are right.

And that is what navigators and geographers have done. Just as we divide a degree by 60 and call the result a minute, we can divide the number of miles-per-degree by 60 and call that a mile. Navigators consider the Nautical or Sea Mile at any place to be the same as the length of a minute of latitude at that place.

But the U. S. official Nautical Mile is a min-

ute of a great circle of a perfect sphere whose area would be the same as that of the earth. That Nautical Mile used to be 6,080.27 ft. In 1954, this figure was changed to 6,076.1 ft., which is the International Nautical Mile.

The British call it the "Admiralty Mile" and have it an even 6,080 ft.

The International Hydrographic Bureau in 1929 proposed that it be 6,076.097 ft. and some countries have agreed to that figure.

The Geographical Mile takes for its great circle the Equator itself, and a minute of that is 6,087.1 ft.

METRIC DISTANCE

Progressive people would like to do *all* our measuring in terms of tens. Ten is the easiest number to use in multiplying or dividing. If we reduced all our measurements to simple decimal work there would be no need to translate one set of figures into the language of another set. No "mixed fractions." Why then have our measuring systems at sixes and sevens? We Americans use the simple tens system in money counting: dimes and dollars. We are so used to it that it has become part of our slang: "ten-spot" and "ten grand." The English system of guineas, pounds, shillings, pence, etc., seems outrageously clumsy to us. Yet, we go on using the same kind of system in our mapping. How often do we use the metric side of our rulers?

Machinists, gun-makers, lens-makers, zoologists, botanists, radio engineers, anthropometrists—all who do scientific measuring—use the metric side. It is the side which the mapper should turn to first, and feel at home with, because he of all scientific measurers has provided the groundwork for the metric system.

The French, who originated it, took a tenths measurement right off the earth. One ten-millionth of the meridian between the Equator and the pole. They called that a meter. This measurement has been standardized on a platinum bar kept at 0° centigrade temperature.

Divide a meter by 100 and we have a centimeter. (Abbreviation: *cm.*) A thousand meters is a kilometer. (Abbreviation: *km.*) And that's the best "mile" of all. Consider how neatly it works out with a map scale: Take an RF of 1:100,000. So 1 cm. on the map means 100,000 on the ground. And 100,000 cm. is a kilometer!

The metric system is as simple as a dime.

It can be applied to the circle. Instead of dividing a circle into 360 we can divide it into an even 400. These divisions are called "grades" instead of degrees. This, too, is neat: a right angle is 100. From the Equator to either pole, 100 grades of latitude. Around the world 400 grades of longitude. This is something in the future which mappers may look forward to. We're coming to it.

During the present period of transition from one system to another, however, we often have to convert figures from metric to English measure, or vice versa. Here is a rough-and-ready figure: 1 km. is 0.62 mi. So 100 km. would be 62 mi. (See pp. 273–274.)

The various devices men have resorted to for doing their geographical measuring are worth musing upon. The French metric system and the nautical (or geographical) mile system begin with the whole cheese and divide it into units. The only difference between one system and the other is the numerical difference between one divisor and another, the difference between 10 and 60. One number builds up or breaks down into "round" numbers, while the other results in dozens, and such parts. But the decimal-metric system and the "dozen-like" degree system both began measuring by dividing: the one divided the earth, the other the year (360 days).

Less sophisticated is the addition, or length, system. Take a stick or a length of string or chain, standardize it, and you will have a sys-

tem of earth measurement. Hence, the *rod* as a measure. A *furlong* meant simply "furrowlong"—a plowman's measure. The *vara,* the Spanish yard, comes from the Latin word for forked stick, and still figures in some of the older surveys of Texas, some of which were done on horseback, counting the horse's pace at about 33⅓ in. In Bengal, a wayfarer breaks off a branch as he goes along and by the time it wilts he will have walked one *kos* (or *krosh*) —anything from 1½ to 3 stat. mi. Naive? It's the same principle that we use with a chronometer or a speedometer: timing. If you sail at a speed which pulls rope off a reel at the rate of, say, 8 knots (which have been tied in that rope at exact intervals) an hour, you are traveling at 8 *knots,* which is 8 naut. mi. per hour. And if you keep count of the speed and time, you'll know how far you have gone across the wet surface of the planet. Astronomers use as their unit of measurement the distance which light travels in one year.

"It's only three blocks away" is good map language. So is "I've a girl who lives 18 townships south of here." Of course, that isn't telling you *exactly* where she lives, but "it kind of gives you a picture." At least, you know you'll have to go no less than 18 × 6 mi. to call on her.

An odd thing about Land Office maps: they show distances in "chains" and "links." In the days before steel-tape measures, surveyors dragged chains to measure land. The one formerly used in the U.S. public land surveys was known as Gunter's chain, named after the inventor, a contemporary and possibly an acquaintance of Shakespeare's. Gunter was the mathematician whom you can thank (or blame, as you feel about it) for such terms as *cosine, cotangent,* etc. His chain is 1/80th of a mile, or 66 ft. long. It is divided into 100 links, each 7.92 in. long. In a township plat you will find along the section-sides the figure "80.00." That means 80 chains, or a mile, which is a side of a full section. Most likely this will be the one in the southeast corner of the township. In the northeast corner you are likely to find for a section-side a figure like "77.75," instead of "80.00." Here again we are reminded that the earth is round and meridians converge. Even in the measurement of linear distances we fall back again and again upon coordinates, the inner and often invisible framework of a map. Knowing them is knowing maps from the inside out.

In the field, the B.L.M. no longer uses the actual chain but steel tapes, 8 and 10 chains long, instead. The terms, "chains" and "links," though, continue to appear on the plats.

These terms, like some other designations on maps, are for surveyors and technical users rather than for map-readers, generally. In this book, however, it is assumed that the reader does not wish to be mystified by anything in a map. And he should not be, especially in a map made by his own government, and perhaps of his own home grounds. Wherever the citizens are "in the know," their way of life can conserve and progress simultaneously. Maps—particularly those made by the B.L.M., the Geological Survey, and the Coast and Geodetic Survey—are tools for citizens who realize that to be owners of a free country they must also be knowers.

4. The Rose of the Winds:
DIRECTION

IN OUR BACK YARD an ant is jeeping across what to him must seem a vast desert. We pick him up and carry him far off his course. Then if we can match our patience with his we shall see him find his way back: through mountain passes, over plateaus, around lakes, and through jungles. And we shall marvel, what is it, this sense of direction? Some kind of instinct?

Looking up, we see a pigeon flying. Perhaps it's a carrier, with a message clipped to its foot. It, too, has this sense of direction and will get there. Wild ducks have it, and so have tame house cats. They always come home.

Still higher than the pigeon an airplane roars through the sky on some vital mission. We hope the pilot has a good measure of this instinct. But if he has none we know he has science. That is his mainstay. Instinct may be the homing pigeon's way. But science is the venturing and homing man's way. A good pilot may have both instinct and science. That is one of the advantages of being human.

This sense of direction we call an "instinct" in animals and men is proving to be nothing more mystical than an eye-ear-and-nose awareness of the features marking a route or area. The bird that navigates by the stars during a migration has but realistically included them in his relevant environment (as people, too, are at last learning to do), and he is merely using his eyes for all they are worth.

The so-called primitive man who reads his directions from ant hills is not a bit like the fortuneteller reading tea leaves but like the ecologist who knows *where* because he makes a study of *here*.

The science of direction goes back to man's earliest (and still valid) observations of nature,° especially the stars and the winds.

When waiting for a wind to move his ship he looked in the direction from which he

° *Nature Is Your Guide* by Harold Gatty, one of the most illustrious of modern navigators, is a practical handbook of non-instrumental, non-graphical ways of knowing where. These will not help a mapper in the field to be accurate but they can make him self-reliant so as to help his morale and enrich his enjoyment of the work.

hoped it would come, begged the god in control of that wind-station to send a favorable breeze. And when the wind came he gratefully named it after its source. "Zephyr" still means west wind. People got into the habit of thinking of *directions* in terms of wind-source. We still speak of the directions as "the four winds"· and ask from what "quarter" a wind, or a rumor, comes.

In Athens, which was the Greenwich of those Mediterranean times, an astronomer built a "Tower of the Winds." It had eight sides, and on top, acting as a vane, was the sea-god Triton, turning this way and that. For the weathervane, too, points in the direction of the wind source. This tower has seen in these 2,000 years the full development of navigational direction-reading, from finger-wetting to the radio and the gyro-compass.

Map-makers affecting quaintness nowadays sometimes put into their maps winged heads with puffed cheeks blowing the winds. In medieval maps, though, these were not mere ornaments any more than are the austere astronomical symbols in the nautical almanacs of today. Those "winds" were direction-indicators.

PILOT PLUS COMPASS

Though man could heed and need the winds and name them, he couldn't see them. He knew which ones to shut his door against; how to draft them to blow the chaff from the seed in his flaying, and blow the sand from the gold dust in his dry placer-mining. Came a wind out of the supposed dark region of the west or the bright one of the east, out of the supposed "nether" region of the north, or the sun realm of the south, the mariner could trim sail to it and harness it to carry him wherever he told it with tiller and keel. But he couldn't see it. When he got out of sight of land and the wind blew clouds across the stars, hiding them, he had no coordinates to let him know which way

he was going. He had given the winds their names but he could not always tell the name of the one which was blowing; he could not always distinguish them by their voices or manners, for they often fooled him. Hence the still-used expression of bewilderment, "I'm at sea."

The direction-finder which finally freed the mariner his dread of getting out of sight of land was the magnetic compass. Nobody knows who invented it or just when. The Chinese, the Arabs, the Greeks, the Etruscans, the Italians, and the Finns all claim to be the original inventor.

In its early form the compass was a magnetized needle riding on a reed or a raft of splinters which floated upon the surface of water in a basin.

The earth itself is like a great magnet, with the principal lines of force running north-and-south. The magnetic needle, having a south-seeking end and a north-seeking end, is all obedience to these lines of force and swings to attention. Then its duty is done.

Winds from a map of 1503

Not so with the dial of the compass. Now *its* duties begin.

"Compasses are for showing north." This is about the total knowledge many people have of one of the most important yet commonplace

instruments ever invented. This fund of knowledge is on a par with that of youngsters who can tell you that clocks "are for telling time by" but who have not yet themselves learned how to tell time by the clock.

The dial tells us what the needle's obedience has to do with the world ranging around the compass. For the dial, in a sense, is a little map too. In fact the proper word for it is *CARD*, which is an old word for chart.

The early mariner charted the eight principal winds, but there was too much leeway in between those directions. Northeast, Southeast, Southwest, and Northwest were not enough points between the four main points to keep him from missing his port. So he split up these with eight "half-winds."

But the world gets wider and wider beyond the local circle of one's home. Divide the horizon with 16 points, and there will still be between one point and the next a gap wide enough for another wind to come through and for another path to get lost on unless you register it on your chart. This the mariner did with 16 more points, "quarter-winds."

Wind rose from a sailing-chart of about the time of Columbus's first voyage

With a 32-pointed dial, now, the sailor had what resembled a 32-petalled flower which he called *rosa ventorum*, or "rose of the winds." He didn't mean to sound poetic; it just turned out that way.

These wind roses became staple on charts and cards. They were often painted in beautiful colors, but again the reason for the beauty was primarily functional and not at all frivolous. It's a principle worth knowing in today's map-making: the relation of various colors to reading ease in artificial light. Often the chart or compass had to be consulted at night with a flickering lamplight and a rocking ship. The eight principal winds were black petals and made a good background for the eight green (sometimes blue) petals of the half winds. And as red is a color which hits you in the eye, the small petals of the quarter winds could use it to high advantage.

Mariner's compass card

The north-point symbol was a dart, a triangle, a sea-god's trident, or a star. How the fleur-de-lis came to be used nobody knows exactly. Perhaps it is only a decorative development of the spearhead or dart. The fashion for it started at about the time of the New-World rush which immediately followed Columbus's voyages. To this day it tops the compass. The Boy Scouts have it as their emblem, because of the accumulated respect for it as a directive symbol. It is often called by British sailors, "the Prince of Wales's feathers."

Thus there is more to a compass card than we at first see, a rich history and a curious ac-

counting for what even might appear as orna-mentation. Thus also the mariner's compass came to have 32 points. When an apprentice seaman can say all these points by heart he has learned to "box the compass." This is to navi-gation what learning the alphabet is to read-ing.° (The Chinese, by the way, divided their card into 24 points, which is like our clock-face principle.) The modern mariner splits the quarter-wind into still finer fractions: four to each wind or point, making in all 128 marks around the compass.

Another style of card is that in the Survey-or's Compass, or, as the Army calls it, the "Watch Compass." In using this you don't say "points" but "degrees." This dial is divided into four parts, to begin with, the same as on the other card: North, East, South, West. Then in-stead of splitting each part in the middle and

Surveyor's compass card

again each part in the middle, and so on, as the mariner did, the surveyor simply divides the quarter-circle into 90 degrees. Same as a right angle. Surveyors deal in angles. Direction to them means an object is so much of an angular distance from a reference point. That would mean so many degrees to the right of the refer-ence point or to the left of it. So this card takes north and south as reference points, and it is marked off up to 90° at left and right of each.

This is how it works. Suppose we are stand-ing at a very definite place on a shore, a certain

pile of a certain dock, say. There is an island; our guess is that it is "pretty close to north of here." But when we consult our compass we sight the island considerably to the right, or east, of the north point where the needle comes to rest: 45° east of north, to be exact.† As you stand there with your compass needle pointing through the north point, a line from the center of the compass and on out to the island passes through the 45° mark. It makes an angle of 45° with the "base-direction line" passing out to the north point.

If we are making this survey for a map we might properly say in our notation that the *BEARING* of the island is "N. 45° E." It *bears* that far from the base-direction line. We'd draw on our map a line from this dock, at an angle of 45° from north. Measuring on that line the right scaled distance, we'd know exactly where to place the island.

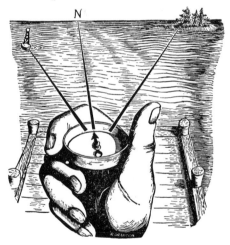

Bearing 30° west of north is a buoy. N. 30° W. Now, if we try to get the bearing of a light-house downshore, we find we have to turn around more than halfway. It is nearer south

° For names and angular values of the 32 points see p. 274.

† Assuming for this example that the needle points true north!

than north, and so south becomes our base direction. "Lighthouse: S. 80° E." A little to the right of south is a church spire. "S. 15° W." That is how this style of compass reads: from the nearer of two points, north or south.

A bearing on a surveyor's card is never higher than 90°—that is, a quarter-circle or a right angle. In the surveyor's sense, therefore, a bearing is an acute angle. And what the soldier calls the "base direction," the surveyor calls with a bit more technological flavor the "reference meridian." Both are good phrases and do the same service equally well for map reading.

The most scientific card of all, perhaps, is the one divided simply as we've always divided a circle; into 360 degrees. (400, as in the French

U. S. battleship compass card, adopted 1918 °

centesimal system, would be still better.) We measure clockwise on this card, and use figures only. North is 0°; east is 90°; south 180°; west 270°. No names of directions to bother with. Saying just "45°" is shorter than saying "northeast" and not any drier than "NE." The only seeming oddity at first is turning clear around and reading "359°." This is like saying, "The time is 1:59" instead of saying, "1 minute to 2." But roundabout as it may appear, 359° is more terse than "N. 1° W."

This card is supplanting the others. The U. S. Navy has replaced the old wordy point-system of the ancient mariner by this degree-system.

° Courtesy of Department of the Navy.

The mariner has been slow, however, in taking to it: helmsmen have difficulty in following it, because they are human enough to think of things by their right names. A port, a country, a sea, a mountain, and a direction all have the names you know them by, just as people have. What if we had to know our friends and relatives merely by numbers! "Southeast" sounds more definite in an old salt's ears than "135°."

Nonetheless, an old-fashioned nautical point is exactly 11° 15'. For, 360 ÷ 32 = 11¼. It comes to degrees after all.

Astronomers, geodesists, air navigators, the infantry, and the artillery; military, naval, and civil engineers, and radio engineers have all adopted the 0-to-360 compass card.

It is called the *AZIMUTH* card or circle. Az'-i-muth. *Az* as in "as"; *i* as in "in"; *u* as in "us." A word that every serious map-user, same as every surveyor, Coast Artillery and Anti-aircraft man, should know. All it means is "direction," horizontal direction. Same as bearing, except that bearing usually is thought of as going only to 90°, while azimuth goes through all the four quadrants of a circle to 360°.

Azimuth is merely a make-over of an ordinary Arabian word, just as *cotton* is. In the Arabic *al-samt* meant "the way" or "the direction" or "the arc." All three senses in one term are just what we wish here and we have them.

The only difference in usage is the choice of reference meridian. The usual practice is to refer azimuths to the south point: measure clockwise from the south meridian. Astronomers, geodetic surveyors, and most landlubbers do so. On sea, though, the north point is preferred for the taking of azimuths.

Every trade to its tastes, but the map-user must know the tricks of several if he is to feel at home on any card or chart.

The ordinary man asks, "What's the direction?"

The mariner and the land surveyor ask, "What's the bearing?"

The celestial navigator, astronomer, artillery man, etc. ask, "What's the azimuth?"

The terms are synonymous ordinarily, but strictly speaking, *bearing* and *azimuth* mean the same only up to 90°. Then it's azimuth. *Azimuth* is measuring in terms of the whole circle; *bearing*, in terms of the quadrant. To say, "Bearing 345°," would not be entirely incorrect, but better technical usage would be, "Azimuth 345°."

Here then are three ways of expressing a compass direction:

MARINER'S COMPASS: West, Southwest (WSW)

SURVEYOR'S COMPASS: S. 67½° W.

AZIMUTH COMPASS: Z 67° 30′ (from south point)

AZIMUTH COMPASS: Zn 247° 30′ (from north point)

Another abbreviation for azimuth is **Az.**

NORTH AND SOUTH

North and south are definite points on the globe: the poles. Each pole is the meeting point of the earth's axis and of all the meridians. The meridians are halves of great circles. We can also say that any circle passing through both of the poles is a great circle and its direction is true north-and-south.

Our entire network of coordinates is pinned to the globe at these two points. Our whole reference system of directions and locations is based from these points. We say *"northeast"* and *"southeast"*: we don't say "east" first, we don't say "eastnorth." In fact, north and south divided the compass between themselves first.

North and south are ultimately *places,* the poles. East and west are not. You can keep going east and never arrive at an ultimate east point where your direction would change. In order for it to change to west you have to make an about-face. East and west are directions, but north and south are directions to distinct points—the poles.

In the northern hemisphere, the oldest and still the most dependable marker of north is the North Star (Polaris). It is only a little more than one degree off the celestial pole. Fix a pointer to that star in your back yard by sighting two plumb lines on it, then driving pegs in exact line, and you will have a precision mark hard to beat. Many a country has set its boundaries by sighting at that star. In celestial navigation the North Star is still looked up to, the queen of 50 guiding stars. Stars are old but not old-fashioned; still are up-to-the-second mapping points.

In the daytime the sun is our heavenly marker. Instead of finding north we find south.

Hold a watch face upward with the hour hand aimed at the sun. South will be halfway between that point on your watch and 12. One exception to this is at noon, when the hour hand, 12, and south are all together. Another is in the southern hemisphere, where the watch has to be held face down. The mid line then points north.

In order to spare the eyes a direct glance into the sun try holding a match or pin at the edge of the watch, and line the shadow through the point of the hour hand.

If your watch is on daylight-saving time, it is one hour fast. So place the match at the point where the hour-hand had been just an hour before.

The watch method, though, is either difficult or impossible when or where the sun rides too high, as in the tropics. It is, in fact, at any time or place nothing more than a very rough directional method.

Another daytime south-finding trick is one that has come down to us from the ancients, and it still works. All you need is a plumb-true stick in the ground, a long piece of stretchless cord, and the sun.

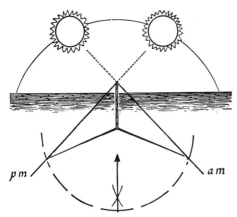

Loop one end of the cord over the stick. About two or three hours before high noon, when you can have a good long shadow, measure that shadow's length with the cord. Use that length as a radius and draw an arc. Mark the point on the arc where the shadow's tip touches. In the afternoon, when the shadow's tip just touches the arc again, mark *that* point. Now simply bisect this arc, using the two points as centers. Draw a line from the stick to the point of bisection. That line will be a bit of true meridian. It will be true north-and-south.

This stick which you and Eratosthenes have used so well deserves and has a suitable name. "Gnomon." In Greek that means "one who knows." The gnomon which Eratosthenes used was perhaps a monument or obelisk. It is considered to be perhaps the earliest of all scientific instruments. It was not only a meridian fixer and sun-clock but also a latitude finder.

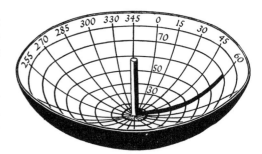

Gnomon in Scaphion *or "small boat"*

In an improved form, it was a pin in the center of a bowl, like the bowl of the heavens over us. This bowl —known as a *scaphion*—was scored off with lines which made sense wherever the gnomon's shadow touched them. The sense was: the time of day and the latitude of the observer, lining him up with the universe and letting him know (more or less) where he should be on the map.

In putting up a gnomon to find where the true meridian runs through your back yard, don't forget that your watch, registering local time, is not likely to have both its hands lifted straight up to heaven at exactly the same moment that the sun is highest in the sky on your meridian, which is your true solar noon. And you and gnomon may not be exactly on the standard time meridian. So leave your watch out of it. Just mark the semicircle before the gnomon by the shadows of the same length, and bisect your arc. Next day at high noon, the shortest shadow should lie smack on that midline, and you and the universe will have signed a contract satisfactory to both parties.

MAGNETIC NORTH AND MAGNETIC SOUTH

The terrestrial globe is not a dead, fixed geometrical figure especially constructed to satisfy the requirements of the exact sciences. It is a living, ever-changing body.

Our globe is magnetic; not in a mechanically uniform way, but in a temperamentally uneven way. Mappers have had to put up with its magnetic behavior, and they have done so cheerfully, with interesting results. Nobody can be said to know how to use maps until he understands their relation to the earth's magnetic field.

This magnetic field is not what too many people suppose it to be. If the magnetic element were a huge bar identical with the axis of the globe, like a magnetized axle through it, then of course our compass needles would all obediently line up with that huge pin. They would point directly to the north and south poles. Compasses would point true north, as people who don't know them think they do.

But the earth's magnetic field, like the earth itself, is spherical. This sphere is not composed of a single substance, like an iron cannonball, but of many substances, more or less magnetic, and some not at all. Nor are they uniformly distributed. This makes our compasses point variously, depending upon where we happen to be using them. Even so, irregular and wavering as the lines of magnetic force are in this globular field, they do tend generally northward and southward. They appear to run parallel with the earth's surface, and as they get farther and farther north (or south) they come closer and closer together, somewhat like meridians. As they do so, they also run less and less parallel with the earth's surface, until where they finally come together they are practically vertical to it. Here, the magnetic needle, instead of riding horizontal, dips. A special "dip needle" will stand almost vertical, sometimes at one spot, sometimes at another, in this region called the magnetic polar area. The "pole," though, is only in a manner of speaking rather than an actual, definite point like the geographic pole. Each of the vertical-dip regions is over a thousand miles away from the North or the South Poles.

But even if they were right smack on the Poles our compass still would not everywhere point true north or true south. For the compass is not controlled by the magnetic pole, either. What happens is that it points a direction in accordance with the total effect of all parts of the earth on a needle at the place we

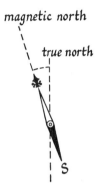

are standing. This direction is our magnetic north.

On our compass card the sight line to magnetic north and that to true north form an angle at the pivot. This angle is the number of degrees our needle at that spot bears away from true north. This bearing has two names: "magnetic declination" and "variation of the compass." Take your choice.

We have to know this bearing in order to correct our compass at any certain place. At a certain place our compass points 10°, say, to the left, or *west* of true north. 10° W. is then the variation of the compass in that locality.

Knowing this, we turn our compass so that 10° west of north comes under the needle. Then we are set right. If, as is a natural habit with a compass, we brought the north mark and the needle together, then to set ourselves right we should have to read 10° as true north. We, therefore, *add* that to the needle to get true north. Here, then, are two ways of correcting your compass: The first is to let the needle read the variation and so let the north

mark read true north. The other method is to bring the north mark and the needle together and let the variation figure read true north.

By either method, a mapper should know the difference between a true bearing and a magnetic bearing. Suppose the variation is 5 E. Now, to the right, or *east*, of true north is a hilltop. It is 15° east of true north, to be exact. That's its true bearing. 15° E. But because the needle is deflected 5° east of true north, the hilltop bears only 10° east of the needle, or magnetic north, and so its magnetic bearing is 10° east.

Ordinarily, it is the magnetic bearing we know first. Then by allowing for the variation we get the true bearing.

The direction of the earth's magnetism varies not only from place to place but from one time to another. In one place the annual change will show increase by so many minutes; in another it will show a decrease in the variation. For example, in a certain year the variation in a certain place was, say, 10° E. The annual change is 1′ increase. So, 4 years later, there would be 4′ of change, and that would pile up a variation of that place amounting to 10° 4′. In some localities the annual change has been as much as 6′.

Scientists have zealously observed these magnetic phenomena now for many generations. In recent years observers have conducted magnetic surveys in a nonmagnetic ship. Today, marine and aerial navigators may have on their charts correct compass information for almost every place on earth. The Coast and Geodetic Survey has made observations at about 7,000 places in the United States and Territories, and this includes almost every county seat. Each of these places has been made a magnetic station, with a marker: a bronze disk set into a stone or concrete post. (See p. 236.)

Periodically, this bureau gets out a map of the U.S. Note the crooked lines on the exam-

ple shown here. They resemble jittery meridians. Yet it is a sober fact that along any one of these "isogonic lines," as they are called, the variation of the compass holds the same. What the Survey has done is to draw a line through all the points of equal declination, trying to get a "smooth" distribution, rather than to cover every point in the country. The lines jiggle at magnetically "disturbed" regions, making for irregularity of readings within comparatively short distances. This local "disturbance" might be some geological deposits more attractive to the needle than the general magnetic field is in that vicinity.

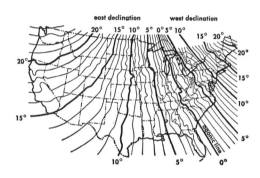

Simplification of a U.S.C.G.S. magnetic map
*—undated**

Canada, also, publishes magnetic maps. These are based upon over 25,000 measurements made in the Dominion since 1880.

The earth is alive with attractions, or rather "distractions," for the needle. There are minute variations from day to day, and even during different parts of the day. Then there are magnetic storms that you wouldn't dream were going on, but your compass will know it.

The only compass that is innocent of magnetic bias and is never bothered by steel sur-

* Actual map shows an isogon for every degree of declination from 1° to 24° and also has lines showing rate of annual change.

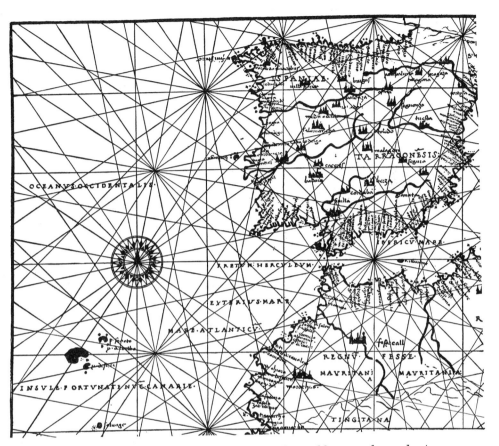

Portolan chart, executed in several colors, including gold, on parchment by Agnese of Venice sometime after 1543. Original in the Morgan Library, New York City

(See next page for discussion of portolans)

roundings, as in a modern ship, is that hummer the gyro, the super-development of the spinning top. When it gets going it lines up its axle with the earth's axis and that's that. True north. Lieutenant Commander P. V. H. Weems of the U. S. Navy says, "Although the earth has been rotating for many years, the gyro-compass is the only man-made device which makes practical use of this rotation."

Anyhow, the magnetic needle obeys the at-

traction of the local or general field and not, as is so often thought, of the poles. Neither the geographic nor the magnetic poles attract the needle. Only the lines of force in the field do so, and they in the long run get to the poles.

Magnetic maps are full of interest. Note the 0° or "agonic line." Any resident on or near its course can brag that, at least, where he lives the compass points true north—which is more than can be said for most places. In northwest-

ern Washington the compass points 23° E. of true north! But the main thing to note is that east of the agonic line the declination is westerly, and west of that line it is eastward.

DIRECTION AIDS ON MAPS

Like the aeronautical charts, all serious maps should supply the user with adequate direction-aids and correctives.

The wind rose appeared on charts before it did on the compass card; for mariners, by observations of the heavens and other means, estimated the bearings of various ports and capes from certain initial points, and so they made roses on their sailing charts before they had even heard of the practical use of the magnetic needle at sea. But later the rose became so closely associated with the compass that it got to be called *compass* rose even when it appeared on a chart.

A type of medieval sailing chart famous for these roses was the portolan. Many of them were made on fine skins and highly prized for their use and beauty. Many survive to this day and may be seen in various map collections. In a museum in Majorca there is one on which is written, "For this large geographical skin Amerigo Vespucci has paid 130 golden ducats." His own handwriting: he must have been proud of having what was even to him an antique.

These charts took their name from seaman's manuals, called portolanos, with which they were bound. Port-finding charts in a small maritime world, they had no meridians and little accuracy. At the center, or at some known point would be a rose whose petals became 32 rays reaching to shores all around. In other parts of the map would be auxiliary roses or "rosettes." Sometimes these lines crisscrossed bewilderingly. But to the navigator they were the most valuable feature on those charts,

for they represented straight courses.

These lines came to be known as "rhumb lines" and the 32 points of the compass from which they extended were called "rhumbs."[°] These terms remain in good maritime use to this day.

A mariner would head his ship on one of those lines and keep thus headed and going, God willing, until arrival. He may or may not have noticed the variation of the compass, in comparison with Polaris; but variation at sea is fortunately more uniform from place to place than on land, and his voyages were never so long (except those of the Vikings, much before this time!) as to make a big difference.

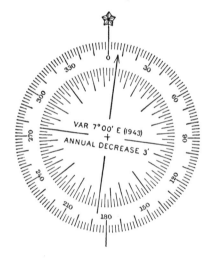

Compass rose from U.S.C.G.S. chart

Today we still use compass roses, but for another reason. On nautical charts they aid in correction of the compass. On aeronautical charts they act as a protractor in estimating directions. On radio direction-finding charts, a

[°] In Shakespeare's *Twelfth Night*, at the end of Scene 2 of Act III, Maria says of Malvolio: ". . . he does smile his face into more lines than is in the new map with the augmentation of the Indies. . . ." This has been interpreted as a comparison between rhumb lines and the lines radiating at the corner of the puckered eye.

special rose is used for plotting magnetic radio bearings. On these 0° is at magnetic south. Every modern map-user should know his compass roses. These roses are not quaint, romantic devices.

In Europe the term "compass rose" is used to refer to the dial, as when we say "compass card."

Most technically useful maps show plainly in their margins the difference between true north and magnetic north. Two arrows, or pointers, together. The true-north pointer is usually a star-tipped line. Easy to remember, for it makes us think of the North Pole as a flagstaff with the North Star as a finial. Sometimes the symbol for true north is a double-barbed spear. A single-barbed spear always denotes magnetic north.

One clever way of giving magnetic information is that of the Canadians in some of their National Topographic Series maps. In the margin at the bottom is somewhat the same map in miniature, diagramed to show detailed isogons. These lines of equal variation appear also on the large map in a more general way. They are red dotted lines overprinted for *quick recognition,*—a requirement especially vital when these maps are converted into aeronautical charts. In some of the Canadian Aerial Strip Maps are pairs of colored over-printed arrows to give the flier at a glance the magnetic variation of the place. U.S. official Aeronautical Charts also use dashed lines as isogons.

GRID NORTH

On grid-system maps there is still a *third* north! This plain, four-square way of mapping has had such an increase of everyday use that soon every good citizen interested in local geography or real estate could be expected to know "the three norths of a map."

The third north is known as "grid north." It is the direction of the vertical lines in the rectangular grid. Because of the earth's curvature we must often pull these lines a little away from the true meridian in order that we might have a straight-line, rectangular layout of coordinates. So it is a mistake to take these vertical lines for meridians or think they point true north. They may deviate from true north as much as 3°. One thing to be thankful for, though, is that this is not changed by the passage of time, as magnetic declination is. If you draw a grid with a y (vertical) coordinate 2° east of true north, that's the way it will stay, regardless of the earth's fickle magnetic lines. The symbol for grid north is a vertical line, or spear-shaft, topped by that "y" already familiar to you as the vertical coordinate in the grid system.

Always look for the north pointers on a map, and know which of the three norths you are at any moment dealing with. If it has no north pointers don't take chances. Unless you are

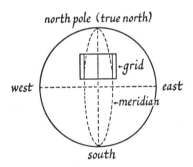

Why rectangular grid lines do not run true north °

thoroughly acquainted with the structure of the map don't assume that the rectangular coordinate lines are true pointers of the cardinal

° After Department of the Army.

directions. Never use the sides of a map as true north-south or east-west lines even though there are some maps on which one can do so.

USING THE COMPASS

For most ordinary marchings, reconnaisance, and operations in military and civil work requiring map and compass, magnetic north is enough. True north is a base from which you can figure the amount of the other variations. Once you know the variation of the compass at a certain place, you will find it easier to take all your bearings as magnetic while working, and make the allowances later.

There are several ways of ascertaining the variation of the locality. The government isogonic map may not come quite close enough for every place, but it is indispensable to compass users. Another U.S.C.G.S. help is that appearing each year in *The World Almanac* under the heading, "Magnetic Declination Tables." This shows the compass variation for the current year in over 100 cities, in all the states. The chief engineer's office of your town or county will perhaps oblige you with local magnetic information, and tell you where the nearest magnetic station is and what the readings are there. Or still better, he may tell you where to look for an Azimuth Mark. This is a U.S.C.G.S. disk with an arrow on it like that on the official Reference Mark. If you are at the station you can get not only an exact geographic position but also a true azimuth for testing the deflection of your compass needle in that vicinity.

Finally, there is the reliable Big Dipper at night, and at day you have Old Sol in combination with a good watch or a gnomon, as already explained. (See also p. 277.)

Be sure whenever you use a compass you are a good distance from bicycles, cars, iron tools, tanks, railroad tracks, steel structures, etc. Coast and Geodetic Survey men doing reconnaissance or triangulation walk 15 or 20 paces away from their truck before taking bearings with a hand compass. Here are some minimum safe distances from local attractions:

High tension power lines	150 yards
Heavy gun	60 yards
Field gun and telegraph wires	40 yards
Barbed wire	10 yards

Face the object whose bearing you are taking, and in the palm of one hand bring the compass about breast high. Take your time and slowly turn the compass box with the other hand to bring the north point under the north end of the needle. Now take a quick sight over the pivot toward the object, reading as you do so the degree mark through which your sight line passes. You will be doing well if you hit it within 2°.

The needle will not freeze dead still for you. As long as it sways the same number of marks on either side of the aimed point, you're getting service from it. You can't split hairs with a compass needle.

To slow the motion of the over-jittery needle, tilt the box gently so that the needle for a moment drags at one end.

Laying a pencil across the compass face is helpful for beginners in getting a sight line to the object. This makes a definite angle with the needle, which of course is a line to magnetic north.

Another aid is holding the pencil or a match vertically at the far edge of the compass and in line with the object. This picks out and holds the tiny degree mark for you so that you won't "lose" it when you shift your eye to read it in relation to the object. With practice you will be able to sight on the object and read the card at the same glance.

But you needn't plague yourself trying to pick out which fine degree mark is in line with the object. Let the needle do that for you while you aim the arrowlike north mark at the ob-

ject. That's much easier than aiming at the object with one of those fine ticks. Many expert compass users prefer this method. With the plain, easy-to-see north mark pointed at the object you can read the degree mark at the point of the needle as quickly and surely as you can read the minute mark at the point of the minute hand on a watch.

This, however, results in something curious.

Suppose someone is taking the magnetic bearing of a distant mountain peak. The first illustration shows how things would line up on an ordinary watch compass if the user let the north mark be together with the compass needle. "Why not?" he may think quite logically. "The north mark is printed on the card to show north!" But when he goes to read the degree mark in line with the object, he cannot pick out that 15° tick on the right, or east, side of the needle.

So he tries our method: decides he doesn't need *both* the north mark and the needle to point magnetic north for him but gives them each something to do for him. He aims the north mark at the object. Now he reads "15°" at the point of the needle. But as you will see in the second illustration, the curious thing has happened: the card reads *west!*

Nothing to get rattled about, though. The object is still east of the *needle;* neither of them has moved. Only the card has moved, bringing "N" in line with the object which in reality is not north, and "W" in relation to the figure which in reality is not west. The figure 15° is still right, for instead of reading a mark 15° on the right side of the north mark we read the 15° on the left side. So our correct reading is "N 15° E."

For this excellent reason, many surveyors have west and east switched on their compass cards, so that east is on the left and west on the right of the north mark. Then they can aim their north marks at the object and read exactly what their needles point at.

North mark and needle together; degree tick is sighted on object, which is east of needle

North mark aimed at object, which is east of needle (magnetic north), but card reads west

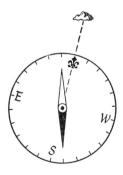

Reversed card: object is east of magnetic north, and reading is east

PROTRACTOR TO THE MAP

Even before you apply a compass to the map, it is well to know how to take bearings on it with a simple protractor. This is merely a matter of drawing a straight line between two points on the chart, then measuring the angle this line makes where it crosses a meridian.

Let's call the place where you are making the observation the point of reference or *A*. Call the object *B*. Draw a straight line through these two points, prolonging that line until it crosses the meridian or any true north-south line *NS*. This will form angle *NCZ*. Apply your protractor to that angle, for it is the azimuth or true bearing of *B*.

The first thing to do, as you will have seen

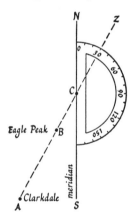

from the example above, is to draw a line through the two points concerned. The second step is to extend that line far enough to go beyond a north-south line. Note where these two lines cross. This is always *the* point to center the protractor. Thus, you don't have to have a north-south line drawn through your actual position, *A*. Simply use the north-south line which is already made for you on the map. It is parallel to the north-south line you might draw through *A*. So the angle made by the

cross line at *C*, is a corresponding angle, and equal in number of degrees. (See p. 40.)

Now that you have worked the trick and reviewed it to get its principle, let's apply it to a map.[*]

In the first job the only novelty for us will be an obtuse instead of an acute angle. Otherwise it is the same as the one we have just done. In other words, the object instead of being somewhat north of our position is somewhat south of it. Our position is *A*, a crossroad. Our object is *B*, a house. What is *B*'s azimuth (*Zn*)? The picture shows the line drawn through *B* and *A* to the nearest north-south line. You can read the result for yourself.

Our next job is with a still wider angle, so wide we no longer think of it as an angle in the ordinary sense. So let's call it an azimuth. It's almost three-fourths of a complete turn; the *Zn*

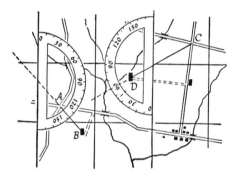

Protractor at left: measuring a map azimuth of less than 180°; at right, of more than 180°. Note how sight lines are extended to accommodate setting of protractor on a good line

of the house at *D* as observed from the crossroad at *C*. If we use a protractor which is a complete circle instead of a semi-circle, the reading of 240° is at once clear. But with this ordinary protractor, we simply add 60 to 180 (which is the half circle missing here) and get

[*] After Department of the Army.

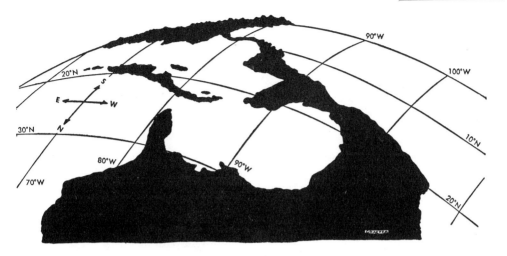

Heading southward °

the required azimuth: 240°. This simple matter of adding 180° gets you what's technically called the "back azimuth." (See p. 218.)

There are two other methods of locating objects on maps: by resection and by intersection. We can learn these more easily later on, in the field (p. 72).

If the vertical lines on your map are grid-system lines instead of true north-south lines, state your results as "grid azimuth." That goes, too.

FITTING THE MAP TO THE PLACE

We can scan the history of civilization as well as of mapping itself simply by observing which direction has topped the map. Erwin Raisz, the Harvard authority on cartography, says, "It seems to be a tendency among map makers of every country to put at the top of the map the direction toward which national attention is turned."

The Romans headed their maps as they so often did their empire-stretching ships, eastward. So did the Crusaders trying to recover the Holy Land. Many medieval wind roses have a cross as an east-mark. The wealth of the Orient was what attracted Columbus's ships westward and Vasco da Gama's southward, as the earth proved round. Arabs looking to Mecca headed their maps south. Early American maps virtually said, "Go west, young man!" For on some of them the west was at the top.

"North" anciently meant "nether," or *infernal!* If you faced the sacred east, north was on your left and, therefore, sinister. Most modern maps head north. The compass, the North Star, the search for a northwest passage, the sometimes considered "friendly" Arctic as compared with the generally desolate Antarctic—all and more have given prestige to north, that once dread direction.

In fact, many air navigation maps now place north in the *center!*

A serious map-user should rid himself of the naive "up" and "down" geographical conceptions. They are picturesque but not true. "Down under" for Australia. *Lower* California.

° After Harrison.

Lake *Superior*. We can't change these, but let's not refer to Indiana, for instance, as being just "above" Kentucky; or Borneo "below" the Philippines.

This does not mean that a generally accepted direction for mapping is not wise. On the contrary, it is very expedient. Turn a map so that you face north on the earth and on the map at the same time, and you're "all set." It is a convenience to have this as a universal practice.

Setting a map or finding one's place is still called "orientation," from the days when most ships, camels, and maps headed eastward.

Orientation is strict business in navigation, military science, and engineering. Many a battle has been lost because some one failed to set and read a map correctly.

In your use of maps hitherto, you have perhaps already done some orientation fairly well without much thinking about the process. Your common sense led you to ascertain at least three definite relationships:

1. Yourself and the ground: "Over there is north."
2. The map and the ground: "Here's north on the map."
3. Yourself and the map: "Here on the map is where I am standing now."

But you may have met some difficulties. The more seriously you use a map the more likely you are to encounter them. Here are procedures for handling the usual land situations They carry out the three steps you may have naturally worked out by yourself.

Orienting oneself, as we have seen in previous pages, is merely a matter of using the polar star, a good watch, or an understood compass. Even without these, wherever we roam, in the mazes of a wilderness or of a city, we should keep our eye alert to the "north-looking" and "south-looking" sides of things—until our constant self-orientation seems to another person

an "instinct." It is one of those "gifts" we get by helping ourselves. But always have your guess checked by star, sun, or compass before you base a map upon it.

ORIENTING THE MAP

Here are three methods of setting a map in the field so that the map's direction corresponds with the directions of things on the ground.

1. *BY A ROAD OR LANE*. The picture illustrates the method. If you can get on a straight road or some other definite nearby linear feature shown on the map, all you need to do is to turn the map until the road on it lines up with the road on the ground. Be careful that you note how the positions of houses, windmills, bridges, etc., around you match up with the symbols of those ground features on the map. In the army this is called the method of "Inspection," and is considered the most practical for ordinary purposes. It is good to use as a rough check after applying the two following more detailed methods.

2. *BY COMPASS*. This is similar to the protractor job we've already done, p. 68.

Find the magnetic-north arrow on the map. Place the compass on map so that N–S on the dial lines up with the arrow on the map. You can do this in two ways. Either let compass's

is also on your map, some well-defined object, like a tower. Place a pin in the map where that is represented. Now, sight at the tower on the ground until you bring the pins in line with it by turning the map. Oriented! Just for extra accuracy, pick out another distant point and sight at it.

With your map set, or oriented, and your own position known to you, you can now find the true direction of any other point on the map. You can add to the map (or to an overlay of tracing paper) any other details useful to your own special purpose: the accurate location of a swimming pool, eagle's nest, proposed building site, enemy as target, etc.

line continue the magnetic north line, as in illustration, or place the compass so that a line through N–S on it will be parallel with the arrow line on the map. Then turn the map with the compass thus lying upon it until the compass needle is pointed at N. Your map is now oriented.

3. *BY DISTANT POINT*. You may find yourself without compass and too far from any distinct linear feature to use either of the two methods just explained. But if you already know on the map where you stand, such as near the corner of a fence, you can put your map right with the world.

Put a pin on the map to mark the spot where you stand. Pick out some distant detail which

FINDING YOUR OWN OR ANOTHER POSITION ON THE MAP

In the second chapter, "how to find places" was a matter of referring to the framework of the map. We used the readymade coordinates. But often in the actual showdown in the field we must scheme our own coordinates to locate a place.

The map can be set right with the world so as to line up with what ground features you can identify. Yet you may not be able to say for sure just where on the map *you* are. This is easy enough to do when you can recognize certain distinctive features around you—such

as crossroads, bridge, hill, etc.—which are also on the map. But what if you should find yourself standing map in hand and nothing close by on the ground is shown on your map? Then where exactly on the map could you put a dot and say, "This is where I am"?

This situation calls for a time-honored but easy mapping operation.

RESECTION FROM TWO KNOWN POINTS. Orient the map. Pick out two definite landscape features, *B* and *C*, which are also represented on the map. Call them *b* and *c*. Put a pin at *b*. Lay a ruler alongside the pin and, sighting, turn that straightedge until it lines with *B*. Draw this line (or "ray") on the map, from the pin at *b* toward your position. Now take feature *C* and do the same with point *c*. At the point where these two lines cross is your own position *A*. Be careful not to shift the map; keep it securely oriented throughout the operation.

This trick of using a ruler or other straightedge to sight with on distant points is a fundamental operation in making and using maps. Simple as it is, it opens up a wealth of applications. The map fan who gives himself only ordinary practice with a sighting rule will soon surprise himself with his own resourcefulness.

However, you can also sight the two distant points with a compass. Then with a protractor

on the map, plot their bearings with two lines, which will come together just as your lines did by the sighting-rule, and likewise locate your position on the map.

If you don't like to mark up your map, use tracing paper. Do the sighting and marking directly on the tracing paper without the map. Then lay the tracing paper over the map. This is often done in resecting from *three* distant points.

INTERSECTION FOR LOCATING A DISTANT POINT. What if the observer wants to find exactly where on the map some other point should be? He can see that point on the ground from where he stands, but where should he dot it to place it on his map? This situation calls for a kindred operation to resection.

In resecting, the idea is to locate oneself on the map. In intersecting, the idea is to locate the other fellow (or place) on the map. Just as this is only a switch of viewpoint, the one process is merely a turn about of the other.

Suppose that instead of being at *A*, as in the previous example, you were at *B*. You can see *A* plainly enough from *B*, but it isn't on your map, and you'd like to put it there. *B*, however, is on your map this time. So all you need to do is to sight a line from *B* towards *A*, and draw this ray. Then hike over to *C*—which is also already on your map—and from there sight again on *A*. Where these two rays cross on your map, you can be pretty sure *A* should be placed.

In navigation this trick of crossing two lines to locate a distant point would be called getting a "fix" on *A*.

It can be worked with compass and protractor too. Instead of sighting with your ruler, do so with your compass. Then, also as before, the bearings you obtain, apply to the map with the aid of a protractor.

Intersection and resection are not only de-

vices for using maps but also fundamental surveying operations for making them. In the grand triangulations of a continent, the trick of locating an unknown point from two known points is worked much the same as you see it shown here. Surveying demonstrations will be found in Chapter 8.

When using a map in the field to sight on distant objects, find some nearby convenient support upon which to rest the map (or tracing sheet) horizontally. A flat-topped stone, a fence post, a stump, or a nice level spot on a hill. Another hint is: whenever you have anything to say about the size of an angle you are working with, choose it so that it will be no smaller than 30° and no greater than 150° where the two lines cross upon the point you are investigating. If you get an angle under 30° the lines will appear to close up before they come to the actual point, and so that point will not be easy to get down accurately. If you get an angle over 150°, again the point will be difficult to hit accurately, this time because it will appear lost in the near-flatness of the angle. A safe angle is about 90°, whether at your own position (resection) or the other fellow's (intersection).

5. Making Mole Hills out of Mountains: CONTENT

ALMOST EVERYONE LIKES the birds-eye view. We get an exalted feeling from a panorama. Deep in our nature is a need of maintaining a sense of security. Wanting to know where we are. We share this need of reconnaissance with dogs and eagles. And with all other animals that have sense enough to be on constant lookout for food and dangers—sniffing, listening, gazing, making rounds and soaring, going over the situation. Mapping it.

We enjoy seeing the country spread out below us like a map because such an uninterrupted prospect relieves us from the limitations of our own personal scale: our feet as factors in comprehending the distances, our height as a factor in comprehending the areas. Once we get above our own body's height and that of our customary surroundings, our horizon increases and our vision takes on a bigger job. We get a better idea of the direction of a certain road as it bears from a certain point on a winding river. We see the relation between a dam, a power line, and a factory-group. We can see the whole of a forest instead of only trees. We see its shape, and the shapes of fields seamed by fences.

These features compose themselves into patterns which we can comprehend now as we could not when we were in the same horizontal plane with them.

Not only the pattern of the countryside do we see but its texture too: where rough or smooth, jagged, rolling, or flat. And still more than that, these textures compose themselves into a series of levels and inclines. And these result under our eyes into a system of water drainage and airflow.

Artists and map makers call these ups and downs of a surface its "relief." (Latin: *re-* "again," or, as we say, "some more,"+ *levare-* "to raise," or "lift up.")

From many maps, practical in their own way, we demand but horizontal information: location, mere outlines of bodies of water and land, horizontal distances and directions.* But there are times when we must have vertical information about the terrain. Ups and downs—as anyone who has done any walking knows—alter distances. Also climates and many other circumstances vital to humanity.

The way a map depicts relief is often a hallmark of merit "that distinguishes the handiwork of someone who knows," says Joseph T. Maddox, a geographer and also what might be called a connoisseur of maps. "Mountains are not heaped up haystacks of earth; they have length, breadth, and structure. Rivers are not mere wavy lines; every turn and bend is in re-

* Such facts are classed as *planimetric*, because they deal with measurements of the earth as a *plane* surface. *Hypsometric* (Greek *hypso*, "height") facts, or hypsographic maps, show the elevations,

sponse to forces of nature, and the wise read from the map the forces to which that river has responded."

We want a map to show us as vividly and accurately as possible "the lay of the land." Often by the shape of a hill as shown on a map a traveler can tell where he is. Or by a kink in a valley, or by the depth, direction, and pitch of a draw. If he is driving a truck or packing in afoot he desires a map to tell him what grades he'll encounter, so that he may judge how much weight he can take along. Military personnel must know ahead of time what kind of ground the heavily equipped troops will have to move over as well as fight on. A few feet rise or fall in ground may make enough difference to change the course of history, as though history were a stream flowing over that very ground.

Relief was critical in the foot and wheel age, and now in the wing age it is still so. A pilot doing contact flying must have trustworthy map information of the features over which he passes.

These features must be even more explicit and precise for such on-the-ground-experts as conservationists, land-use specialists, structural engineers, prospectors, mining engineers, infantry commanders, or any of us on an extensive hike or hunt.

The texture of the land surface—its hill and valley forms and patterns and its natural or artificial systems of water drainage (streams) and collection (lakes)—has much to do with the site and type of human habitaiton and employment. Thus the relief is a factor in providing the content of maps.

It is also itself sometimes all of the content.

In the three previous chapters we looked upon a map as a network and framework for locating points, representing distances between points, and for indicating the relative positions of points as respective directions. Except for those points any network or frame-

work would be empty, and the map would be without content. In this chapter we will look upon the map as a container, noting some of the many different sorts of content that various kinds of maps have to show and how they can do so.

They begin with some concept and artifice of *reduction:* reducing a mountain to its miniature token, reducing any feature or fact to a *symbol.* A good cartographer is a practical, and often a truly imaginative, symbolist.

The physical features of an area, natural and man-made, are called its topography. Because a topographic map shows the relief, many people think that the term itself means the *tops* of the hills or the general topping of the area, but the word is derived from the Greek word for "place." A topographical map shows—more or less—what *kind* of place a certain area is. It often provides abundant information of this kind.

This does not mean, however, that all maps rich in content are topographical. Whether topographical, "political," statistical, or simply "geographical" in a general sense, maps are information-givers, and as such they have endlessly varied capacities. No other contrivance of man tells so much about so wide a realm in so small a space.

LIGHT AND SHADE

The cartographer has had to prove himself pretty clever whenever the facts he had to show upon a flat surface were themselves about flat matters, merely two-dimensional. But in showing three-dimensional facts on a flat surface he displays his true ingenuity. Here he combines the suggestive devices of the artist with the precision methods of the scientist.

Visually, relief on maps is a trick of light and shade. If you are at a considerable alti-

tude looking straight down when the sun is also, you will see very little or no relief in the terrain below although it may be quite bumpy. All light and no shadow. For this reason the great landscape painters have been known to get up at dawn, not only for the clarity of the air but for the pronounced light-and-shade effects which revealed the relief and therefore the deep structural meaning of the scene. Oblique lighting, as from a low sun, provides a principle of the map relief method known as "hill-shading."

Relief in a 16th century map: hill profiles shaded with hatchings

Man could make an impressive birdseye map before he knew how to fly. We can't help respecting the featherless biped for it a bit the more when we see how he did it. The early wood-engravers used to imitate the shadowed side of an object by making fine lines called "hatches." (Same derivation as "hatchet" and "hash.") Mechanical draftsmen, cartoonists, and graphic artists in general still express shadings by this stroke. Now, as anyone knows who has tried his hand at drawing, you can show the forms of things without drawing their outline (since outline is usually a flat idea of it) if you just show the lights and shadows. Hatchings became a favorite trick for making objects stand out in relief, but especially so with the cartographer, for showing mountains.

Until two centuries ago the cartographer had to be content with drawing mere tiny pictures of hills to indicate almost all relief. A cluster of little mounds might represent the Alps, a row the Andes—with or without benefit of hatchings. That was about as much mountain form as he attempted, whether showing an entire range in small scale or a bit of broken plateau in large scale. Nor had he any graphic way of showing elevation. Indeed, not until after the invention of the barometer and other hypsometric instruments had he but small accurate knowledge of the altitudes.

As the engraver improved his art of shading, and printed maps from copper or steel plates, which allowed for finer gradations or lines, a more precise system of expressing relief developed.

This was a refinement of the hatch: a short, controlled line the French called a "HACHURE." By the way in which the cartographer chose to draw these hachures thick or thin, to pack them together, slant them, shorten or lengthen them he could not only depict the contour of the hill but also show the varying slopes of its sides. The most notable trick was, perhaps, drawing these short lines in the direction of the water flow down the sides of a hill from its steepest parts, for by this device the *degree* of the slope can be somewhat definitely indicated. The steeper the slope the closer together and darker the hachuring.

Some 19th-century methods of hill-shading set a specific thickness of hachure for each, say, five-degree variation of slope. The map reader had to consult a specially provided scale of sample hachures—rather tedious business. Myriads of dark, straight little lines gave the map a stilted look, and rather dour. Despite their air of painful precision, so much respected by the soldiery of that decorous age, these hachured maps could not be exe-

*Dufour "hachure metre," showing number of hachures per inch for each five degrees of slope *

*Study models of hachuring, in 19th century textbook. Upper left: Dufour system. Other three: the ultra-precise Lehmann system. Note outlines of cross-sections or profiles *

cuted with sufficient accuracy or rendered to give enough facts of the terrain to be as practical as required. They were often so loaded with hachures that people could not read the map for the data. Their darksome heights seemed to say that mountains are ever gloomy.

Cartographers today, though, look with unceasing admiration upon the amazing skill displayed in the workmanship of those old maps. If you wish to see specimens of hachuring at perhaps its best, look in some large library for the Dufour maps, particularly the atlas of Switzerland. In the Dufour style the hills are given sunny as well as shaded sides, with striking effect of three-dimensional reality.

One manner of hachuring in small-scale maps became so sophisticated that it merely

* From *Manual of Topography* by Joseph Enthoffer (of the U.S.C.G.S.). D. Appleton and Co., N. Y., 1869-70.

hinted at the fact of a hill without bothering to shade it for particular shape or slope. This is the "caterpillar" style which now, oddly enough, seems naive to us because we so often see it in the maps made by school children. Nevertheless it can show more than one kind of hill: half-caterpillars for single ridges or foothills, caterpillar parades for mountain chains, and pattern formations for mountain groups.

During the 19th century over 80 different methods of hill shading were put forth, but none of them told clearly and accurately enough the four principal facts of relief we usually require of a topographic map. These facts are: 1, the shape of a hill or depression; 2, its size; 3, the slope of the ground; and 4, the elevation of the ground.

Let us, in passing, consider the fourth. In many maps, particularly those confined to these former methods, altitude figures are placed near certain hilltops (usually only the highest peaks) and sometimes near an important city. These figures, in map parlance, are

Portion of map from G. H. Dufour's atlas of Switzerland, 1833-63

CONTENT

"Caterpillar" relief in news map. Note table-lands, also utter simplification °

"spot heights," and they make indeed a very spotty way of indicating elevation.

The relief method which finally worked out best, satisfying *all* these requirements, was in essence so much simpler than the others that we may wonder that it had not been thought of from almost the beginning. Instead of a hash of short lines, it is a system of long lines.

IMAGINARY
WATER LINES

The principle is one which may have occurred to you when standing on the shore of a lake, river, or even on an ocean beach at low tide. You perhaps noticed the line left by high-water. No matter what the shape of the shore, that waterline marked the same level on every bend with unerring fidelity. It in fact accentuated the contours of the banks and beaches.

Map-makers thus have taken their cue from nature. They call these waterlines contours.

Supposing there were a flood over the whole earth, as in the time of Noah. Each time the water went down ten feet, suppose it left a mark on everything it surrounded, until it got back to its present sea level. Its last mark was, say, exactly ten feet above sea level.

° Courtesy of New York *Daily News.*

Then, suppose you could get up in a balloon and accurately draw all these contour lines on a piece of paper. What you'd have would be the best kind of relief map so far invented to give on flat paper all the facts about the wrinkled, dimpled, pimpled, fissured, dented, swollen, hollowed, roly-poly surface of the earth.

Suppose, again, we take objects of different shapes just as an imaginary experiment.† One a cylinder, another a cone, a third a cone but a lopsided one. Set them in an aquarium; put in an inch of water-dye that marks a line. Another inch of another color, and so on until each level is marked on the objects in a different color-line. Now, taking them one by one, how would

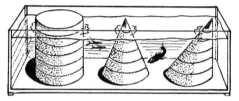

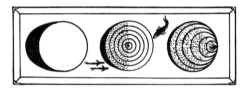

Water lines on simple forms

the markings look from the top? (We know by now that the top view is the map view.) The cylinder with its perpendicular sides would be just one circle to our eye looking down on it. But the cone would show a nest of concentric circles. They would be evenly spaced, because the cone has the same slope from base to apex. But now look at the unsymmetrical cone, which has different grades of slope on its sides, and so comes more nearly to what we find in nature's hills or islands. Where the slope steepens, the

† Illustration redrawn by permission after *Topographic Maps and Sketch Mapping* by J. K. Finch, published by John Wiley & Sons, Inc., New York, 1920.

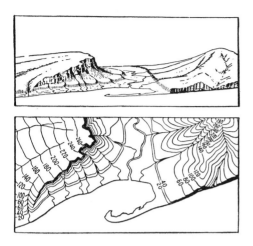

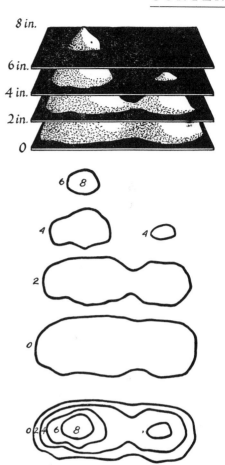

*Landscape sketch (upper) with contour
map (lower) of identical ground*

lines come closer together, and indeed, join
into one line where the side of the cone is per-
pendicular to the base. In a contour map, an
absolutely perpendicular cliff would be shown
by one contour line. (Examine some topo-
graphical maps of the Grand Canyon, Yosem-
ite Valley, or the Jersey banks of the Hudson
River.) But this line would be a thick one, as
it is a coming-together of *several* lines.

As every shoreline completely encircles an
island, or even a continent, so each contour
line closes on itself, either within the frame of
the map or (supposedly) somewhere outside
the frame.

Technically, the whole principle of the con-
tour-line system comes down to this simple de-
vice: the use of imaginary horizontal planes
cutting through the vertical features of the
earth's surface. Imagine a sheet of glass
through a sandpile (or a mountain, or an
island) and note the contour line made by it.
The table top on which the sandpile sits is of
course another plane. This makes a shore line,
or base contour. We can number it our zero

*After U.S.G.S.

*Horizontal planes defining contours at
successive levels †*

line, to figure from. Here we are again, back
to the mapper's old standby, the concept of
planes. Almost whenever anything about map-
ping seems bewildering, you can straighten it
out by reducing the matter to planes.

In very informal mapping, when the survey-
ing has been insufficient to give accurate fig-
ures, these contour lines merely give a general

† Illustration redrawn by permission after *Surveying* by
C. B. Breed, published by John Wiley & Sons, Inc., New
York, 1942.

idea of the slope of the country and the forms of the relief. They are therefore called "form lines," and the term *contour* is reserved for the more accurate lines, which show actual measurements.

THE LOGIC OF CONTOUR LINES

Perhaps the most obvious advantage of contours is their direct way of giving us the elevation of not just a few scattered spots, but of almost any place you might point to.

You couldn't ask for a simpler arrangement. Zero level is sea level. The geodetic surveyor's

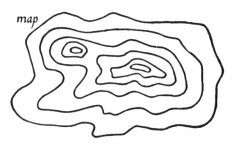

map

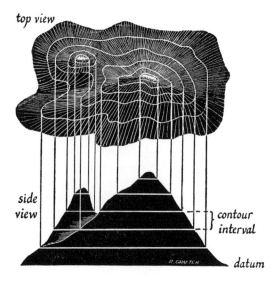

top view

side view

contour interval

datum

word for zero level is *datum*. "Datum is mean sea level," is the statement in the margin of many a map.

The next level would be, say, 25 ft. above sea level. That would be the first contour line above the datum. Every point on that line, wherever it goes—close to the shore or ever so far inland—would be just 25 ft. above sea level. This vertical measurement is called the *CONTOUR INTERVAL*. Or, as some say, the *vertical interval*. Now just as when building a stairway, you would put each step at the same "rise," one above the other; so when making a contour map the cartographer states each contour line at the same vertical distance, one from the other. He may choose a 100-ft. contour interval, or a 50-ft. one, or a 10-ft. interval. Usually the map states in the margin in plain words and figures what its contour interval is. To help out the eye, ordinarily, every fifth contour line is bolder than the others and is marked with figures of the exact elevation.

The first thing to note on a contour map is the vertical interval between the contour lines. Once you do that, a contour map will no longer look like the mysterious lines of a thumbprint.

On a certain map a certain hilltop does not occur exactly on a contour line. But the nearest contour to it reads 1520. And the contour interval is 20 ft. So the summit of that hill is somewhere between 1520 and 1540 ft. above sea level, perhaps 1530.

It is always wise when you have to hazard a guess like this to use a bit of precautionary pessimism. Guess an altitude a little higher, if you'll have to clear it, or climb it.

One of the most important things to know about country is its drainage. Nobody should ever buy a farm or country place without studying its drainage. Here again contours excel. They give not merely the lineaments of a few hills but, almost at a glance, the drainage of the entire area covered by the map. All we need to understand is that the lines are like

rungs of a ladder, or steps of a stairway, and that water flows downward. The drainage goes *across* the contour lines. Rivers, creeks, rills riffle downward *across* the contours. The horizontal lines on a shingled roof are crosswise to the flow of rain-water; so are contours, which map the natural watershed of the earth's surface.

Note that where the contours come to a stream bed, they turn in the upstream direction. But where they cross a ridge they bend in the direction of the down-ground. You can see why, once you visualize level lines running "up" into ravines and then coming back out again along the nose of a hill.

The slope of the ground may be so gentle that the eye can't detect it, but the contoured map will tell you in plain lines and figures. The slope may be only a foot to a mile. The map may then have a contour interval of only 1 ft.

And if the scale of the map was, say, a quarter-inch to the mile, then the contour lines would be just ¼ in. apart.

If the slope keeps just the same for miles and miles, those contour lines would tell you so by their equal spacing on the map. Equal spacing does not mean level ground; it means an unvarying degree of slope.

But as soon as the slope changes, say, from one to two feet in a mile, there would be two contour lines instead of one every quarter-inch on a scale of a quarter-inch to the mile.

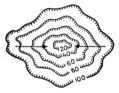

Contours enable us to estimate the extent of high or low ground. All we need to do is to use the scale of miles that comes with the map and apply it to the contours.

Take some low ground as represented on a U.S.C.G.S. map. This is a dry lake, say, on your farm and you want to know its area. Simply apply the scale to the outside line, by using the method of squares, as explained on p. 229. The same principle works on the base contour of a hill or island.

That's how well the contour system works together with the scale system.

Bear in mind that "contour interval" means *vertical* interval only. And the figures tell you exactly what that is. They never refer to a distance on the surface of the ground. That's the *surface* interval. The spaces you see between the contour lines on the map are not the vertical intervals but only the horizontal intervals; they are the *flat* distances between those lines just as you see them on the flat paper. Those flat distances, those spaces between the lines, belong to the scale of miles. The lines themselves belong to the measure of altitude, one line for each "step" higher.

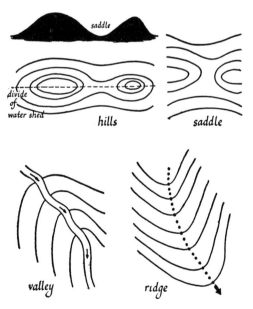

Characteristic contour (or form) lines. When lines are numbered, no arrows are needed to show descent

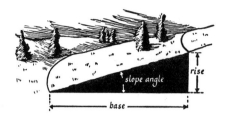

SLICED LANDSCAPE

Contour lines are a way of measuring vertically, as scales are a way of measuring horizontally. Let's put the two together in the simplest manner: if you sliced a hill in half, as in this cross-section, you'd get, for your convenience of measuring, a right triangle. The actual distance on the sloping ground would be the hypotenuse of that triangle. The horizontal distance would be the base. The contour interval would be the rise. And as for the angle of the sloping ground, you will find on p. 230 the standard modes of stating it in precise figures.

If you are a ski fan looking for a good slope, here is where the contour map becomes your friend, just as much so as it is to the road-builder, geologist, oil prospector, irrigation engineer, or pipe-line layer.

From a series of contour lines a good map reader can work out graphically a vivid cross-section, or *PROFILE* of the ups and downs in a piece of country. The process at first glance seems difficult, but anybody who knows elementary arithmetic can learn how to do it, and will find it fascinating.

Although you can do it on plain paper, there is a special cross-ruled paper made for the job. It is ruled horizontally for one scale and vertically for another. (See pp. 263–265.)

The only hitch comes in using two scales: one, a horizontal scale for the base; another, a vertical scale, for the rise or contour interval. The reason for this is that if you used the same scale for both the vertical and the horizontal, the vertical spacings or rises on paper would come out too small to work with. You can see from a mile away a hill 100 ft. high, but get those proportions down on paper to the same scale, say, 1 mi. to 1 in.; you would have to represent that hill's height within a space of only 1/53 in.!

That would not give you a good idea of the cross section of the country. But exaggerate that vertical scale enough and you'll get a good picture of the relief. Making a profile is the same in graphical effect as it would be to slice a hill in half the way you would a cake.

Our knife, in this case, is a sheet of paper. Then it is as if the vertical plane of that sliced hill left its imprint on that "knife," our sheet of paper.

Here is a piece of a contoured map. We have to set up a camp at each point indicated by X. Now, just from seeing the map, how much of an up-and-down communication trail should we expect to make between them?

First thing we do is to connect the points with a line. That's the line we'll slice on, and our slicer is cross-section paper. It has evenly spaced parallel lines on it. To give our "blade" a keen precision edge, we fold or cut it along one of those lines.

Now bring that "cutting" edge to line XX on the map.* The highest numbered contour that it crosses is 80. So, one or two lines away from the edge, we begin numbering the lines on the paper in the same order and the same figures as the contours. This will exaggerate our vertical scale sufficiently to make the ups and downs stand out; these lines are ¼ in. apart.

Suppose this map is on a scale of 1 in. representing ⅛ mi., which means 660 ft. of ground to 1 in. of paper. Or 165 ft. of ground to ¼ in. of paper. Then, with a contour interval of 10

* Imagine the "blade" slicing the hills in half by coming upward from under the earth; the hilltops would then have their mark closest to the "cutting edge."

ft. we are using a ¼ in. to represent only 10 ft. in our vertical measurement as against 165 ft. of horizontal measurements. This is an exaggeration of 16½ times! But here is a case where telling a tall story makes the truth all the clearer. All we need to do to justify ourselves is to state on the profile that we made things 16½ times as tall on paper as they are in nature.

The slopes will look steeper, too, than they actually are. (Ordinarily, the vertical scale should exaggerate the horizontal from 5 to 10 times.) Now, to draw the actual profile:

Wherever a contour line touches the edge of the profile sheet drop a perpendicular dotted line down the sheet, stopping at the line whose number is the same as the contour's. That marks where the profile goes; for after you have dropped perpendiculars from all the contours, all you need to do is connect the points with a line, and that's your profile.

If all this seems too complex, skip it for the time being. The best way to learn to read a contoured topographical map is out in the field

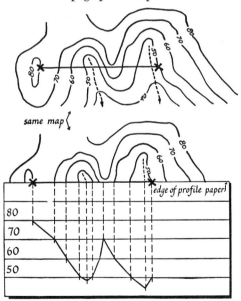

same map

edge of profile paper

with the map in hand. J. K. Finch, a noted instructor of cartography, wrote in his own book on topographic mapping, "The actual relation between scale and contours of a map, and the ground represented, cannot be taught in books. It comes only from actual practice in using a map in the field where it can be compared with the ground, and the student gradually acquires the ability to picture in his mind the ground represented when looking at a map." It is possible to become so expert in reading contours that without visiting the place you can draw a landscape of it by only looking at the map.

CHOOSING THE INTERVAL

What factors determine the contour interval, whether it should be 1 ft. or 1000 ft.? The nature of the country, the purpose of the map, and the scale. A flat country, like southern Texas, will call for a contour interval of 1 ft. on a topographical map, because that's the most appreciable rise you can show if you are going to show any rises at all within the area the map represents. A U. S. Aeronautical Chart will have a contour interval of 1000 ft. Again, a landscape gardener may use 1-ft. intervals in his plans.

We sometimes have to order maps which we have not seen, and often the catalog will tell the scale but not the contour interval of a topographical map. We may wish to know ahead just what height one contour line represents above the next line to it, for if we are laying out a recreational section and wish to figure on every 25 ft. of rise of ground but receive a map which shows only 100-ft. lines, we're stymied. There is, however, a good rough rule for estimating the interval by the scale.

$$\text{Contour Interval} = \frac{60}{\text{no. of in. to the mi.}}$$

The normal relation is a 60-ft. contour interval

for the inch-to-the-mile. If the scale is 2 in. to 1 mi., the interval might be just half of 60, or 30 ft.

If the catalog says the scale is only a half inch to the mile, then:

$$C.I. = 60 \div \tfrac{1}{2}$$
$$\text{or } 120 \text{ ft.}$$

British practice is to use 50 instead of 60 as the normal interval figure.

BENCH MARKS

On topographic maps you often find what appears to be an elevation figure next to the mysterious abbreviation "B.M."

This is the *BENCH MARK*. This does not mean a bench upon which one may sit to contemplate the prospect below, but a point of reference from which you may make accurate vertical measurements. The word "bench" derives from the same source as the word "bank," and river banks or raised level surfaces of ground are traditionally considered good spots to mark the altitude, as are peaks. But thanks to the development of the science of "leveling" (finding the differences of level between one place and another) bench marks are now placed wherever they are most likely to be discovered, used, and preserved. Along lines of survey, from tidewater flats to remote mountain ridges, they are the salient points of the relief map.

State Surveys, the B.L.M., the U.S.G.S., the U.S.C.G.S., and the Geodetic Survey of Canada have established thousands of bench marks, pinning to earth a great leveling net.

Finding a bench mark is about the first thing to do after orienting your topographical map in the field. Indeed *any* station-mark hunt adds interest to a hike, and teaches you more than a book can about applying your map to reality.

The official descriptions, as of the locations of other standard marks, make great reading for the map-muser:

"S.6.—On the Richardson Highway, about 9.2 miles south of Richardson Road House, 15 yards northeast of a small wooden bridge over Tenderfoot Creek, about 25 yards northwest of a deserted cabin. . . ." *

"W.2. At *Princeton*, Mercer County, on the Campus of Princeton University, at the main entrance on the north side of Nassau Hall, in the capstone of the landing 8 inches out from the wall, 2½ feet from the base of the bronze tiger. . . ." †

On some marks the stamping has not been completed, because after the field work of placing the tablet is over, there follows a period of office computations and adjustments. So a stamping-party may have not yet come to put the finally determined elevation of a particular bench mark which you may have stumbled upon.

Anybody who doesn't know the government-made maps simply doesn't know how to get his taxes' worth of citizenship. The Geological Survey has established at least two bench marks in each township or equivalent area it has covered (except where overforested) and placed the marks along leveling lines at intervals of about 3 mi., never over 4. You will find them near township corners, large lakes or reservoirs, at junctions of the larger streams, at divides, near active mines, and in every town or large village traversed. The work is adding up into a great master-map of the country, showing every physical feature. We are safe in inferring that never has a government bureau wasted less money or given the citizen more return value for taxes paid than have the bureaus whose business it is to make maps. You can't help having a little added respect for those mapping-fellows who never make a noise in Washington

* *First Order Leveling in Alaska* by H. S. Rappleye, U.S.C. G.S. Special Publication, No. 169, 1930, p. 16.

† *First Order Leveling in New Jersey* by H. S. Rappleye, U.S.C.G.S., Special Publication No. 172, 1931, p. 11.

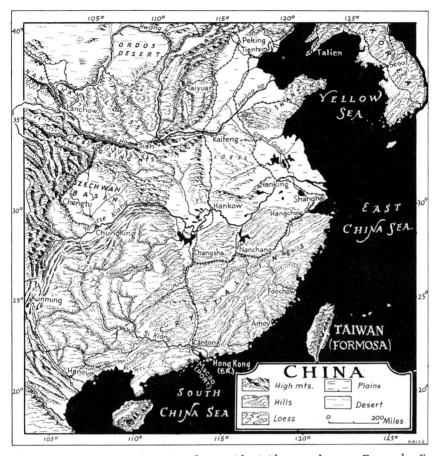

Land-form map. Accurate information shown with vividness and grace. Drawn by Erwin Raisz for a geography textbook °

nor ever try to make anybody anywhere shut up. There must be something about mapping from the ground up that broadens the mind to fit the country.

PICTORIAL AND OTHER GRAPHIC RELIEF

We speak of the "face of the earth" and call somebody's face his "map." Both of these metaphors (even though one is slang) are meaningful—and to us who enjoy cartography,

particularly significant. A moment before the ruined lady Lucrece kills herself, as Shakespeare tells the story,† we see how

". . . with a joyless smile she turns away
The face, that map which deep impression bears
Of hard misfortune, carved in it with tears."

° *A Geography of Man* by Preston E. James. Courtesy of Dr. Raisz and Ginn and Company.

† *The Rape of Lucrece*, lines 1711–13.

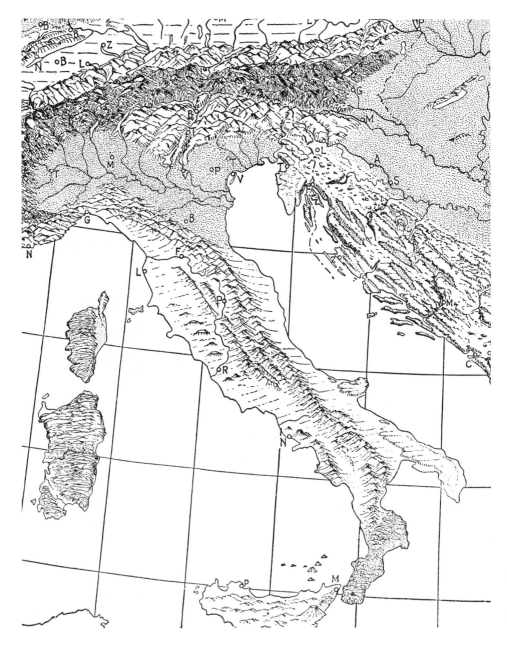

*Portion of a physiographic diagram (Cities designated by initials)**

* Drawn by A. K. Lobeck. Courtesy of The Geographic Press.

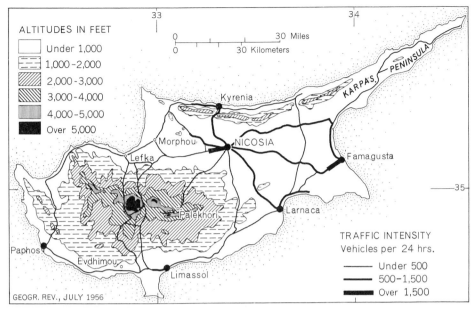

Differences of altitudes emphasized by differences of hatchings in contour planes †

Frequently quoted by writers on cartography, these lines are for us more than a literary enhancement of their subject or a historical curiosity to afford surprise that anybody as early as 1594 had taken note of the stream-erosion process ° and had associated it with mapping. The significance for us is the analogy—thus perceived by an imaginative mind —between the face as a revealer of a person's experiences and the map as a teller of the earth's.

Pictorial quality in a map is pleasant, but its faithfulness to nature must be measurable. The fact that the hills look "real" doesn't mean that they are right, and if we are going to do any fighting or farming in them the map must show

° James Hutton, 1726–97, and John Playfair, 1784–1819, are considered to be probably the earliest scientists to make such an observation in accounting for a land form.

† The island of Cyprus. Drawn by Alexander Malamid. Courtesy of *The Geographical Review.*

them pretty nearly right. Many a "real-looking" relief map is actually false. But if it is partially true it may have its partial uses.

The better newspaper maps are often quite excusably nothing but pictorial approximations of the exact relief. Their purpose is to remind us of the general character of the country where military or civil operations are going on, and although our attitude in reading a newspaper may be casual or hurried, these maps when good are neither casual nor slapdash.

Occasionally, as is in book maps, what we wish is not so much a picture of the relief as a simplified *idea* of it. To make the contour planes show up distinct from each other, cartographers sometimes put hatchings in them, a special hatching or patterning for each level. You can then at a glance pick out in different parts of the map the sections of the same general elevation, and also get a fair no-

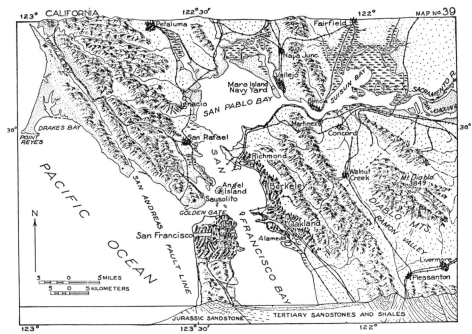

Land-form map with a geological cross-section °

tion what proportion of the country is above or below some altitude. What we have then is, essentially, a kind of distribution map, showing the distribution of high and low ground.

However, hatchings are likely to obscure other details in a map. So tints are often used instead. A different transparent "layer" of color for each level permits symbols and letters to show through and yet emphasizes the difference between elevations. The lower levels may be in grayish greens which seem to fall back, the middle levels yellow, and the higher levels brownish reds that seem to come up toward you. Likewise, deeper water, deeper blue. What we must bear in mind, though, when using these "layered" maps, is that colors show the difference between one level and another along a contour line sharply, while on the ground you'll find no such sharp difference.

But there are maps in which contour lines are not just outlines of flat-faced layers. We can have the "real" look of the terrain and the most accurate contour work together. Here's where hachuring, unstilted now, comes back into the picture. When added to contour lines, hachuring shows the steepness of slope from one level to another. This kind of shading is most effective when done with a brush, especially an airbrush. It is as if some kind of plastic substance were used for modeling the features of the face of the earth, and so the technique is called "plastic." When you get plastic *boosted by tints* as well as controlled by contours you have about as much depiction of relief and precision of measurement as is possible to put together on a sheet of paper.

For impressively realistic examples of this technique, see the shaded relief maps published by the U.S.G.S., a checklist of which is usually available on request. There are also some shaded relief maps that simulate third

° Drawn by Guy-Harold Smith, in *Airways of America* by A. K. Lobeck. Courtesy of The Geographical Press.

dimension but contain no contour lines or altitude colorings. Some of these maps are printed in only one color with subtle gradations of tone, as in a monochrome photograph. Whether these maps have only one or several colors, the purpose is usually to give a very general idea of a very large surface, in a scale small enough to fit into the page size of a magazine or book. So the relief features are grossly generalized—sometimes coarsely. If the colors are used symbolically, they may show successive elevations only indirectly, by indicating the type of native vegetational cover: kinds of grassland, desert shrub land, forest and so forth, on up to tundra. These maps in the hands of artistic cartographers have tastefully selected hues, an intelligent range of tone values, and as much precision as is feasible, so that they combine the appeal of beauty and the assurance of adequate fidelity. For vast spreads of continent or of island-dappled ocean, these maps can be excellent in providing you with a unified, vivid, correct mental image of a large geographical complex. But often they are for the most part flashy glamor; their eye-catching hues, like some kinds of photocolor, are false in overstatement, and their land forms and textures crudely modeled.

Of all truly serious maps, the kind that physiographers have developed gives a spread of definite, visible information most directly and most fascinatingly. And with minimum means, for these maps are usually plain penline sketches. They show the details of different types of country by special pictorial symbols, much in the same way as railroads, bridges, swimming pools, etc., are shown in ordinary maps by conventional signs. There are special pictorial symbols for folded mountains, dome mountains, plateaus, drumlins, different kinds of plains, etc.

What the physiographer is trying to do with this map is to *write a description* of an area, and these symbols are his "words." He is literally, here, a physio-*grapher*. (An individual volcano, such as Vesuvius, he specifically *names* with the symbol he uses, for it looks like that particular volcano.) In the eighth chaper of Raisz's book, *Principles of Cartography*, you will find such a "vocabulary" of these physiographic details.

Whoever has a liking for maps will put these *PHYSIOGRAPHIC DIAGRAMS*, as they are called, among his favorites. They resemble landscape as it might be sketched in perspective by an observer at a great height; yet they are thoroughly maplike, with coordinates and adequate indications of scale and direction. That is, they are *interpretive*, as a mere picture is not. They are called also "landform maps," and what they show is sometimes referred to as "the physiographic landscape." Such landscapes would be supremely interesting subjects for murals. Take a small home region and a large wall in the lobby of a public building, then let the two artists get together: the land-form cartographer and the mural painter. Fight as they may and aggrieved as each might be by what one made the other do or kept him from doing, the subject and purpose would be strong enough to prevail. Few other public murals are likely to be looked at so long and repeatedly.

TACTILE RELIEF

The actual three-dimensional relief maps are often impressive because of their sculptured verisimilitude. They are something like toys, for they evoke the play feelings in us when mountain chains are perforated with tunnels through which small trains run, and seas gleam with moonlight. But their playvalue, it seems, soon gives out, and like their utility seldom seems commensurate with

their expense and bulk. The most useful relief models, therefore, are most often just blocks of very small portions of country. The smaller the chunk of country the larger can be the chunk of map in proportion, and less need be the difference between the horizontal scale and the vertical scale. A map of the globe, for instance, on an 18-in. ball could not have very visible relief if the elevations were kept at the same scale as the rest of the map: the world's greatest deep (35,410 ft.), off Mindanao, would be but a dent, 1/67th in. On the other hand, in many relief models of large regions the compensatory exaggeration of vertical scale (often from 20 to 40 times the horizontal) results in misshaping the mountains, making them so much sugar-loaves and turrets, that the "real look" is destroyed and the essential purpose of the map defeated.

An instructive aspect of some relief models is that they are made with layers of plyboard, or planes of other material, having a uniform thickness, placed one upon the other. Here, then, in the very construction of a relief model is a practical working out of the identical principle of the contour line. For what is a contour line but one of those planes jigsawed to the shape of the hill, and what is a contour interval but the thickness of one of those planes!

A child can get his first truly geographic concepts in a sandbox with a few tiny toy cars, spools or small pieces of wood, and he alone knows what else, which, with his imaginative ingenuity, he will convert into veritable cartographic symbols. As he plays in this sandbox country of his he will discover by himself basic ideas of relative location, scale, elevation, and drainage. The more elaborately constructed terrain model his

elder friends might be making in high school is the same wonderful lesson, with more materials and skill involved and a heritage of terms and attitudes applied.

There is more to be gained from making such terrain models than in using them, because they are not so inspiring to look at as they are to work on, they cannot be very accurate, and they are so unwieldy and yet so fragile that they can't be safely moved and stored.

This is not so of the professionally made maps whose relief is raised by molding or embossing in a thin, lightweight, tough plastic, such as high-impact styrene. During the second World War, the A.M.S. worked out the precise methods of making them.

The accurate terrain model has several military uses, particularly in planning various operations and in briefing the task forces. It can give to a novice—soldier or civilian—an improved sense of both terrain and map. It can give young students a vivid, instead of a vague, familiarity with the over-all configuration of a continent, or with the details of a region—especially the home region, which often is largely foreign to them.

Incidentally, let's here definitely clarify once and for all the choice of names.

Model. Think of plan *vs.* model. To make a relief model you would first need a "plan," or map, wouldn't you?

Plastic relief map. This is the official Army description: "A topographic map printed on plastic and molded into three-dimensional form."

Terrain model. Same source: "This particular type of map product is a three-dimensional representation of an area, modeled in plaster, sponge rubber, or other materials. It is distinguished from other map types by showing some cultural and terrain features realistically instead of by topographic symbols."°

° *Military Mapping and Surveying.* AR 117–5. Department of the Army. Washington, 1959, p. 11.

The relief *globe* is the ultimate in geographic realism. Of all world maps it is the easiest to understand and the most difficult to make.

As long ago as 1837 a relief globe was made for the blind. (It had over a century of use in the Perkins School, at Watertown, Mass., where it is still kept.) Rondure and relief must be either felt as seen or seen as felt to be truly appreciated for a geographic concept. In both cases palpableness is the thing.

To combine the rondure of a globe with the multiform relief of the earth's surface so that a person can comprehend them together and do it accurately is an immense feat.

"The visualization of a three-dimensional relief from a smooth globe or flat map requires a cartographic sense and ability possessed by few persons," William A. Briesemeister has said in an account of a few of such achievement.*

One of these is the six-foot "Geo-Physical Globe" conceived by Sam Berman, a sculptor, and executed through a collaboration with several cartographers and technologists. In order to avoid gross misshaping of mountains through the necessary exaggeration of vertical scale, they decided upon a "sliding scale." At sea level, where usually the elevations are so slight that they would not otherwise show, the vertical exaggeration is as much as 80 times the horizontal scale. But where the mountains rise highest, an exaggeration of only about 10 to 1 suffices.

Sometimes, instead of making a whole globe, cartographers make only a segment of one, like a low dome. This combines the advantages of a globe and a large-scale map. That is, it gives spherical rondure to a small area. And then three-dimensional relief can put up a good show. A famous example is the map of the United States at the Babson Insti-

* "Some Three-Dimensional Relief Globes, Past and Present" by William A. Briesemeister, *The Geographical Review*, Vol. 47, April 1957, pp. 251–60.

tute, near Wellesley, Mass. It is 65 ft. across and has a horizontal scale of about 4 mi. to the inch. The vertical scale at elevations higher than 6,000 ft. is only a 6-times exaggeration. This would make the highest peak, Mt. Whitney, some 4 in. high. From a balcony around this map, the observer has the somewhat same perspective of the entire country he might have from a satellite at an altitude of 700 mi.

A fact as forgettable as it is obvious is that a map, be it flat or spherical or segmental, can carry but a limited amount of content. The more relief it exhibits and the more realism it puts into that, the fewer symbols of culture (boundaries, cities, roads, canals, bridges, etc.) can it contain or indicate clearly, let alone emphasize. An overloaded map is really worse than an underloaded one, for when the excessive detail is jammed in so that it's crushed beyond recognition, the entire map is spoiled, the mountain masses along with the seaports. You are more likely to get lost in such a map than you are in the country itself.

The coordinate lines in relief models—even good relief models—are often lacking or poorly indicated; sometimes they appear crossing ocean areas—but think of Eurasia!

Some relief globes are left blank—white, without markings of any kind. You can mark them and color in the features yourself. If you add too much, make an error, or wish to change the theme of your selection, you can remove the matter without harming the globe.

THE GEOLOGIC MAP

Anyone who wishes to appreciate maps should become acquainted with the geologic map even though he may not intend to pursue that most fundamental of the earth sciences.

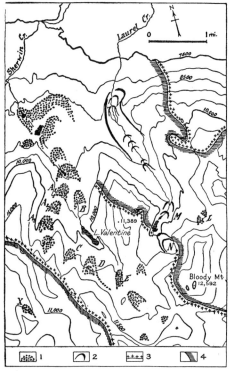

Key: 1. rock streams; 2. moraines; 3. granitic rock; 4. meta-morphic rock.

Geologist's sketch map. Note use of symbols in combination with contours °

There is a mutually helpful relationship between geology and cartography. As soon as cartography had invented certain graphic techniques and developed, geology (and its kindred sciences) made use of these techniques and developed too. And with an increase in geologic science, cartography in turn prospered. "In order to understand topography one must understand geology" has become an adage among cartographical engineers.

° From "Rock Streams in the Sierra Nevada," by John E. Kesseli, *Geographical Review*, Vol. 31, p. 205. Courtesy of American Geographical Society.

The physical makeup of a place is nearly its whole picture. The artificial features, called "culture," are related directly and indirectly to the natural. Geology is a broad science, part of which includes the study of the character and processes of the ground—the whole ground structure and composition—past, present, and future—from the bottom up. (Some day there will be geological mapping from the core of the earth outward.)

As a topographic map may have colors and tints to show different kinds of surface, and a political map to differentiate countries, states, and provinces, a geologic map may employ them to indicate the types and ages of rock. In addition to colors it may have its own set of special symbols. These may appear along with conventional cartographic symbols and contour lines. Color raises the cost of map-printing, and as almost every geological treatise needs several maps, the authors usually have to make do with black-and-white. This limitation is more likely than not to increase their cartographic ingenuity, as well as their readiness to borrow devices. It's an amiable commerce, with little or no danger of plagiarism, for a new cartographic device is often like a newly coined word uttered quite distinctly in public by somebody whose name was scarcely heard.

A physiographer may draw a land-form map with a geological cross-section. A geologist may draw a geological profile and then, to show what kind of country it underlies, put above it a physiographic diagram. It's an interservice between two disciplines more intent upon giving forth knowledge than upon keeping themselves separate.

But there is a cartographic difference between them. As an eminent geologist has pointed out, it's the difference between showing the appearance of an area at a certain moment and telling some of its story as it changes through a passage of time—the differ-

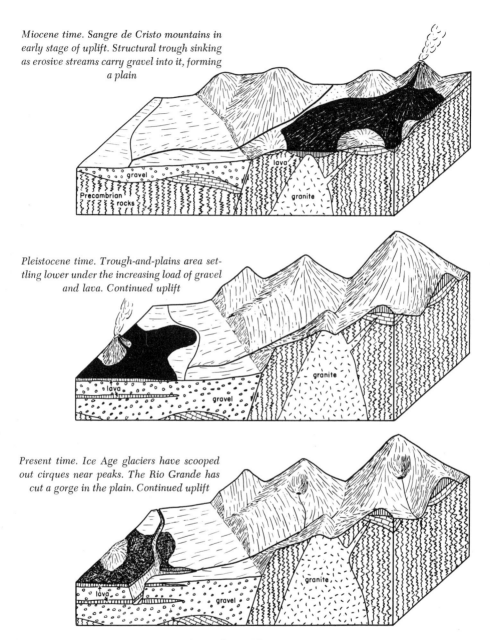

Miocene time. Sangre de Cristo mountains in early stage of uplift. Structural trough sinking as erosive streams carry gravel into it, forming a plain

gravel

Precambrian rocks

lava

granite

Pleistocene time. Trough-and-plains area settling lower under the increasing load of gravel and lava. Continued uplift

lava

gravel

granite

Present time. Ice Age glaciers have scooped out cirques near peaks. The Rio Grande has cut a gorge in the plain. Continued uplift

lava

gravel

granite

Block diagrams depicting some of the geological history of the Taos region, in New Mexico. Drawn by John H. Schilling °

° Courtesy of the New Mexico Bureau of Mines and Mineral Resources.

ence between a single frame of a moving picture and some of its run.° The deeper a geologic map goes into the past, the more specific is the designation of its form. So there are also *paleogeologic* maps, *tectonic* maps, and *paleotectonic* maps.†

The combination of a land-form map and a geological cross-section, however, can be made in such a way as to deal with either a moment of time or a succession of eventful moments. In either case, such a map is sometimes called a *BLOCK DIAGRAM.*

This name seems more fitting when instead of showing only one vertical side of the block the drawing shows two or three. The "sliced landscape" is then somewhat like a cube, or other polyhedron, of cake. It's as if you made a terrain model and then a perspective drawing of it.

Sometimes the surficial plane of the block shows no definite geographic area, merely a hypothetical one, and so does not seem to be truly a map. It seems to be more like a cutaway drawing of a mechanical or anatomical subject, to illustrate various internal aspects of a structure or of the stages of a process. Well, we needn't get into an argument of definition, but there is a deepening of the concept of mapping: the structural and historical *process* of a place or region is mappable in itself. Also, let's not dismiss block diagrams as

being mere teaching devices; geologists use them as a recording language in attaining their own understanding.

The physiographic diagram, or land-form map, and the block diagram have become familiar in schoolbooks, popular science magazines, and in the pamphlets issued to passengers of railways and airlines. Thus what originated as tools for advanced science and would have at first been regarded as too formidable to interest children and the general lay public have become trustworthy attractions. Like do-it-yourself tools which once were jealously kept in the hands of special trades, the maps of special sciences are becoming know-it-yourself tools for an active-minded public.

UNDERWATER RELIEF

Just outside New York Harbor is a submerged grand canyon, the old bed of the Hudson, palisades and all. Off the coast of California are deep submarine valleys whose currents wrecked ships. Off the Florida coast, 2½ mi., is a spring of fresh water, 135 ft. deep, with an uprush so strong a sounding boat can scarcely stay in place over it. In the Philippines, off the northeast coast of Mindanao, is a hole of 35,410 ft., a depth exceeding the highest mountain on dry land by 6,269 ft. Pinnacles narrow as skyscrapers but much taller—ship rippers. Deadly ship traps made of ever-changing fluvial deposits: fanlike ridges, mounds, fingers. Swirls and currents formed by the peculiar configuration of general land masses and in turn forming deposits, lengthening and shortening peninsulas, connecting islands. Wind-waves and currents building up new shoals. That and a whole geography bookful of rough, big country is what Davy Jones has in his beautiful deep blue locker.

Rocks and poorly charted shoal waters at the

° The analogy is suggested by Philip B. King, in *Evolution of North America* (Princeton University Press, 1959) which is chockful of geological maps in black-and-white with a splendid variety of cartographic ingenuities—and which in its introductory pages, also contains a fine explanation of this kind of map.

Another instructive, brief account of geologic maps, particularly for anybody who wishes to do some field work, is "The Geologic Map" by Quintin A. Aune, in *Mineral Information Service*, Vol. 13, No. 8, August 1960, published by the California Division of Mines, San Francisco 11.

† The U.S.G.S. has been issuing among its miscellaneous Geological Investigations Maps an important series of folios with the key title *Paleotectonic Maps* for the geologic historical systems, such as the Jurassic and the Triassic.

approaches of a harbor form as treacherous a blockade as a school of submarines.

While the U.S.G.S. and the A.M.S. have been mapping the relief of the land the U.S.C.G.S. has been mapping the relief of the sea floors. The inshore relief prefigures the offshore margins. So the Coast Survey includes 3 to 4 mi. of topography inland. From hypsometry (height-measuring) to bathometry (depth-measuring).

Its hydrographic work includes the great coastal plains with their sunken dangers of mountain crags and ravines, currents that kidnap and shoals that ensnare—out to the edge of the continental shelf, where from a 600-ft. depth the main blue water begins. This shelf on the Atlantic coast is as narrow as 2½ mi., off Miami, Fla., and as wide as 85 mi., off Nantucket.

"It is tragic but true," the Director of the U.S.C.G.S. told The Institute of Navigation, "that our 'maps' of the ocean floor are about comparable to the maps of North America at the time of the American Revolution."[*]

The terra incognita of the old days is small compared with the submarine one we have only recently begun to explore in earnest. Now, it's "the ocean frontier," as Albert A. Stanley, also of the U.S.C.G.S., has expressed it, "a frontier comprising two-thirds of the earth's surface about which [man] is grossly ignorant." All that is known of most of the ocean floor beyond the Continental Shelf is "only the gross features of shape and structure."[†]

Probably no survey in the early days had to be done under conditions so strenuous as those the seafaring topographers are now encountering. Even though they have the most

* "Ship *Pioneer's* Recent Surveys in the North Pacific," by Rear Adm. H. A. Karo, in *Navigation*, Vol. 9, No. 1, Spring 1962.

† U.S. Department of Commerce release, "Science and Technology," Oct. 14, 1961.

modern equipment, they have to do their work in the worst kind of weather, and that is not the least bit better than it ever was. Hurricanes and typhoons, tide rips and violent cross-seas are still dangerous. But an ocean-survey ship must take them all with dauntless poise. It must be a "platform" for precision tasks, no less than the platform of a Bilby tower is; it must sturdily support winch operations and the handling of delicate instruments used in oceanography.

We might reduce sea-bottom surveying to three distinct operations. Finding sunken dangers with a drag—before some ship finds it by a collision and is wrecked. Secondly, sounding depths and shallows. And thirdly, ascertaining the exact locations of these points so as to place them where they belong on the chart. A map-reader will recognize in these the familiar steps: exploration, vertical measurement, and horizontal measurement.

Two launches drag between them a wire buoyed so as to sweep through the water at a definite, even depth. Any obstruction of less than that depth will catch the wire drag, which then from a curve straightens to form an angle, locating the wrecker. Then a party goes over to it and gets the details. These sweep wires are ordinarily up to 4,000 ft. long, but in Alaskan waters they have been as long as 15,000 ft.

Just as in air navigation the ceiling has a vital relationship to the land relief so in water navigation the tide and the sea relief are in serious cahoots against the safety of the traveler.

As for the midcontinent landlubber, though he may never think of it, the bench mark on the knoll in his tranquil pasture depends for its precision on the rise and fall of tide! The basic mark for vertical control is datum zero (0), and this is mean sea level, which is the "average height of the sea for all stages of the tide. Mean sea level is obtained by averaging observed hourly heights of the sea on the

CONTENT

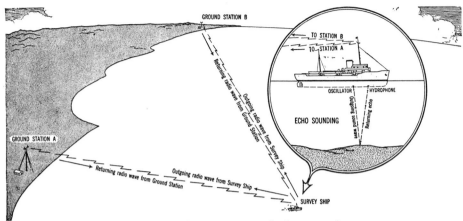

Hydrographic surveying with electronics °

open coast or in adjacent waters having free access to the sea, the average being taken over a considerable period of time."[†] This calls for the use of tide gauges, which record the height of the tide at definite places. Some gauges are automatic, that is, self-registering, and record the tide graphically, during fog and clear, day and night, doing the work of many mathematicians.

In former times depth sounding was done with a sinker and line, but today's fathometer is a radio-echo contrivance. The salt-water surveyors (knowing just how much salt is in the water, by the way, for that makes a difference in sound transmission) send a sound down directly under the boat and time the return of the echo. That timing tells the depth.

Today there are several kinds of echo-sounders, or fathometers, that can take good soundings in the deepest waters of all the oceans. Some have recorders and thus become graphic instruments as well. The Lamont Geophysical Laboratory, for example, set a high-precision mark when it designed one for

° Courtesy of U.S.C.G.S.

[†] Mitchell, H. C. *Definitions of Terms Used in Geodetic and Other Surveys*. U.S. Dept. of Commerce, Coast and Geodetic Survey, Washington, 1948, p. 55.

the Navy Bureau of Ships, measuring depths to an accuracy of 1 in more than 3,000 fathoms. Sometimes cameras are lowered to photograph the bottom surface as the ship drifts in a definite direction. Not only that: in many deep parts of the ocean the floor is covered with sediment thousands of feet thick, and the hydrographers, by using grenades in their sounding technique, can trace the contours of the rock bottom lying beneath this cover!

You can find your position on water by using the same principles as to find it on land. Take two or more known points to sight on. Where these sight lines intersect on your chart you have a "fix" of your position, an X that marks the spot. (These lines are actually radiuses from these known points. But afloat you cannot stay plumb still, like a landfast tripod. Besides, your known points may be as invisible to you as anything at the bottom of the sea. Here, again, electronics time-measures the distance, by a to-and-fro process. Time-measuring of distance is really an old idea, and only the means used is modern. People have measured distances by using pipefuls, tales, prayers, and songs as time units. Anciently, a master wishing to find the

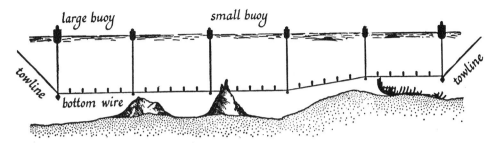

Wire drag used in exploratory stage of underwater mapping

distance across a stretch of country to a certain visible feature, say, a mountain spur, would send a slave walking there and back to see how *long* it took him. ("Long" here is a valid pun! Nowadays a ship's master sends forth radio pulses.)

Electronic positioning originated in the navigational emergencies of the second World War. For example, shoran (short for *short range navigation*) was designed for the use of aircraft on bombing trips.* It later became useful in aerial photography and hydrographic survey. To attain accurate control beyond the range limits of shoran, the Navy Bureau of Ships built in 1944–45 an Electronic Position Indicator, "EPI." And to do precise positioning beyond the limits of *that* equipment during the same war period, a *long range* navigation system, called loran, necessarily evolved. It was devised to allow a navigator to fix the position of his ship without using any radio transmission. Instead, she *receives* the synchronized signals from at least three known points. The crossing of two lines of position gives the navigator a position fix in loran coordinates. His loran chart has loran lines of position which are superimposed on a geographic plot. So the location of his ship's position in the loran coordinates gives him directly the location in terms of earth coordinates.†

Loran C is a development of the early system (Loran A) to suit the U.S.C.G.S. requirements for an accurate position system involving great distances offshore. There are several other systems (some of them commercially produced for the market) such as Consul, Decca, Electrotape, Gee, Hiran, Omega, Raydist, and Secor.

The position-finding systems vary in the kind, as well as the extent, of their performance. So some are used to supplement others. They vary in efficacy in day use as compared with that in night use, and in utilizing groundwaves (radio) as compared with efficacy in the use of skywaves. They vary also with respect to stations. One of the stations may be mobile—aboard ship—and the other fixed, at a shore point, both of them transmitting radio signals. One system may use only two shore stations, another three: the center one the master and the two others the slaves.

Sonar is the short term for *sound navigation and ranging*, a radar contrivance.

If you are interested in electronics, you will enjoy "shopping around" among these various

* *Range:* "In general, two points in line with the point of observation. . . . In hydrographic surveying, a range formed by two short objects, if suitably located, aids in keeping a boat moving in a straight line; the line defined by the range." *Ibid.*, p. 66–7.

† Abstracted from *Use of Artificial Satellites for Navigation and Oceanographic Survey*, by Paul D. Thomas. U.S. Dept. Commerce, Coast and Geodetic Survey, Tech. Bull. No. 12, 1960, pp. 5, 6.

instruments as they are described in a grow-
ing mass of literature issued by the govern-
ment agencies.

"Reading" the topography hidden under
water. That's what supplies the critical "read-
ing matter" for ocean maps. These maps for-
merly useful only to the general geographer
and the navigator now must contain informa-
tion required by geologists, prospectors, ma-
rine ecologists, archeologists, and physicists,
as well as all-around oceanographers.

An up-to-date nautical chart shows a navi-
gator the topography of ocean bottom so well
that he can use the underwater valleys, ridges,
etc., to guide himself by. With his chart spread
before him he looks at the azimuth line of
his true course and can see where it crosses
each depth contour. The fathometer of his
ship reports each depth as he comes to it, and
so he always knows just where he is. Or if he
is trying to pass a dangerous headland in bad
weather, he can select a contour line at what
he considers a safe depth and follow it with
his fathometer to keep clear of the foul area.

Topography of the ocean floor appears also
in the capacious sheets of the American Geo-
graphical Society's *Map of the Americas*
(1:5,000,000) and in its contribution to the
International Map of the World, the *Map
of Hispanic America* (1:1,000,000).

ISOGRAMS AND
OTHER SYMBOLS

One of the most useful Greek prefixes in sci-
entific wordmaking is that three-lettered han-
dle *iso*, which means "equal." We have just
dealt with a system of expressing relief by
lines which connect points of *equal elevation*.
And it may have occurred to you as being the
same old trick as is used in magnetic maps (see
p. 62) where lines connect points of equal
declination: isogonic lines. A contour line con-
necting equal depths below water is an *isobath*.

Any line which connects points of equal
value is an *isoline*, or *isogram*. The isogram is
surprisingly versatile in making maps talk.
Talk about the weather, glacial epoch, salt in
the sea or any gamut of uniformities you'd
care to know about.

There is no universal agreement among
cartographers as to which term to use as the
general one for lines signifying equalities.
Some prefer "isopleth" to signify iso-markings
in general, some "isarithm." Some would limit
"isopleth" to special equalities, such as of
population. A fairly well-accepted distinction
is that the isarithm tells us how *much* (as
rainfall, heat, altitude, etc.) while the isopleth
tells us how *many* (as persons, divorces, thun-
derstorms, etc.).

Not all isograms are for showing topograph-
ical relief, yet figuratively speaking they do in-
dicate the ups and downs. Take for instance

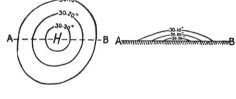

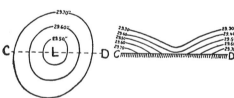

*Upper: High-pressure area and cross section.
Lower: Low-pressure area* °

the *isobars*, which connect lines of equal baro-
metric pressure. We can think of high pressure
as forming an airhill, and of low pressure being
a valley between hills.

° Courtesy of Hydrographic Office, U. S. Navy.

These lines of equal pressure,* like lines of equal elevation, have on each map a uniform interval. While the contour map has an interval of so many feet between its elevation lines, the weather map has an interval of so many

Various forms of isobars. (Compare with illustration, p. 81)

tenths of an inch between its isobars. Its intervals are "vertical" though, much like the other's, if you keep in mind the column of mercury in a barometer. Air pressure might be slack and let the column sink to 29.30 in. in height, or it might be heavy ("high") and push the column up a whole inch to 30.30 in. Also, if the vertical interval of a weather map is, say, .10 in., it means that a barometer at one place through which an isobar runs on the map will show a tenth of an inch difference in atmospheric pressure as compared with a barometer at another place through which the next isobar runs.

Barometers are sometimes marked off in millimeters instead of inches. But the millibar is a still more suitable unit for atmospheric measuring and mapping. Radio uses the millibar reading in its weather flashes to navigators. The reading may be, say, 1016 or 1020 millibars, but the chart abbreviates these figures, as "16" or "20." The intervals range from 1 to 5 millibars.

* Illustration courtesy of U. S. Weather Bureau.

Then there are *isotherms*. They perform the same service for temperature. In the usual weather map† the difference between one line and the next is 10 degrees of temperature. But this interval, as in this map of the world ocean may be only 5 degrees. The dotted lines are sea-surface isotherms. The heavy broken line shows the extreme limit of sea ice. Note the relation of these lines to the latitude and longitude lines, for only by these geographical coordinates can one tell where the information applies. And still more interesting is that heavy line around the edges of the continents. That is a 200-meter isobath,—that is, a submarine

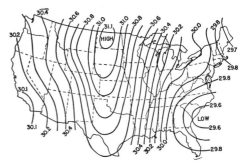

Distribution of air pressure (in inches) during a strong norther in Gulf of Mexico‡

contour line. Beyond this depth the submerged margins of the continents end, presumably, and the true deep sea begins—making a considerable difference in water temperature. This map, then, shows how closely related are the two kinds of isograms: the isotherm or heat-line and the isobath, or depth-line. They are related both in technique and in physical signification.

† Everybody talks about the weather but few know how to read a weather map. That is, few know anything about meteorology, the science of weather. Uncle Sam's Weather Bureau publishes and sells for a few cents millions of dollars worth of meteorological instruction. All you need to do is pick out of his catalogue the titles which interest you most.

‡ Courtesy of U.S. Weather Bureau.

CONTENT

We might well call the isogram a lineal technique for the invisible topography of the world. For we cannot see air-ridges and heat rivers, though we may feel them as we come to them or they to us. Indeed, measurement is itself abstract in nature: though we can see the difference between the base and the summit of a hill we cannot see the *feet,* or measured altitude, except on a yardstick or a chart. That's why we have maps and charts: to visualize what is abstract, as well as what is too immense or distant to see. A map with a scale and isograms is virtually an illustrated yardstick.

Alexander von Humboldt (1769-1859) the great explorer of the Orinoco and the Andes, invented the isothermic map. Joseph Henry (1797-1878) the inventive American physicist, after whom the *henry* (a unit of electric self-inductance) was named, organizer and first president of the scientific Smithsonian Institution, made the first accurate weather map and originated the use of isobars. And Lt. Matthew Fontaine Maury, U.S.N. (1806-73), induced skippers all over the world to note down in special log-books the currents, salinity, and temperatures of the ocean wherever they happened to be, and thus he inaugurated modern oceanography. Today the pilot charts of the Navy's Hydrographic Office still proudly state their indebtedness to his researches. Thus, for anybody who knows their stories these technical lines on charts bespeak the valor and the quiet glory of scientific men.

The isogram technique can also express such abstract data on maps as relations in which time is an element. It can show not only actual phenomena, as pressures and temperatures at a certain hour of a certain day, but it can also show *tendency.* The *isallobar* connects places which have the same tendency of pressure change within a specified length of time. All places where the atmospheric pressure falls (or rises) the same amount, say, 2 millibars within three hours, are in the same isallobar.

World ocean map. (Hammer's Equal-Area Projection, p. 166.) °

° Illustration from "Maps of the Whole World Ocean," Contribution No. 318, Woods Hole Oceanographic Institution, by A. F. Spilhaus, in the *Geographical Review,* Vol. 32, No. 3, 1942, courtesy of the American Geographical Society.

*Weather map with content provided by cloud
photographs from Tiros satellite* °

The *isallotherm,* likewise, connects places of equal change in temperature during a specified length of time.

A few more interesting isograms are:

The *isabnormal* line: for equal departure from normal temperature within a given time.

The *isanemone*: for equal wind velocity.

The *isanomal*: for the same anomalies, or abnormalities of temperature, pressure, etc.

The *isanthesic* line: drawn through different places where the blossoming of a plant occurs at the same time.

The *isobase*: for places that have been raised the same amount since some certain time, as the glacial epoch.

The *isochrone:* for equal amounts of time involved in travel, growth, processes, etc.

The *isohalsine,* or *isohaline*: for equal salinity, in the ocean.

The *isohel*: for equal duration of sunshine.

The *isohyet*: for equal rainfall.

The *isokeraunic:* for thunderstorms—equal

frequency, or violence, or for simultaneity of occurrence.

The *isopach:* for equal thickness in a geological formation.

The *isopycnic* line: for connecting points of equal density, particularly air density.

This list suggests a rich variety of special maps. Many of these an average person is unaware of, let alone able to read. Yet they are among the most fascinating of all maps. But unless one has some understanding of the science that the special chart speaks for, one cannot read the isograms or symbols on it intelligently. It is futile to learn the vocabulary of a language and nothing else: never knowing how to converse with the people or enjoy the literature employing that language. Maps and charts are a language—a kind of sign language, if you will—for the sciences. And each science has its own dialect. Not only a grammar of isograms and a vocabulary of hatchings and

° Courtesy of the U.S. Weather Bureau.

CONTENT

DATE PALM AND BANANA

DATE PALM
- Areas where crop is staple or co-staple
- Areas where crop is economically important

BANANA
- Areas where crop is staple or co-staple
- Areas where crop is economically important
- Further areas where crops occur in unimportant capacity

0 500 1000 1500
Miles

GEOGR. REV., OCT.,1960

Pattern symbols used qualitatively. Note that they are easily distinguishable †

tints but also a list of idioms. Symbols.° These are Greek to us—hieroglyphics, secret code—unless we know something about the science. The symbols then become words with definite meanings.

° An excellent article about this phase of map language is "Map Makers Are Human," by John K. Wright, in the *Geographical Review*, Vol. 32, p. 527.

Usually a map or chart containing special symbols will have a key to their meanings. This accommodation is not likely to be as helpful as you might expect if you don't already understand much of the subject, or science, for which the map or chart was made.

† Courtesy of *The Geographical Review*.

And yet, it and its symbols might possibly help you to that very understanding.

The symbols may be pictorial or abstract, or they may be pictures conventionalized into abstractions, as for example slanting lines for rain or tiny cross-marks for snow. Besides form-lines, tints, and emblems, the cartographers use dots, various shapes in graded sizes, dotted patterns, line patterns, shape patterns, and graded densities of these patterns for symbols.

If a map's contents are *only the visual* features of an area (those details of the general landscape that you and perhaps your camera might see there and carry away in the form of an image) the symbols, if any, in that map are little or no problem for either the cartographer or the reader. Green or a mass of tree-shapes will easily denote "forest." It's when the map has to tell what kind of tree, or whether the stand is sparse or dense, that some difficulty enters, and the reader may not be able to tell the trees for the forest. When a symbol must definitely qualify or quantify, specify or measure—as when maps are used for records and statistics—then the symbol itself and not just the abstruse subject alone, may make the map hard to read.

The main thing to understand about cartographic symbols themselves is whether they are intended to tell *what* or *how much—many, big, high, fast, early*, etc. That is, whether a symbol is qualitative or quantitative in its signification. If you overlook the quantitative intent of a symbol and regard it merely as a "what," the meaning of the map or chart will perhaps be mostly lost. If you're interested, say, in a certain mineral and note on a map only where it occurs (that is, *what* is where) instead of how much of it is available where, you won't be using that map for all it's worth.

Don't blame yourself, however, if in a map or chart which is supposed to show, say, the distribution of anything, the symbols are ill-chosen (obscure the map, have misleading forms, etc.), are inadequately differentiated (in tint or pattern), or are badly drawn and printed. This often happens in professional cartography that may be otherwise excellent.

Neither blame the map or chart if its quantitative purpose requires you to take count or measure though you might prefer to "read off" its statistical information quickly. All highly intelligent pursuits have their tedious phases. In dot maps or charts, each dot may mean exactly so many cows, cases of flu, etc. Now, a dot is the simplest symbol possible, and it occupies for what it has to say the smallest space on paper. If within a square centimeter of paper space (equivalent perhaps to a square mile of ground area) there are only 4 dots, we'll have our "easy reading." But if each dot stands for, say, 100 TV sets, the dots are going to be denser in the urban than in the rural parts. Of course, a good cartographer will be foresighted in planning the job so that in no part will the dots be crowded too close together to be individually visible. He may have to assign a larger numerical value to each dot, or he may have to enlarge his scale. And even then, we might have to use a magnifying glass to count the dots. In fact, there are special instruments for measuring precise densities of dot clusters in maps and charts.°

Maps and charts—you may have noticed in this chapter the repetition of these two words. What's the difference in their meaning? Charts are maps with a special, practical purpose such as navigating, weather forecasting, and population studies. A chart is a map on which to work with protractor, compass, dividers, and gauges—even a densitometer.

° See "Use of the Recording Densitometer in Measuring Density from Dot Maps" by William G. Byron, in *Surveying and Mapping*, Vol. 18, January–March 1958, pp. 41–48.

CONTENT

MAPPING WITH THE AIRBORNE CAMERA

When we are aloft, our eyes take in both a wider and *fuller* view—more detail, with more *significance*—in a moment than in hours of laborious observing when we're right on the ground. Aground, our view is limited to the sides of buildings and mountains; but aloft, we behold the entire ground plan of artificial and natural structures. We see the texture and the pattern of the outspread landscape. We see what is otherwise hidden from our sight because of being too close to our eyes, and to our habits—our mental habits especially.

On high we see strung across the countryside the faint, broken traces of old, bygone roads that the contacting foot or wheel no longer knows. We see surprising revelations of such vanished things as ancient village sites —the foundation lines, vegetation patterns, and other ground scars indicating them. We see actual *history*. On high we have the perspective (the "look-through"!) that enables us to see down into bodies of water and discern submerged hills, stream-deltas, canyons. Also, we see the fish traps and other works of primitive man: archeology. The high view penetrates both tide and time.

Faster and more accurately than the eye, the airborne camera sees and collects these visual details for the content of maps. But it's the mind that reads the significance of these details in the overview. The camera gathers more details than the mind and the subsequent map can use. For although the camera has no prejudices, it also has no particular interest; it doesn't really map.

An aerial photograph is not a map, not even when it's a composite of many shots covering a large area. But when a military staff or an explorer has no map of a certain region, such a picture of it becomes a helpful *map-substitute*. And if the existing maps of that region are out of date, too meager in content, badly drawn, or prejudicially erroneous, the aerial photograph can serve as a supplement or corrective. It's no map but it's sometimes an excellent *map-critic*. Like the little child who noted that the Emperor's new clothes were no clothes at all, the photograph speaks with astonishing frankness. (Maps, from the earliest times, have called for the services of that child.)

Photography and cartography sometimes combine in a superficial way for the *PHOTO-MAP*. This is an aerial shot, or an assemblage of shots, upon which grid lines, boundaries, place names, and perhaps form lines or contour lines have been drawn. It may have also some scale indications, or at least a notation of distance between two or more certain points. Such a map may be a bit more than a makeshift, but usually it has more realism and less reasoning in it than is necessary for any but tentative use.

Aerial photographs, however, whether used as map substitutes, map supplements, or basic sources of map information, have become a major factor in nearly all kinds of cartography, from official achievements down to amateur attempts.

The U.S.C.G.S., referring to its series of small-craft charts, says "New air photography is taken for each area immediately before field work for a chart is to begin. Topographic detail in the area is corrected from these aerial photographs." (Note particularly the words "new" and "immediately before." The information for nautical charts must be the very latest, and the camera is the quickest, most direct means of keeping up with the ever-changing scenic information needed for map content.)

In the B.L.M., aerial photography is the official method of locating water boundaries.

Submerged lands in the Gulf of Mexico, off the coasts of Florida, Louisiana, and Texas, are so rich with mineral resources that the winged camera must help to determine the boundaries of the outer continental shelf for cadastral surveys.

The Map Information Office of the U.S.G.S. keeps "records of aerial photographic coverage of the United States, its territories and possessions, based upon reports received from numerous Federal and State agencies and commercial concerns." Annually it issues free of charge a marvelously compiled map showing all the states and their counties and the "Status of Aerial Photography" (the title of this map) that has been done of these areas by the various aerial surveys, both governmental and commercial. Not only that—you can buy from or through the U.S.G.S. prints of the actual air photos!

Such photos are among the most useful and trustworthy records ever made by man. As the camera memorizes a maximum eyeful of details for maps (and history) it also perceives the spatial relationship between those visual features. That is, it affords a report of the relative distances and angles between them.

This camera version is so frank and, *within its own laws,* so consistent that you can translate it into the plainly readable and precise version we demand in maps.

To have a rudimentary idea of how a camera does this measuring—at least of distances—let's imagine an experiment. Suppose we take a picture of a brick wall. We have our camera face toward the wall. (This means that the lens is parallel with the wall.) Then shoot.

Let's examine the print of our shot. All the bricks are distinct. But of course the bricks in the center of the picture are more distinct than those at the edges—just as the faces of people in a group shot are. So let's look at the

middle bricks. Say, five in a horizontal row. In our picture these five measure 2½ in. On the wall they measure 40 in. Well, 2½ is 1/16th of 40. So that's the scale of our picture. Its representative fraction (RF) is 1:16. This would work the same way with a straight-down, or vertical, shot taken of the ground from aircraft. Then, instead of bricks, to use as units of measure, there may be city blocks in the center of the shot, or a "measured mile" we know the definite marks of on a straight highway, or any other precise distance we might know between two points in the heart of our picture.

Many settled areas of the world are rich with right-angled, or at least straight-line, detail, and although almost never as uniform as a bricklayer's pattern, such detail can be used for the scale of maps.

But suppose we photograph a fieldstone wall, with not a straight line or a right angle anywhere inside it. And no two stones (units) the same size. We don't wish to bother trying to measure one of the middle stones with a ruler. Nor do we have to. If we know the distance between the wall and our camera, and the distance between the lens and the film (that is, the focal length) we'll have all the figures we need for knowing the scale of our photo. Say, the focal length of our camera is 2 in. (It of course is most likely known to you only in millimeters, 50 perhaps, which is a bit less than 2 in., but let's keep this simple), and our distance from the wall is 240 in. (20 ft.). Then the scale of our shot will be as 2 is to 240, or 1:120, which is our RF. If we wanted to "map" that wall, we'd have at least *that* to go by.

The science and art of measuring by photography is known as *PHOTOGRAMMETRY.* It is used in astronomy, geology, meteorology, archeology, architecture, surgery, agriculture, criminology, and in many other practices besides that of mapping. Merely to begin to

understand it one must appreciate the fact that its basis is *light*. The speed of light is a unit of measurement in physics and astronomy, and in surveying and mapping this speed serves both as a unit and a unique advantage. Moreover, the *behavior* of light as it passes through different mediums—such as lenses, layers of atmosphere, and various fluids and solids—and as it strikes upon various surfaces helps and advances surveying and mapping by the very complications, or the special "difficulties," of that behavior. This book isn't big and deep enough to look into those complications; all we can do here is to glance at a few of them.

To take fullest possible advantage of the subtly complicated behavior of light at the very outset, the photogrammetric camera is in itself one of the most admirable achievements of technological craftsmanship. To turn out a lens for it requires as high an order of skill and conscientiousness as that of the fine violin-maker, whose genius happens to be in coping with the conduct of sound instead of with that of light. To change the seeming perverseness of the ways of light into a valuably productive cha'ienge, every part of this whole measure-taking instrument must be mathematically and geometrically accurate to a degree surpassing that of any other kind of camera. If ever you lose your respect for man and think you prefer the company of the other animals, either listen attentively to a good symphony or look carefully at a photogrammetric camera—or do both.

This ultra-precision instrument down on the ground, in the physics and chemistry laboratories, measures ("mappingly," so to speak) the infinitesimal at close range, and in observatories the huge and distant, such as the lucent surfaces of the moon and Mars. As a photo-theodolite it does superb ground-surveying. As a stationary ballistic camera, it takes the measure-picture of the flight-track,

not only of missiles and rockets, but of space vehicles and satellites. Even when the latter are toting their own active cameras gathering measure-pictures of the ground.

To aerial photography, photogrammetry adds engineering. This means an addition of not only instruments but know-how, some of the finest in modern technology. And know-what too. The airborne camera is a reporting, fact-collecting instrument. It works with a company of translating, interpreting, rectifying, interpolating, extrapolating, and drafting instruments—all of them functioning in a collaborative sequence to produce the true survey. But still more marvelous than the performance of this grand apparatus is the mind-work of the cartographic engineer.

Mapping the ever varying surface of the earth and other planets through the changes of time and probing and mapping the ever widening complex of space is a task that continues to be too big for mechanical contrivances to do alone. The human brain is constantly needed in attendance, and even more so in advance, of the processes. Likewise, to become acquainted with some of the principles of photogrammetry is more important than becoming familiar with the names and looks of its amazing instruments.

Setting out with this premise, let's go aloft again.

There are two ways for the camera to view the ground from on high. One perspective is oblique, as when we look aslant on the valley below from a hill, or from the side or fore windows of an airplane. The other perspective is vertically downward through a hole in the cockpit; straight down facing the ground squarely. These two different outlooks make surprisingly different pictures.

The oblique perspective gives us that popular favorite, the bird's-eye view. If one readily enough discerns in the picture the way the light falls upon objects so that they cast shad-

ows which make them almost seem to stand out, an oblique shot becomes quite scenic. The monarch-of-all-I-survey feeling is then irresistible and not altogether a delusion of grandeur. With such a grand survey before one, one is naturally and by rights a monarch.

The oblique view, however, is inclined to distort and exaggerate. But the difference between a prejudiced person and a biased camera is that the latter is always candid, and it is as honest about the exact amount of its deviation from the truth as the operator is in working with a camera.

This candor is brought out when we compare a "low oblique" with a "high oblique."

The *low* oblique shot is one that slants away from the straight-down line about 30°. (No deception about the *amount* of the slant; it's purely a matter of how honestly careful we are in noting it.) This view takes in an area that spreads farther away than the area of a vertical shot and stretches the scale in doing so. And the directions go a bit awry. In the *high* oblique, the lens aims away from the vertical about 60°, to reach out across an area far enough to take in the horizon and some sky with it. In this slant, the relief shows up less well than in the low oblique. (And it doesn't show up much in a low oblique if the aircraft is at a great altitude.) The distances are stretched and the directions are warped *just so much more* at this increased angle. It's a problem but not a deception.

In the vertical shot things appear somewhat flattened out. And aren't easy to recognize. This photographic aspect of terrain is recent in human experience. When we're not used to seeing from a great vertical distance the topsides of things, we can't readily identify them. They look "abstract." And even more so in a picture on paper. A ring-like feature might be an empty pool, a silo, or a crater made by a bomb or a meteorite. A lake may show white or black, depending upon whether or not it is reflecting light. A field of golden wheat may appear dark because from directly above, one sees only the shadows of the stalks. But in plowed ground the soil, though of the blackest kind, may show very light because the furrows would be reflecting the sun much more apparently than they would be casting shadows.

Although the vertical photograph looks much less like a picture than does the oblique, it is a bit more like a map. Its aspect of flatness is not altogether a limitation but a gain, because that two-dimensionalness is appreciably valid. Having a trustworthy right-angle relationship between lens and terrain, to begin with, the picture yields true directions and distances.

Many of the aerial cameras are combinations: a central lens for verticals, surrounding lenses for obliques. The simultaneous shots form a composite. Some of these multi-lens, wide-angle cameras photograph, in one flick of the shutters, the terrain from horizon to horizon.

A photographic aircraft must fly as straight a course as conditions permit. It must double back, as parallel as it can with the previous lap, again and again until the camera, taking a continuous progression of overlapping shots, has covered all parts of the assigned terrain.

In fact, these overlaps effect virtually a double coverage. The forward, or end, overlap of the photographs is at least 60 per cent of their length. The side overlap, which joins the adjacent flights, is from 15 to 50 per cent.

This continuous overlapping renders several benefits. It provides for the orientation of each of the pictures as it forms a continuous directional strip from each heading. Each part of the terrain is taken by the camera from at least two exposure positions, and so affords a surveyor's intersection from two points. Thus it makes the photographs practically

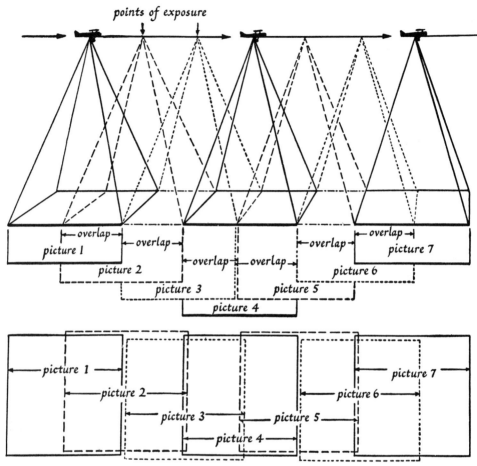

points of exposure

picture 1
picture 2
picture 3
picture 4
picture 5
picture 6
picture 7

overlap

picture 1
picture 2
picture 3
picture 4
picture 5
picture 6
picture 7

How photographic shots are overlapped in aerial mapping °

"self-checking." And in the vertical shots, the centers or "hearts," where definition and accuracy are best, link in a continuity of reliable detail and data.

If two photographic aircraft fly abreast of each other they can do a still more complete

° After Fairchild Aerial Surveys, Inc.

†For an explicit statement of just how much such a duet can accomplish cartographically in a single operation, see "The Dual Aircraft Mapping System," by Q. C. De Angelis, in *Photogrammetric Engineering*, Vol. 28, July 1962, pp. 442 ff.

job. They take their shots simultaneously, and, at the instant of every such dual exposure, they make an electronic measurement of the distance between themselves.†

In some mapping flights, particularly those conducted by military engineers, the aircraft receives electronic assistance from the ground to hold and register its course. The tracking devices are such ranging systems as shoran. Decca, Hiran, Raydist, and Shiran also do this guiding.

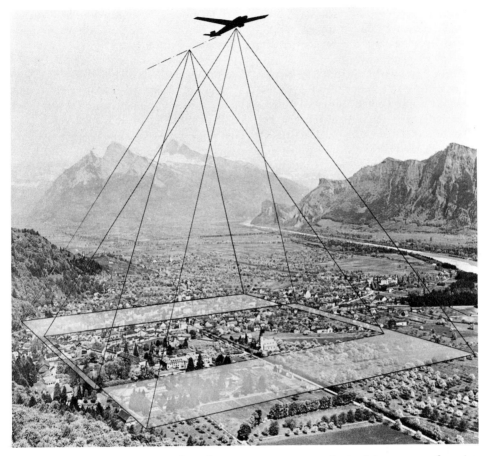

Photograph diagrammatized to show the optimum picture as obtained from an overlap of successive shots in flight °

The plane sends its radio signals out to two or more successive ground stations, just as a ship does to shore stations. This makes a three-point, or triangular, communication, and because the distance between each two transponding stations on the ground is already definitely known, the mechanical computer in the plane can record precisely the location of each picture.

Although the airborne camera can cover in one day much more area than the best sur-

veying parties on the ground could in several months, and although it can fly over such otherwise inaccessible portions as swamps, jungles, lava beds, badlands, and treacherously crevassed deserts of ice, there must still be on the ground some established geodetic control. And this must be identifiable in the shots. The cartographical results will not be first-class unless the ground-surveyor with his

° Courtesy of the Wild-Heerugg Instruments, Inc.

traditional hardihood has somehow penetrated deep enough into the area to establish somewhere within it a few points that will "true up" the planimetry.

Of course even without these, aerial photogrammetry is so accurate *within itself* that the datum-points it obtains in the air are consistent and true *in relation to one another*. But to be true in relation to the geodetic data already established *outside this mapping flight,* the photogrammetry needs figures for at least one position and an azimuth.

If it has also figures for the elevation of one or two places on the ground, it can take pictures in which (as will be discussed later) experts can read the altitudes of uplands for precise indications of relief.

The A.M.S. has developed the Airborne Profile Recorder, however, which "continuously measures and graphically records a cross-sectional profile of the terrain by transmitting a high-frequency radar beam from an airplane to the ground beneath."[*]

The aerial phase of cartographic photogrammetry may at first seem to be the most, or only, exciting part, but the work done by the experts and instruments on the ground is the more marvelously elaborate phase. So much so, indeed, that to avoid bewilderment it is advisable, in a first look at the operations, to attempt a glimpse only at a few of the main features.

What the winged camera brings down from the sky is really a load of field notes in the form of images that as such are intrinsically accurate but that as abstract information are only more or less accurate and complete.

The ground people and instruments must develop, print, interpret, rectify, evaluate, select, arrange, and re-photograph the assemblage of pictures. This assemblage—or "mosa-

[*] *The Army Map Service—Its Mission, History and Organization.* Corps of Engineers, U.S. Army. Washington, D.C., 1960, p. 33.

ic," as it's very descriptively called—is what the cartographers and their instruments translate into a drafted map.

If you examine a topographic map that has on the other side of the sheet the photomap (or mosaic composed of the hearts of the aerially taken pictures) from which the map derives, the difference tells a bookful. It's the difference between natural imagery and conceptual expression. One merely has the facts, the other uses those facts for a clear idea. The map is actually simpler, more practical, and is more gratifyingly an expressive design than the picture is. For most of this difference we have to thank the operations aground.

Air photos stay in the class of "nature in the raw" much because of what may happen aloft. The aircraft may tilt, and then the lens won't keep its true parallel with the datum plane of the ground. Or the aircraft may strike a cross wind, then have to slip sidewise, or "crab," in order to hold its flight line. This will push a vertical shot out of true line. These are only two examples of what may have to be corrected in the laboratories and drafting rooms.

Photo-interpretation identifies objects and also recognizes the over-all three-dimensional aspects of the terrain. The photo-interpreter trains his eyes to see the pictures stereoscopically even though he uses also various stereoscopic devices. These "grow up" into the complicated instruments of *stereophotogrammetry,* which plots out from the photograph the points and lines for showing on the map the relief with precision.

We can get a general idea of the work done to make aerial photographs into maps if we look over a few terms designating the names and functions of some of the instruments.

Comparator: for measuring rectangular coordinates of points on the plane surface of a single aerial photograph.

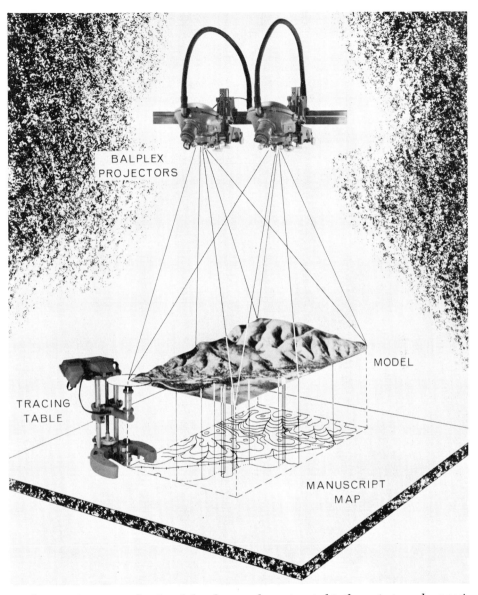

BALPLEX
PROJECTORS

MODEL

TRACING
TABLE

MANUSCRIPT
MAP

*In this mapping system, "copies of the photographs are inserted in the projectors whose position and attitude may be adjusted to correspond with the position and attitude of the aerial camera at the time the photographs were exposed. The position and elevation of every point in the model are then established by the intersection of two light rays"**

° Quoted from *What about a Career in Photogrammetry?*, a brochure published by the American Society of Photogrammetry. Illustration, courtesy of Bausch & Lomb.

CONTENT

Coordinatograph: a table used in connection with plotters and stereoplotters for compiling maps and profiles.

Multiplex: for making precisely contoured relief maps from vertical aerial photographs by "reading" them stereographically in pairs.

Orthophotoscope: for changing stereoscopic images into a photograph with a constant horizontal scale.

Rectifier: for changing oblique shots or tilted shots into the equivalent vertical shots.

Stereoplanograph: for plotting the relief of land and the heights of objects by stereoscopic inspection of pairs of aerial photographs.

Stereoplotting instruments: for determining in an aerial photograph the exact positions and elevations of certain points on the ground, and also for connecting these points so as to draw true to scale such lines as contours, streams, roads, canals, shores, etc.

6. Flat Maps with Round Meanings: PROJECTIONS

ONLY A GLOBE can give a valid picture of the earth as a whole. No other kind of map can represent the true forms of continents in the full as they fit into, and indeed are part of, the rondure of the earth. It is the most nearly true to scale of all maps in each and all of its areas and in its distances from any one point to every other point. You can see on it as you can on no other map the exact proportions and positions of oceans and land features in relation one to another as they are on the earth.

It is not an imitation of a sphere but an actual sphere itself; you need resort to no optical illusions to visualize the continents, or coordinates, or great circles. A globe does not need to simulate the spherical relations of the earth we live on: it *has* them.

But globes do have certain practical disadvantages. Good ones are very expensive. And often the finest one made could not serve as a working-map. We cannot see both sides of a globe at the same time, nor can we fold up a globe and carry it in our pocket. And imagine how large a globe would have to be to give us a good, detailed idea of some comparatively small area, such as Yellowstone Park! Take the flat International Map of the World on the scale of one-to-the-million, for instance. A globe to the same scale would be nearly 50 ft. in diameter. You would need a mobile scaffold-

ing around it to read it as close up as you can one of the separate sheets of the flat map.

A well-stocked library can get along well with but one globe. But it must have hundreds of flat maps to serve practical uses which the globe cannot. The importance of flat maps is that they can be drafted to suit special needs. The importance of globes is that they are the basis of flat maps. Experts say that if a globe and a flat map don't agree the chances are the flat map is wrong. For just as we speak of Mother Earth, we may respect globes as the mothers of maps.

The flat children of this round mother would like to have all her traits without her roundness, but that is both physically and mathematically impossible. If a plane could be globular it wouldn't be a plane.

Round is round. Roundness is all over the earth. From any point it curves off in all 360 directions and in all those in between. Move on the terrestrial globe and you either stay on that curve or get off the earth.

Now, what matters when we supposedly peel a continent off the globe and lay it out flat is not merely the cracking up and buckling which we see in the thick orange peel of the schoolroom demonstration. We can take that "skin" off as thin as you please, and it can be infinitely flexible. Just the same, many arcs would have to flatten into a single plane, and

in order for that to happen the coastlines would stretch here and shrink or kink there. One town would be shifted in its direction from another, and no distances would remain the same as they were.

In the preceding chapters our concern has been with the map's *framework* and its designation of *content*. The framework of coordinates enables us to place the details of the content accurately, and to note them according to measure in size, distance, and direction relative to one another. The content-designation enables us to include in a map virtually any fact, concrete or abstract, pertaining to geography or astronomy.

In this chapter our concern is with the *foundation* of maps. Just as a building's foundation must come to terms with the ground, a map's projection must come to terms with the earth—and in both cases, to support a certain kind of structure with a certain kind of burden and use.

VALUABLE PROPERTIES

We must accept the inevitable: that there is no way of flattening out a global surface and keeping intact all the useful features we wish maps to have.

Within the scope of a map representing a few square miles this loss is so slight that the difference would be microscopic if we tried to make up for it. After all, it is but a tiny speck of the entire world you can see from any one point, and it looks flat, no less flat than a sheet of paper on which you'd put the map. And the paper is much smaller, which makes the difference still smaller. Similarly, you can lay a piece of tracing paper on a fairly large globe and copy off a tiny island or district without distortion. We are, therefore, not worried about maps of counties or of small regions in this flattening-out process.

But when it comes to a flat map of the world

—or of a hemisphere, or even of a continent by itself—we must make sacrifices. Or rather, we must make up our minds just what merit we wish any certain map to keep.

Do we wish so much to keep the *shapes* right that we'll pay for them by letting the scale go wrong?

Or do we wish correct *area* even at the expense of good shape?

Or shall we be content to compromise: have less of every advantage that we might enjoy at least a little of each?

Our decision will depend upon what definite use we have for the map. If our purpose is strictly scientific we may require the map to be perfect in one respect at any price. (You'd be surprised how "strictly scientific" some of your purposes actually are.)

Cartographers call any valuable asset a map has its "property." That's a well-chosen word —in all its senses. For it means what a map retains possession of, what it should have rightful "title" to, as lawyers say. And what is *proper* to that map.

A little knowledge of just what these map properties are will enable us to select the best maps for our needs. Let's evaluate the main properties: Shape

Area

Distance

Direction

SHAPE. Eskimo fishermen whittle out of wood small pocketpieces in the shape of the bit of Alaskan coast line along which they go in boats. These tiny wooden maps have nothing written on them; it's simply their *shapes*— the *feel* of them, we might say—that makes them maps. They are practical charts which show the fisherman how many bays he is from his home bay.°

We are not very different from those fellows

° Maps for finger reading also prove the importance of shape. The blind who have a globe with raised forms or lines to use in comparison with flat maps can get just as sound geographical conceptions as can others.

ourselves. We are so accustomed to recognize anything by its form that for most of us a true representation of shape is the one property we require a map to have. Yet it is the one which no flat map can give us completely for any large region.

If it were possible to put the correct shape of an entire continent down on a flat surface, it would be possible to make a flat map perfect in all the other respects too. For isn't this matter of shape just what we've all this time been talking about—the shape of the earth? It's the round shape that makes all the difference. Shape is the whole story.

We can do very well on shape anyhow. We can get at least an approximate likeness of a large continent, so that anybody can identify it. And taking any small region by itself within that continent on that same map, we can get *that* just about perfect. North America, for instance, will be a little better than recognizable, like an old friend with a swollen neck. Yet take any of the Great Lakes by itself and it will show up in good shape without a thing wrong anywhere.

This is about as much conforming to nature as we can hope for in any flat map. When a map preserves the shapes of very small parts of the mapped surface, even though it cannot preserve the shape of a whole continent or of a large country it is considered to be a CON-FORMAL map. Another term, less generally used in America, is "Orthomorphic." According to that source-language of science, Greek, *ortho* means "right" and *morph* means "form."

The navigator, the engineer, and the military strategist all ask for conformal maps. The shape of a country tells them what kind of mobilizing, fighting, or construction to plan. The configuration of neighboring shores decides where steel bridges or air-bridges can go.

AREA. We do not need to consult maps to learn the area of any one place by itself. Such data we can get more briefly in words and numerals. We go to maps because we wish to *see* the area in pictured space. We wish to see the size of one place in comparison with the size of neighboring places. One state as compared with another. And each state as compared with the country as a whole. Or the countries as compared with one another and the world as a whole.

Obviously, the area of the map can't be the same as the area of the ground, for then the map would be as big as the ground—"life-size." What we ask is that the map must be in a definite *proportion* to the areas it represents. That is, its area should be "in scale." We may have to be content with a map having a scale so small that it is only 1 millionth of the area it pictures. Yet if that is its proportion, 1 to a million, we wish that scale of area to hold true all over the map. Not become 1 to 5 million in another part, and 1 to 10 million in still another. We want a square inch of paper at one part of the map to represent just the same number of square miles of ground as a square inch does in any other part of the map. If we place a penny upon South America we ask that it cover the same amount of "ground" as it does when we lay a penny upon Greenland.

If a map passes this test it has the honor of being an *EQUAL-AREA* map. Other names for this property are: "Equivalent," "Proportional," and if you'd like a very scientific sounding word, "Homolographic."

You can lay on an equal-area map a piece of transparent paper which is cross-ruled to form many small squares, and by counting those squares covering any particular country you can accurately compare the area of that country with the area of any other country on that same map. (See p. 229.)

Equal-area maps are indispensable when we wish to show, for instance, population-per-square-mile of one country as compared with another. Or, as in other "distribution maps" where symbols are used relating number of trees, sheep, tons of coal, kilowatts, schools,

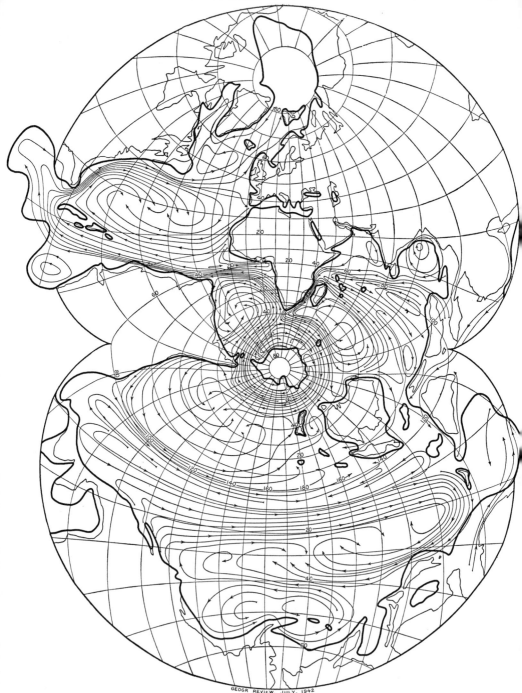

The Whole World Ocean. A special, conformal map to show surface currents in winter, north-
ern hemisphere. Heavy line shows continental shelf. See p. 166.*

* Source same as illustration on p. 100. Courtesy of the American Geographical Society.

airports, missions, or salesmen to area. The symbol might be a dot or a tree of a certain size to stand for a certain number. Or a certain number of dots or trees may carry the idea. Either way, the areas must be represented rightly if the map is to play fair.

Here, then, is an instance where the unscrupulous propagandist can get in his dirty work. He can give a picture of one country being impressive or insignificant as compared with another, by using a map in which the countries are not shown in their truly equivalent sizes. Many good-looking, otherwise trustworthy maps, are not equal-area. How would the average person, who never heard of this peculiarity, suspect anything was wrong?

Getting the areas right is no great problem if you don't have to worry about the shapes. When the label of a can of varnish informs you that the contents will cover the area of 40 sq. ft. it need not specify any *shape* for that area. The shape can be anything. It can be 4 x 10, or 5 x 8, or any dimensions that make 40 sq. ft.

Again, consider a pack of cards. Stacked straight, the pack shows its edge in definite shape with a definite area. Push the pack so as to change that shape. The area remains the same, doesn't it? You haven't added or taken away the tiniest imaginable bit of cardboard surface.

This commonplace stunt will explain what for many people might seem a most fantastic mystery about maps. Engineers call this alteration of a parallelogram "shearing."

If you draw a small irregular shape on the oblong edge of the pack, every tiny part of that picture will change when you shear the oblong to form a rhomboid. Only the area remains the same; and only the sides, which are straight and parallel, remain straight and parallel. But oceans and continents are not parallelograms!

Map-makers who are determined to get equal-area maps will shear continental shapes. Note what has happened to North America in the equal-area map on p. 124.

As long as one is free to pull a continent out of shape when taking it off the globe and laying it flat, one can preserve the proportion of the areas. There are parts of these maps which aren't tortured so much as other parts, and there are some equal-area maps that are a little easier on the shapes than others are. But at best, the shapes take awful punishment to yield us the areal property.

Two geographical features that are very different in shape may have the same area, but you'd never guess so just by looking at them. Mere appearances often tell us nothing about comparative areas, not even on equal-area maps. We must apply an areal scale to them if we wish to make accurate comparisons. The equal-area map is therefore primarily one for the strict illustration of statistics rather than for giving us pictorial impressions of the sizes of geographic features.

Here, then, you have had a glimpse into the chief difficulty at the roots of map-making. In expressing the earth's spherical surface on a flat-map surface, we cannot keep both the equivalence of areas and the similarity of shapes. We cannot eat our cake and have it.

DISTANCE. We can keep our scale of area constant all over the map—at a price. But we can't keep the scale of *distance* constant all over the map at any price. For what do we mean by scale distance but a direct line between two points? And a direct line is a line with a definite *shape*. You can't pick the surface off the globe and slap it down flat without

changing the forms of the lines any more than you can without changing the forms of the masses.

But you can save *one* or another of the lines, say, the Equator or a meridian. The scale of miles will then be the same along that favored line on the flat as it was on the globe.

There is no flat, large-region map in which the scale is true and is the same constant scale, measuring in all directions from any and every point. This is possible only on a globe.

In addition to our ordinary interest in distance it is very important in physical geography for estimating the velocity of wind and ocean currents, tidal waves, and even seismic waves.

DIRECTION. Atop a barn is a weathervane. The tin rooster turns with every wind and seems to say, "It's this way. No, it's *this* way! No, —" Below him is a simple cross like a plus sign, its tips marked "N, S, E, W." Unlike the bird, the arms of the cross stay fixed. And what is that cross but parallel-and-meridian!

But only if they consent to curve with the earth. Only if the E-W bar will go all around the earth the same as any other parallel ring. And only if the N-S bar will extend in a great arc to the poles and come together there with all the other meridians.

If, however, the cross arms stay flat at right angles, and remain rigid straight lines; if they continue out that flat and straight for thousands of miles, they would cease to be parallel and meridian. They would not be compass directions at all, but only a pair of monstrous crossed bars tacked upon the earth.

Now, with a magnifying glass to your globe examine the intersection of a parallel and a meridian. You could almost liken this to the weathervane cross; so flat and straight does it seem within this very tiny scope. One would hardly guess from seeing only this bit of it that this is not a part of a rectangular grid as flat and straight as a checkerboard.

Here we have the happy situation of any small-region map. Like this tiny intersection on the surface of the globe and like the weathervane cross, it can appear flat, straight-lined. Within its tiny scope it can tell us all its directions truly.

This is merely saying all over again that the world is spherical. Many people think themselves sufficiently aware of the fact; yet they are nonplussed when they first hear the subsequent fact that the earth's compass directions are also spherical.

Compass directions, everywhere on earth —curve the way the earth curves. You can't simply plunk a protractor or compass down anywhere you please on any kind of flat map and hope to get the right azimuth from that to any other place.

It all depends upon the make of the map: what its structural principle for being flat is. Most flat maps are so made that you can trust the curved or straight parallels and meridians to run truly in the four cardinal points. But that doesn't mean you can be sure about all the azimuths in between these four points being true. And there are 356 of them. A pair of north and east lines might flatten out nicely into a "tri-square" with a 90° angle, but it is the space in between where all the stretch and squeeze happens. Imagine a spherical right triangle made of cellophane which exactly fits your globe: can you not visualize the buckling and splitting in an attempt to flatten that triangle, the destruction of its accuracy?

Here is another parable worth remembering now and then: On the earth is a place, A. A few thousand miles northeast of it—that is, at an azimuth of 45°—is another place, B. Now, on our flat map the best we can do is to *locate* these two places right. We can see to it that A is on the map exactly where its observed local parallel and meridian cross. Likewise with B. But when we place a protractor at A we shall find that B may be at an angle of 41° or 48°! If it were Wake Island, which is only

1 sq. mi., that mere 3- or 4-degree miss in navigating couldn't be laughed off. And, incidentally, this is a good instance to show what we more than once have to be reminded of: true *location* on a map does not always mean true *direction*.

Some maps flatten out in such a manner that all the directions are true from one *but only one* point. We shall deal with them later.

a grandiose caption, "The World," but if you know how to look into its depths you will find a goodly amount of human humbleness in it.

If cartographers have a tacit slogan, it is, "Let's make the most of it." The result is a fascinating variety of maps.

Here, then, we shall look over some of the many antics, ingenuities, and devices cartographers have resorted to in the age-old en-

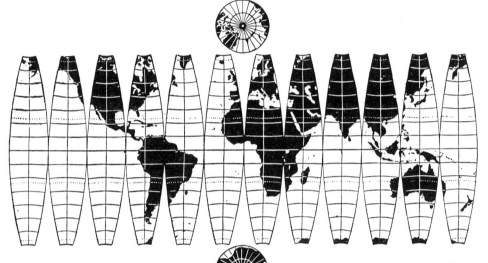

Flat pattern for a globe. Perfectly made *terrestrial globes are expensive and rare*

TAILOR-MADE MAPS

We have seen that when we try to work shape, area, distance, and direction into flat maps it's a matter of give and take. We can't have everything. But these very deficiencies in maps make them more interesting than we would ever think they could be from casual acquaintance. In a map we have not a lifelessly perfect diagram but a human confession. Man goes up against certain phases of the universe to adapt them to his needs, and must publicly admit that for all his cleverness there are some things he can't do. A map may have

deavor of making the most of the world as it is: round and immense and impossible to see all at once.

Perhaps you have noticed that the map on your globe is of paper glued to the ball. With machine-made globes this pasting-down is not at once apparent, because the globe is made of two previously stamped-out or molded hemispheres. But on handmade globes you can see the pasting-down seams. So, it may have occurred to you that this paper was once flat, a flat surface. Now it's a globular surface.

The answer is: a pattern. *And* a lot of stretching. The coverings of baseballs, tennis balls, basket, and volley balls are stretched-on

patterns. So is the pattern of a handmade globe. Twelve gores and two polar caps. (Keep an eye on those caps.) The gores, being 12, each has a width of 30°, or two 15°-meridians. Each gore has a meridian down the middle, a "central meridian" to hold true to.

Cutting a ball into parts for the "Butterfly" map

Then there is the Equator, a true line tying all these together. Whoever drafted this layout originally did so from all manner of careful computation, made through centuries of surveys and spherical mathematics. He gave himself also the advantage of working within these narrow strips, or doing a small separate portion at a time. Even so, he had to draft certain parts a definite amount short of the truth, so that they could be stretched the same definite amount when applied to the globe. To effect this stretching the globe-maker wets the paper gores a certain controlled amount and with very skillful fingers pastes them down. Then we have the only possible true map, a globe.

But the "map part" of it was flat first, yes. It's a flat version of the globe all right. A pat-

tern tailored to fit the global form. We even use a garment-maker's term, "gore." A more geometrical term for this crescent shape which is formed by two arcs or meridians meeting, is "lune."

A few years before the first World War, a California architect and a California orange got together and the result was Cahill's Butterfly World Map. Instead of 12 lunes, he decided that 4 would be enough. Then he cut these in

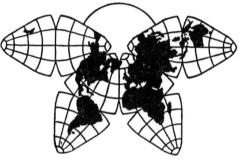

Cahill's Projection °

half so that he had 8 curvilinear triangles, because he figured that ⅛ of the globe is about as much of it as you can show flat at one time without intolerable distortion. Each of the octants gives us 90° of latitude and 90° of longitude, in which we have a map with approximately true shapes, areas, and scales.

It is not necessary to cut out a pattern to fit the globe *physically* (with a little prepaid stretching!) if we intend to keep the map flat. In Cahill's and other similar patterns the "fitting" can be done *mathematically* instead.

Some of the other bizarre designs we get are stars, hearts, diamonds, ovals, triangles, trapezoids, collars, and torn breeches. However, their object is not to be fantastic. And although these cannot really be pasted upon a globe

° Courtesy of B. J. S. Cahill.

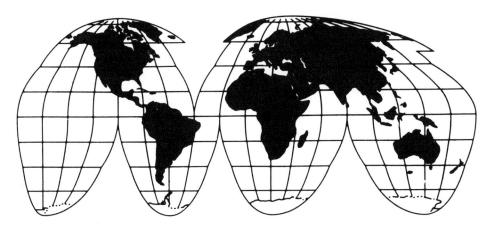

Goode's Homolosine Equal-Area Projection. Oceans interrupted to exhibit continental areas

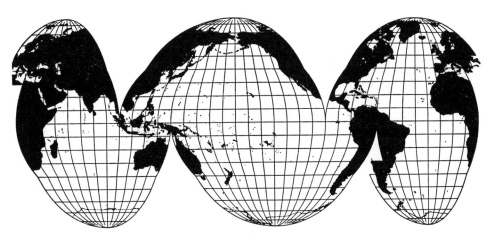

Goode's Homolosine Equal-Area Projection. Continents interrupted to exhibit ocean areas*

after all the mathematical manhandling, each has its special global significance.

These maps usually go under the classification of "interrupted" designs or projections. The interruptions can be allowed in any part of the world which we don't use the map for especially.

* Courtesy of University of Chicago Press.

One of the best interrupted designs is the Homolosine, made in 1923 by J. P. Goode at the University of Chicago. In one of its useful forms it is an equal-area map of the world to show ocean basins. For to oceanographers, sailors, and followers of maritime affairs the true size of an ocean matters more than the looks of the continents, any of which can be

cleaved and put on the opposite side of the map from the rest of itself. Each lobe has its own central meridian. Along this line and on the parallels, the scale is true for 40 degrees north or south from the Equator. Cut this pattern so as to split the seas instead and we have each continent kept intact, balanced on its own strong mid-meridian like a ship on its keel. Goode devised this projection as an improvement of his very similar Homolographic of 1916, on which a linear scale is almost useless.

Before we dismiss the interrupted designs as "unnatural" or "awkward," let's appreciate the fact that they have their logic. After all, the familiar pair of flat hemispheres is an affair of interruption too. Yet we accept such maps, because we wish to see both sides of the world at a time. We know that the way to get more properties into a map is to be content with a smaller portion of the world. Well, the interrupted design realizes just that; only, it assembles the separately treated sections so as to make up a world view. It is a combination of "regional" maps. Our nice, plain, rectangular maps of small sections in large scale are, when you get right down to it, interruptions too. Or excerpts "removed from their context," as a story-teller would say.

Indeed, all maps are fictions! They must be. All maps must say, "As if . . ." The art of making and understanding maps is one of interpretation: getting at the earthy reality despite the necessity of using an artificial means of expression.

Still, it is not agreeable to see the form of the earth rended, "cut out like paper dolls," in order to preserve the individual shapes of continents. White-outs are no pleasanter than black-outs. On a map they denote vacuum, but look like real space, when indeed nowhere in all the universe is there space which is supposed to be no-space, a nonentity. Nobody enjoys being required to imagine just Nothing. The former Geographer to the Department of State—himself the designer of an excellent interrupted projection—laid stress on what he says is "man's growing desire to 'see the world whole.'" [*] We don't like to see a cut-up world signify our whole world entire. Continuity, or call it unity, is also a very serious map-property. The most technical cartographer no less than the ordinary map-user likes maps better when they have small circles unbroken from east to west, and in "smooth curves."

John Donne made a sublime symbol of the interruption that must take place in any flat map of the whole sphere. His "Hymne to God My God, in My Sicknesse" draws this comparison of mortal man lying on his last bed:

> As West and East
> In all flatt Maps (and I am one) are one,
> So death doth touch the Resurrection.

JUST WHAT IS A PROJECTION?

Using a slang expression most literally, we might say a projection is a "take off" on the globe. A plane trying to imitate a sphere.

The main job in transforming globes into flat maps is to save the precious coordinates. We may distort shape or sacrifice area; we may fudge on distances and connive about directions, take in a little here and let out a bit there, making one quality pay for building up another. But one function of a map is indispensable: showing *true location*. No map-user is going to stand for meddling with locations. They have to be right, no matter what kind of map we get: globular or flat, round, oval, triangular, square, or polyhedral.

When we take that network of orderly lines off the globe and cast it upon a flat surface we must in all conscience be sure that the

[*] S. W. Boggs, in *The Geographical Journal*, Vol. 73, 1929, p. 241.

lands and seas which come off with it remain in the same corresponding positions as they had on the globe. Same for every city, bay, cape, island, lake, mountain peak, and what have we. If a certain place is located at the intersection of the 37th parallel and the 119th meridian on the globe that's where it must be on the new map. No matter how much we bend, or curl, or flatten those netlines, or change the bearings, we must keep each location at its exact crossing of coordinates.

The verb "to project" means literally "to throw forward." A map projection is this network of coordinates picked off the globe and thrown forward upon a plane surface.

You can think of "projection" as a moving-picture operator does: throwing an image on a screen. Or as a mechanical draftsman does: drawing a three-dimensional (solid) object upon a two-dimensional (plane) surface.

And to get a more understanding way of looking at the grotesque distortions of shapes in some of the experiments, we may think of projection as it takes place when we stand before joke-house mirrors. A cylindrical mirror which is set one way elongates our image; one set another way broadens it. Somewhat the same laws operate in map projections.

Of course not all map networks called "projections" are really *projected*. Only a few of them might be called "perspectives." Some of the simplest projections to use are almost entirely the result of complex mathematical computation. Even so, the map-maker often bases his figuring upon some shadow-casting trick or other.

A look at the principal projections will give you a little insight into the profoundest and most wonderful part of map making. The scientific map-maker usually begins by saying "Just suppose," or, "Imagine for instance." But however much make-believe he may ask of you, he always keeps you in contact with reality—the reality of the globe.

The points of contact are simple and unforgettable. You can take a plane and make contact with a globe at one point, at *any* one point you wish. Put a sheet of glass to a globe, and you will see the truth of this. In fact, you've already demonstrated it by laying a tracing paper, perhaps, over some very small island. You saw that regardless of how pliable that tracing paper might be, the farther you got away from that only point of contact the less exact was your copy. Anyhow, you can be sure—absolutely sure—of that one point of contact.

In technical language this kind of touching is "tangency." The sheet of glass is a "tangent plane."

This plane can be "tangent at" the North Pole, or South Pole, or at the point where a certain parallel crosses a certain meridian—anywhere you please.

Another bit of map jargon is calling this sheet "the plane of the projection." For *upon* it, as upon a movie screen, we project a map.

If the plane is flexible, like a sheet of tracing paper, it will bend to the curve of the globe along a meridian, a parallel, or any great-circle line. A line is, of course, only a moving point. Thus wherever the sheet touches the globe, along that line you will have complete contact just as you had only on a single point with a stiff, flat plane of glass. You can copy with complete accuracy everything right on that line. But trace details ever so little a distance away from it and your copy will be less accurate. And less and less accurate the farther away you get from that line.

So we have two kinds of contact with global reality: a point, and a line. Keep your eye on these contacts. If you know where to look for these in a map you will know just where the map is accurate. Often these are the *only* places where a map is as authoritative as it appears to be.

The ancient Greeks used to tell a story about a great giant, Antaeus, who was the son of the

god of the sea, Poseidon, and of Gaea, the god-dess of the earth. As long as Antaeus kept in touch with the earth, his mother, he was an invincible wrestler.

And that is—as slang would best say it—the low-down on map projections. They derive their strength from Gaea (*geo*-graphy!) their mother, and where they lose touch with her they weaken. Making them requires sometimes much mathematical wrestling, subject to

the same rules of the game as for Antaeus, after whom it might be well to name books of projections, just as we name a book of maps after Atlas.

There are many tricks of projection. Every map-user should be acquainted with the principal ones. These are performed with

Cylinders
Cones
Planes

MAP NETS PROJECTED UPON CYLINDERS

You hear mathematicians and cartographers talk about "developable surfaces." They mean a surface which, as Webster says, "may be imagined flattened out, without stretching any element, upon a plane."

A globe does not offer a developable surface. But there are some curved forms which do. One of them is a cylinder. You can roll a flat sheet of paper into a cylinder. Or split a cylinder down the side and roll it out flat. A cylinder has only one curve, and that goes only one way. The rest of it is as straight as a plumbline.

If you roll a sheet of paper around a globe, the one curve of the cylinder will completely contact at least one curve of the globe. Say, the Equator. Suppose the globe was surfaced like an inked rubber stamp. Then the Equator would print an exact facsimile of itself onto the cylinder. Unroll the cylinder, and that part of the new map would be perfect. But the other parts of the globe, away from the Equator, would not touch the paper cylinder. We'd have to "throw them forward" upon the paper in some way.

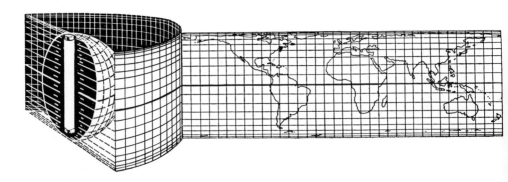

*Shadowgraphing globe upon cylinder of same area. Note parallel rays
(supposedly produced)*

That means a projection. This time suppose that our globe is a translucent sphere. In its axis is some special kind of lighting which can send level rays, projecting a shadow map upon the cylinder of paper surrounding the globe. Let us further suppose that our cylinder of paper is photo-sensitive, and that any image cast upon it sticks. Makes, as photographers say, a "positive" print.

Well, let's unroll the cylinder and see what kind of map we've projected upon it. The first thing we notice is that the arctic regions seem to have been through a candy-pulling party.

The reason is simple. On the globe the pole is a point. On our projection the pole is the whole topside of a rectangle. It's only a phantom pole now. Indeed, the expression, "to stretch a point" may be taken literally here. The meridians that come together at the pole on the globe are in our new map spread as wide apart in that region as they are at the Equator. And naturally the lands had to stretch along with this. Then again, look at the 80th parallel on the globe; it is a small circle compared with the Equator. But here on our map its circumference is opened out to the same length.

Yet the cylindrical map net also has its advantages. All the lines are straight lines. They are straight north-south or east-west direction pointers. They cross at right angles. It is a convenience to see east represented on a map as being at a right angle (90°) from north, the way it is on the ground, instead of appearing to curve off into an unnameable direction. Another merit is that this particular projection is cast on a sheet which has the same area as that of the globe, and consequently is an equal-area map.

The way the higher latitude-lines pack together, though, is unpleasant. Let's play around with our globe for a different result.

This time it's a light bulb in the very center of the globe. In order to catch enough rays, our cylinder of magic paper will have to be much taller than the diameter of the globe. Every line cast upon this paper will be related directly to the *center* of the globe instead of to its axis. And what a difference!

Now we have neither equal-area or conformality. And look at the latitudes. The ten degrees spacing from 60 to 70 is many times that of from 0 to 10. And from 70 and beyond, it is inestimable, somewhere off in a mathematical never-never land, in "infinity."

Our grid has become a torture-rack for the continents. Yet this is a good experiment. It shows that we can stretch the map north-and-south to compensate for the inescapable east-west stretching. Our trouble is that we have over-compensated. We have swung from one extreme to another. Can't we somehow "balance" the stretching in both directions? Can't it be figured out mathematically so that the pulling this way and that will have some ratio, and so at least save the general shapes of things?

It most certainly can. This would give us the classic map of the cylindrical family: the most famous projection ever made.

THE MERCATOR PROJECTION

This is the only projection most people know by name. It is the only projection name that some atlases have printed on any of their maps. It is perhaps the most familiar and at the same time most misunderstood projection of the lot. We see it so often that we may as well take a little extra time now to see what there really is to it.

First, it has the conformality (the property of "shape") we were after. By mathematical toiling Mercator and his successors balanced the stretching of latitude with that of longitude. They equalized this four-cornered tug-of-war.

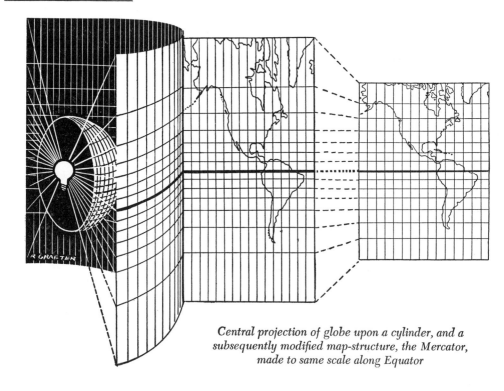

*Central projection of globe upon a cylinder, and a
subsequently modified map-structure, the Mercator,
made to same scale along Equator*

To understand just how, look at the Equator. Here everything is "in contact" so to speak; here the map-sheet went smack onto the globe. Tangency. So the scale of distance is exactly the same. The Mercator has an errorless Equator.

As in all cylindrical projections, the meridians cut the Equator at equal intervals. Also, instead of all coming closer and closer together until they meet at the pole like all good fellow-meridians on the globe, these smart lines keep their distance from each other the same all the way. On the globe only the parallels were parallel, but here the meridians are parallel too!

"All right," thought Mercator, "for every bit the meridians are more apart from each other than they were on the globe I'm going to move the parallels just that much farther apart from each other."

For instance, on the globe the small circle of the 60th parallel is just half the size of the Equator. But on this map it's the same size as the Equator. To make up for this east-west exaggeration, Mercator made at that part of the map a north-south exaggeration in the same ratio. Just double.

The result of this well-balanced stretching is that the total shapes retain some semblance of their true selves, yet it is only in the small that you can be sure a shape is true—a bay, or island, or lake. For Mercator went to one latitude and pulled the shape as far one way as the other; then he stepped over to another and did so again, and again until he had covered the world. He didn't do the world all in one grand jerk. Remember that no flat map can preserve true forms, absolutely, except in bits of regions taken by themselves.

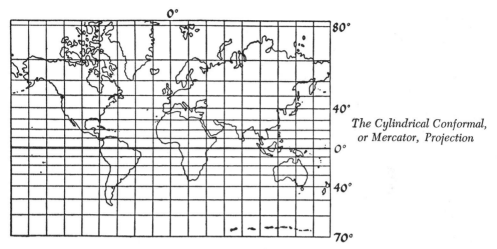

The Cylindrical Conformal,
or Mercator, Projection

All this pulling adds up, no matter how much justice Mercator put into it. You can't do any stretching both ways without making things look larger. The farther you get away from the Equator on this map the greater the stretching and the larger do things look.

MERCATOR SCALES. Stretched areas. Stretched scales.

Compare the mesh at the Equator with the mesh in the high latitudes. Along the Equator each little rectangle is almost a square, almost as wide as it is high. As you go north the rectangles become more and more oblong. They keep the same width but get taller. Now, just to look at them you'd think they covered as much more ground accordingly. But they don't. At lat. 80° they make a place out to be 36 times its real size. Fortunately, the Mercator world map goes north (or south) no farther than 80° 30'. But if it did, at this rate it would show at 89° an area 3,000 times as large as it shows the same amount of ground at the Equator!

Think what this must mean in scale. Lay your scale along any meridian. At lat. 60° you must use twice as much scale as you do at the Equator for the same amount of north-south distance.

Also with east-west distances. For example, go beyond 60° N.—along the icy shores of the Arctic Ocean. The scale there is three times as large as at the errorless Equator. Suppose you have a desk atlas containing a "Map of the World—Mercator Projection." Its scale is 1:131,470,000 along the Equator, which is 12 in. long, across the page of your book. Roughly, then, that means 1 in. shows 2075 mi. there. But in the Arctic that map must take 3 in. to show the same east-west distance!

If when measuring north-and-south you estimate a distance in terms of *degrees*, though, you will be safe. And remember the nautical mile! Each great-circle degree has 60 naut. mi. From Santiago de Cuba almost due north to Philadelphia is 20°, which is 1200 naut. mi., on

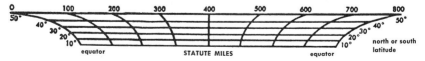

The Mercator requires a "several-decker" scale of miles

a Mercator or any other kind of map with any kind of scale *but with correct geographical co-ordinates.* (If *these* aren't correct it's not a map.)

Publishers should caution the user of the ordinary Mercator that the scale is true for the Equator *only.* We have to use a different scale of statute miles for each latitude. The more accommodating of the publishers furnish on their Mercators a special compound scale. Though it may at first sight appear a complicated geometrical gadget, all it really is is several scales, one for each parallel of latitude. Measuring east-and-west, with the right scale for the parallel you can estimate correct distances clear around the world. That scale will serve also for a few north-south degrees going away from or *across* that parallel.

Here, in this very circumstance of a scale being the same in both directions for a very short distance, we have the secret of what produces conformality. The double requirement for making a map conformal is: (a) The two coordinates must be at right angles with each other. (b) They must both use the same scale. You can see how this same-angle-and-distance trick actually works if you ever tried to copy a shape by the method of small squares. (See p. 182.)

The Mercator has been a favorite schoolroom map because it shows almost the whole world simply—in a single continuous panel. It does not seem to distort shapes. Its enlargement of northern areas makes it easy to see certain small European countries which in another kind of map of the same size and scale would be almost invisible.

But by the same token it makes out that our good neighbor Canada is twice as large as the U. S. and it presents the U. S. as larger than our sister republic of Brazil, while indeed Brazil is the larger. South America is over nine times the size of Greenland, but who would believe it from this map?

Years before the airplane made the public look critically at world maps, scientific men were warning that "people's ideas of geography are not founded on actual facts but on Mercator's map." [*]

Misuse of a map like this can make people a prey to the unscrupulous. But people should know better. It's not this map's fault.

The Mercator is both an honest and eminently useful map. It should not be blamed for lacking what it never has pretended to have. It is a special-purpose map.

THE MERCATOR RHUMB. "If you wish to sail from one port to another," the Flemish map-maker wrote of his work when he first brought it out in 1569, "here is a chart, and a straight line on it, and if you follow this line carefully you will certainly arrive at your destination. But the length of the line may not be correct. You may get there sooner or may not get there as soon as you expected but you will certainly get there."

This is the most interesting straight line ever put on a map.

On portolan maps rhumb lines were all the go long before Mercator's time. But they were on maps which were not only flat but made for a flat world. In those old port-to-port charts, the Mediterranean was for most navigation the largest span. It's a different matter putting a straight rhumb line on a map made for a *round* world. And on a map made for the *whole world.*

But mariners demanded it.

And Mercator gave it to them. It cuts every meridian at the same angle. All a navigator need do is to see that he crosses each successive meridian at the same angle, the angle of this straight line.

[*] Morrison, G. J., *Maps: Their Uses and Construction.* London, 1902, p. 38.

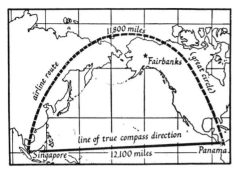

*Great circle arching a rhumb
on the Mercator* °

Just as mariners speak of sailing a rhumb, aviators speak of "flying a Mercator course."

"An airplane maintaining a constant course," says an army technical manual on air navigation,† "will trace the path of a rhumb line on the earth's surface. Hence, the track or course to be made good will show as a straight line on the chart. It follows that an aircraft flying a constant course plotted on a Mercator chart will pass exactly over the points through whose charted positions the line passes. This important feature is true in no other projection."

There are other projections whose parallels and (or) meridians, like the Mercator's, are straight lines. And indeed any of these lines can serve as rhumb courses, holding due north or south or east or west. But if we plot on one of these other projections a course in any *oblique* direction (northwest, southeast, etc.) our course will show as a curved line.

In fact, this happens even on a globe. Any oblique path crossing each meridian at the same angle must keep curving aside to do so. If this path continues it will take the form of a spiral, curling around the pole; coming nearer and nearer to the pole and yet forever by-passing it. (In an illustration on p. 138, the line designated as "Line of Compass Direc-

° Courtesy of Consolidated Vultee Aircraft Corporation.
† *Air Navigation*, TM 1-205, 1940, pp. 137–138.

tion" is an example of how an oblique rhumb curves on a non-Mercator chart.)

This odd curve is known technically by two very descriptive names. The equiangular spiral. And the loxodromic curve. In Greek, *loxo* means "slant" and *drome* means "running." And slantwise running is what rhumb navigation usually amounts to. Mercator, by dint of springing the meridians apart, as we have seen, and by respacing the parallels accordingly, fixed things so that a rhumb line could be straight and still be correct as a direction of route.

RHUMB LINE AND GREAT-CIRCLE LINE. So much for how a rhumb line behaves on a globe or any map as compared to its behavior in the Mercator straightjacket. Now for the way of a great circle on a Mercator. The Equator is an unswerving curve on the globe, and so is any meridian. And these great circles are straight lines on the Mercator. But they are the only great circles that are. All others, the oblique ones, when put on a Mercator show as curves. Surprising, maybe, but easy to understand, once you realize that an oblique great circle cannot cut all the meridians at the same angle, as a rhumb line does. A great-circle line, whether in the form of a stretched string aslant on a globe or an oblique flight-path, cuts the meridians at a continually changing angle because these meridians are continually curving until they converge at poles. If you draw such a great-circle line, then, across a Mercator grid you will get a curve.

A peculiar thing about this great-circle curve is that on the map the curve always has its hollow side toward the Equator. In Chapter 3 we saw that even on a globe, a great circle will arch across a parallel of latitude. Only natural. So, again picture to yourself how the plane of a great circle slices into the globe.

Any bit of parallel of latitude can be thought

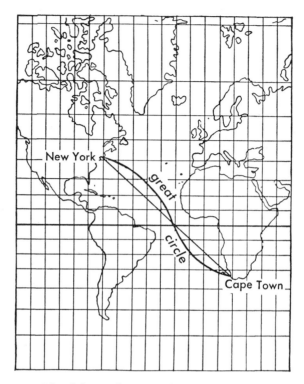

*Rhumb-line and great-circle paths athwart the
Equator on the Mercator*

of as a rhumb line—a line of true east-west direction between two points—and the great-circle path appears to form an arch between them. Indeed, all the parallels and the meridians can serve as rhumb lines. But the Equator and the meridians are the only rhumb lines which are also great circles. If you run an *oblique* rhumb line, say, a southeast line from New York to Capetown, on the Mercator, the great-circle path will entwine it as a spiral. The pilot who takes that path will have to be as continually changing his direction with respect to meridians as this path does on the chart.

For that reason, the navigator thinks of an oblique great-circle course as a line of inconstant direction. Though it is indeed the short-est, most direct route between two points on the earth's surface, you must be ever changing your compass direction with respect to those converging meridians if you would stick to the oblique great-circle route. You have to do so not because the course bends to right or left but because the meridians do. The meridians, though, are not wayward or wandering; they hold a constant angle to a certain point, the pole. So all you need to do is to hold a constant angle to each of them. Even though you must bend your path to hit each one at that constant angle you don't bend your compass direction. It takes you the longer way, but the navigating is easier. You don't have to work out complicated computations all the while, as you must

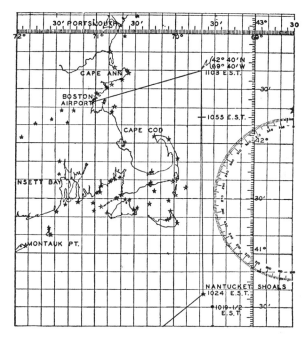

Portion of (Mercator) chart of flight by dead reckoning: final legs or rhumbs. Note side-scales of minutes °

on an inconstant-direction great-circle course. No wonder Mercator's rhumb has meant so much to the practical skipper! Safe direction comes before saving distance.

A MAP OF PARTS. To many people unacquainted with maps, the Mercator seems to be the simplest kind of world-map—just a plain rectangular layout. But like many other things plain-looking on the surface, the Mercator, as you see, is complex and deep. In fact, not until the Scottish mathematician, John Napier, several years after the debut of this map, invented logarithms, and still another mathematician, Edmund Wright, applied those tables, was the job technically completed.

The Mercator's practical use is not as a world map at all. Within 15° either side of the Equator it is at its best. But it has earned its

fame beyond those limits and has done so entirely on the strength of its straight rhumb line. It makes a fine nautical chart when it takes but a small section of the world at a time. Then the scale variation is seldom enough to worry about. You can put next to it the next sheet westward or eastward, and keep on doing so till you get around the world. If these charts are the same size they will have the same east-west scale and keep the same orientation, fitting one another to a T.

Geodetic engineers, like Deetz and Adams, do not hesitate to praise it for such plain merits as appeal to the ordinary map-user: "meridians, north and south lines, are always up and down, parallel with the east-and-west borders of the map, just where one expects them to be."

° Courtesy A.M.S.

On professional navigation sheets the side borders have distance scales convenient to all parts of the chart. In any latitude you simply refer to the nearest side-scale.

When Mercator's invention came out it was the first major change in map-making for over 1400 years.° The portolan rhumbs were only short-winded compass rays which didn't cut meridians at a constant angle, and didn't cut enough anyway to matter. Portolans were not projections. Mercator was the first to use the word "atlas" for a book of maps and he got out some fine ones, worthy of the name of a Greek god. And though his map was not the first to have the word America in it, it was the map that finally fixed that name in the public mind. Had he not put that word on the north continent, North America might today be known by another name. He himself was a poor boy, originally named Gerhard Krämer, which means "trader" in German. In his time there was a fashion among the scholarly to latinize their names. A *mercator* was a "*world*-trader." On his map more than on any other the merchant marine has spanned all the seas of the world.

His sailing chart was in its own way a kind of "air map." Its motive theme was wind, especially the trade winds, which were as valuable to commerce as coal and diesel oil came to be later. So he laid the keel of his map midway between these sources of power, at the Equator.

Mercator at a Glance

Recognizable Traits: Parallels and meridians are straight lines at right angles. Meridians equally spaced but the parallels proportionally farther apart as the latitude increases.

Properties: Rhumbs or true courses shown as straight lines. Conformal.

° Except perhaps that of Glareanus, p. 150.

Uses: Navigation charts.

Notable Examples: Many of the U.S.C.G.S. Nautical Charts. National Geographic Society maps of the Pacific and the Indian Oceans. U.S.N.H.O., sea and air charts, "Time Zone Chart," etc.

Caution! Apply given scale at Equator only, unless scales are furnished also for the several latitudes. Don't take long-range radio azimuths without first learning how to convert mercatorial bearings into true bearings.†

TURNING THE TABLES

When an artist or architect speaks of an "axis" he usually means what in a symmetrical design is a mid-point or line between well-balanced elements. A map projection is nearly always a symmetrical design. A surprisingly obvious fact, the first time our attention is called to it. But ever afterwards, almost the first thing we shall look for in a projection will be its axis, and that is well, for the axis is the backbone or "main stem" of a map's structure.

This gives us two kinds of axis to keep in mind: the axis of the earth (which is a study in symmetry, too!) and the axis upon which turns the design of a map.

The axis of the Mercator, of course, is its contact line, the Equator. Turn a Mercator world-map so that the Equator is up-and-down, and note the perfect balance of the grid. Very obvious, and very significant. For, remember that on either side of that axis we have 15° of as good a map as anyone could ask. A strip of excellent mapping about 2,070 mi. wide all around the world!

† The Coast Pilots published by U.S.C.G.S. provide conversion tables. See p. 162.

Construction plate of Transverse Mercator Projection of a hemisphere. (The full rounds are the new latitude-lines, the equatorial region passing off to infinity. To view the normal Mercator grid—dotted lines—turn diagram endwise) *

Instead of using the Equator as the contact line, a cartographer can switch the cylinder halfway round and use a meridian. Then that meridian becomes the axis of the map. Again we get a band 30° wide around the world, but this time from pole to pole. And because you can select meridians crossing more land and populous areas than the Equator crosses, the Mercator twisted this way bestows its conformal boon where it will mean the most. But at a cost: we lose the straight rhumb line and also, in large-area charts, the straight parallels and meridians.

Turning the projection *across* its former center-line—that is, *trans-versing* it—gives it a new name, "the Transverse Mercator."

It has several uses of paramount importance, some of which we will look into. But for the moment let's consider another version even more crosswise. We can take as a center-line of contact for the cylinder *any* great circle. It can be one that crisscrosses the meridian and the Equator obliquely. Then we have "the Oblique Mercator." It is useful for areas that lie mainly along a line oblique to the meridians. The N.G.S. maps, "West Indies" and "Countries of the Caribbean," use

this slantwise affair for good scaling where most of the distance-measuring is likely. The Aircraft Position Charts, #3096 and #3097, published by the U.S.C.G.S. also use it for long areas reaching "diagonally," as it were, from Hawaii to Scandinavia.

But the Transverse Mercator, which has a meridian for its backbone, is useful everywhere. The U.S.C.G.S. employs it even for the North and South Pole sheets (GNC 1 and 26) of the Global Navigation and Planning Charts. In Canada it is the foundation of the National Topographic Series. In England, where it is known also as "the Gauss Conformal Projection," it serves as the basis for many of the pleasant-appearing Ordnance Survey Maps.

Some of the U.S. State Plane-Coordinate Systems use the Transverse Mercator. It accurately correlates for these states the straight-line coordinates of a grid (which is most practical in local surveying) with the curved-line coordinates of the earth. As it is a conformal projection, it provides true angles of direction at all points within the grid. It provides true

* Courtesy of U.S.C.G.S.

Transverse Mercator supposition of cylinder secant to globe of derivation. Map-to-be is within the strip, or "ring," outside the cylinder. Note that the central meridian is parallel with the sides of the strip °

north-south measuring lines. (The scaling advantages of these lines can be spread out a little.) So a state extending mostly in a north-south direction (e.g., Maine, Indiana, Alabama, Nevada) has the Transverse Mercator as a global basis in the Plane-Coordinates System that was custom made for it by the U.S.C.G.S.

Instead of supposing a cylinder wrapped around—that is, tangent—we can suppose a *secant* cylinder: one slightly less in diameter than the globe and shoved through the globe so as to cut away from it a band like a wedding ring, which is the part to be mapped.

Using this as a basis and calling it "the Universal Transverse Mercator" (UTM), the U.S. Army has developed an extraordinary grid system. The "wedding rings," or *zones*, (which is the proper term), are 6° east-and-west wide. The zones go from 84° N to 80° S. Each has its own central meridian, which is geodetically true. Every grid square in every zone is of the same shape and size. Hence the merited name "Universal."† Several other

° Courtesy of Department of the Army and Department of the Air Force.

† For complete explanations of the Universal Transverse Mercator grid system and its developments, see the latest Field and Technical Manuals dealing with this subject.

countries besides the U.S.A.. are using it for their military maps. As it is based on a world-wide system which among these countries is recognized as standard, it is somewhat analogous to the State Plane-Coordinate System in its intent of accommodation.

It functions at home, too, in civilian maps. The U.S.G.S. topographical quads, with the exception of those produced several years ago, have in addition to the ticks for the State Plane-Coordinate grid, which are black and represent distances in feet, blue ticks representing distances in meters for the grid of the UTM. Thus we have a regional map that strengthens its individual reliability and yet increases its connections by bringing together several different systems into a convenient arrangement without conflicts.

OTHER CYLINDRICALS

You have perhaps seen in Bartholomew's and other atlases some rectangular maps which closely resemble the Mercator, except that Greenland instead of appearing like a huge thunderhead cloud seems to be floating off somewhat dissipated.

This is Gall's Stereographic. If you examine the parallels you will notice that their minimum spacing is wider than that in the Mercator but that the widest is not nearly so great.

The supposition behind its making is curious. A cylinder cuts through the globe at the 45th parallels north and south, like a roll of tin through a cheese ball. Then the "picture" is taken on the cylinder. Both 45th parallels, therefore, are the contact or "strong" lines, and this gives the projection two axes. The gain is enough uniformity in the busier parts of the world to make this a fair map for showing various distributions: economic, climatic, population, etc. It is neither equal-area nor conformal,

Gall's Stereographic Projection

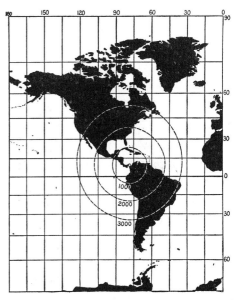

Miller Cylindrical Projection. Each circle shows the scale variation in equal distances (st. mi.) radiating from Panama *

and the scale is not constant. Atlas-makers seem to like it because it takes up less room on the page, for the same amount of world and general scale, than the other—25% less space— yet can include the North (or South) Polar Line, which the Mercator chart cannot. Meteorologists prefer Gall's world layout because its north-south distances are less stretched, and as the differences in air pressure and temperature are distributed most markedly in this direction, the isobars and isotherms don't have to be so unduly far apart as in the Mercator picture. James Gall, an Edinburgh clergyman devised this projection about 1855 while working on an atlas of the stars.

After all, what the average non-technical map-user desires in a world layout is not the exact proportions of distances and areas, but a readily intelligible picture which gives him a good "general idea." And why not? Don't cartographers "generalize" coast lines and relief, and for economy of attention as well as of

paper space? Projections can be generalized also as well as specialized. There are times when general ideas exactly suit the purpose.

Perhaps the secret of the Mercator's popularity is its plainness. It is like the plan of a field, or one's own backyard. And what has been sorely needed is a plain, straightforward, four-sided map with the Mercator conformality (now as familiar as that of the globe) but with the areas moderated so that a person does not get the *wrong* general ideas. Gall tried for this, but popular favor seems still to find the Mercator shapes more plausible.

The need appears to have been better met by a cylindrical projection which O. M. Miller, of the American Geographical Society, has worked out after reviewing the best-liked cylindricals for a pooling of their merits to-

* Map from the *Geographical Review*, Vol. 32, No. 3; courtesy of American Geographical Society.

ward a total improvement. He modified the latitude-line intervals of the Mercator so as to have them increase less rapidly—less than they do even in the Gall—but still increase sufficiently so that the continents would retain the familiar Mercator look—and at the same time have also something of their relative natural sizes. From the Equator to the 45th parallels, therefore, the Miller projection looks very much like the Mercator. Beyond that latitude, the north-south distances do not have the exaggeration of the older chart: Alaska has lost its Mercator mumps, and we must let our eyes

travel to lat. 70° before the east-west stretching becomes noticeable (as compared with the Mercator's "balanced two-way" stretching) and things begin to seem a bit stranger than on a globe. The Miller Projection was given preliminary publication by the Department of State, whose Geographer, S. W. Boggs, had urged Mr. Miller to make it. Its first general publication followed soon afterward in the summer of 1942 as an oil company presentation, the "Esso War Map." The A.M.S. has employed the Miller Cylindrical for outline maps of the world, viz., #1104 and #1204.

MAP NETS PROJECTED UPON CONES

A cone is another round shape which can be unrolled to lie flat. It can fit a globe as nicely as a hat can fit a head. And the "sweatband" will take an accurate print of everything it touches on that dome. Slit the cone from rim to point, roll it out, and you'll have a kind of fan. The ribs of the fan will be meridians.

This is a very old trick. About 1800 years ago, over in Egypt, a map-maker worked this trick and made a splendid map of the then-known world. It extended from the longitude of Ireland to that of "Silk Land," or China. On the right-hand edge he labeled the latitudes, 15° S. to 60° N. On the left-hand edge he put figures showing the number of hours in the longest day of the year at each latitude.

This conical projection was the crowning achievement of seven centuries of science. Claude Ptolemy, the maker, without leaving his home town, Alexandria, perfected a method of diagramming the earth by the use of lines, to show latitude and longitude, and is said to have located over 8000 places with them. He was the last of scientific map-makers for more than thirteen centuries.

People forgot the fact that the world is round. Sailors used portolano maps full of dazzling compass roses but nary a meridian. Mapping returned to a primitive state. Mapping, which perhaps was invented before the art of writing, relapsed from science into superstition. Map-makers made up with ornaments what they lacked in knowledge. They filled the "unknown" or forgotten lands with fanciful monsters, umbrella-footed men, men with eyes in the chest, etc. As Swift, the author of *Gulliver's Travels,* said of those medieval devices:

> "So geographers, in Afric maps
> With savage pictures fill their gaps
> And o'er uninhabitable downs
> Place elephants for want of towns."

Such maps held little geography, but tricked out sumptuously, pleased the luxurious classes.

Only the Arabs retained any knowledge of Ptolemy's coordinates: they and a few scholars, like the English scientist, Roger Bacon, who could read Arabic.

Christopher Columbus, influenced by his

older brother Bartholomew,* an expert chart-maker, was among the many intellectuals of his time to dust off Ptolemy's conical map at last. He was curious as to what might be beyond that westernmost meridian. He extended its longitudinal reaches by going there himself.

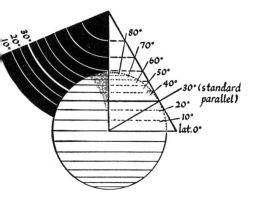

Central projection of part of globe upon a cone tangent at lat. 30°

The first map to bear the name of America was based upon Ptolemy's conical layout. It was made in the tiny college town of Saint-Dié, in Lorraine, by Martin Waldseemüller, a cartographer and printer, who published it in 1507 with an essay suggesting: "... now that these parts have been more extensively examined, and another fourth part has been discovered by Americus Vespucius, I do not see why we should rightly refuse to name it America after its discoverer, Americus, a man of sagacious mind, since both Europe and Asia took their names from women." This map has been called "the baptismal certificate of the New World." The name appears in the middle of South America near the line of the Tropic of Capricorn.

* See his map, p. 204.

SIMPLE CONIC PROJECTION

Suppose we have a cone upon a centrally lighted globe of the world.

Note where the cone *touches* the globe. This can be best at a middle parallel. On the line of contact the map will be errorless. So this band is called "the standard parallel."

The other parallels on the cone, just like the circles of latitude on the globe, will become smaller and smaller as they approach the pole. Concentric circles. But their spacing will not be the same as on the globe: how this happens is obvious in the illustration.

As for the meridians, we can imagine each picked up and straightened, so that all of them will come together at the apex of the cone somewhat like sticks in a wigwam. When we open out the cone our resultant fan will be made up of concentric arcs, and the "sticks" will be their radiuses. This would be a central perspective conic. It is interesting to us at this point because it gives us the essential idea behind the conic projection.

However, practically all conics in use are mathematical, rather than shadow-casting, jobs. To take our next example, instead of letting the latitude circles come wherever they are cast, at varying distances from one another, as we have seen in our shadowgraph, we can by computation space these circles at *equal* distances, as they are on a globe, and true to scale. This spacing gives us what is generally known as the Simple Conic with One Standard Parallel. ("Simple Conic" for short.) In it the pole is no longer at a point, where the meridians meet, but is represented by a circular parallel. Our map, though, is still like a fan.

This fan might be a large one, showing much of the world. Atlas-makers cut up such a fan into sections, so that each section will be a page. Any meridian can serve as a central meridian and run down the middle of the region shown.

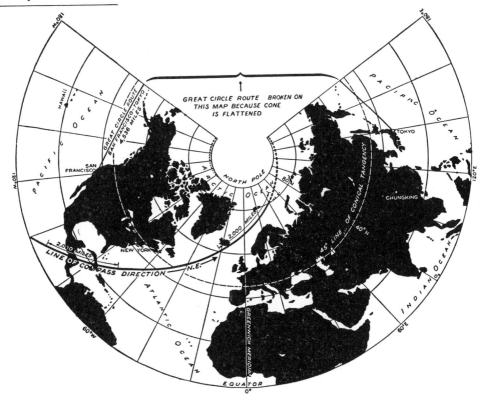

Full spread yoke of Simple Conic Projection. Note spiral of line of constant oblique direction °

W. W. Jervis, University of Bristol, points out that what we often desire in a map is "an effective compromise between all kinds of error, so that none is too appreciable at any point on the map." That is what the Simple Conic offers. "A balance of errors," as cartographers also call it. The Conic is at its best in the middle latitudes. A straight line on it will show almost but not quite the shortest distance between two points. In a conically based map of the U. S. the scale error need not anywhere be worse than 2%. The Simple Conic should not overreach itself by taking in too much latitude, because the farther it extends beyond its standard parallel of true scale the less true its east-west distances become.

The base map of Europe published by the University of Chicago Department of Geography is a good typical use of this projection.

Simple Conic at a Glance

Recognizable Traits: Straight-line meridians, rays equally spaced and coming closer together as they go poleward. Parallels, concentric arcs, equally spaced throughout.

Properties: A compromise of shape, area, and scale—being neither perfect nor excessively wrong in any of these respects.

Uses: Series maps of world-sections and countries, as in atlases. Temperate zones.

° Drawn by Harold Faye. Courtesy of *Life;* copyright, Time, Inc., 1942.

Caution! Scale true only along standard parallel, usually near the middle of the map; fairly true, however, along the meridians.

LAMBERT'S CONIC CONFORMAL PROJECTION

J. H. Lambert, an Alsatian who was probably the greatest of contributors to modern cartography, invented a much more capable conic. An odd fact about cartography is that some of its most valuable developments were made by workers in other scientific fields. Lambert was a philosopher who made signal contributions also to geometry, trigonometry, physics, and astronomy. Like Mercator, he had been a poor boy who had to earn his education. When Lambert demonstrated that we could get truer shaping and areas into our

those two standards. That part inside sucks in everything on the curve outside. This means doing some scale-work, which we'll not go into, but the result is one of our most valuable projections. Lambert brought out this projection in 1772, but not for nearly a century and a half did experts realize its full merit. It proved a life-saver for the French armies in the trench warfare of the first World War, because the battle maps based upon it had their scale and angle distortion down to a minimum. Keeping true angles along with the same scale for a short distance on both sides of the angle, remember, is what gives you true shape.

Just as we look to Mercator's Conformal for the pattern of things along the Equator we look to Lambert's Conformal for the same kind of faithful job in the middle latitudes. Especially in a country sprawling east-and-west, as the U. S. does. In state maps, at any point the

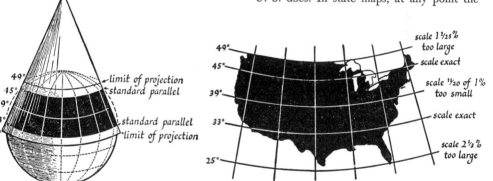

Lambert Conic Conformal Projection and resultant grid

maps if we but made more use of mathematics he opened a new era for the science of cartography.

Lambert's Conformal is a conic based upon two parallels. The illustration gives the idea better than words can. "Limits of projection" means that beyond those lines distortion is too great. The cone cuts through the globe at the parallels chosen as the standards. A part of the secant cone is inside the globe between

shape is right, and from any point enough distance is right to make the Lambert very dependable for engineering projects.

The conformal property is important to pilots who are doing landmark flying and want a map to tell them what the country really looks like. And for radio navigation of the U. S. it is far and away better than the Mercator. Radio signals take to great circles, for one thing, and a great circle is a shorter trip than

Mercator's rhumb line, which is a straight line only on map paper. Lambert's shows a great circle on paper much more nearly like the straight line it is on the earth. For instance, between New York and San Francisco a Mercator rhumb will swing you 181 mi. wide of your great-circle shortest track. The Lambert bends only 9.5 mi. *at the most* in all the way across. This means you can make your course by going just about over the charted features and still go great-circle. And for shorter hops a line 200 mi. long in a radio range in the same locality and going the same way, the Mercator rhumb will swing wide 3.7 mi. while the Lambert straight line will be off only a skimpy third of a mile.

After all, the Lambert is made upon two parallels right here in this country; while the Mercator chart, even when it shows the U. S. exclusively, takes its base from the distant Equator. The Mercator is capable of making a scale error of 40% at the northern border of a U. S. map. But the Lambert, sitting pretty on the 33rd and 45th parallels both, is off scale about a half of 1% in that whole spread of country from coast to coast and from lat. 30½° to lat. 47½°. In order to find it off scale as much as only 2½ mi. in 100 you'd have to do your measuring off the tip of Florida. On the straight true distance of 2,572 mi. between New York and San Francisco its scale misses by being short only 12 mi. That's midway between the standards. Along them it holds a constant scale, but along the meridians it shows slight variation.

As a requirement for getting conformality is that the coordinates cross at right angles, you may wonder how this can be true for the Lambert, whose meridians are lines which converge somewhere on the earth's axis beyond the pole. How can lines which are not parallel cross a line at right angles? Well, of course, they can't. But please again be reminded of our weathervane atop the barn. Put your wing-compass point into one of those in-tersections of parallel and meridian on a Lambert Conformal map, and draw the tiniest possible circle. You will see that the parallel-and-meridian cross divides that circle into four apparently equal parts, of 90° each.

That small circle is probably equivalent to the area that you could see from the top of that barn. It describes your horizon: in fact, is technically known as a "horizon circle." And your conformal map only claims to be conformal within this small scope.

We must repeat this principle in different ways to see through it and get a deeper understanding of maps. After all, it is merely a matter of relativity. Human sight and height are comparatively so small that we cannot from any one point behold enough of the earth to see its curve. It seems flat, and if it were marked with natural meridians and parallels they would seem to cross at right angles. That is why on large-scale maps of small areas the grid appears rectangular. In such maps even experts cannot always identify the projection. The recognizable traits apply only to major-region maps.

Like the Universal Transverse Mercator, the Lambert Conformal, with its fidelity of angles, is a projection eminently suitable to the needs of the State Plane-Coordinate Systems. Both projections "cut a wedding ring" from the globe, the one as a secant cylinder, the other as a secant cone. Because the Lambert's standard parallels are globe-true lines, it affords true-scale advantages in an east-west direction just as the Transverse Mercator does in a north-south direction. So the states that extend mostly in an east-west direction (e.g., Connecticut, Pennsylvania, Tennessee, Washington) have as a projection basis for their Plane-Coordinate Systems the conic invented by Lambert. Florida, at one part, extends mostly north-and-south; and in another part, east-and-west. So its particular system employs both projections.

Lambert's Conic Conformal at a Glance

Recognizable Traits: Same as Simple Conic, except that the parallels are spaced at *increasing* intervals the farther north or south they are placed from the standard parallels.

Properties: True shapes. Straight-line meridians. Other great-circle lines can be shown approximately straight.

Uses: Large countries in temperate zones, having predominating spread east-and-west. Military and civil engineering. Federal adaptation of plane-coordinates to the state systems. Cross-country flying.

Notable Examples: U.S.C.G.S. maps of U.S. #3060, N. Atlantic Ocean, #3070, and some Aeronautical Charts. Maps in the *National Atlas of Canada.*

ALBERS' CONIC EQUAL-AREA PROJECTION

Albers' Equal-Area projection is a neck-to-neck rival to Lambert's Conformal for a map of the U.S. Similarly, it is a conic based upon two parallels. It is about the same age: H. C. Albers of Gotha worked it out in 1805. It looks very much like the other. It is just as well suited to this broad country whose "depth," north-and-south, is less than 3/5th the "breadth," east-and-west. It has nearly as good conformal properties and also two standard parallels of true scale.

These are four degrees farther apart than are the standards on the Lambert, and that gives a wider distribution of good scaling. In fact, the Albers is richer with true scale than you'll find almost any other projection when used for this particular area. True scale seems to run all over the map. For example, in many maps you take big chances measuring on "oblique" lines: northeast-southwest, or northwest-southeast. But on the Albers you can lay

the scale "diagonally" at any point and be fairly safe in the distance estimate. For the southern parts of the U. S. the Albers does better than the Lambert.

It's only midway between its two standard parallels that it is inferior to the Lambert. Here, on the New York-San Francisco line, it goes shy by 19 mi. as compared to Lambert's 12. But taking it all-in-all, it has practically the smallest scale error that you can get on a one-sheet map of the U. S. With its standards on the 29½° and 45½° N., in a U. S. wall map made by the Geological Survey on a scale of 1:2,500,-000, the Albers' greatest sin is only 1¼%. Other maps of the U. S. err up to 7%.

Best of all, this true scaling is combined with equal-area representation. That means a true geographic picture of the country for all kinds of statistical comparisons. As a map of the whole country, for general purposes, it perhaps has the edge on the Lambert. But they are so nearly the same that if you made maps of both projections, say, to a scale of 1:5,000,-000 and 25 × 39 in. the two maps would differ at the corners by only a seventh of an inch.

Albers' Conic Equal-Area at a Glance

Recognizable Traits: Same as Simple Conic, except that parallels are spaced at *decreasing* intervals the farther north or south they are placed from the standard parallels.

Properties: Equal-area. Breadth of true scaling.

Uses: Maps of Russia, Central Europe, U. S. A., Northern hemisphere stretches of east-west traffic and commerce. Political divisions and distributions. Visual statistics of natural resources, cultural activity, population, etc. in relation to areas.

Notable Examples: Bureau of the Census "County Outline Map" (of the nation).

N.G.S. "Central Europe," "Northern Europe," "Mexico and Central America," etc.

There are still more networks in this group of simple, or as Hinks calls them, *"normal,"* conic projections. For example, conformal and equal-area projections can also be made on *one* standard parallel. And not all conics on two standard parallels are either conformal or equal-area. It depends upon how the parallels are spaced.

Let's now see what happens in *modified* conics.

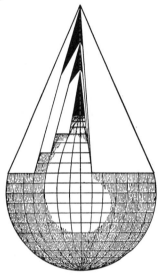

Theory of Polyconic Projection (Artist has "cut" an opening in the cones to expose their manner of succession. Dotted line is an extension of central meridian.)

POLYCONIC PROJECTION

The Coast and Geodetic Survey was begun before the United States grew into a stout country. In 1820 this was a gangling, coastal country and no easy job to map. It sprawled aslant the meridians like a young fellow flopping diagonally across a bed too short for him.

Ferdinand Hassler, the organizer and first Superintendent of the Survey, contrived a special projection to take care of this awkward youth.

Not just one or two cones, but a lot of cones. In fact a cone for each parallel, as if each were the chosen one. In this way Hassler spread out the contacts, as he said, "in an assemblage of sections of surfaces of successive cones." The part of each transparent cone where it overlapped the shorter one made a collar-like zone, and that's where the picture "took."

He chose a central meridian to act as a back-

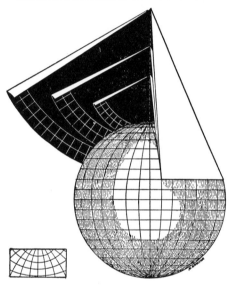

bone for the projection. And the job turned out to be a great success.

It is so identified with this country that Europeans refer to it as "The American Polyconic." The U.S.C.G.S. uses it to this day for its field sheets. The U.S.G.S. bases its topographic maps upon the Polyconic. These sheets are favorites with ranchers, miners, woodsmen, hunters, rangers, anglers, and all who wish to enjoy an intimacy with the terrain on which they live, work, or loaf.

These maps find serious use also in geological studies, engineering projects, and military

Polyconic Projection, from Pole to beyond Equator

What happens when the Polyconic is developed to include the entire sphere

tactics. For although this is a "compromise" projection, being neither strictly equal-area nor conformal, it fills the bill of accuracy within such small spans of ground as are shown on these sheets. You have to go 560 mi. east or west of the central meridian before the scale error is 1%. And usually the quadrangles are not that large: they only range from 6' to 1° in extent.

One "quad" neatly fits its neighbor's corresponding border for a few sheets east-and-west, but any number of sheets north-and-south. You could string them from pole-to-pole if that many existed. For the peculiarity of this projection is that it suits regions which reach out north-and-south but are narrow east-and-west. Just the opposite of those east-westers, the conics.

The wrong application, then, of the Polyconic is for too much east-and-west. A Polyconic attempting the entire breadth of the United States will go wrong by as much as 7% on the north-south distances along the Atlantic and Pacific coasts.

Polyconic at a Glance*

Recognizable Traits: Curved parallels, being arcs of different radiuses and drawn from center-points on an extension of the central meridian somewhere beyond the limits of the map. Curved meridians concave toward central meridian, equally spaced and coming closer together as they go poleward. Parallels cut central meridian at equal intervals but get farther apart at east and west borders of map. Central meridian and Equator, straight lines.

Properties: Compromise of all. Central meridian held true to scale. In small-area maps: true shape, proportion, distances, and directions.

Uses: Narrow east-west plottings.

Notable Examples: N.G.S. "British Isles," "Philippines"; U.S.G.S. quadrangle maps. A.M.S. "Iran Road Maps," "Melanesia," and "Philippine Islands."

A polyconic variation is to set it upon two standard meridians. Same stunt as we did

* To transfer detail from a Polyconic quadrangle to a state plane-coordinate grid (which is based on the Transverse Mercator or on the Lambert Conformal) or to show a state grid on a Polyconic quadrangle, see U.S.G.S. Circular 57, State Coordinates and Polyconic Maps, May 1949.

with the conics when we put them on two standard parallels. This gives us two strong lines instead of only one. The famous example of this is the International Map of the World. The standard meridians here are 2° on either side of the central meridian. Any sheet can take the four neighboring sheets just right.

OTHER CONIC COUSINS

A projection familiar in European atlases is the Bonne. Map-users have liked it because, for middle-latitude countries of not much extent, it gives fair shapes while at the same time

meridians are concave toward it. Beware of the NE and NW corners of these maps, as that is where great distortion occurs. Notable examples of maps on the Bonne Projection are those of Mexico and of China together with Japan, published by the University of Chicago Department of Geography; also the N.G.S. "New England."

To look at the network of this and of other projections in maps which we ordinarily see we would hardly suspect the fantastic pattern which the net has when extended full range. This "behind-the-scenes" aspect of maps is something that every good map enthusiast should let himself in to.

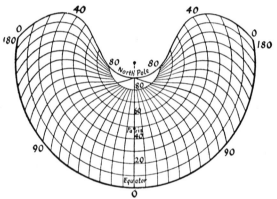

Bonne Projection of hemisphere: cone tangent along 45° N.

showing strictly proportional areas. And mapmakers have liked it because it is easier to construct than are most of the other projections.

They select a standard parallel to run through the middle of the map, and for an axis they choose a central meridian. The cone is like a hat somewhat too large, so that it comes pretty far over the ears; *i.e.*, the standard parallel of the globe touches the cone rather far up inside. The parallels are all concentric arcs equally spaced. They are all true to scale just as if they were all standard parallels. The central meridian is the only straight line; the other

Sometimes the Bonne "hat" is imagined over the globe so that the Equator is the standard parallel. The result is an equal-area affair technically described as "sinusoidal" and sometimes called the Sanson-Flamsteed Projection.

Note that although the central meridian is the only one which is a straight line, all the parallels are straight. Each has the same length it had on the globe of its derivation. Each is at its true distance from the Equator. Along each of them the scale is true. A good

* Courtesy of U.S.C.G.S.

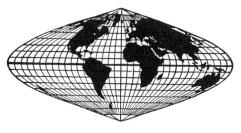

Sinusoidal Equal-Area Projection of sphere

deal of equidistance value for an equal-area layout! Imagine selecting for it certain mid-meridians that are "land-rich": 90° W, or 15° E, 120° E, etc.

By slitting the Sinusoidal in a few places, we get a fine interrupted projection known as the Mercator Equal-Area Projection. Don't think this a make-over of the famous nautical chart; it is not a cylindrical projection. It has Mercator's name because it appeared in some of his atlases. It not only affords true area scaling throughout (for showing how thickly populated or how rich in resources certain sections of the world are per square mile) but also the distance scaling along the central meridian of

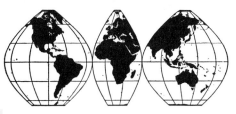

*Interrupted Sinusoidal Equal-Area Projection *

each part is true. The University of Chicago Department of Geography publishes Sinusoidal Equal-Area maps of Africa, Australasia, and South America.

Perhaps the most bizarre but serious map ever made is one which we might call the cartographer's valentine. This heart-shaped

° Courtesy of Consolidated Vultee Aircraft Corporation.

equal-area affair is the result of doing the Bonne trick again, but using the pole to serve as the chosen "parallel" for the base of a tangent cone. Note that the central meridian remains a straight line. It is cut at true distances by the parallels. This network was invented by Johann Werner, a young contemporary of Columbus. He knew nothing about the Arctic and perhaps very little more of the realms of west longitude, but he knew his sphere and how to unwrap it mathematically.

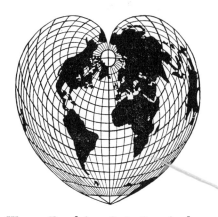

Werner Equal-Area Projection of sphere

A brilliant trick with cones is one which the cartographers O. M. Miller and William A. Briesemeister have performed for the American Geographical Society "Map of the Americas." Just as a projection may have its own axis (which is not to be confused with the axis of the earth) a projection may also have its own poles. For instance, if you set a cone obliquely on a globe, your projection-pole there will be the point right under the point (apex) of the cone. In the A.G.S. projection are two such poles, one in the south Pacific and one in the north Atlantic; and the line connecting them cuts through the Isthmus a bit west of Panama. This is an over-simplified description of what is called the Bipolar

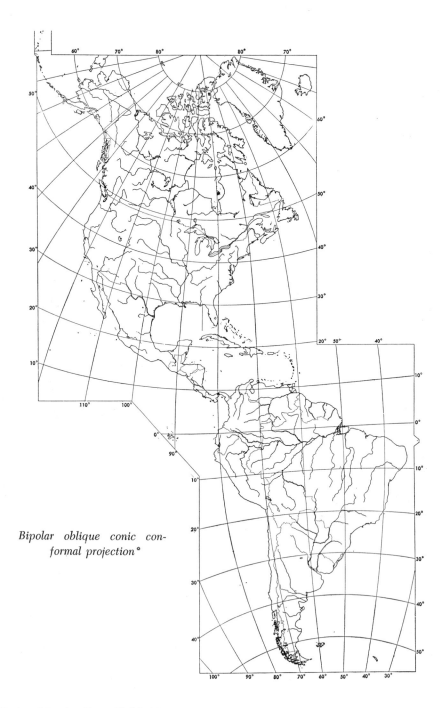

Bipolar oblique conic conformal projection°

° Courtesy of American Geographical Society.

Oblique Conic Conformal Projection.* But the resultant map is as simple and practical as a jackknife. Note on the globe that the Americas themselves have an oblique trend, slanting from northwest to southeast. Not only is this new map conformal with excellent distance

representations, but it has facilities also for measuring areas. The projection accomplishes the feat of making the two Americas almost as good neighbors on a flat map as they are in reality on the globe.

MAP NETS PROJECTED UPON PLANES

We come now to a family of projections which have a strong appeal to the modern mind. Yet some of them were among the very first to be conceived by the imagination of the ancients.

You remember how in Chapter 2 we sliced through the globe anywhere we pleased with geometric planes. We didn't stop to project map nets upon them, but it can be done, and rather beautifully, too.

We can have a plane secant at the Equator, throw a powerful imaginary lamp ray or eye ray, and project the globe's network upon that plane as though this were a mirror. We can have the plane secant at any of the other parallels, or at the meridians. Or we can have the plane outside, *tangent* at any part of the globe.

We can have our eye or lamp at any point on the globe, inside it, or at an infinite distance from it. This is called "the eye point," or "the point of projection."

Each way we do, it gives us a different "slant" with a gain in one property and a loss in another.

But all the ways with a plane are alike in one respect: they all focus upon a center. This center is "the pole of the projection," because an imaginary pole goes through this center.

Often this is the North or the South Pole, and the map seems to be pinned in the center by the pole. Then indeed it is a "pole-centered" map. But often, also, the map is centered elsewhere on the earth, on the Equator, even, and still this center is called "the pole of the

Equidistant projection of world, centered upon North Pole †

projection." The imaginary pole still goes through the center to make the construction possible. From a structural viewpoint, then,

* For an explanation of its structure by one of its makers, see the *Geographical Review*, Vol. 31, No. 1, 1941, pp. 100–104.

† Drawn by Richard Edes Harrison. Reprinted by permission.

these are all pivotal maps, whether the pivot be a geographic pole or a technical pole.

When cartographers center a map net on the North or South Pole they call it "the polar CASE" of that projection. Similarly they speak of "the equatorial case" and "the oblique case." Both of these latter cases are what we can think of as side-views of the earth. In the equatorial case the earth appears "straight," with its polar axis vertical, and the center point on the Equator. In the oblique case the globe is tilted, and the center point may be north or south of the Equator.

The first thing to do with a map made upon any of the projections we are about to examine is to find the center point. These are the only maps in which the center is sure to be important enough to find right away, although at that point the corresponding place on earth may be of no importance whatsoever. The importance of the map point is that no matter how the grid lines go around it—whether they center upon it or ignore it as a center and swerve past it—still it is the center of all safe measuring on that map. It is like the pivotal center of a compass card. All the lines you might care to radiate from that point will be lines of true direction. True azimuths. As true on this map as on the earth itself. That's why these are classed as "Azimuthal Projections."

Many people object to that term because it is such a mouthful. They would prefer "Zenithal." The zenith is the place the pivot of your compass would reach if one end went down to the center of the earth and the other extended up into the sky as far as there's any going. That term is all right for sky maps but too far off for down-to-earth considerations. Anyhow, whenever you see either of these words applied to a projection you will know the map net is one of the following.

The first two are, strictly speaking, not *projected* map nets. They are not perspective but arithmetical constructions. They are some-times classed as "arbitrary" projections, because we arbitrarily select what principles shall determine their construction instead of letting the laws of perspective dictate the selection.

AZIMUTHAL EQUIDISTANT PROJECTION

Big as this name sounds, the map net is easy to make in the polar case. All you need is a globe to work from.

Now, your own globe is a certain fraction of the size of the earth. If you know what that is (see p. 49) you will have the scale for your Azimuthal Equidistant map.

First decide how far you wish the map to extend: to the Equator? the 60th parallel? Then, with a strip of paper measure along any meridian the distance from the North or South Pole to that chosen circle. With that as radius draw the circle. Now, draw evenly spaced radius lines or "spokes" to represent your meridians. For the parallels, measure on the globe the distance between any two parallels and use that unit to mark off on one of the "spokes" the equal spacing of your inner circles. There's your grid.

And it's a good one. *All* the distances going out from one point, the pole, will be true to scale. This is something no other projection we've looked at can give us. This is the method often used to make polar caps for globes. It is such a favorite for showing the Arctic and the Antarctic that it is nicknamed the "Polar Projection," although there are other polar projections as good in their own way. And because the Arctic Ocean has come to be thought of as today's Mediterranean, this centrifugal projection is hailed as something "modern," although it is older than the Mercator. Still, the significance of this and all polar maps is this: formerly on maps the nations sat in the hall of

the world as though it were a square room and the rostrum were somewhere off at the "head," so that all the members facing it were half turned from each other. Today the hall of the world is a round stadium and we all face one another. Each of us may speak and be heard from where he stands, and there is no need for a detached stage at one end near to which some have better seats than others. Today all the round world is the stage and all of us are the actors.

In a sense, Mercator seated the nations of his world around a center too: the Equator. The equatorial belt was in his awakened time the heavy traffic lane, with the trade winds as the dominant motive power. And just as his map showed up reliably here but had to strain the polar regions to the breaking point to do it, so must these polar maps stretch out the equatorial shapes. This stretching is more horribly obvious than Mercator's; so we are not likely to be misled this time.

But here's our caution: there is more than one "polar projection." They look very much alike, but as we shall soon see, are easy to tell apart. It is important to know how. For example, there is only one polar map with rings of latitude dividing the "spokes" of longitude at equal intervals so as to afford us a true, constant scale of distance from the center to all other points. And the Equidistant Projection is that one.

To become even more intimately acquainted with it, we might call it "The Hometown-centered Map of the World." For we can make the point of the projection anywhere on earth. Your town, for instance. Simply pin the center of the projection upon your town as if the civic-center flagpole were the North Pole. Then the map will show your home town as the "hub" of the whole world. You will be able to measure correct distances from it to any other point on the face of the earth. The General Electric Company centered such a map upon Schenec-

tady, N. Y., in order that radio engineers might the more easily interpret transmission tests. They can lay off on this map a straight line from this town out to a far-flung station anywhere, and that line will be on a great circle—the same as the meridians are up at the real pole. Since radio waves take great-circle paths, the engineers can see exactly what land and water factors will affect signals transmitted between Schenectady and the distant station.

Equidistant projection (oblique case) of world, centered upon New York °

As you see, when you center this map anywhere but on the North or South Pole, you have to erase all the "spokes" and "rims" you used for construction. The meridians and parallels that will show are all curiously curved, and the result of a separate computation for the central city.

Although the forms at the periphery of this projection are necessarily "rubberized," we should make the just requirement that the places remain somehow recognizable, either through more careful drawing than this map

° Drawn by Harold Faye. Courtesy of *Life;* copyright, Time, Inc., 1942.

often gets at its edges, or through precise locating of place-names. For what is the use of knowing the exact distance if we can't tell to where?

graphical puttering around provided us with the earliest examples we have of the world divided into two circles to represent hemispheres. And he was also among the very first

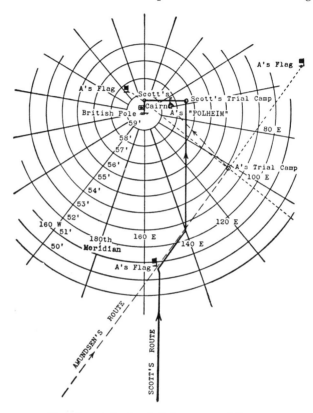

Mapping at the South Pole—routes of the Amundsen and the Scott parties °

The earliest known example of a polar equidistant projection is a map in manuscript form, made about 1510 by Heinrich Loriti, of Glarus, in eastern Switzerland. Glareanus, as he came to be known, was a leading thinker of his time and an intellectual jack-of-all-trades. He was a poet, philosopher, musicologist, mathematician, and an experimental geographer. He was perhaps the first to explain a practical method of constructing gores for a globe. His carto-

cartographers to imitate Waldseemüller by putting America on the map.

He had never seen the Pole nor anyone who had. He could not have known what, if anything at all, might be there to map. But he did know that since the earth is a globe we should have a polar way of looking at it. He had sci-

° From *British Antarctic Expedition 1910-13, Report on Maps and Surveys* by F. Debenham. Committee of the Captain Scott Antarctic Fund, London, 1923.

entific imagination. And this, even when a bit naive or not strictly professional, is much healthier than the most erudite stagnation. Think of it: a yen to plot the earth's countenance polarwise long before there was any likelihood of anybody getting to the Poles! But that is the scientific spirit of the true mapper: to confront the intellectual frontiers, through a kind of patient impatience, while awaiting the chance to tackle the physical frontiers. And Glareanus had the mathematical curiosity to do this. For all we know, he was the originator of the Polar Azimuthal Equidistant Projection.

It appeared often in the 17th and 18th centuries. Some 19th-century explorers made practical use of it in their circumpolar charts. And after the Poles had been reached, the atlases used it. But it had no popular appreciation as a global purview until 1941, when the cartographer Harrison reminded the world of it in *Fortune.*

The Debenham map may seem to be but the button on the polar cap. Yet when we make a down-to-earth consideration of it we must reflect that here at this point on the terrestrial sphere the mere on-the-ground mapping, once you recognize such a thing as a pole, takes place without any intermediate construction of a projection to fit the map to. For here the direct mapping itself constitutes the projection, and instead of getting a rectangular affair as we would of a place of an equivalent area at a different part of the earth, we get inevitably a circular map.

Azimuthal Equidistant at a Glance

Recognizable Traits:
Polar Case. Latitude rings equally spaced.
Equatorial Case and Oblique Case. As difficult to describe as to compute, but the grid with its odd meridians clasping and *encircling* the poles is almost unmistakable. If only a part of the world is shown, as in a continental map, the net closely resembles that of the Simple Conic.

Properties: True-scale distances and true azimuths from pole of projection.

Uses: Polar regions, hemispheres, continents of somewhat equal spread in all directions, like Asia. Celestial maps. Ranges for radio, cruising, bombing, etc. Zone maps—for communication rates, etc.

Notable Examples:
Polar Case. Canada: Dep't of Mines and Technical Surveys, "Northern Hemisphere"; N.G.S. "Northern and Southern Hemispheres," "The Top of the World"; N.G.S., "Antarctica."
Oblique Case. U.S.C.G.S. #3042, "The World . . . Centered at New York City"; U.S.N.H.O. #6705, "Great Circle Distances and Azimuths from Washington, D.C. to All Points on the Earth's Surface."

Caution! Scale not equidistant for parallels. Areas disproportional. Beware of great circles shown as straight lines, unless they are "spokes."

LAMBERT'S AZIMUTHAL EQUAL-AREA PROJECTION

If you draw on a sheet of paper a circle half the area of your globe you will have the basis for this projection. If you can measure on your globe the chord distance from the pole out to any circle of latitude you will have the radius for drawing the corresponding circle in your map net. Each of these circles will equal in area the corresponding polar cap on your globe. Your map will be in the same proportion to the earth that your globe is.[*]

[*] A diameter is the longest chord of a circle (or of a globe's great circle). Using your globe's diameter as a radius, you get a circle of the same area as that of a hemisphere. Of course, the circle can also be drawn to equal the area of a whole sphere, too, for this projection

That's what makes this an equal-area map. It is rated as the most important of the azimuthals. Lambert made it at about the same time he made his famous Conic Conformal. What gives this azimuthal map its distinction is that it provides a complete round of true directions from one point along with the property of equal-area. A combination hard to beat.

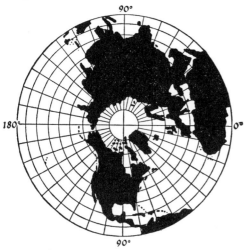

Polar case of Lambert Equal-Area Projection °

Although the Albers Equal-Area (p. 141) is fine for east-west stretches in the middle latitudes, this of Lambert's goes well anywhere, at the poles, between them, or on the Equator. It takes to large "square" areas, continents which are about as big one way as the other.

Note that in the equidistant net the circles cut the "spokes" at equal intervals, but in this net the circles come closer together as you go out to the edge of the map. This means that the scale changes accordingly, becoming just that much too small to measure the true distance.

A distinction claimed for both these projections is that they are the only ones that do not split the world somewhere so as to show us all sides of it at once.

° From Deetz and Adams.

Azimuthal Equal-Area at a Glance

Recognizable Traits:

Polar Case. Latitude rings decrease their intervals proceeding from center outward.

Equatorial Case. Parallels are curves flattened in the middle. This flatness increases as we leave the poles until the line becomes

Equatorial case of Lambert Equal-Area Projection †

straight, i.e., the Equator. Straight central meridian. Spacing of meridians and parallels decreases proceeding from center outward.

Oblique Case. Parallels: a complete circle around the North or South Pole, followed by arcs of wider circles, non-concentric. Meridians: arcs radiating from pole. Spacing closer proceeding from center outward.

Properties: Equal-area combined with centrally true azimuths.

Uses: Polar and hemisphere maps. Census and statistical maps of extensive areas, except those much greater in one direction than in another.

Notable Examples: U.S.C.G.S. Outline Base Map of U. S. #3068. (This takes in a large

† From Deetz and Adams.

part of Mexico and so is better suited than the Albers for that extent of region. Worst scale error, at eastern and western edges, only 1⅞%). National Geographic Society Map of the World. Weber Costello map of Africa. University of Chicago Department of Geography maps of World and Northern Hemisphere. American Museum of Natural History Hemispherical Map of the World (oblique case: Northern Hemisphere, Southern Hemisphere). *Caution!* Not equidistant.

Our light will not be an artificial man-made light, but one from a distance so great that the rays appear practically parallel: sunlight. Why *parallel* rays? Merely so we can cast the shadow of this wire globe *squarely* upon the screen: a straight silhouette of a full side of the earth, a hemisphere. *All* the rays meet the plane of the map at right angles, at the edge as well as at the center; none of them slant so as to "megaphone" the image of the globe onto the screen.

*Oblique case of Lambert Equal-Area Projection
Centered at lat. 50° S., long. 160° E.* *

ORTHOGRAPHIC
PROJECTION

Let's return to our shadow-play. Our imaginary equipment is a skeleton globe made of wire parallels and meridians, a screen plane, and a light.

If we hold the globe so that a pole is in the center of the projection, the parallel rays will carry the latitude circles to the screen, each one spaced the same as they would appear to the eye: the circles near the edge of the globe appearing closer together than the smaller ones near the pole. Indeed, if we think of a plane

* Courtesy of the American Museum of Natural History.

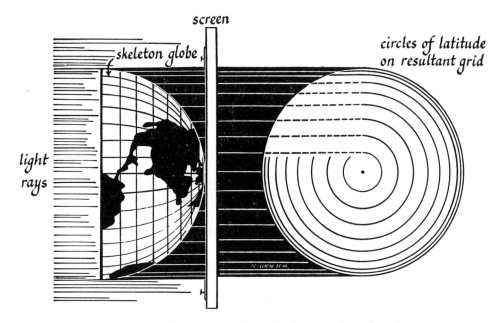

Supposition of Orthographic Projection (circular figure to the right is front view of map "screen")

intersecting the globe through any of these circles so as to cut (as such a plane naturally will) the rays and the axis at right angles, we can see that the way to get our radius for drawing any of these circles is to take simply the distance between each circle and the axis. In other words, push a hatpin through a latitude circle on your globe so that the pin will meet the pivot at a right angle, and you will have the length of the radius for drawing this circle. (This would be for an Orthographic Projection in the polar case.)

Now, to illustrate the equatorial case, let's turn the skeleton globe so that some point on the Equator is in the center of the projection. The shadowgraph we get this time will show the latitude lines straight. Easy to see why: the plane of each latitude circle is the same now as that of the rays.

However, if we tilt the globe so that the center-point is not on the Equator but on one side or the other, we make these latitude planes oblique, and the lines show up curved again. This is perhaps the most "realistic" pose in the Orthographic Projection, which is becoming increasingly popular in the presentation of "global facts."

Richard Edes Harrison, who has given the Orthographic the impressive treatment it invites, says that it might be called "the architectural projection," because it is constructed "from plan and side view as an architect does the façade of a round building." It is "the only map on which distortion is a visual aid."

It has, like all projections, its faults: scale variations, limitation to hemispheres. The land shapes are asquint at outer parts of map, but none the less plausible, because that's just how they'd look in a picture of the earth. The thing that's "ortho" about this projection is not the

land forms (it is not ortho*morphic*) but its "graphic delineation of the sphere." Here, we feel, is the earth's portrait. No wonder that it was the projection which we first really liked in our school geographies.

However, it has a definite scientific use. If it's a "moon's eye view of the earth," it is certainly an earth's-eye view of the moon. The Orthographic makes excellent moon maps!

Orthographic Meridional Projection of a hemisphere †

Properties: Pictorial. True bearings at central point. Scale true along circumference and along all circles centered on that point.

Uses: Geographies for early grades. Orna-

Orthographic Polar Projection of a hemisphere °

Orthographic at a Glance

Recognizable Traits:

Polar Case. Rings of latitude decrease their intervals proceeding from center outward, and come much closer together at periphery than they do in the Azimuthal Equal-Area.

Equatorial Case. Straight parallels and straight central meridian, spaces almost closing up at periphery.

Oblique Case. Parallels and meridians are ellipses spaced as in the other cases.

° From Deetz and Adams.

Tilted, or oblique, Orthographic ‡

† From Deetz and Adams.

‡ Courtesy of Consolidated Vultee Aircraft Corporation.

ments, trademarks, emblems, seals. Magazine, newspaper, cinema dramatizations of global facts. Lunar maps.

Notable Examples: "Orthographic Series," in *Fortune,* June, 1942, to January, 1943.

Caution! Not equidistant. Areas disproportional. Not to be confused with the Camera Perspective Projection, the result of photographing a globe, which is not the same as "orthographing" it with the hypothetical "light rays" virtually parallel and at right angles to plane of "picture."

a flat sheet touching at the opposite side of the globe all the lines and features of that opposite side of the globe.

We can visualize this process a little more practically if we take our wire skeleton globe and project part of it against the screen. The light should be at a diameter's length from the point where the globe and screen meet.

This projection is an old-timer. It and the Orthographic are credited to Hipparchus, who lived in Greece from about 160 to 125 B.C. He was the father of systematic astronomy as well as of mathematical mapping. He is the man

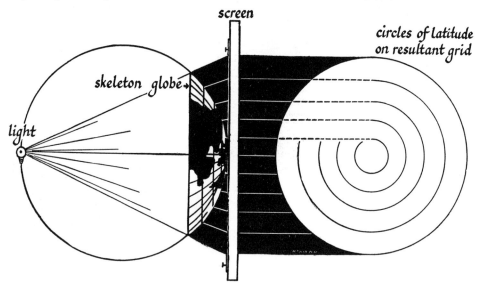

Supposition of Stereographic Projection

STEREOGRAPHIC
PROJECTION

Stereo is Greek for "solid," and *graph,* of course, is Greek for "write." Writing out a map through the solid earth! Suppose you have an x-ray eye. It goes up to a point on the Equator as to a peephole in a fence and sees right through. Not only that, it throws forward upon

who gave us the first solution of the problem of rolling out the earth's surface flat upon a map plane.

Like the Mercator, the Stereographic is a widely known projection. It too is conformal; in fact it is *the* conformal among these radial maps and is sometimes called "The Azimuthal Orthomorphic Projection." It is the only azimuthal without angular distortion.

That means, as with all conformals, take any

tiny rectangle made by meridians and parallels and that rectangle will be identical in its shape to the corresponding rectangle on the globe.

Just as Mercator's parallels become more widely spaced the farther away they are from the Equator, so do the parallels of the Stereographic get more widely separated the farther

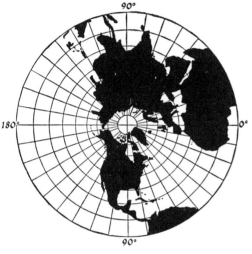

Polar case of Stereographic Projection [*]

they are away from the center of the projection. And again, that means larger and larger scale to stand for a given distance. But, these scales increase in the same proportion going along either side of a given right angle—as with all conformals.

It makes an almost perfect map if used for only 2° each way.

It is easy to construct [†] with a compass. Its curves are all true circles; for, every line which is a circle on the globe is projected here as a circle, excepting those which pass through

[*] From Deetz and Adams.

[†] Space does not permit giving the simple but many-step process here. See S. L. Penfield's interesting article, "The Stereographic Projection and Its Possibilities, from a Graphical Standpoint," *American Journal of Science*, Ser. 4, Vol. 11, 1901.

the center, and they are simply straight line diameters.

Although the more familiar Stereographics are meridional (having the bounding circle a meridian and the poles at top and bottom of map) the polar versions are useful for navigating in the far north and far south. In these, the eye-point is at a pole and the plane cuts through at the Equator and rests upon it.

Stereographic [‡] at a Glance

Recognizable Traits:

Polar Case. Latitude rings spaced farther apart proceeding from center outward.

Equatorial Case. All parallels, except Equator, are curves, curvature of each rapidly in-

Equatorial case of Stereographic Projection [§]

creasing as we go toward poles. Spacing of parallels and meridians increases, proceeding from center outward.

Oblique Case. Distinguished most markedly by one straight-line parallel (all the others, in-

[‡] Gall's Cylindrical is also known as the "Stereographic." Here too we "see through" the globe.

[§] From Deetz and Adams.

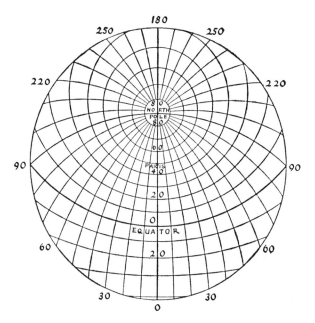

Oblique case of Stereographic Projection,
centered on Paris

cluding Equator, curved). This straight line is as many degrees of latitude on one side of the Equator as the center or "pole" of projection is on the other.

Properties: True-shape. True bearings at central point. True short-distance scaling. Best conformal for large areas.

Uses: Hemispheres, Continents, Polar caps.

Notable Examples: A.G.S. "Antarctica"; A.M.S. Universal Polar Stereographic Grid for areas north of 84° N. and south of 80° (not covered by Universal Transverse Mercator Grid); Christian Science Publishing House, Boston, "Mapparium" (a spherically walled room representing a globe as seen from within); U.S.C.G.S. SP-1, "Air Distance Chart of the World."

Caution! Areas not correct. Scale inconstant.

GLOBULAR PROJECTION

The Orthographic shrinks areas on the periphery of a hemisphere, and the Stereographic stretches them there. We can strike a mean between these excesses if we arbitrarily mark off the central meridian and the periphery so that the latitude lines will cut them at equal intervals, and likewise mark off the Equator for the meridians to cut it in equal parts. The result is a hemisphere familiar in schoolroom use, the Globular projection. It has no special scientific properties but readily affords general notions of the chief land masses, and is easy to draw. It is useless for measuring and plotting distances and directions. The only reason for showing it here is that it is sometimes mistaken for the highly valuable Stereographic or other azimuthals in the equatorial case.

Globular Projection of hemisphere °

GNOMONIC PROJECTION

This curiously named projection comes out of the wonderment in the minds of people looking up into the dome of the sky. Twenty-

five hundred years ago one of these wonderers was Thales, a statesman and philosopher. He is supposed to have been the first man to predict an eclipse and the first to think of this projection. Thales had a pupil, Anaximander, who is credited with being the maker of the first world map. Also the earliest of all scientific instruments. This was the gnomon (see p. 60), a sun-clock and latitude-finder.

And at the time of Columbus, there was a Swiss physician named Paracelsus, very learned and famous. He introduced opium, mercury, sulphur, iron, and arsenic into medicine. Also he said that there were some people living inside the earth, swimming around in it like goldfish in a bowl. They could see out anywhere, and so were tremendous wise. He named these folk "gnomes."

The angles which this central light casts are mathematically similar to those cast in the bowl-like gnomon. Because of this trick, this map net is sometimes called the Central Pro-

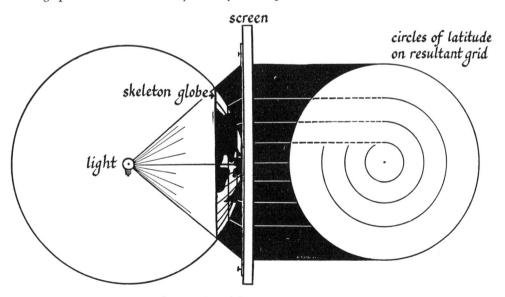

Supposition of Gnomonic Projection

° From Deetz and Adams.

jection, but somehow the magic of the word *gnomon* ° seems to have taken a better hold.

We will pass up the mathematical shindig of these gnomonic angles and instead look at the lines of our shadow picture cast upon the projection sheet. For what we get is a true perspective network. If the sheet is touching the wire globe at a pole, we get a wheel—as with all the pole-centered projections we've looked at. A wheel with straight spokes radiating from a central hub. Meridians.

But if we put the sheet tangent at another part of the globe—the Equator—we get a new slant on things. The parallels change from circles to arcs, except for the Equator, which is straight, of course. So are all the meridians—straight lines. They're great circles.

So here's the payoff: our centrally lighted sphere projects great circles as *straight lines* upon a tangent plane.

How come? Well, you will recall from Chapter 2 that every great circle is simply a line you get from shoving a plane through the center of the sphere. Now, imagine this plane continuing outward so that it passes through our flat-map plane. Where this intersection takes place will be a straight line. No matter at what angle the great-circle plane cants through the map plane it will make a slick straight line. Just an old geometrical custom: two planes *always* intersect on a straight line. Therefore every straight shadow-line on our gnomonic map-plane is nothing more or less than a shadow print of a great circle of the globe! The Gnomonic takes any number of great circles, come as they may, and keeps them straight.

Think what this must mean to the navigator. This line is the shortest distance between two points anywhere you put it. It represents as straight a course as you can possibly travel on

the earth or over it. It never bends to right or left: the only curve it takes is the earth's curve. And it shows straight on this map. The pilot can see exactly what places to fly over in order to take the shortest route, for contact flying.

For actual navigation, however, he must know at what bearing he should cross this or that meridian. And every oblique great circle crosses every meridian at a different angle. (Try that one again on your globe. You'll see it's true.) Only a Mercator rhumb line cuts every meridian at the same angle. And it does that only on paper. On the earth itself, you will remember, that the rhumb, in order to keep cutting each meridian at the same angle, takes some pretty considerable bends to right or left. It goes the *long* way. But it is a sure way of getting anywhere.

What the navigator does is to combine the Mercator and the Gnomonic in his route charting. One chart for the meridian cut and the other for the short cut.

Part of Gnomonic grid: great-circle path (solid line) and rhumb-line (dotted) between same points. Compare with illustration, p. 129

You can picture this navigating situation to yourself if you imagine rowing a boat across a large bay in a fog. If you hug the shore you will find your way across definitely enough, but it will be a long pull. À *la* Mercator. On the other hand, if you try to cut directly across you will lose your course in the fog out of sight of the direction line made for you by the shore. But you can do something in between: bear toward the short cut as much as you can without losing your curving line of "direction."

° Several inventions which at their introduction may have filled people with wonder have sported this mysterious term: a carpenter's square, an arithmetical trick, an austere wisecrack, etc.

A Mercator rhumb line, let us repeat, is straight on paper but roundabout on earth. As roundabout as that shore. Yet if you know ahead of time exactly at what angle you will fly across each successive meridian, that rhumb line will be every bit as definite and in its way as visible to you as that helpful shore line.

However, except at the focal point of this map, where it is supposed to have touched the sphere, all the angles go awry. A navigator needs a special compass rose for each separate station in order to plot a bearing from that station on a Gnomonic chart.

The Gnomonic and the Mercator are actu-

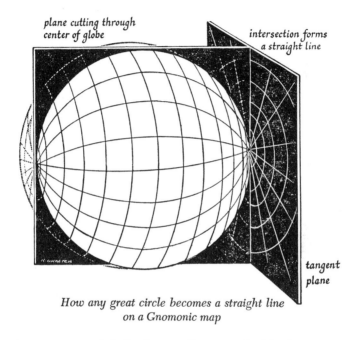

plane cutting through center of globe

intersection forms a straight line

tangent plane

How any great circle becomes a straight line on a Gnomonic map

On a Gnomonic map, a great-circle line between two points is a straight line, as it is on the earth; while a rhumb line between the two same points is an arc.° The navigator planning his flight picks from the Gnomonic chart the latitude and longitude where the straight line crosses each fifth meridian. Then on his Mercator chart he plots these positions with "rhumb-line chords." For on the Mercator the great-circle line is an arc and the rhumb is a chord. (Just the reverse of the Gnomonic.)

A further usefulness for the Gnomonic is in the relation of radio to great-circle paths.

° Always lying on the equatorial side of the straight line.

ally cousins. Look back on p. 126 and you will see that the cylindrical projection in which we recognize the proto-Mercator is, like the Gnomonic, also the result of a "centrally lighted" sphere. The Gnomonic is cast upon a tangent plane, yes, but what is a cylinder but a pliable plane wrapped around the globe! Only, instead of being tangent at a point, like the Gnomonic's plane, this cylindrical "plane" is tangent on a line, the Equator. However, the reason that this gnomonic cylindrical affair is not so practical as the affair of the gnomonic plane is that the latter makes azimuthal use of this tangent point. From that point all azimuths are true, and all these are on great-circle lines.

The Mercator has no such focal point. It can have only two great-circle lines straight and crossing at a point: the Equator and a meridian. And as radio takes great circles, the azimuths you get from them don't all plot directly on a Mercator chart. Except for the Equator, no great-circle path of a radio wave from a station crosses your meridian at the same angle as would a rhumb line from that station. Navigators, therefore, when locating their position

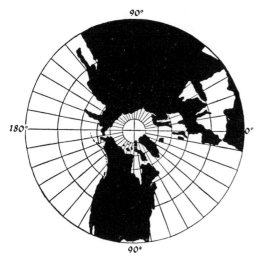

Polar case of Gnomonic Projection, extended to Lat. 30° °

by radio, must distinguish between true and mercatorial bearings. If you wish to see this difference in its simplest form, think of any east-west line (except the Equator) on a Mercator. Now recall the arc a great circle makes over this line. The two lines of direction can't tell the same story, can they?

This is as deep into this as we'll go. To see it worked out, read the Admiralty Notice to Mariners, No. 952, reprinted in *Elements of Map Projections,* by Deetz and Adams, pp. 145–147. The important point for us here to

° From Deetz and Adams.

realize is that although the Mercator is praised as a chart of true compass directions, and indeed, its rhumbs are lines of true traveling direction, still in the great-circle terms of radio you can't count on its azimuths. On the azimuthal projections, though, and particularly the Gnomonic, there is at least one point where you can get a full round of true azimuths.

Just as a Mercator requires a special compound scale, the Gnomonic necessitates special methods for measuring distances. On the conscientious charts which the Hydrographic Office issues, one method is explained with the admonition that it must be used. A gadget known as the nomograph, used for reading off

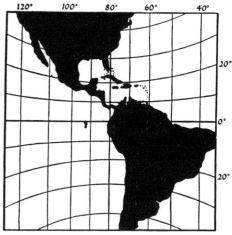

Equatorial case of Gnomonic Projection, centered at 80° W †

the numerical values of variables, has been adapted to scaling distances on this highly professional type of map. Also, special compass roses must be computed for all radio stations on a Gnomonic except the station at the point of tangency; else the angular distortion prevents getting true bearings from those stations.

† From Deetz and Adams.

Even so, it makes a pretty fair map within 30 degrees of the pole. And in an oblique case its sins, within so small a scope, are slight. So, occasionally a Cahill octant (p. 120) is made gnomonic.

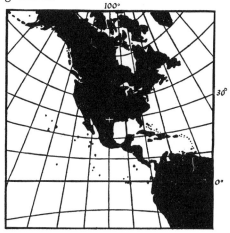

Oblique case of Gnomonic Projection, centered at 30° N., 100° W °

Gnomonic at a Glance

Recognizable Traits:

Polar Case. Very rapidly increasing interval between latitude rings as we go from the center outward.

Equatorial Case. Equator a straight line. *Meridians also straight and parallel, while the parallels are neither* but are curved, convex to Equator. Rapidly increasing intervals between all lines as we go from the center outward.

Oblique Case. Parallels: arcs convex to Equator (a straight line) but spacing increases outward from point of tangency, as does that of the meridians, all of which are straight lines converging at North or South Pole.

Properties: Straight line indication of great-circle paths.

° From Deetz and Adams.

Uses: Trans-polar and trans-oceanic routes. Radio and seismic work. Working-partner to the Mercator.

Notable Examples: U. S. N. Hydrographic Office single sheets of the N. Atlantic, S. Atlantic, Pacific, N. Pacific, S. Pacific, and Indian Oceans. Same by the British Admiralty. Great-Circle Chart of the U. S., #3074, U.S.C.G.S.

Caution! Always be sure when measuring distances to follow the instructions which should accompany the chart.

SUMMARY OF AZIMUTHAL MAPS

All the maps of the azimuthal family have certain brilliant features in common:

They are *focal* maps. They are all focussed upon a certain point. They are all built like clock or compass dials.

They are *radial* maps. The rays or radiuses from the center have correct bearings. These radiating lines are also great-circle lines and are always straight. Take the equatorial or oblique cases of *any* azimuthal, and all straight lines through the center will be shortest distances. (True to scale, though, only in the Equidistant!)

Any true circle you draw around this focal point will represent a true circle around the corresponding point on the earth. It will connect equal distances. It will be a "horizon circle." That is, it will show the circular horizon limit of view from that center-point. Just as the higher you stand the farther you can see, so the higher the altitude of your eye above this point the greater the horizon circle.

All places on the same horizon circle undergo the same degree of change in shape, area, and scale according to the projection.

The azimuthal projections in the polar case differ from one another merely in the length

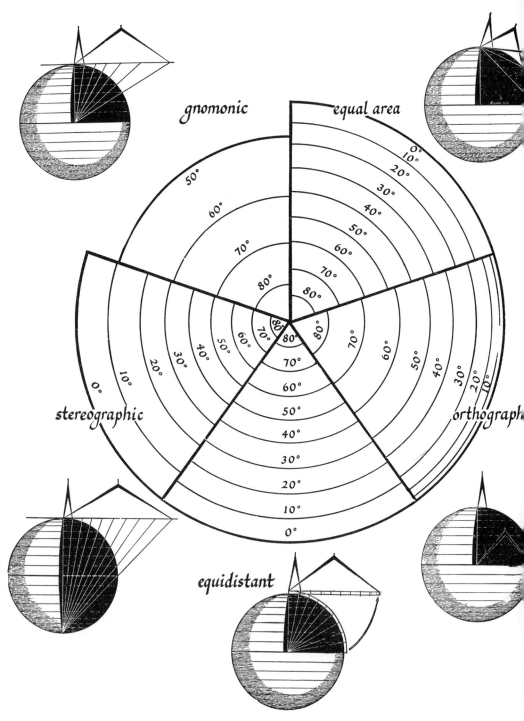

gnomonic

equal area

50°

60°

70°

80°

0°
10°
20°
30°
40°
50°
60°
70°
80°

stereographic

0°
10°
20°
30°
40°
50°
60°
70°
80°
80°
70°
60°
50°
40°
30°
20°
10°

orthograph

equidistant

0°
10°
20°
30°
40°
50°
60°
70°
80°

Comparison of spacing of latitude circles in polar azimuthal projections, and methods of obtaining radiuses

of the radiuses of these horizon circles. By only changing these radiuses you can transform one of the projections into another. It is merely a matter of how these radiuses are derived. (Illustration opposite.) Try them out on a circle the same size as your globe.

The polar grid is the invisible framework behind the equatorial and oblique cases. By laying it over a grid of either of the others, the same size as the polar, you can see the relationship.

For methods of transforming projections, see *An Introduction to the Study of Map Projections* by J. A. Steers. For drafting an azimuthal in the oblique case, graphically and without any mathematics, see "The Nomograph as an Instrument in Map Making" by Richard Edes Harrison, in the *Geographical Review*, October, 1943. His nomograph for azimuthals is simply an accurate grid in the equatorial case of the projection to be converted. Revolving this grid under a tracing sheet, he gets all the points he needs for making the oblique case. The nomographic principle, as he points out, is also useful in both the conical and cylindrical projections for converting grids and for drawing and measuring great circles.

"THAT OVAL-SHAPED MAP"

It's easy to see why a hemispherical map would be made within a circle; any way you'd slice through a sphere you'd get such an outer boundary. But why would anybody want a map to be *oval*—or, more precisely, elliptical—in shape? Simply this: it's a good way of spreading out the *whole* world within a shape that provides the illusion of "globalness."

When we show only *half* of the world within a circle, the outer boundary is easy to visualize as a definite thing, such as the Equator, or a pair of continuous meridians, or an

oblique great circle. But look at what happens when a perfectly circular outer boundary is forced to include the world entire. Back on p. 147, the azimuthal projection of the whole world has a *circle* represent the South Pole, which in reality is a *point*. This projection asks us to suppose that a pole that is the center of one circle can make sense as the circumference of another circle. It can, but such "sense" is in itself almost useless. Ahead, on p. 167, is another attempt to include the entire globular world within a flat circle. That projection too has an implausible look, especially in the Antarctic. Neither projection looks like an imaginably flattened-out globe.

Somehow though it seems if we could only slit an elastic sphere down a meridian, from one pole to another, and then open the sphere

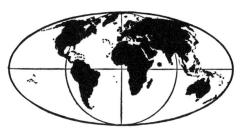

Mollweide Equal-Area Projection of sphere

out to form a flat spread, we'd get a kind of "stretched circle." That is, an ellipse.

One of the most famous elliptical presentations is the Mollweide, sometimes called Babinet's Equal-Surface, Projection. The shorter axis—here the Greenwich Prime Meridian—is just half the length of the longer axis, the Equator. These lines and the parallels of latitude, when drawn, are the only straight-line coordinates. All meridians other than the central one are curved. The two meridians forming the circle in the middle of the projection mark off an actual hemisphere. The lunes on either side of this circle include all of the other

half of the world's area. All the curved merid-
ians except these two are, when drawn, ellip-
tical, or "smooth," curves. The meridians are
evenly spaced on the parallels, but the spac-
ing between the parallels gets smaller north-
ward and southward from the Equator.

The Mollweide's linear scale is true only
along the major axis (Equator). The shapes
become more distorted the farther they are
away from the center of the map. But it is
truly equal-area in every part. Atlases and
books on economic geography and on other
world-scanning subjects make use of this pro-
jection to illustrate the relation of the areas to
the various distributions, such as population,
vegetation, rainfall, and diseases.

When the Mollweide is cut into and pulled
a little—that is, interrupted—the shapes of the
oceans and continents improve. It is used also
for hemispheres and smaller areas. It can be
turned around to make a transverse, with ad-
vantage to the polar regions.

Another elliptical projection using the same
ratio of long and short diameters is the more
plausible one devised by Ernst Hammer.[*]
Its parallels, except the Equator, are curves,
and the shapes are not pushed around so
much. This, like all equal-area orbs, is interest-
ing because of its usefulness to astronomers in
their plotting of the stars. For it can represent
in a single map not merely the dome of the sky
but the whole celestial sphere so that in one
look we can seen in what manner the stars are
strewn throughout the various departments of
the heavens. It is also good for presenting
world statistics, isobars, isotherms, etc. A fine
example is that on p. 116, a map of the whole
world ocean, centered on the South Pole.

[*] For many years, in almost all English language refer-
ences to this projection, the name of Aitoff has been erro-
neously used. See "Aitoff and Hammer: An Attempt at
Clarification" by John B. Leighly, *Geographical Review*,
Vol. 35, April 1955, pp. 246–249.

Hammer's Equal-Area Projection of sphere [†]

To get a *conformal* idea of this body of water
a special projection is necessary. One is a "two-
cusped epicycloid" known as August's Projec-
tion. A transverse of this, p. 116, shows the
entire ocean's surface currents as they are dur-
ing the northern hemisphere wintertime. The
black line is a 200-meter isobath, which is
really the ultimate edge of the world conti-
nent—"the continental shelf." Conformality
counts much for showing the patterns of cur-
rents: their direction and speed, where the
streams converge and sink and where they di-
verge and well up, the degrees of distance any
one current takes in its career, etc. That's how
articulate a map can be!

Most of the world's land surface is in the
northern hemisphere. So an equal-area map
dealing with on-land matters can give its best
to the majority of its relevant areas if we shift
its projection northward to an oblique version.
Our two choice ellipticals, the Mollweide and
the Hammer, respond nicely to this change of
case except for one quirk of theirs. Around the
North Pole and in the sub-Arctic surrounding,
the lattitude circles become *too* oval; the geo-
graphical relationship between Asia and the
Americas is badly pictured. To remedy this,
William A. Briesemeister, in 1952, devised an
elliptical equal-area projection with a major
axis only one and three-fourths, instead of
twice, the minor axis. This equal-area design

[†]Courtesy of Consolidated Vultee Aircraft Corporation.

has proved practical enough to warrant the publication of large outline maps for users to fill in with statistical information.[°]

Denoyer's Semi-Elliptical Projection is a compromise between Gall's and Mollweide's. While Gall's has the parallels get farther apart toward the poles and Mollweide's has them come closer together there, Denoyer's has them equal. And again, while the poles are thought of as full-length lines in the cylindrical model, in this compromise the poles are lines one fourth the Equator's length, giving us a bowl shape with flattened base and top. It makes a useful schoolroom map, showing the entire world and its curved nature in one image, without making faroff lands look queer and unvisitable.

Denoyer's Semi-Elliptical Projection [†]

The ellipse seems to be visually more feasible for showing the whole world at once in the round than is the perfect circle, which our eyes readily enough accept for hemispheres. The Van der Grinten Projection puts the entire world within one circle. The area of this circle is equal to that of a globe of one half the diameter of this circle. The central meridian and the Equator are straight lines; the other lines are all curved. And though the meridians are divided into 180°, as you'd expect, the Equator must be divided into 360°! It is only

a *diameter* of the circle before us, but it represents the *world's circumference.* In some versions, this projection's practically non-existent polar regions are lopped off, and we have again our strangely more feasible oval. Its value is pictorial rather than technical. A very pleasing example is "The World Map" of the N. G. S., which gets the polar caps in as corner pieces.

Van der Grinten Projection of sphere within a circle

A mathematical marriage between the Mollweide elliptical and the Sanson sinusoidal has resulted in a fine equal-area projection known as the Eumorphic.[‡] According to its inventor, Samuel Whittemore Boggs, eumorphism is intended to connote good shape of large areas, just as 'orthomorphism' is used to signify true shape in small areas." (See illustration on next page.)

In its basic version, the Eumorphic is a full-round ellipse, but in order to impart more plausible form to the great continental shapes while holding them strictly to account in area,

[°] Sheets obtainable from the American Geographical Society.

[†] Courtesy of Denoyer-Geppert Company.

[‡] Goode's Homolosine is also derived from a fusion of these two projections. His Interrupted Homolographic, however, is based solely upon the Mollweide.

Mr. Boggs has made interruptions. Very ingeniously he also "interrupts" his central meridians. Instead of letting them run north and south their full length, each to waste its beauty

This projection appears in various scientific works and presentations of international affairs. A version of it is among the schoolroom maps published by A. J. Nystrom & Co.

Boggs Eumorphic Projection. Note meridian of construction, dotted line at long. 30 E °

in lesser populated parts to which the map does not essentially apply, he makes the meridian of 60° E. run northward as a central from the Equator until the shape-saving meridian arrives at lat. 40°, where the population of Asia thins out. Here he "offsets" the meridian (which accounts for the kinks along the 40th parallel) and shifts the construction central westward to 30° E., to function *north* of the 40th, for populous Europe. We get then something rare in equal-area world maps: these two great population areas presented in a one-piece continent with their over-all shapes preserved.

And these parallels of latitude all hold out as parallel straight lines, which is what we want in viewing the various climates, population densities, and distribution of natural resources across the world. When we say "world-wide" we like to have a map with straight east-west lines: we can then take interruptions.

THE WORLD IN FACETS

On March 1, 1943, the magazine *Life* introduced to the public a new projection. It was the invention of R. Buckminster Fuller, an engineer and veteran innovator who had in 1927 evolved what he called his "Dymaxion house," and in 1933 his "Dymaxion car"—both prophetic forms. And then his "Dymaxion World."

It is a cube with the corners cut off so that the result is an affair of 6 squares and 8 equilateral triangles. Two of these squares center on the poles, and their diagonals extend out far enough for the corners to take in lat. 50°. The other squares touch these at the corners, and touching each other likewise at corners, they go around the "sides" of the earth. The spaces between these squares form the triangles.

° Courtesy of S. W. Boggs.

What we have, then, is an interrupted projection that we can readily unify into a "globe," we might say, "with flat sides."

The diagonals and sides of the squares are great-circle arcs expressed as straight lines. So are the central meridians of the triangles.

of the map without too much overall cost in properties. But its legend candidly tells us that the scale varies from 1:34,300,000 to 1:51,500,-000. That means an inch may represent as many as 325 mi. more in one part of the map than it does in another part. It is not the first

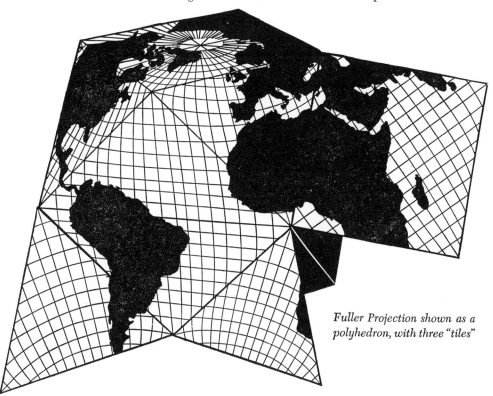

Fuller Projection shown as a polyhedron, with three "tiles"

By laying the pieces like tiles in various arrangements we can make any number of instructive flat maps, "interrupted" of course. These interruptions need not break the story but can help to shape it, as when we show east-west or north-south layouts. Or northeast-southwest. Or northwest-southeast. We can use as a world-focus any continent, important archipelago, or either of the poles.

It is a "balanced budget" projection enabling us by nice compromises to make an overall use

representation of the earth as a flat-sided solid. The Gnomonic Projection, for instance, can cast the world in the form of a cube.

Nor is there anything new about the *shape* of this crystal of paper. Some 22 centuries ago Archimedes, the mathematician and inventor who leapt out of a bathtub shouting, "Eureka!" when he first thought up the principle of specific gravity, and who said only give him a lever and a place to stand and he would move the world, figured out there were only 13 possible

solid shapes that could be made up of facets that are regular polygons with equal angles. And "Fuller's Earth," as it has been nicknamed, is but one of these: the cubo-octahedron.

★ ★ ★

Perhaps the essential lesson to learn from the "odd" projections is that it is logic which makes them weird. And the logic of each is its utility. They seem less fantastic as soon as we make appropriate use of them. What is really weird is a limited conception of the world, and maybe by dint of some irony deep within the mathematical nature of forms the fantastic appearance they have for us at first is only a gentle ribbing of us for our still somewhat inflexible minds.

For our minds in the use of maps must be even more "developable" than surfaces. In viewing the world in its many phases we must do a great deal of mental projecting. Maps are but the mere apparatus for this function.

Nobody now wants a flat earth any more than he wants a flat tire. But we must have flat maps. Flat maps with round meanings.

In this swift, superficial ramble through the processes of projecting the arcs of the sphere upon supposable facets and other planes we have had a peek into the most difficult but most wondrous part of maps and their making.

We might at first feel that these are a great many projections to become familiar with. But a kitchen may have more utensils, some of which require a bit more practiced skill of the user. J. A. Steers, a leading geographer, says, "It would be a very good thing if a greater variety of projections came into everyday use."

Unless a map-user knows a little about projections he may get the wrong map for his purpose, or use the right map in the wrong way. Unless he knows the properties and shortcomings of a map he may get the wrong idea of the country and be lost within an inch or two on paper.

Since no one projection can have everything, each should have "what it takes." And we with our specific purposes are the judges of that. But people with the all-or-nothing temperament will get nowhere with maps.

*Goode's Polar Equal-Area Projection, derived from Werner's, p. 145**

A good technician knows his tools. He knows the specific use of each and respects each for it, never misapplying it, then blaming it for a "fault" which is his own. Projections are precision instruments, but all such are blunderbusses in any other than their intended uses.

By looking for the "recognizable traits" in the various networks discussed in this chapter, you will be surprised how many projections on world scale or hemisphere scale will soon be old friends to you. Understanding maps depends upon our ability to see how in each one the skeleton determines the character and lineaments of the body.

Thoroughly understanding a projection, however, would require our going deep into it by mathematical means. The graphical view, indispensable as it is, does not much more than depict for us what might be called the outer parts of a projection; we don't peer into its inner workings. Those marvelously coordinating lines that were derived from the

* Courtesy of Consolidated Vultee Aircraft Corporation.

sphere merely demonstrate the product; they don't exhibit the actual developing process. A mathematical insight into projections is necessary for judging their possibilities and for making the most of any one projection within its inevitable limitations. The invention of one—the creative thinking behind it—is nearly always mathematical. And so is the practical showdown. This has become more rather than less so, what with electronic computing machines goading cartographers to get at the statistical aspects of the most challenging geographic problems.

In the foregoing pages projections have been grouped according to their modes of construction; but in the Index they will be found handily classified also as to utility under such heads as: "Conformal," "Pictorial," "Temperate zones, projections adapted to," "Hemispheres, projections suitable," and so on.

This classification is only a provisional one; we have used it to suit the needs of our present interest in projections. It has been a convenient way of sorting them for easy comprehension and for packing them so they might carry well in our minds. We might classify them differently and the rearrangement might bring

out fully something of their nature not emphasized here.[*] Of the making of projections there is no end, and there will be as many ways of classifying them as there will be reasons for doing so at all. There is really no perfect and final way.

By making some of these projections yourself you may easily discover a deeper and more gratifying knowledge of them. There are at least a dozen of them you can quickly learn to draft without using mathematics. Of course if you already know a working amount of math, this graphic play will afford you all the more meaning. A simple recipe book for drafting most of the principal projections described in this chapter is *Construction of Map Projections* by H. A. Hoffmeister. Another short course of practical, "essentially nonmathematical" guidance is a chapter in A. H. Robinson's *Elements of Cartography*, second edition.

[*] See "A Classification of Map Projections" by Waldo R. Tobler, in *Annals* of the Association of American Geographers, Vol. 52, June 1962, pp. 167–175; "Analytical Key to Map Projections" by Hugh E. Spittal, in *Journal of Geography*, Vol. 48, No. 9, December 1949, pp. 364–366; and "Classification of Map Projection," in *Elements of Map Projections* by Deetz and Adams.

Part II
Making Your Own

7. Basing Maps on Other Maps: COMPILATION

SUCCESSFUL AUTHORS say they never hit their stride until they began writing about places and people close to home. By sauntering and prowling along familiar byways they mastered the strange ways of their chosen craft. Map-making is also a kind of authorship. Maps, like stories, have main theme, point of view, plot, and style. And like the beginner in literature, the beginner in cartography will make the quickest and most headway if he deals with the subjects he knows best.

There is something very likable about a homemade map of the home grounds. It is worth making, not only for the training you get out of it but for the map itself. Your first map can be a satisfying and satisfactory job, alive with interest and even expressive of whatever charm you may feel abides in your town or countryside.

But you must give yourself a break from the outset. Don't attempt too much. If anything, let your early trys be at something too easy rather than too difficult. Feel the springboard effect of a little initial success.

The preliminary considerations, whether you are a beginner or an expert, are: the terrain, the purpose of the map, and the technique. The only difference for the beginner is that these three should be extremely simple.

Not only should the terrain be familiar, but it should be simple. If it is very hilly and tortuous, for instance, map at first a small enough part of it to make the doing easy and pleasant.

A word about purpose. If a map hasn't a purpose there's little use in doing it; the feeling of uselessness will creep up on the mapper while he's working and take the life out of his job. With a definite purpose in his mind the learner immediately gets the full meaning of every step, and that makes each step easier.

What's the map for? To direct visitors how to get to your house from the station? Then subordinate everything else to that, even scale. The point is to simplify your guest's way to your residence. The simplification may reduce your project from a map to a mere cartogram. No matter: it will still be cartography. If it works, that's something. A map's first business is to function. Utter simplification need not inhibit interest, and it may even improve the design. The simplest map can be fascinating, though obvious.

Now about technique. It may seem odd to urge simplicity of method when the following pages are loaded with processes. As you glance ahead over the various procedures the outlook may appear bewildering. But do not let the number of words or steps balk you. In mapping, the actual doing is swifter than wording the way to do it. Often several words are necessary to explain a single, simple motion. Then too, what lies before you is not a multitude of operations to make one map but a variety of methods for making many maps. One of these methods is likely to suggest the map you may wish to try for a starter. So sit

back and read through this chapter in a leisurely way, imagining as you go along the working out of the processes that interest you, and skip the others. You will easily pick out what you need for the particular job you may have in mind, and leave the rest of the instructions until you have occasion for using them.

GATHERING MAP
INFORMATION

The first stage in making any kind of map, professional or amateur, is getting together the cartographical data. It's the phase of the frontiersmen, and the three who ordinarily carry it out are the explorer, the surveyor, and (believe it or not) the librarian.

Let's assume that the exploring is already done. As for the surveying, we shall not need to do any for our first map or two. You will find yourself surveying to more purpose and better effect once your hands have got the feel of drafting maps based upon ready-made surveys.

There is nothing unprofessional about using other maps as bases for your own. Copying, even tracing, another map is not necessarily a lazy man's way to get out of doing his own drafting. The idea in map compilation (as this operation of adapting available materials is called) is not to evade work but to utilize good work which has already been done. It is a regular procedure in both military and civil mapping. For example, some official cartographers making a chart of Buzzard's Bay, Mass., used, besides their own data, 116 surveys performed by others. They selected information from 94 previous hydrographic sheets and 61 topographic sheets.

Knowing where to look for the right base maps and other data to suit your special needs is as much a knack for the mapper today as knowing how to find your way through a primeval forest used to be.

That's where the librarian comes in. If you expect to do any considerable mapping of your neck of the woods, make a survey of your public library's collection of maps and local history. A survey of surveys. There are also other sources for base maps, especially those which you may acquire for your private collection and use without fear of infringing upon someone's copyright. These are discussed in Chapter 9.

Several considerations arise in selecting the right base map to suit the special purpose of the new map.

Is the information in it up-to-date or obsolete? If you are making a map to show what the region looked like at some certain period in the past, you may have to check the base map with data in books of local history, in order to avoid anachronisms. Treaty House may have been moved from the original site to the present, or the exact location may be controversial. Spellings may have changed. (Avoid as much as possible any affected archaism. It might surprise some people how very little of Ye Olde Stuffe is to be found in old maps.)

Is the base map an expert's job or a homemade affair? Either kind, indeed, may have its errors. An old survey may be wrong in its azimuths, because of compass trouble. Some of the landmarks and monuments it used may have been moved or lost, so that today's boundaries may have changed somewhat from those on the base map. Old homemade maps, though cherishable and not to be dismissed, are not always right on distances. The oldtimer may have measured his miles by his pipefuls. The grades of the roads may have been changed, which would alter the distances. And which do you wish: The road (hilly) distance or the horizontal (plane) distance, as the crow flies?

Yes, if you fuss too much about all these little matters you may never get your map started. It all depends upon how much accuracy the *purpose* of your map requires. It's no great trouble but often a little fun to go out

into the fresh air and check on a critical angle or distance before taking the base map's word for it.

The next consideration is the scale of the base map, and here we are getting into something serious. The size of a base map should be generous enough to give you what you can't get in any other way. The detail should be large enough for you to pick it up with the point of a pencil. Much depends upon the base map's size and scale as compared to the size and scale desirable for the new map. But what should that be?

What determines the size of the new map?

That's easy. We can't make a map any larger than the sheet we use, unless we make the map in sections on separate sheets and put them together. And again *purpose* is a deciding factor. A map to guide a visitor driving a car should be small enough to handle. When he arrives you may wish to show off the wonders of your region in a large wall map. Or you may wish to have a pocket map ready for him to carry with him on hikes. Or you may be planning to do a uniform series of maps showing not only the various parts of your region but its various aspects—a little atlas, so to call it, of your district. Then 8½ x 11-in. folder paper, punched 3-hole to bind neatly into a volume, might suit you.

The base map is likely to cover much more country than you wish to put in your map. But if the scale is the same as you wish for the new map, everything will sit pretty. In fact, for a first map, nothing could be more advisable than a base map of the same scale. Then all you need do is to copy off the section which your smaller map covers. Say the base map is 14 x 17 in. You wish your map to be 7 x 10 in. No hitch there. No more than if you laid a 7 x 10-in. picture-frame upon the base map and decided to cut out just that much. Taking half a portion of pie doesn't change the size of the raisins.

But maybe that's what you'd like to do: enlarge the raisins! Larger detail. Instead of trying to squeeze this farm into a half-inch along a road you'd like to have a whole inch for it, so as to indicate more easily the gates at each end. It is often impossible to draw detail as small as it appears in print on a base map. The fact may be that the original of the base map was probably drawn twice as large in the handwork stage, then was reduced by photography for the printed version. And apart from the difficulty of drawing too small, you may not wish to be stingy in the display of your section. The chances are that the best base map you'll be able to find will show too much territory at the expense of your own section of the country.

Such circumstances call for changing the scale. This is easy enough, if you know what you are doing. If the scale of the base map is an inch to the mile, and you make it two inches, you'll of course be doubling the scale, making every length just exactly twice that on the base map, and giving you much more room for the pet details which necessitated this new map.

Never use a road map as a base unless all you wish to get from it is certain distances on *certain roads as of certain years*, and unless, also, you can be sure that those distances were consistently drawn true to scale. The mileage figures printed on those roads may be correct, and then perhaps only for the year of the map, but that doesn't mean the roads themselves are scaled correctly.

Many beginners, far from ignoring scale, go to the other extreme of undertaking the conversion of too many different base-map scales at one time. It's all right, and not always difficult to work from more than one base map, but if they have various scales and your own map is to have still another, you might find yourself in more trouble than a juggler on a roller coaster.

Sooner or later, by agreeable stages, you will discover the technician's satisfaction in making

true drafts. And if at the outset you choose not to ignore scale entirely, draw your graphic scale and go to work. This scale will be a line keying your own map to the base map as well as to the ground. And it is the very first map-line you draw.

PENCIL DRAFT

Sharpen a 2H pencil to a slick, streamlined, conical point, and keep that point trim so the work will be consistent.

Plot the framework by first laying out the rectangle which will serve as the working border of the new map. Then measure on the base-map the coordinates which pass through the section you are using. Carry these measurements to the new map and point them off on the border.

There are several ways of doing this. The choice will depend mostly upon where the section you are using happens to be on the base map.

If the section is in the interior of that map, so that there are no borders which will coincide with the borders of the new map, you may for a moment feel lost. But with straight-line rectangular coordinates you might take your measurements directly from four of them, as though *they* formed a border.

Perhaps the section you are mapping is close to the border or a corner of the base map. One or more of its borders there coincide with the borders of the new map. Then simply take the measurements with a pair of dividers or good compass points. Or else a straight-edged strip of paper, ticked with pencil points where the two points you are measuring occur. *Never use a ruler for transferring map measurements from one place to another.* Ruler edges make shadows. Besides, in accurate work like this, the ruler's markings don't always jibe with the distance you are measuring, and if they do, they are usually too fine to keep an eye on.

If the base map is your own property, you might try transferring these plotting-points by pricking them with a fine needle. It is a very accurate method. Secure the sheet of the map-to-be *under*—that is, on the reverse side of—the base map, so that the base map is face up. Let one corner or two sides be free, so that from time to time you can peek under the base map and recognize the points. Don't do too many at a time, so that you will forget which is which. Afterwards, heal the needle holes by laying the sheet face down on a smooth surface and rubbing the reverse side with the bone handle of a knife or of some manicure instrument.

Should the new map be an enlargement or reduction in scale of the base map, see p. 180 for instructions.

Now, something about those coordinates themselves. If they are geographical coordinates (parallels of latitude and meridians of longitude) only mark them on the borders of your map, but don't draw them. Especially if they are curved: too much grief. On charts showing a considerable water spread, however, sometimes a meridian and parallel or two look pretty trim crossing the otherwise almost blank water space (but stopping at the shores). If your base map is a U. S. Aeronautical Chart, you will find the parallels and meridians only 1° apart. Not only that, but some of these co-ordinate lines are ticked off to show minutes. These will guide you to plotting a very dependable system of coordinates for your own map.

As soon as you have plotted the coordinates for the new map, register the direction-pointers in the margin. These arrows are really a part of that system. They should show True North and Magnetic North. Give the variation between the two Norths, both by a figure, as "5°," and by drawing the two pointers at that angle. State the date for the taking of that magnetic variation or declination as it is given on the base map. If you have more recent information, draw the magnetic pointer at an angle in

accordance with that. If the base map states its Grid North and you are using that grid for the placing of your detail, then it is the Grid North of your map, too. Copy the Grid North pointer.

We now have a framework for the new map. Our next step is to transfer to it the details of topography we wish to borrow from the base map. There are several methods of making this transfer. We have already considered one —pricking with a needle.

TRANSFER

A tracing sheet acts principally as a medium or vehicle between one map and another, a conveyor of graphic facts. A good tracing sheet is something to take pride in. It can even serve as the final map, albeit a substitute or temporary map, for most tracing material is flimsy stuff, and the very transparency which is an aid to copying becomes in an actual map a hindrance to quick reading. But whether you use a tracing sheet to carry details from one map to another or whether you ink it in as the final draft, it will serve you more faithfully if you respect it as a *provisional map* and not a mere scrap of incidental material.

Unless the tracing sheet is itself of plastic be sure to use such material along with the tracing paper, to act as a shield for protecting the base map against the scoring effect of the hard pencil.

Fasten the drawing sheet to the base map securely to prevent shifting. There are several ways: Scotch drafting tape—but be careful with this, for it sometimes pulls the surface off map paper; folding an edge of the tracing paper over an edge of the other sheet and using clean, unsprung paper clips; spring clothespins; heavy but soft paper-weights, such as cloth bags partly filled with BB shot. If original is a book page a rubber band will sometimes work.

Before tracing the detail, make register ($+$) marks in the four corners, and keep an eye on them as you work, to see that there has been no slipping.

Don't trace out straight lines, or plottable curves. Register their points, so that you may afterward use the straight-edge or compasses for more workmanlike results. Trace only the salient points. Don't try to get on your tracing sheet lines which are too close together. You can do better afterward working freehand on the transfer paper. Follow the order of steps as advised, page 183.

It is best not to copy the lettering.

To increase visibility of detail in tracing, cartographers sometimes lay the work on a pane of plate glass, under which is an electric light. Such tracing boxes or frames are easily rigged up at home. With small maps and good daylight, a clean windowpane will serve the purpose, although working on a vertical plane is awkward.

To convert the tracing sheet into transfer paper: *after* the tracing is complete, put the tracing sheet face down on a smooth surface, and with a blunt, very soft pencil blacken the back of the tracings. Spread the pencil graphite evenly by rubbing it with a soft pad of cloth. Now lay the sheet, face up again, upon the "fair sheet" (this is what the mapper calls the clean sheet) for the new map. Fasten these sheets securely, as before. Carefully retrace the lines with a pencil or, better, some smooth point, like that of a crochet hook. The result should be a faint but dependable transfer to guide you for the finishing of the new map.

Some cartographers use blue chalk instead of pencil graphite for preparing their transfer sheets. It's tidier, and blue doesn't photograph. Carbon paper is disliked because it is ink-resistant and unerasable. For retracing they use agate points.

Nearly everybody knows the trick of copying a picture by dividing it into tiny squares.

In any one of these squares we can make out a simple enough bit of the picture's line to imitate it easily in a corresponding square on another piece of paper. It used to be a familiar "drawing lesson" device on the children's page of newspapers. We shall find that when we use this elementary method of copying a picture or a map that we shall make things still easier by numbering and lettering the lines which form these tiny squares, so that we may readily locate the corresponding square within which to draw each bit of line we are copying.

Whether this net is already partly made for you on the base map or has to be entirely made by you for the new map, it will catch all the detail you wish to take. A river can twist and squirm, but it can't escape you. You have it pinned down. Wherever it crosses under a net line, mark with the pencil point the corresponding net line on the map-to-be. After making a series of these points or dots to guide you connect them with a line and you will have transferred the river. There will be some details—such as islands, town points, peaks, wells, etc.—which do not occur near enough to a net line for you to be sure of them. Then divide the square in which they are into still smaller squares to net them. Sometimes only a diagonal through the square in which a detail seems lost will get it for you. But with reasonable care, nothing can elude you.

ENLARGING AND REDUCING

The method of squares enables you to both transfer and enlarge a map at the same time. It is a combination process.

If the squares of the transfer grid on the base map and those on the new map are the same size, the scales of both maps will be the same. Let us say they are quarter-inch squares. And the scale of base map is 1 in. = 1 mi. Then the side of each square would be ¼ mi. A quarter-inch on the new map would represent a quarter-mile of ground distance just as quarter-inch does on the base map. The scale of the new map is also 1 in. = 1 mi.

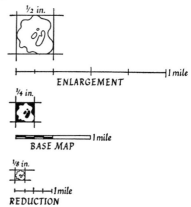

But if we use a half-inch square on the new map instead, and keep the square on the base map still a quarter-inch, the new map will have squares whose sides are twice as big as those on the base map. And just as we double the length of those sides we double the scale. From only a quarter-inch for a quarter-mile (or 1 in. = 1 mi.) we increase the scale to a half-inch for a quarter-mile (2 in. = 1 mi.).

Likewise we can *reduce* the scale of the base map by reducing the size of the squares of the transfer grid on the new map.

Let's take a typical example of a man trying to enlarge a map. Mr. Quid, let's call him, lives in what he considers to be "the finest square mile on the face of the earth," and naturally wishes to make a map of it. It not only has a pond but the pond has an island. And not only is there a creek but a creek with a cataract. It has a hill, too, which he calls Mt. Prospect. There are two springs in the hill, besides a cave, and, if you listen to him long enough, perhaps a gold mine. Anyhow, no arguing with him, it's worth mapping.

He has a U.S.G.S. "topo quad" which he got at the leading stationer's in town. It covers

some 50 sq. mi., and its scale is 1:31,680. So his marvelous square mile is exhibited within the confines of a 2-in. square. If he doubles the scale, he figures he will not get enough more map to bother with. But if he triples the scale (makes it 6 in. instead of 2 in. to the mile) he will have something worth framing, or preserving between the leaves of the family Bible.

True, tripling the scale is giving it quite a stretch, inasmuch as the field scale for making that base map, according to the U.S.G.S. own figures, was no larger than 1:24,000. But let this pass. He knows this mile so well he can go out and make the salient corrective measurements right on the ground and still get home in time for dinner. So triple the scale he does.

He draws a line 6-in. long, and names that "One Mile." His graphic scale. Then he makes his quadrangle, 6 in. each way. And here arises his first question. How fine a mesh should he make for a transferring grid? A quarter-inch is nice to work in; that is, on the base map. On his new map, then, the corresponding lines will be ¾ in. apart.

With a very fine-pointed 3H pencil and a light touch he draws a quadrille of lines ¾ in. apart on his map-to-be. His fair sheet is of good hard drawing paper, and he expects to erase these construction lines with art gum after the map has been inked in. (With softer stock for his map, say, bond paper, he'd have used perhaps a 2H pencil.)

On his base map he clips a sheet of tracing paper very securely, and draws a quadrille of ¼-in. spaced lines covering the section he is transferring.

Now he has his working controls ready. He numbers the horizontal lines and letters the verticals. As he transfers the details, he becomes aware of certain distances. For instance, ¾ in. on his 6-in. scale represents 660 ft. of ground. As he draws some feature, he realizes what this means: 660 ft. distance for every interval the feature spans. To check up he may later go outside and take a measurement. He makes a note on the side rather than at once drawing in the detail. After he has taken all the desired detail from the base map, he goes out on the ground itself and gets notes locating many interesting features the U.S.G.S. passed up but which mean all the world to him.

A surprising amount of topography can be transferred and even originally located by this method of squares.

If you have a pair of proportional dividers, you can adjust them to your scales and measure with them the points on the base map for transference, but if you haven't and must at times guess, you are training your eye in an excellent way. Keep referring constantly to the base map when you are connecting points on the new map. Work slowly and deliberately. The time taken out for cussing and correcting mistakes adds up to much more than is consumed in slow, calm work.

For the quadrilles you may be able to find cross-ruled paper which will exactly suit your needs. The quality of this paper is often good enough to use for the map itself. Certainly, for practice maps of almost all kinds, the right ready-ruling is a great help and time-saver. If the ruling is faint you won't mind it much in the finished map. And if you wish to reproduce the map, the blue ink of the rules will not photograph, and the resultant map will be free of them.

For reduction, of course, the process is just the reverse of what Mr. Quid did. The wide-spaced quadrille would go on the base map and the narrow-spaced one on the new map. For example, Mr. and Mrs. Quid, being very hospitable, have scores of friends in surrounding towns, and wish to send out a standing invitation. What could be better than a mimeographed letter having on the same sheet a map showing the route from the nearest well-known point, some 4 mi. distant? Well, that means re-

ducing his 2-in. base-map scale to an inch-to-the-mile. Just half the scale. So the transfer quadrille for the new map will be just half as wide a mesh as that for the base map.

In this method of enlarging or reducing by squares, what we have been doing is merely applying the simple geometrical principle of "similar figures." Two squares, though they be of different sizes, are similar figures, because they have the same shape. As long as two or more figures have the same shape you can vary the sizes as much as you please and they will remain the same in every respect but that of

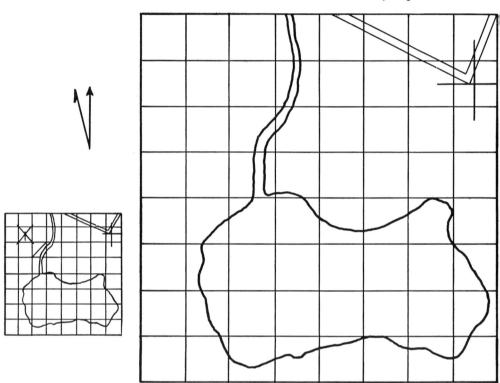

The only boner in figuring that is likely to occur is in thinking that when you increase or decrease the *scale* by a certain amount you are doing exactly the same with *areas*. But a glance at this diagram will show you that when you, for example, double the quarter-inch square to a half-inch square (as you would in doubling the *scale*) you increase the *area* to 4 quarter-inch squares, not just 2.

size. The angles will remain the same. And the corresponding lines will be proportional.

Another graphical trick on the same principle is that of enlarging or reducing a rectangle. Say, you have a map that is x-long and y-wide, and you wish to enlarge it so that x will be X in length. Now, you know how many inches x is and how many inches you wish X to be. But how many will Y be? Yes, you can do it arith-

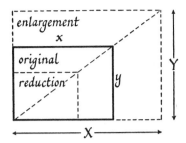

metically if you like to figure. But this is the simple way that most graphic craftsmen do it:

Extend the side x to the length you wish.

At the end of this line erect a perpendicular of indefinite length.

rectangle *inside* the old rectangle, because the new one is to be smaller.

"Similar figures" is one of the most useful of all geometrical principles to the practical mapper. It saves him many a long hike in field work. And here, in compilation, it is very handy in enlarging or reducing certain kinds of features. Long, meandering features, such as shore lines, rivers, mountain ranges, road strips, crooked boundaries, traverses, and the "meanders" in Land-Office maps and plats.

Suppose we have a base map on which ½ in. represents 1 mi. We are compiling a map of twice that scale: 1 in. to the mile. There is a

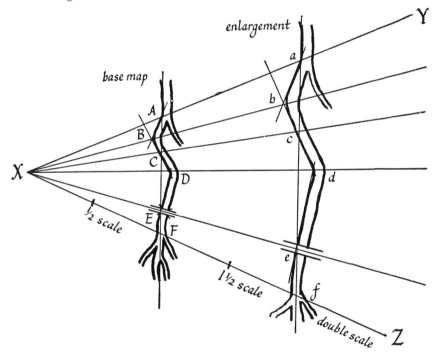

Then from the initial corner of the rectangle extend a diagonal. It will cross the perpendicular at the exact point to define the length of Y, the side of the enlarged rectangle.

In reduction, the process is the same, except that you erect the perpendicular of the new

river running through the base map and we wish to transfer that river to our new map, keeping the enlargement of the bends in scale, especially since we wish to be sure of getting the bridge in the correct relative location.

These splayed lines are simpler than they ap-

pear! They are drawn on an overlay of tracing paper. This is how:

At a good stand-off distance from the feature which we are taking, we select a point X. From this point we draw two rays—XY and XZ—which will cut through the "ends" of the feature, and go on beyond for a liberal distance.

Then, from A, at one "end" of the feature, we draw a line to F, at the other "end." This gives us a base-triangle; see it? It's XAF.

Now, if we wish to double the size of any part of this triangle—particularly side AF—all we need do is to make a similar triangle just twice this size. That's merely a matter of doubling the length of the sides. Add the length of XF along the extension ray XZ. Xf is then twice as long as XF. Do the same operation on the other side of the triangle. Draw line af. It will turn out just twice the length of AF. Triangle Xaf is twice as large as the original base-triangle, XAF.

To aid in taking the curves of the river, extend some supplementary rays through the main points. This will afford us, for instance, the convenience of drawing a smaller triangle like ABC for transferring the detail from there. We have now a frame for imitating very closely the pattern of the base map, even though we enlarge while we transfer.

For a reduction we merely make a smaller triangle, by working *between* the feature and the point X.

FILLING IN THE DETAIL

Whether you transfer detail from previous maps or insert the detail from your own field observations, there is an orderly way of going about it. As you run through these steps on first reading, you will glimpse the underlying cartographical principle: working from the whole to the part.

1. Take the longest lines first in about this order: shorelines, rivers, boundaries, railroads, highways and side-roads, and power-transmission lines. This lets you have a general idea of the map's scope early enough in the game for your hand and eye to get used to it, and so have better control of the many other features.

If it is to be a city map, take the longest straight street first, even though it may not be the main or noisiest. It's the main stem for the map. But if it is the longest straight street merely by virtue of being on the bias, let it wait. Prefer the street, or streets which run parallel with the sides of the map, and so give you right angles to work from.

Here's an oddity about city maps: the width of the streets has to be exaggerated to allow for lettering-in the names. So the blocks may have to take a cut. If this looks like robbery to you, remember a map's purpose comes before anything else. If its purpose is to show what streets to use to get somewhere, then the streets are the feature and the blocks must do the stooging. If, on the other hand, one or more blocks are to be shown, then the streets must be subordinated.

2. Now for the main *spots,* or points. In large-region maps, these would be cities. In maps of but a few miles extent, or less, villages or maybe only a main farmhouse or a school. The idea is that these points are the targets or destinations of the long lines you have just drawn.

3. Now mountains or hills. They had to wait until now, even though they might in actuality dominate the scene. On paper, they have a tendency to hog up the space and get in the way of placing the other features accurately and clearly. Of course, if the whole idea of your map is one certain mountain, that then is the *purpose* of your map and all the other features must let it come first.

It is not necessary or always well to copy the style of the base map in showing mountains, or other relief features. Likely as not these have been put in with drawing instruments you may not possess or have not learned how to use. You

will have more success for a while by copying some of the recommended simple relief conventions which follow this section. In compiling the first few maps, it is advisable not to attempt the contour lines, simple as they may appear. Instead, read their elevations correctly and place the figure beside the name of any site or summit where the altitude would be of interest.

4. Minor streams, trails, and fences. The hills, you see, have told most of these where to get off—or on.

5. Bridges, culverts, mines, springs, windmills, ponds, tanks, and other culture. Use conventional symbols.

6. First check-up.

7. Lettering.

8. Second check-up.

9. Inking in and/or coloring.

Some extra tips. Pencil all plotting lines very lightly. Never let pencil dig into paper. Let pencil lines cross a bit at corners if you plan to ink them later: this will prevent runover. Keep protractor handy for constant check of bearings. Never use a harsh eraser. Accuracy of later lines depends upon an uninjured paper surface. When leaving unfinished work for the night, cover it carefully to protect the sheet from dust and effacements.

SYMBOLS

A cartographic engineer with the U.S.C.G.S. has pointed out that a map or a chart is not merely a pictorial but also "a literary contribution" and that that is why we speak of *reading* maps and charts.° They are like condensed reports, eye-witness descriptions. And the symbols are just "the map maker's shorthand."

Our phonetic alphabet developed out of pictographs. "B," for instance, was once the floor-plan of a house; "M" was the sign for water. However, we are not going primitive when we use pictographs in mapping. These symbols have developed along with mapping, and in your hands they will continue to do so.

° *Aerial Navigation* by Thoburn C. Lyon, National Aeronautics Council, Inc., New York, 1942, Chapters 4 and 5.

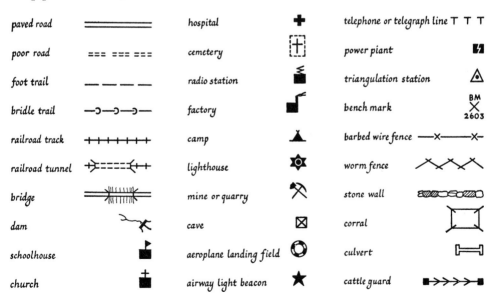

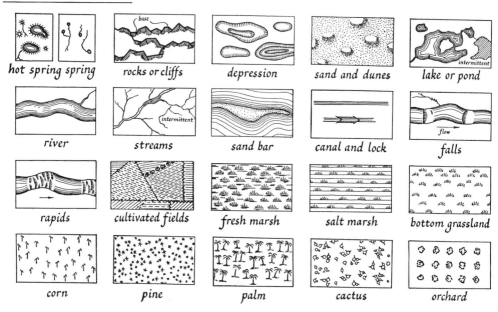

hot spring spring rocks or cliffs depression sand and dunes lake or pond

river streams sand bar canal and lock falls

rapids cultivated fields fresh marsh salt marsh bottom grassland

corn pine palm cactus orchard

There is a knack, a *style* about handling them. In all likelihood the conventional symbols on your base map will not be your style at all. Besides, you may wish to add some of your own. It wouldn't do to mix styles. These shown here are merely suggestive. The moment you put your hand to them they will have to change, the same as an alphabetical character submits to your style. But avoid any elaboration of them if you wish them to be convincing. The more you try to change them for originality the less they will actually have. Try to get their directness, conciseness, and clarity. And while you think you are simply copying them you'll be surprised how your own individuality will come through, unforced.

As austere a mapping organization as the U.S.C.G.S. says to its workers, "It is important that an easy and natural appearance should be given the sheet; more than a mere rigid adherence to conventional symbols is necessary. While there should be no deviation as regards symbols, at the same time the draftsman should strive to represent the country as it actually appears.

"There is a great difference with regard to this among topographers. Comparing two correct sheets of the same section of ground, executed by different persons, one may have a stiff and ungraceful look, while the other will appear artistic and natural, giving at once the impression of a true representation of the country surveyed." [†]

There are many more symbols in many more variations available for your selection, to adopt or adapt in building your own vocabulary of them. Two official vocabularies are the sheet "Standard Symbols," published by the U.S.G.S., and the book *Topographic Symbols*, published by the Department of the Army.

Using conventional symbols may be considered a step toward the pictorial map. Primarily, this is an enforcement of the main meaning a given map is intended to have.

The animated maps of the movies show strict economy of elements to put over a map-notion. In the few seconds that a map is on the screen,

[†] O. W. Swainson, *Topographic Manual*, p. 92.

Pictorial map symbolizing three conventional divisions of U.S. and economic activities of various regions. Note: (a) *synthesis of the denotative and the decorative,* (b) *intelligible design to prevent clutter, and* (c) *absence of irrelevancies**

our eyes must be directed to the salient feature without our loss of whereabouts. A train arrows across the continent to a seaport, where a ship arrives from the opposite side of the map, and a plane takes off. Mountain peaks pass under it. We follow all these motions with comprehension, and when the plane lands we know the place at once by the Washington Monument, which is now used as a map symbol. All because nothing competes with anything else in the map for our attention.

This is a long way from those supposedly "artistic" maps which are no more than mere outlines cluttered up with "Ye Olde Towne Pump" and "Here Ye Game of Golf Is Played" and the like, until, even though the elements purport to be there for aiding us in location, we are more lost and confused than ever.

This is not to say a map should be austere,

always humorless. Make it as pictorial as you like. It can be very engaging so that the user will chuckle or brood over it for hours to see all that is in it—and all to the good. For what is our idea here but dramatizing the map? But be sure the elements bring out the map instead of the other way around: the map bringing out the elements so conspicuously at its own expense that it becomes but an indistinct ghost of a map. A map is not to be smothered like a florist's wire frame; it is not a support for the exhibitionism of somebody who likes to draw pictures. It is itself the picture. Being that, it should have design. The uneasy feeling we get from some "decorated" maps is usually caused by jumbled arrangement, which crazes a map, making it seem more crowded than it is. This can be largely avoided by the rudimentary

* Courtesy of the Bell Telephone System.

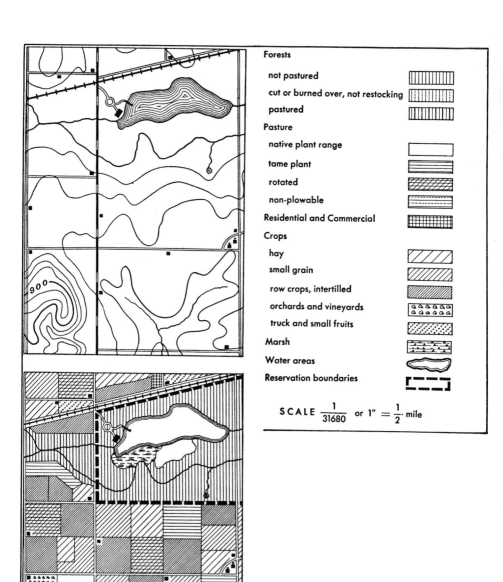

Forests
 not pastured
 cut or burned over, not restocking
 pastured

Pasture
 native plant range
 tame plant
 rotated
 non-plowable

Residential and Commercial

Crops
 hay
 small grain
 row crops, intertilled
 orchards and vineyards
 truck and small fruits

Marsh

Water areas

Reservation boundaries

SCALE $\frac{1}{31680}$ or $1'' = \frac{1}{2}$ mile

Contour map and land-use map compiled upon it, with the set of hatchings and symbols employed

Prepared in Office of the National Resources Committee

principles of composition an artist uses in organizing the detail of his picture—subordination of certain elements to lead the eye along main lines. The idea is to steady the attention of whoever looks at the map.

It can be rich with beauty and wit. In a whimsical map or even a fairly serious one, certain features, certain thumbnail sketches may have a cameo quality, and may appear either in a humorous vein to taunt the scale or in a grave manner to transcend it. But the very pictorial effect of these features is enhanced when all the little mountains and people and their wells and houses and neighboring griffins and ships and dolphins seem to be held within the geography of the map and spellbound by it—as anyone who really likes maps often finds himself.

Symbols are sometimes just patterns. As you may surmise, drawing monotonous lines and dots directly on your map would be tedious and risky. It is more feasible to use a separate sheet and cover it with the uniform pattern, then paste small pieces of this on your map. In shops carrying art and engineering supplies, you can buy sheets of ready-made patterns, in much variety. Some already with adhesive on them. They are called "Ben Day," "Stick-up," "Stick-put," "Zip-a-tone," etc. Where these ready-made applications are not practicable, it is possible to make your own. See "Embossed Patterns for Map Shading," by Stephen L. Stover, in the *Professional Geographer*, Vol. 14, July 1962.

To be sure, a map with bits of this and that stuck to it—though ever so neatly—looks rather makeshift. But make some photocopies of it and you'll be surprised, especially if you reduce the size (*keeping your scale in mind!*) and see the new definition. Reduction sharpens the outlines of images just as it does the edges of blades.

What you have to be careful of if you use patterns all of the same kind but with different values—such as thinner and thinner lines or smaller and smaller dots—is to be sure they will be easily distinguishable when they are on the map. In the margin, tiny swatches of these graduated patterns placed right next to each other, as a "key" to the map, may seem easy enough to distinguish—that is, for *you*. But probably not for somebody else, who hadn't seen them before and selected them. The different weights of line, or the different densities of dots, become harder to discern when the patterns are on the map and far from the key. Still more so when widely separated from each other. Still more so after printing. This happens, too, with tints of similar colors. Professional cartographers, precise about everything else, are often lacking in foresight about this trouble, which even a novice can avoid.

*Cartogram by Fritz Eichenberg, artist,
printed on his stationery as a guide
for his guests*

Perhaps the subject-matter of a map you're planning will claim maximum attention from you and the user while there will be no need for more than the merest minimum attention, if any, to be given to longitude and latitude,

terrain, true shapes and angles of direction, equivalent distances and areas, elevations, etc., despite the fact that these are usually prime geographic requisites for a good map. This supreme emphasis of the *theme* and suppression of the basic geography is often justifiable in single-purpose maps and charts. For example, a simple, terse guide-sketch, showing one or two routes—well-marked or easily recognized—to and *for* one certain spot. Or, as a complex example, an elaborated structure of particular statistics in their particular

*The artist Charles B. Wilson used an
Indian Agency base map for this one*

setting (world, regional, urban, etc.). In either instance you may rightly assume that your reader has a "general geographic idea" of that setting. Once this can be taken for granted, both cartographer and reader can have more paper space and mental room for the single theme of the map.

To accommodate this specific theme, continents or countries of minor political divisions may have their curvy boundaries changed to straight lines and their irregular shapes to geometric ones, all rectangles probably. These might be abstractly similar to their actual shapes: els, broad or narrow oblongs, etc., to facilitate recognition. Also, it is wise to arrange them with respect to their

actual positions relative to one another although the angles of direction won't be exactly right: roughly northwest or southeast will suffice. But the areas may have to be proportional to each other *in terms of the single theme.* A state or province which is small in its physical area but large in population would have to be shown large in its thematic area—the area on paper. It might be the smallest-sized county in the state but you would draw it proportionately larger than the less-populated though larger-sized counties.

Such cartographical designs may become so abstract, so "unlike nature," so diagrammatically symbolic that they cease to resemble maps. A map that must sacrifice to its monopolizing theme many of the basic geographical factors which are usually present in maps is a *CARTOGRAM*.

But there are certain geographical obligations you may have to continue to observe. Even though waivers are to be expected in cartograms, it is wise to reconsider all the geographical omissions and to think all the statistical facts over again, with imagination as well as with scrutiny, before going ahead with the layout. The inclusion of some particular coordinate might heighten the emphasis of the theme—as, say, retaining the 100th meridian, west, in a farm-produce cartogram of U.S. Likewise some physical features: mountains and sea coasts in a cartogram dealing with the incidence of a certain disease, such as goiter.

Ingenuity in symbolizing facts in conjunction with their geographical aspects can be exciting. It has contrived some of the most fascinating devices in graphics. Cartograms are still in an early phase of development. They call for cartographers with special wits, such as imaginative resources in symbolism and design, mathematical acumen, and that

A FARM VIEW OF THE UNITED STATES

TRACTORS

1950

50,000

© CHAUNCY D. HARRIS 1953

*By retaining the relative positions of the states but altering their ground areas and shapes, the cartographer has made each state into a symbol that both identifies the state and represents a thematic quantity. Here the "paper" area of each state is proportional to the number of tractors on farms in a certain year**

* This diagram is one of two examples in the especially instructive article, "Distorted Maps, A Teaching Device," by Chauncy D. Harris and George B. McDowell, in *The Journal of Geography*, Vol. 54, September 1955, pp. 286–289. The authors give these directions for the construction: "First the over-all size of the map is determined. The total quantity is then divided by the area. For example, if 160 million people are to be represented on a map of 32 square inches, the scale would be 5 million persons per square inch. Then the area of each unit is made proportional to its appropriate figure. In drawing such a map it is useful to utilize tracing paper laid over cross-section paper ruled in both directions with ten divisions to the inch. Each square on the paper then is a hundredth of a square inch. By counting these small squares, areas of various sizes can be measured without elaborate calculations. Thus . . . a state with one million people should cover two-tenths, or twenty-hundredths, of a square inch. Its area is easily adjusted to cover 20 squares on the cross-section paper."—Courtesy of Dr. Harris and *The Journal of Geography*.

clarity of logic that many map-readers suppose is "only common sense."†

LETTERING

When using a map, we like to read it without twisting our heads this way and that. So the idea to keep in mind is that the user faces the bottom of the map and reads the names from left to right. The following reminder-diagram,

† For further explanation and examples of the use of symbols in cartograms and in other abstract cartography, see Raisz's *Principles of Cartography*, chapters 19–23, and Robinson's *Elements of Cartography*, chapters 8–10. T. W. Birch's *Maps Topographical and Statistical* and W. C. Brinton's *Graphic Presentation* were published much earlier but contain fundamentals that are still useful.

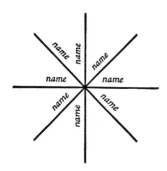

suggested years ago by Major Henry A. Reed, of West Point, is a neck-saver. If your lettering must take a curve, as on an ocean or continental expanse, make it as nearly a horizontal curve as you can. It is not necessary or especially good-looking to make this curve an exact geometrical arc. Zig-zags of letters won't pass muster.

The position of the name with respect to the kind of detail should be as follows:

CITIES. Order of preference is: (1) to the right of city-symbol, (2) below, (3) to the left, (4) to the left and above. The latter choices are often forced in order to avoid crowdings and collisions. Names should be parallel with bottom of sheet, but sometimes a slight bias or a gentle arc will avoid clashes or squeezes.

PEAKS. Same as with cities, unless method of showing relief (hachures, etc.) interferes; then an arc may be plainest.

LAKES. If large enough to contain entire name, allow the lettering to take a direction in conformance with the general shape of the lake. If too small for this, lakes should be labeled in the same fashion as cities. If a portion of a large body of water (cut off by edge of map) is so small as not to allow space for the name, either put the name in the margin of the sheet or omit it, especially if anything so obvious as "Atlantic Ocean."

RIVERS. Most difficult perhaps of all features to letter. Follow the courses. If directly north-south, put letters on western side. See Major Reed's diagram. If stream is wide enough, put name within channel; if not, along bank, preferably above, keeping a clear space of about half the height of the letter between the river and the letters. Mountain chains are treated more or less in the same fashion.

There are two forms of lettering everybody knows: upright, *slanted.* There are two ways of using each of these forms: ALL CAPITALS. Capitals with lower-case. This gives us four styles of lettering names on maps:

ALL UPRIGHT CAPITALS

ALL SLANTED CAPITALS

Upright Capitals with lower-case

Slanted Capitals with lower-case

A cartographer adopts some definite scheme for using these four styles to go with the different classes of map features, according to what he thinks is an order of importance.

Here is a useful scheme:

1. States, counties, cities, etc.—all upright caps.
2. Towns, villages, etc.—upright caps, with l.c.
3. Bodies of water, large rivers, etc.—all slanted caps.
4. Smaller streams—slanted caps, with l.c.
5. Contour numbers—slanted, all other numbers upright.
6. Public works (dams, railroads, bridges, etc.) —slanted caps., usually of smaller size.
7. Other map features—upright caps., of smaller size.

Put the title all in capitals, either upright or slanted. The rest of the matter in the margin generally looks well in slanted characters, capitals with lower-case.

Don't bother to say "Map of —"; you will have doubtless done too well to need to remind

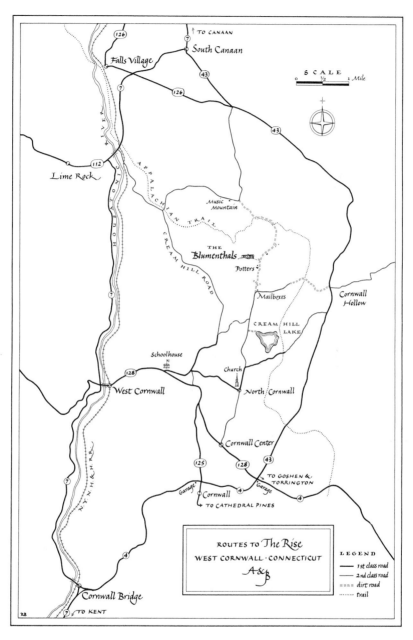

Guide map for guests, by Rey Biemiller *

* Courtesy of Mr. and Mrs. Joseph Blumenthal.

One stroke: a b c e g h i j k l

m n o q r s u v w y z

Two strokes: d e f p t x

One stroke: C I J L O S U V Z

Two strokes: A B D G K M N

P Q R T W X Y

Three strokes: A E F H

H. Scott

Alphabet of easily made characters

anybody it is a map. But own up that it is your work. Sign your name and give the date.

If you already have had some practice in mechanical drawing, you may wish to use that kind of lettering on a map, and there is no law against it. It is certainly better than sloppy lettering. But it is pretty rigid-looking stuff for anything so close to nature as a map. Freehand lettering, even of moderate homeliness, seems to have more life in it.

Whatever you do, don't mix freehand with mechanical. It is quite all right to draft some guide lines with a light touch of a hard pencil.

The lettering demonstrated here is one which is gaining favor among cartographers.

As Hilda Scott shows the trick of it we can see how it is a *written* style. This is more pleasing in a map, usually, than the drawn letter or painfully built-up "print." It is a basic "hand" and very easy to acquire. In the lower right-hand corner, above the calligrapher's signature, we see the broad pen that is used, and both its broadest and narrowest strokes. No stroke can be broader than the breadth of the nib, nor narrower than the thickness of the nib's edge. Between these two extremes, though, occur the beautiful gradations. They are merely a matter of what direction you move the pen. The secret of getting them is not pressing upon the pen, nor twisting

194

it: simply holding the pen the same through-out, that is what so agreeably thickens or thins the stroke as the direction of the movement changes. Within a single stroke you can almost reverse the direction without lifting the pen, as in making the *h*. Down for the shaft, and then up again for the arch. In forming some letters, it is necessary to lift the pen, viz., to make the crossbar on the *t*. Likewise to make the lobe on the *p*. Each new stroke requires lifting the pen, but the pen is not lifted except for a new stroke. Never push the pen directly against its broad edge, as one does a chisel or shovel.

Anyone with but a little graphic knack and some liking for pen forms will surprise himself how quickly he gets on with this lettering. The slanted—"cursive"—character is easier than the upright to learn. Keep the slope 5° to 10° from the vertical. The height of the *o* is about four to five times the breadth of the pen. This will hold for the upright alphabet too. Perhaps the only letters which you may have to form differently from the sloped forms will be the "a," with its hook coming over the lobe, and the "f," which need not descend below the line.

For practice, begin with the *i*. Next, the *n*, and then the *c*. Follow up with *a, d, o, q, s.* The letters in the illustration are exaggerated in size, so as to show the stroke-direction arrows clearly. Using a much narrower pen and making much smaller letters will speed your mastery of the form for mapwork.

Avoid tiny, crabbed lettering. Make lobes open. Exaggerate the lobe in *e* if your hand-writing is prone to let it close up blind. It is better to exaggerate the height of lower-case letters than of capitals. If you keep your capitals down to the height of the "l," or even a mite under, you will be surprised at the trig effect.

The one thing that gives lettering "that right look" is uniformity of heights and slants. After that, the telling qualities are: even weight or shading of lines, regular spacing, and a kind of

Cabeza de Vaca en la América del Sur

Same alphabet as p. 194, in a map °
(See also the agreeable
lettering in Peattie's map, p. 239.)

rhythm which is fun to feel while you are doing it (or only fooling around with a pencil) and very agreeable to look at. Gradually, follow-ing these few requirements, your hand, almost without your realizing it, develops skill in shap-ing the letters.

To spare your fair sheet the mistreatment of much erasing, try a few names at a time first on a bit of tracing paper, to see how they "fit." If you plan to ink in the map later, be sure to use the lightest touch in penciling, because graphite on paper fights ink.

° Drawn and lettered by Hilda Scott. From *Siglo de Aven-turas* by Arjona, 1943. Courtesy of the Macmillan Com-pany.

*The western cartographer Norton Allen compiled this panoramic from government base
material, personal observation, and photographs °*

INKING IN

Perhaps by now you will feel the map is complete, and rather than go on to ink it in, you are eager to try another map. That would be good sense. By all means do so. Neat pencil maps are better looking than unsuccessfully inked maps. And it's the actual mapping practice you are after.

Skill in inking can well afford to wait while you develop skill in plotting and compiling accurate layouts and in drawing neat, convincing topographical features.

But sooner or later you will come around to the bottle of waterproof ink. Wash your hands, dust off the sheet and all the drawing instruments, adjust the light so that no shadows are in the way, and go to work.

Here is the odd part of the job: the lettering is inked first! Just the reverse of the drafting order. The reason is that a bit of mountain, or river, or boundary line can be nipped off by a

letter or two, and nobody will miss anything. But nip off a part of a word or letter and it is ruined.

The remainder of the order is: Symbols of various culture detail. Relief, such as "caterpillars" and "pine branches" for mountain chains and hills, hachuring, etc. Rivers and water lines. Roads and railroads, canals, etc. Boundaries. Parallels. Meridians.

Extra hints and warnings: Ink circles and arcs of circles before you do the straight lines, because it is easier to make a straight line tangent to a circle than vice versa. Ink horizontals before you do verticals. When lines meet at a point, ink *from* the point, if possible. Working toward it piles up ink at the meeting point. Always let one line dry before inking another to join it. Dust off every speck of erasing litter, room dust, etc. from sheet; any tiny bit of it is likely to foul your pen. Pull out thumb tacks, scotch tape, etc. so that your sheet will be free

° Courtesy of *The Desert Magazine.*

for shifting into convenient working position. Keep a protective sheet for the hand to rest on, since oil from hands or hair, though invisible, will prevent ink from taking to the paper. Good idea to use this sheet even while doing a pencil draft. Never put an ink bottle on the drawing-board. Never dip or fill a pen over the board. Replace the cork after every fill. Keep pen clean by frequent wipings. A good trick is to wrap a piece of wiping cloth around first joint of middle finger on left hand (on right hand for southpaws) like a surgical dressing.

COLORING

In the early grades our teachers thought to make geography more interesting for us by the device of letting us color maps. Children like to splash color around. Not so, real map-makers.

Putting on color is serious business, a vital operation which might kill the map. A good coloring job adds, sometimes, to the pleasant-ness of a map, but beware of the "oh, what lovely color" impulse.

Coloring a map is serious, also, because color can sometimes be very useful. The U. S. Aeronautical Charts have some of the contours colored in, to accent different elevations. This facilitates quick reading where the reading must be quick. The American Geographical Society employs on its great maps of the Americas layer tints to show topography. Color is excellent for indicating geological formations, soil types, land classifications, historical changes, and human and other distributions. It can even substitute for lettering and conventional symbols.

Even in informal maps, though, use color with logic and taste. Rivers and creeks should be a deeper blue than the expanses of water. Tints along boundaries can give the entire map a colorful liveliness. Contrasts help out the concision of the features, but garish clashes

cheapen a map and may unjustly give it an appearance of poor drafting. Faint colors make strong maps. A little knowledge of color perspective may come in handy; for instance, that red comes forward and hits you in the eye, and blue retreats and gives you a sense of distance.

Before applying the color be sure the sheet and all the tools and materials are "clean behind the ears." Do not wet paper before painting, unless you are certain that the kind of paper you are using will not swell and buckle. (It usually will!) Use a faint wash: it looks and works better. Mix more than enough of each color.

Work on a slightly inclined drawing board, 5° to 10°, so that the color will flow nicely in your general working-direction, down toward you. Lay color on in horizontal strokes, from top downwards, with a full brush, never once letting the working edge go dry. Pick up excesses by first squeezing brush dry. Any attempt at retouching or patching-in will wreck the train. Allow the map to dry in the inclined position on the board.

Play around with the colors before risking them on your map, to see how they behave. The chances are the greens will tend to spottiness. Does your yellow dry yellow?

Every map, even a minor practice chart, is an adventure and experiment.

HOMEMADE TERRAIN MODELS

Except as an instructive form of play, making your own terrain model usually becomes more fuss and mess than it will prove to be worth in actual cartographic service. It is liable to take up too much space in your room, and to be so bulky and breakable that you can't safely move it or store it away when you tire of seeing it gather dust.

Yet if a terrain model is carefully and taste-fully made, then put in a somewhat permanent public situation (library, school, local-

Inner structure of terrain model built by "step method":
contoured layers mounted on a base board °

history museum, hotel lobby, country club, chamber of commerce, county court house, etc.) its fascination and helpfulness may become a continuous performance for a long time, especially if it is a mapping of the home region.

But you may have to allow yourself one or two failures before you'll make a map that good. A map rather than a crudely literal miniature is what it should be. But unless you can bring together some extraordinary skills, instruments, tools, and materials, don't try for more than ordinary precision. Nobody is going to base any construction work or property claims on its measurements.

It should be trustworthy to sightseers and plausible to old-timers: visitors will use it to get an overall, unified impression of the region; residents, to get a coordinated, enriched conception of the total home scene. It should be neat and a bit pretty, even if the terrain itself is not; that is, the *work* in the map should be. It should give anybody "a good general idea" of comparative distances, rather than strive to be everywhere "made exactly to scale." It should show slopes where a walker would notice any; it should show them accurately enough, at least so that they wouldn't have runoff water going the wrong way—rather than attempt to indicate the ex-

° Courtesy of the Department of the Army. For more details of this and other methods, see *Terrain Models and Relief Map Making*, TM-249, Department of the Army, Washington, April 1956.

act grade. Probably the most important to get as true as you can are the angles of direction and the respective positions of features and objects. Next in importance are their shapes as viewed from one quarter or another.

But remember, their entire aspect must be what you see from *above*. Or from afar. By placing your eye down at the base of the model, you wouldn't see those shapes as if you were standing at that particular point on the ground but as if you were at enough clear distance from there that the smallness of those features in comparison with your own size would seem but the result of perspective. Perspective! Keep it in mind throughout the job.

Now for the actual method. If you have read this chapter from the beginning you will know virtually all the precision procedures needed. As for the rest, you will perhaps find that using a few main hints, in trial applications, will prove more congenial and effective than studiously following several detailed processes.

The use of plyboard, as hinted in Chapter 5, is fundamental to the most feasible method. The material may be wood, fiber, cardboard—any tough nailable or glueable sheeting with *uniform thickness*. For you must keep in mind the relation between the thickness of the contoured layers and the vertical scale you have chosen. This must be probably three or more times larger than the horizontal scale, even though you may have already planned *that* to be larger than it is in your base map, whose contour planes you are using for the outline patterns of your contour layers.

After you have fitted these and fastened them one on top of the other, your skill changes from that of tailoring and carpentering to sculpturing. So the next principal hint has to do with the plastic material for covering the contour planes.

Here are two formulas developed by the U.S. Navy[*]:

1 pint sawdust (ordinary)
1 pint plaster
½ pint library paste (the white kind)
3 drops Le Page's glue

Dissolve paste in water to thin slightly.
Add glue; add plaster; add sawdust; knead to a consistency of tough dough.
Test: *Setting time:* 8 hours.

2 pints newspaper pulp (wet)
1 pint plaster
¼ teaspoon Le Page's glue
½ pint water

Soak newspaper (torn in small pieces) in water over night. Rub wet paper between palms until it is ground to pulp. Add glue to water; add plaster; add pulp. Knead to a consistency of heavy dough.
Test: *Setting time:* 3 hours.

These doughs when dry will take poster paints, tempera, or oils.

If your terrain is of a desert region or shows large parts bare of vegetation, the very earth from those grounds might make good symbolic colorings. Sift it fine and uniform, even if it is rock dust. At first try various adhesives elsewhere than on your model, until you get a thin stickiness that will hold the colored dust without changing its natural shade.

TRY IT ANYWAY

A few suggestions to prime the pump. There's no use making a map, unless there's a use for it. So, don't do it "just for practice." Motivate yourself.

Sometimes we never get a notion of our need for a map until once we lay eyes on a good base map, just as the acquisition of a

[*] *How to Build Terrain Models.* Navexos P-296. 1945.

"Then-and-now" map of a city neighborhood *

good earthenware beanpot reminds us of our
need for the nutriment of truly baked beans.
Maybe you have some base maps lying around
the house that you thought were only maps.

Many people who live in the suburbs would
be less lonesome if they did their friends the
favor of making a small map showing how to
get to their house from the station or the main
highway. These maps or "hospitality" carto-
grams can be small enough to go on the home
stationery, which in turn becomes more suit-
able than ever for writing invitations upon.

Local history provides an authentic call for
maps. The map of Harsenville, for example,
was made in the Readers' Association of the
Riverside Branch Library in New York City.
The section shown is now a thickly populated
part of upper midtown, but with a little re-
search in the library and an old map or two to
compile from, the amateur cartographer has
made a contribution to his library's archives.

There is many a large American city whose
various sections were at some early date sepa-
rate villages. And as for small towns, nearly all
have gone through a metamorphosis since the
pre-highway, pre-railroad days—and how few
local residents today have any idea what their
town was like then! An early picture of the
place, even in the form of a homespun map
made today, is very likely to be cherished.

A small scale map of the country or the
world can be a base for a fascinating map of
a family's genealogy, or of where its members
are now scattered, or of the distribution of
alumni, or of the mother-colleges of a teaching
staff, or of the routes of the pioneers of your
community showing the original homes they
left behind, and an inset showing the sites of
their first, here. Maps nobody else will make
for you, or could as well as you can.

* Courtesy of Riverside Branch Library, New York City.

A map's over-view best shows "how it happened" *

And one of the best ways of expressing one's love of a home region is to make a map of it showing the features which create that affection.

The local newspaper may not maintain a cartographer, but things happen every year worthy of showing in a bit of map. A child is lost, and people throughout a county stop their work to join the search. What better report for the paper and record for the library than a map which retraces his wanderings and shows the place of his rescue? Likely as not it can be based upon a U.S.G.S. quadrangle—with perhaps some important additions by the mapper who may have a bit more intimate feeling for his native heath than one should require of a visiting official engineer, however goodhearted. Old road maps and topographical sheets may suggest a map that might lead to a system of bike paths or ski grounds. The mapping of a highway accident or crime is a patrolman's, or state trooper's, job but it is no

less that of the capable citizen who happens to be a witness of the incident or who comprehends the scene. Such maps have value not only in court and insurance investigations but also in the public forum of the press or civic billboard, as graphic arguments for highway improvements. Homemade maps, like homemade speeches, can be powerfully convincing. Patrick Henry's argument was homemade, like the maps of George Washington's surveyors. And the Declaration of Independence. (Peter Jefferson, and John Henry, fathers of Tom and Pat, made the first truly good maps of Virginia.) In fact, this is a homemade nation. And just as the ordinary citizens renew the vitality of their government by now and then putting a hand to the work usually done by their professional statesmen, so the amateur mapper with his wit and enthusiasm, and occasionally some anger,

* Accident maps should have true distances and angles. They can often tell more than photographs, from which, though, they may be compiled with great accuracy.

may contribute liveliness to cartography, which should not be limited to the workaday output of the professionals.

Too many professionals are lacking in the very feeling for style or the kind of tactfulness you may already have to bring to a map. They have lost the sense of what a map looks like to a person who doesn't draw maps but needs them very much. Their scanting of good taste in their colors and letters almost becomes an indifference to good manners. For some excellent advice on the esthetics and intelligibility of maps, see "Art and Common Sense in Cartography," by Richard Edes Harrison, in *Surveying and Mapping*, Vol. 19, March 1959.

8. Basing Maps upon the Ground: SURVEY

<<<<<<<<<<<<<<<<<<<<<<<<<<<<<<<<<<<<<<<<<<<<<<<<<<<<>>

IF BY NOW YOU HAVE compiled a map or two, you will go out into the field with something of a practiced eye. Even when you were compiling maps you perhaps discovered yourself looking at the familiar country about you with a different eye. Wondering about the bearing of this road and of that fence; the distance of a bridge from a crossing; the way of a creek. The country became *terrain* to your eye. You began to visualize it on paper.

TAKING IT IN YOUR STRIDE

The next time you are out walking, let the notion come over you to count every time your right foot comes down. Whether you are in town or in the country, just count, or grunt, or squeak every time your right foot comes down. Keep doing this until it seems a habit, kind of mechanical. For a man, just an ordinary walking man, is a pretty good measuring instrument.

All he needs to do is let the legs do the walking, same as always, naturally as ever. He keeps count every time his right foot comes down. He does not tell the right foot when or where to come down. The right foot tells *him* when to count. And there you have the whole mechanism.

After you have got the mechanical knack of counting every time your right foot comes down, get a tape and measure off 100 feet on the old tramping ground. Now walk over that stretch and see how many times your right foot comes down. Do it several times. Four or five, to get the average number of strides per hundred feet. Then you've got your own number for good.

Say it's 20 strides per hundred feet. Chances are, it will be a number like 21 or 17; but let's have round numbers here in this explanation. Now break that figure down: 20 strides per hundred feet means 5 feet per stride. 2½ feet or 30 inches per pace or step.

A stride is two paces. The average man's stride is 64 in.

It may be exciting to discover that you can sprint 100 yards in 10 seconds flat, but it is more important to find out how many strides your legs take in naturally walking that distance.

After you have become accustomed to striding over smooth ground and level roads, perhaps you would like to take your measure over mixed ground,—both level and up-and-down—according to the U. S. Army method.

Lay out a stride course, ½ to 1 mile in length over the type of ground that most of your mapping must be done on. Measure this length carefully with tape, and state the length in inches.

Then with your regular weight of clothes and mapping materials, do two round trips, counting every stride each way.

Take the average of the four figures. If any

one-way trip differs from the average by more than 1%, throw it out, and stride another trip and another, until you get an average that is within 1% of every total that composes it. Then you'll be sure.

Finally, take this average figure of the number of strides and use it to divide the number of inches the stride course is in length. That will give you the average length in inches of your stride on average terrain.

Now that you know something about yourself you did not know before, put it all down in your notebook for keeps: it's your individual data and personal business. How many strides to the mile? Half mile? Quarter, eighth?

Keep private tables of your stride factor, so that you don't always have to stop during a survey to do the figuring. A five-foot stride is .0009 + of a mile. What fraction of a mile is *your* stride?

There are, also, some interesting variations in strides. A person takes a longer step when fresh than when fatigued. So, be sure when you are estimating your stride or are measuring various distances, like the sides of an area, you get well rested after one hike before doing the next. Otherwise there will be errors. It's

wise to stride the longer courses first. If you are older than 25 you may find that your stride has a tendency to decrease as your age increases, year by year. If you are under that age check your stride periodically for increase.

An important fact to keep in mind is that it is the horizontal distance between two points (not the sloping distance) which a map should show.

The length of stride changes also on a slope. A person walking uphill takes shorter steps (paces) than when walking downhill on the same slope. And those downhill steps are shorter than the steps he takes when walking on the level.

However, if you're doing a grade of less than 10% (about 5½° slope) it will hardly be worth your while to trouble about the difference. The best accuracy you can hope for on the level is likely to have an error equal to that difference anyhow. Some striders do not take the slope into account until they strike a 15% grade (between 8° and 9°).

For methods of measuring and expressing slopes, see pp. 228–231.

Every craft, trade, and profession has many tedious phases, and this counting of strides is

Sketch map by Bartholomaeus Columbus, 1503.

the map-maker's monotonous moment. It isn't so bad, though, if you keep thinking of your map and don't let mere legwork blind you to the pride you will take in that map. Professor Debenham, who trained explorers in map-making, received from one of his former students a map made in Kenya, involving a stride count for 280 miles!

Pedometers are good for tallying the number of miles in hiking, but for the smaller distance-takings of a map survey, they are crude and erratic compared to a pair of legs under a head that knows how to count up to a hundred or two.

Automobile speedometers tell you only tenths of a mile and so might prove useful only in route-mapping where you have considerable distances of roadway not already measured for you. Bicycle cyclometers on straight, smooth roads might help with measuring some parts of a long, otherwise rough traverse. But if you wish to get the intimate feel of a mapper's survey by beginning from scratch, forget all the 'ometers awhile. It's no disgrace for a handmade map to be footmade too.

SCALING THE DETAIL

The moment you look over the field of the prospective survey, scale considerations begin. What scale you will choose will depend upon three relative necessities:

> Size of the place to be mapped
> Size of the sheet to hold map
> Size of detail to go into map

Again the *purpose* of the map is the deciding factor. The chances are that since you will not undertake a very large field for your first try or two at surveying, its size will not be an unaccommodating element. Indeed, you may soon find that you can achieve the object of your map as well, or even a little better, by taking less ground. The size of the sheet, though, might be the largest piece of good paper you can get, and that would be that. Nobody in his heart can blame a fellow with a fine expanse of fresh paper before him for wishing to use it all on a map. But then it may not be sensible. Perhaps the best use for the map will be within the leaves of a book rather than on a wall. Framing a large wall map is expensive and not framing it is often exposing it to very early destruction. Large maps are sometimes easier to make but always harder to keep.

Now, if within the scope of that sheet you can put all the features you desire to show on the map without crowding or haywiring it, you're all set. If not, you have a little conflict on your hands. Showing these features, *all* of them, may be all that matters. It may be imperative enough for using *two* sheets, or even two *walls*. But very rarely. It is well to regard putting in a great amount of detail an early temptation. And to resist that, consider these few points:

There's no end to detail. No one who uses the map will wish to know every little crinkle in every little rill. And the very width of a pencil line itself may scale some 10 or more feet on the ground!

Over-detailing often defeats accuracy. But good healthy generalizing, while appearing to neglect accuracy, often expedites it in the practical operations which the map is intended to serve.

Remember that when profiling a contour we must often use two scales, the larger one for the vertical measurements in order to make them visible on the map. Likewise with features: almost always they must be drawn out of scale. So, while alertness to scale is one of the marks of a good technician, awareness of the unscalable is part of his commonsense. He does not select too much scale-defying detail. In that way what accuracy he is able to impart to the map will appear to keynote it. Accuracy must not be snuffed out.

A map may be thought of as a show window, but even in that trade the art of selection and suggestion counts.

The watchword, then, in the age-old strife between scale and detail is to keep your map free to realize its main purpose as a map.

THE CONTROL

Here again we use the good old cartographical principle of working from the whole to the part. Having an overall framework of guide lines with which to control the details is a fundamental in all surveying, whether for a map of the home-town golf links or for a map of the nation.

Three methods of surveying are very useful for plotting controls: the Distance, the Compass Traverse, and the Plane Table. They are easy to understand and to apply in a great many different practical situations. Let's take one at a time, as any one of them will suffice for a map.

Believe it or not, the first is surveying without a compass.

1. FOOTMADE MAPS— OR THE DISTANCE METHOD

Conditions are not always favorable for the use of a compass. Nor is an ordinary compass a first-class aid to accuracy in surveying.

Many a good mapper takes pride in his rough-and-ready ability to survey simple enclosed areas without compass or theodolite.

The only distance apparatus needed is a pair of legs. For this is a way of mapping by striding. No angles to fiddle with.

But *tri*angles, yes! The whole business is based on the simple seventh-grade geometrical principle that if you know how long the sides of a triangle are, you don't need to know what the angles are in order to construct another triangle just like it. If you doubt this, or have forgotten, try this refresher: Mark off three lines of random lengths. Assemble them in a triangle. That is the *only* triangle that can be made of them; it has exactly those angles.°

° This is the surveying method called *TRILATERATION*. Although it's the one that Boy Scouts often begin with, it's also about the last word in precise survey by aircraft or satellite. Moral: There's nothing too rudimentary in surveying and mapping to be important in a final showdown.

Of course, you can cut each of those given lines into one half its length, and what will it get you? A triangle just like the first in shape, different only in size. That's all we want. If we know the little fellow is just half the size of the big fellow, we'll have the big fellow's number cold. Same thing if the little fellow is 1/2400th the size of the big one. In other words, we hold the big one to scale.

Now with a pad of paper, a sharpened pencil, a pair of wing compasses and a ruler, let's go out into the field to apply this principle.

The tract of land we have to map, certainly, is not a triangle. But we divide it into convenient triangles. The line *BD* which cuts the four-sided area into two triangles is our "tie line." That's a good name for it, because it ties up that quadrilateral for us so that the corners are fixed. A quadrilateral, unlike a triangle, can keep its same sides and change its angles; but throw a tie line into it and you've roped it.

So we measure *BD* by striding it. As we have decided on a scale of 1:2400, our map will be just 1/2400th the size of this tract of

land. That means drawing on our note pad a line *bd*, just 1/2400th the length of *BD*.

Now we measure *BA* by taking another walk. Its little brother is *ba*, 1/2400th as long. In order to plot *ba*, fix the compasses to a radius of that length and mark an arc at *a*. Then after measuring *AD* to get *ad*, repeat this process with the compasses, marking the other arc at *a*. There you will have little triangle *abd*, an exact replica in miniature of big triangle *ABD*.

Next, do the same to get triangle *bcd*. The control is now plotted. But how can we be sure that it is right?

CHECKING UP

"The easy checking of all work done is one of the maxims of all surveying," says an old-timer.

The easy checking of this control is apparent in the line *xy*. This is known as the "check line" or "proof line." It is simply a fourth line drawn in one of the triangles between two

known points. We know by strides the distance from *B* to *X* is so many feet, and from *B* to *Y* is so many feet. Therefore we know where points *x* and *y* should go. Then comes the test. We stride off *XY*. It is so many strides or feet, which according to scale should be so many inches on our map. Say, 5 ins. Now, if we draw a line from *x* to *y*, and it is 5 ins. long (or about that) we know we have plotted triangle *abd* accurately. Check triangle *bcd* in the same way.

Do not expect hairline accuracy. However, you will find it good self-training to set yourself a limit of error.

What percentage should this be? It all depends upon the character and extent of the terrain. Let us assume that you have selected a small piece of good ground to practice upon for the first map or two. For it is wiser to give yourself easy terrain and be moderately strict, than to give yourself difficult terrain and be too lax.

Now, suppose that check line instead of being 5 ins. is 5⅛ ins. What does that eighth

of an inch mean? According to your scale (1:2400) it represents 25 ft. gone wrong somewhere. You know it could not be in the check line distance you have just done in 20 strides, for with your five-foot stride that would mean 5 strides out of 20! So you have missed somewhere on the perimeter of triangle *ABD*, which you walked around in 150 strides. That's 750 ft. The error is 25 ft. in 750 ft. That is 1/30th the total figure, or 3⅓%. A little too much, don't you think? After all, a thirty-foot house looks pretty big on a 750-ft. lot. An 8th of an inch is not exactly microscopic on a 10-in. map.

Well, being boss of the survey, you tell yourself you will allow up to 3% error. No more. That is 22½ ft. Maybe you'll be even stricter, and make it check within 15 ft. A 2% maximum error. It's up to you.

There is no point in this self-criticism if you have no way of finding what caused the error. The first guess is "Did I blunder in my figuring and plotting?" Did you convert the number of strides to the correct number of inches? Did you plot the lines correct to scale? Did you have an awkward land triangle to work with—one having "illegible angles"? (See pp 225–226.)

Select a better tie line: one that will give you more manageable angles. After making these tests, you may reasonably suspect a miscount of strides. Re-stride the longest side first, for on it are the most chances of error.

FILLING IN DETAIL

Before plotting the accurate framework just explained, you will save time and extra motions by making a rough sketch of the survey triangle in a notebook. Do this even before you begin striding the triangle.

Then, striding away from your first station, you are already on the lookout for detail sig-

nificant enough to go into the map. You see a gate far ahead, leading to the windmill. But long before you get there, at the 14th stride, you are passing an old well-head on the left. So, you make a dot and jot down: "Well-head —14 s." The gate comes at 26. (If you wish to convert this to feet then and there, do so. 130 ft., then.) At 44 strides you cross a bridge. Symbol for bridge. Scribble figure: 220 ft.

And so on. Pick up details along the tie line. Likewise, along the check line. Thus, this little walk does double duty. In fact, a longheaded surveyor always tries to place his auxiliary lines where they will not only help him to plot a framework but also to fill it in with topographical features at the same time.

Some landmarks will not lie directly on your course. Note down, then, at how many strides or feet along the course, you are directly opposite them. For instance, while striding a lane, you find at stride 43 the lane passes nearest the house. About 75 ft., judging by the eye. Jot that down. Eye-judgment is worth cultivating too.

Should a landmark lie too far off the course for *guessing* its distance, measure it by striding to the object, if it is directly accessible from the main survey line. Obviously, the line you take must be at a right angle with the survey line. Determining this right angle by eye-judg-

ment is professional, and will save you time and prove good practice. In surveyor's language this trick of locating topographical features off the main survey line is "by offset." The line for instance, which the man is striding, is an *OFFSET*.

Another way is to consider the object at the apex of a minor triangle. Points *x* and *y* are known points along the survey line. What's more, you know how many strides between *x* and *y*. All you need to do is stride the other

two sides. Then plot that triangle, and you'll have that object accurately located for your map. This trick involves much walking, and it is called for only if there is obstruction, like a hill, marsh, forest, or just bad striding ground immediately between the object and the main survey line.

OFFSETS

Linear features like roads are easy to measure by striding. But a hedge is a linear feature too. So is a brook, the edge of a precipice, a straggling stone wall. We can't stride them, but we can stride a straight line running along beside them so as to form what is called a "meander." And at certain distances along that line we can measure offsets to the crooked feature. Like this:

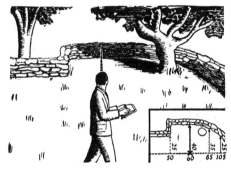

In your notation be sure every offset has two figures: its position on the survey line, and its length from the survey line to the crooked feature. A few salient offsets are better than many finical ones.

The device of measuring offsets is also useful in other methods of surveying, which we shall soon consider.

EXTRA SUGGESTIONS

Before making even the rough layout of lines, walk over the area to plan your procedure. Try to find a straight, level, walkable line that crosses the entire area. This line may not appear in the final map, but it will serve as a survey line for taking many details. If it can serve as a tie line and a linear feature also, that's a combination of luck and good judgment.

Pick out *all* points which will serve as stations (that is, *A, B, C,* and *D*) before beginning to measure.

Be sure that you can see one end of a tie line from the other. In fact, on the other survey lines also you should be able to see from one station to the next, but this is not always possible.

It will save much time and figuring if you try to get along with as few triangles as possible. Don't be afraid of long lines: if they reduce the number of triangles, the longer the better.

Pick out points for check lines that will run close to any important detail, so that you can pick up features on the way, or only a bit off the way.

If you have a clear and accurate assemblage of data in the control framework and notebook, you can safely leave the field and finish the map at home.

2. THE COMPASS TRAVERSE METHOD

Instead of a framework of triangles to establish a control for making a map we can use a series of straight lines. All we need to find out is the lengths of those lines and the compass directions.

This kind of control—the *TRAVERSE*—requires less walking than the previous method.

With just an ordinary compass, you are up against the only difficulty that will confront you in this method. But the amateur mapmaker who will delay his mastery of traversing (and of the compass) until he can get an expensive prismatic or lensatic instrument is giving himself a worse steer than the cheapest compass will give him.

Give yourself a break, and select a traversable area for running a compass traverse. That means, don't try it in a city, where proximity of iron, steel, and electricity cause compass deviations. Open country, sparsely settled, is the best for practice mapping. It should have some ready-made traverse lines which might serve as a boundary for the map. These would be roads, lanes, trails, canals, etc. Each length of these should be a straightaway from station to station of the circuit. In the absence of these advantages, try the edges of groves, shorelines, streams. Or lines struck boldly out straight across country will serve as traverse courses. This last resort requires having visible points (trees, rocks, or stakes driven into the ground) by which to align the course.

For the first map or two, run a traverse having a circuit of not over two miles. Even then, the roads should be straight for fairly long distances so that you don't have to take bearings of more than eight or nine courses. If the country is rather thickly settled and the roads or other traverse features have frequent bends, you will get plenty of initial practice by contenting yourself with areas of from ¼ to ¾ of a square mile.

Another advantage of the method is that no plotting and drafting need be done in the field, only a rough sketch of the survey with clear notations. All you need besides a compass are a pencil, a ruler, and a large notebook with stiff covers.

To give you the general idea of the method at a glance, here is how a "memorandum sketch" of a traverse circuit might look:

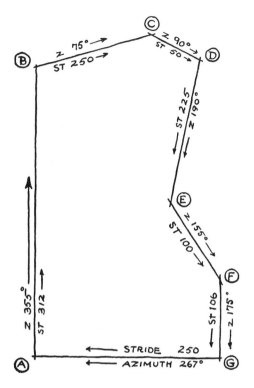

the next azimuth, that of line *BC*. Then the next distance. And so on, around the circuit, back to *A*. That, essentially, is the whole story.

(If your compass card is the surveyor's style [see pp. 57, 67] the bearing of the first course, from station *A*, would read, "N 5° W." The last course, from station *G*, would bear S. 87° W.)

Note that he jots down only the number of *strides* of each course. He does not need to convert these distance figures to feet, out here in the field. He may or may not yet know what the scale of his map is going to be. After he gets home he can convert his stride-figures to any scale he decides upon before actually plotting the map.

PLOTTING FROM FIELD NOTES

When our mapper gets home he plots out the entire bare framework of the traverse before putting in the detail. For, if anything went wrong in this *control* all the detail that had been prematurely put in would be wrong too.

He decides just about where on the sheet the first station of the circuit would be. Good tip: Do this as preliminary plotting, on tracing paper. Once you have scaled off the circuit, so that you see the extent of the map, you can judge to a nicety where to place the map on the sheet.

Indeed, the plotting begins with scale work. Deciding upon the scale is the first step. If we examine the plotting figure of the mapper whose field memo we have just seen, we shall find that he has decided upon a scale of 1 in. for 500 ft. He has a 5-ft. stride. This means for 500 ft. he made 100 strides. So for every 100 strides he noted down in the field he plots an inch on his map at home. Stated briefly, his plotting scale is: "1 in. to 100 of my 5-ft. strides, or 500 ft."

Because we are accustomed to think of the upper part of maps as northerly, we are likely to select for our first line (*AB*) one that runs somewhat in that direction. Certainly, whatever place we take for our starting point, we must begin by ascertaining magnetic north. But it is good sense also, that this should be a well defined point, such as an intersection of roads or any other ready-made lines.

Take your compass sight up the middle of the road. If there is a curb or row of posts, all the better for alignment: use them instead.

Thus, beginning at *A*, this mapper takes the magnetic azimuth (north) of line *AB*.° Makes notation. Strides line *AB* for measurement of length. Makes notation. At station *B*, he takes

° In this chapter, all examples of direction finding will be in terms of azimuths from the north.

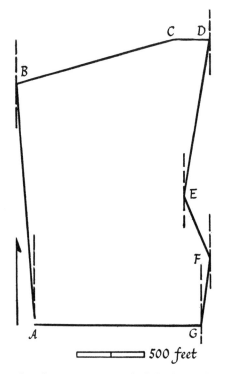

$\boxed{\quad\quad\quad}$ 500 feet

Thus, line *EF* is 1 in., which by his scale is 500 ft. Back in his field notes this distance was put down as 100 strides.

You will not always find that the scale you would wish to have your map in, is quite so pat to your stride as his. Your stride may not be an even 5 ft. Nor can you always get it an even 100 times into the scale-inch. But for the time being, these round numbers will enable you to see the more easily how stride-count in traverse becomes scaled distance in plotting.

Let's take over his draft and assume it is yours in the making.

At the point on the sheet where you have decided to put station *A*, draw a line to indicate magnetic north. (If you use cross-ruled paper, place station *A* on a vertical line.)

With protractor at point *A*, lay off the number of degrees in the magnetic bearing of line *AB*.

Then on this angle lay out the line *AB*, according to scale.

At station *B*, draw another north-south line (parallel to the first, of course).

With protractor at *B* lay off the bearing of line *BC*. Then its length.

And so on, around the circuit.

MAKING ENDS MEET

Unless unusually lucky coincidence favors you, the last leg of the traverse will not close up smack at *A*. If it doesn't, take it easy. This *ERROR OF CLOSURE* happens to professionals. It may be due to a single mistake somewhere along the line, from the first compass sighting to the final plotting at home.

At one of the stations, the compass may have been deflected by unseen iron. One leg of the

traverse may have been over particularly diffi-cult striding ground—brushy or soft. To err is human; to find just where the error occurred, and then to correct it, is scientific. The discrep-ancy, however, may be a compound of mis-takes: miscount in striding, boners in compu-tation, slips in penciling, etc. Often these mis-takes, instead of adding up, will cancel out each other, an excess here will compensate for a deficiency there. This gap, then, is as much error as shows up in the picture.

In professional work there is a maximum al-lowance of closing error. The gap at the end of

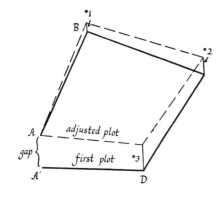

the traverse must not be greater than a certain fraction of the entire length of the traverse. (See p. 17.) For example, in a third-order traverse figure of a rural area, for which the standard allowance is 1/5000, the mapper must not have a gap greater than 1/50 in. if the perimeter of his plotted traverse is 100 in. In military map-sketching the allowance is more liberal: 3%, before the mapper is required to do the work over. That would be a gap of ¾ in. in a 25-in. traverse polygon. But these profes-sional fellows (both civil and military) work with more or less highly precise instruments such as you are not likely to have.

So give yourself a reasonable allowance. Be-sides, it is an old rule in mapping never to squander time and energy on more accuracy than the *purpose* of the map calls for. Leaving the gap open is nothing for the beginner to be ashamed of. It's a candid confession of an hon-est error too implicit in the job, considering his equipment, for him to root out. Of course, if the gap is so wide that it swallows him, con-science and all, he will best go back out into the field and do the survey over, welcoming the extra practice, and perhaps learning more thereby than if he went on to a new job. But even after a recheck he may not get a closure.

However, for the sake of appearance, you may desire a neat closure in the final draft. And why not, if the map is manifestly not intended for too precise a use? Professionals, if they have not exceeded their strict allowance of error, will arbitrarily close the gap in even somewhat precise surveys. They call this an "adjustment of error of closure," and they have a clever way of apportioning the blame fairly throughout the traverse, so as to make ends meet. Here is how they do it:

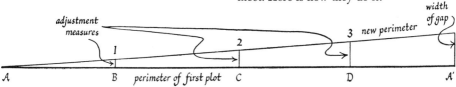

First draw a line across the gap.° Then, parallel with this gap-line draw lines through the other stations (B, C, D). Now on a single straight line lay out the perimeter of the ailing plot. Mark off on it the legs of the traverse: AB, BC, etc. At the end, erect a perpendicular. It should be the same in length as the gap. Connect the end of this line with A, making a triangle. Next erect perpendiculars at B, C, and D. The hypotenuse of the triangle will cut each of these at just the right measure for you to use. Take each of these measures to the corresponding station in the plotted figure, and mark off the parallels drawn through those stations. Through these marked points, now draw a new perimeter. Your new figure will close up snugly.

In a very small error of closure distribute the adjustments around the stations with your eye.

FORESIGHTS AND BACKSIGHTS

For rapid, rough compass traversing, a single sight at each station as our mapper did it may suffice. Perhaps he was working in a place so over-forested that he could not see from one station to the next, and was lucky to have at least some straight lines (such as a path here, a fence there, etc.) to use for estimating angles.

But if the next station is visible he would surely sight upon it. Thus, in the illustration of the traverse on p. 212, the sight from station A to the next station forward, B, is a *FORE-SIGHT*.

Now, suppose before he moves on, he can also see what will be the last station when he completes his circuit: G. That's a *BACK-SIGHT*. It's a pity if he doesn't take it, because having those two azimuths at station A is going to ensure better accuracy of the angle in that corner. Similarly, when he occupies B, his first shot should be a backsight upon A.

° Gap is exaggerated in illustration for clarity.

OPEN TRAVERSE: ROUTE MAPPING

A traverse does not always have to bite its tail. Not all traverses are circuits. Usually, in fact, they are open. Just routes from one place to another. The route traverse is an old favorite with explorers, scouts, and soldiers. They simply make a map of their line of march while traveling along it. (The same as we did with a closed traverse.) The work is speedy and without fuss. At each turn of the road the

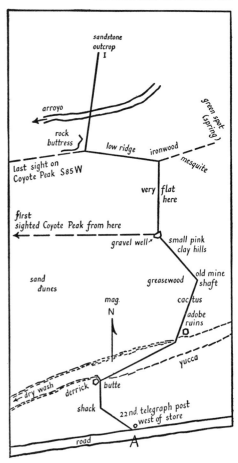

mapper stops only long enough to jot down the distance from the previous point of record and to take the bearing of the present turn. At the end of the trip he has a record of his tracks from *A* to *I* and also a pretty fair notion of where *I* is from *A*.

People are often puzzled by the meaning of "dead reckoning." Well, this is it. Only, this happens to be on land. On water, or in the air, noting the traveled distances is a matter of figuring speed and time; that's the only difference.

There are times on land when the traveler is virtually "at sea": in flat, heavily forested country, for example, where the going is very much as in a fog because one is unable to see from one place to the next. Or where there are no peaks or other eminences to keep an eye on for one's relative position. On rescue missions into lava beds. Or expeditions into bad lands. Or long treks across undifferentiated plains or deserts as hummocky as a rolling sea. Then's the time for some "instrument flying" on the ground: the compass traverse. The worse the country the better the compass must be, and the compass-user.

He will be a hawk for any distinctive details along the way to mark his route and supplement his necessarily short-sighted bearings. If by good chance he gets a glimpse of some distant eminence, familiar or not, he takes a sight on it and notes its bearing as soon as he "finds" it and again at least once more just before he "loses" it. But he will note down whatever immediate marked features he can find at every turning point and what kind of vegetation or terrain the map-user later should look for between these stations, so as to be reassured as he follows the route. The best way to use a compass on traverse is to read it carefully as if you had nothing else to go by, then at once supplement it with other observations as if *they* must do for both compass and distance count.

In desert and other more-or-less roadless re-

gions negotiable by auto, fair traversing can be done by setting the trip wheel of the speedometer 0.0 mi. at some known initial point, then recording distances while passing marked features and when making turns. Always drive the car a good distance ahead, and walk back to the turn for the compass shot.

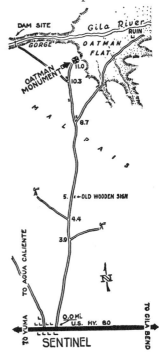

Speedometer traverse (inset to map, p. 233) [*]

The purpose of this loose kind of map is to show the traveler how to return, or the next man over the route how to take it. The compass traverse is made only when no other method of mapping would be either suitable or possible during the expedition; it is merely a slender thread through a labyrinth. It does not provide a strong enough control frame for a map of the region; it is only a feeler into new country be-

[*] Norton Allen says, "Material was gathered as we bounced along over the desert trail northward from Sentinel, Ariz., watching mileage and direction."

fore the coming of the real surveys. But often, with prayers of thanks, it has been a lifeline. A way of mapping all travelers should know.

Debenham, in his excellent book, *Map Making*, tells of "an official method of traverse in regular use" in "parts of West Africa where the jungle is so dense that visibility is reduced to a few yards at a time, and winding native paths are the only means of progress through the forest. . . . A rope, two or three hundred feet in length, is dragged along ahead by an assistant until it is taut. By this time he is completely invisible, and the rope is a series of short straight lines from one tree trunk to the next. The forward man then halloos a few times and the rear man takes a bearing to the sound. This is repeated for each length of rope. The plotting is done just as for a normal traverse except that a deduction for the curvature of the path is made for the distance between each station. Experience has shown that a very reasonable accuracy can be attained, and that the errors compensate each other to a large degree." Of course, these traverses are later trued up to fit within external traverse lines made with precision instruments.

FILLING IN THE TRAVERSE

Unless the control lines are themselves roads or other topographical features that will interest the map-user, they will be erased in the finished job, like scaffolding which is torn down as soon as a dam is finished. They are then only construction lines.

But sagacious is the mapper who selects for his control lines as many as he can find that will later become part of the actual map. In addition to the lanes, curbs, fences, etc. already mentioned, one part of the traverse may run along a river bank, or a shore, or at the feet of steep cliffs. That is, he may have a meander, and take in his detail by offsets, as in the Distance Method, a few pages back.

Also, from that method, he may pick up detail on the courses as he strides them.

As for the minor triangle, though, now that he has a compass to use, he may save himself some legwork. He can work the intersection trick. Remember it back in Chapter 4 when we were using it to locate features on ready-made maps?

First locate the reference points (*R* and *S*) by stride count on the traverse line. Then sight from them on *T*. So, with two angles and the base of a triangle known to you, the correct

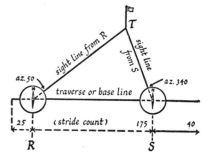

location of the flagmast at *T* will show up on the plotting sheet. The beauty of this trick is you need never leave the road, but can thumb your nose at "No Trespassing" signs, and ignore ferocious dogs, bulls, and poison ivy. It enables you to locate objects across rivers, lakes, swamps, and on distant hills.

Still another trick to add to your bag for locating details is that of *RADIATION*. Like the

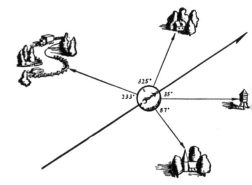

duck hunter who stays in one place and shoots at various angles, you shoot compass rays from one position toward various objects. But after you have hit your "bird" you have to stride out to it to get it. A matter of angle and distance.

These, then, are our four methods of locating detail:

Distance (pick-up on line while striding)
Offsets (eye-estimate or actual measure)
Intersection.
Radiation.

They and the following notebook hints apply not only to traversing but equally well to the other kinds of surveying discussed in this chapter.

When the field notes are completed they should show a rough plan of what you have measured and all the details you will care to have in your map. These memoranda may be in the form of symbols and abbreviations but should not be cryptic, for at home where you will institute them in the map you will not have the terrain to look at for interpreting them. Perhaps because mappers are realists and know that nothing in the drafting room is likely to become more accurate than it was when put down in the field, their notebook entries have almost the neatness of finished work. This direct legibility is probably not so much a matter of skill as of shrewd provisions for use of notebook space. Instead of ruling the rays full length for intersections until the field sheet becomes a madhouse of crisscross lines, make them no more than ¼ or ½ in. long—just enough to mark the located point and show its azimuth from the station where it was sighted. Then label the point: "hospital chimney, lone pine, big rock," or whatever it may be. As for the dummy polygon which you've roughed out to serve as a field figure, even though it be pretty large in the notebook, it may soon become cluttered with details. But an entire polygon isn't necessary for noting down offsets, intersections, or radiations. All you need do is to take one side at a time. The leg AB, for example. Set it down, off by itself, as a single straight line labeled "AB" and use it as a base line for your locations. You won't forget it's a leg of the traverse, a side of the final polygon.

This will bring you so much notebook space perhaps that you will be tempted to take in details on *both* sides of a traverse line, and thus fatten out the map. Go ahead. A traverse is not a stockade to confine the mapper and keep out the features around it. It's a frame for supporting any topography it can, inside or outside its enclosure.

Compass traverse made by Washington at the age of 17 [*]

Geologists and other naturalists often use the compass method in fields full of scattered features, such as dunes, tussocks, rock clumps, etc. They pick up the knack of sketching a complete map right out in the field. Sometimes not making a traverse at all but working from a single base line.

You can make as many intersections from a line as you like, or can get on the sheet. If it's a good strong line, one whose magnetic bear-

[*] From *The George Washington Atlas*, Washington, D. C., 1932.

ing and length are sure, your shots will be well-backed. In order to transmit these shots to the sheet, you will of course need a protractor. Upon drawing the first ray for each point, label that point, so that you will remember it when sighting for the cross ray.

Let us accept the fact, though, that this sketching cannot often be accurate. It's not for precision mapping but for what we might call a "general idea" map.

If, because of its importance, you should wish to intersect some distant feature more accurately, take a third shot at it from some point on the base line. The chances are when you plot the third ray on the sketch pad you'll find that the line won't exactly go through the point where the other two lines cross. That shows one, or two, or maybe all three rays to be a bit wrong. So take a bearing from a fourth point, a shorter ray if you can. Then the choice will be between two of three intersections: the two nearest to each other. If you favor the shorter rays in making your choice, your guess takes chances involving a smaller area of uncertainty.

You might have a notion to get out on one of your best intersected points, because it is a bit more in the clear and will give you an unimpeded farther view for enriching and extending the map. Good. From that vantage point you can take some short radiations. Then while standing there, you might sight on the stations from which you had intersected this new point you now occupy. In other words you will now intersect on yourself, which of course is resecting. (See p. 72.)

A curious discovery will result. Take either of the two rays from the base line. You're now on the back end of that ray. From the base line the azimuth of this point, was, say, 50°. But now if you look back, and from out here take the azimuth of the base-line point, it will be 230°. Just 180° difference. It always is. That's a practical instance of back azimuth.

And it's useful to know. Suppose you are away from your base line but not on an intersected point. To be frank, you don't know exactly where you are. You've found a spring of good water not visible from the base line, and it ought to go into the map. Just where?

Well, although you couldn't see the spring from the base line you can see two very definite yellow rocks on the base line from the spring here. So you resect. Two rays toward those two yellow rocks. One rock is at azimuth 200° from here, the spring. But what you want to put on the map is just what direction the spring is from the base line. Naturally, the map-user will try to get to the spring from some point on the base line, which is a road. Then what is the azimuth of this spring from that yellow rock on the base line? It is: $200° - 180° = 20°$.

So 180 is a magic figure to use whenever you wish to know what a bearing might be if you were looking back from the other end of a ray.

3. THE PLANE-TABLE METHOD

Our third method of surveying is the most interesting of all to do. One can hardly browse through an account of its various operations without wishing to go directly into the field and do them.

Although it is not the most accurate method of surveying, its degree of accuracy can be very high, and if one appreciates how high that might be in any given case as compared with the two previous mapping methods, plane ta-

bling is the quickest. In practical surveying, plane-tabling is expressly for map-making and for that only.

The fortunate part of this is that you are already acquainted with the principles. In Chapter 4, when you applied a sight rule to a map, pivoting the rule about a point so as to aim directly at an object, you were carrying out the essential operation of all plane-tabling: sighting on a distant object to get its bearing, and drawing a line along the edge of the rule to indicate that bearing on the map at hand, whether that be a ready-made map or a map in the making. That's the whole thing in a nutshell.

For example, while we were doing our route traverse, we may have come to a stretch where we enjoyed good intervisibility of stations. We might have lost our compass, or decided to use it only for orienting ourselves with respect to magnetic north, then do our sighting with a rule instead. Our notebook has a stiff back. We lay it on the ground, take a backsight at the previous station, draw a ray. Then, keeping the notebook absolutely fixed in its position, we turn ourselves about it, and sight on the next station, ruling that ray. We get an angle which we ticket with the name of the station. If we have been careful, our error will be less than 3°. Our notebook will look something like this for the first half of the route, p. 214:

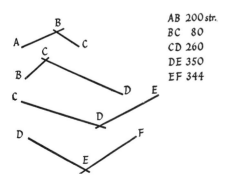

AB	200 str.
BC	80
CD	260
DE	350
EF	344

Now, if you wish to do some plane-tabling in earnest, make up your minimum equipment. The more you keep it down to a minimum at first the more fun you will have and the more likely you are to go through with the business. This is the works:

A plane table
A spirit level
A sight rule
A hard pencil
An eraser
A compass
A pocket knife
A piece of sandpaper
A sheet of drawing paper

The plane table is a drawing board mounted upon a tripod. It can be a kneading or large bread board swiped from the kitchen, if you can get away with one, and if the top is smooth enough to draw good lines upon. A suitable size is 12 x 17 in. As for the tripod, it can be one taken from a camera, or, if you have a knack at carpentry, made with a block and three sticks. It must satisfy two requirements: *Portability,* for you will have to tote it from place to place, taking it down and setting it up again. *Fixedness,* because once you have oriented the board at a station it must stay that way, else the least rotation will make all the subsequent sights cockeyed. Even a bridge table will work, though it's usually springy and a bit low. A plane table should be at least waist high so that you can bend over it to work without being tempted to lean upon it. It should be set up dead level and kept so.

For a sight rule use a 6-in. triangular rule. Its apex edge is the sighting edge, and it can be any one that happens to be on top, but the ruling edge must be the best you can get and must be the same one for every ray. An old faithful to you: in fact, draftsmen honor it by naming it "the fiducial edge," and guard it against the ravages of ruler-biters. If the sight

rule is marked off by tenths it will speed up your computations. Another improvement is to bore a hole through it lengthwise (on a lathe) and fill the bore with lead to weight the rule against the wind's shifting it on the table. But whether you do so or not, it is a surveying instrument. In more elaborate forms it is known as an *ALIDADE*. Alidades are quite expensive, ranging from those with peep-sight vanes to those with telescopes, levels, stadia arcs, and what not. We can have more fun with our triangular rule. Lay it on a plane table and we have the equivalent of the horizontal circle of a theodolite.°

Along with our fiducial edge, most precious to us is the point of our pencil. That's what the sandpaper is for, fastened to one of the legs of the table. After shaping the point on the abrasive, many draftsmen polish it on a piece of rough drawing paper. In the final showdown, all the expensive equipment and the toil of a mapping project are concentrated at the point of a dime pencil. Depending upon the hardness of the paper, use pencils from 2H (on tracing paper) to 4H.

As simple as the equipment is the fundamental process of the plane table. It consists merely of orientation and sighting. As you do this at selected stations, moving from one to the next, the map (not just the plotting but the *actual map*) grows under your hand right out there in the field! You need no helpers. No notes. The original stuff is there before you as you work on the first and (if you wish) final draft. It's mapping direct from nature, at first hand, like a painter with a landscape.

To orient the table, first be sure it is directly over the station. The smaller the area and the larger the scale you work with, the more this counts. If, say, station *A* is a peg in the ground,

° In Raisz's *Principles of Cartography*, pp. 44–45, is a model of the homemade plane table and alidade. The latter has a pinhole peep sight through which you can read distances on a rod (or *stadia*, which is its technical name) marked off with graduations.

the point "A" on the plane-table sheet ought to be directly above the peg. Now set the board to a compass direction. An aid to this is to lay the compass in a corner of the sheet that will not be included in the map and trace a line around the box. When the needle comes to rest, mark a ray at the point a good way out into the sheet. That is, a magnetic north pointer. Thereafter keep an eye on the needle and that pointer, watching that they stay in line. When you set up again, at another station, place the compass within that outline of itself and rotate the board till it is in line again with the magnetic needle. Rotate the board *only for orienting it,* and once that is done the only thing left to rotate is the sight rule.

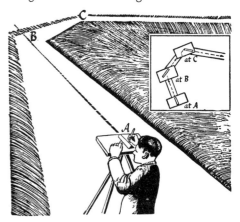

To use the sight rule let the near end of it rest on the point which indicates the station you occupy and aim the other end at whatever you're shooting. To rotate the sight rule so as to bring it upon your objective, use the nail of the little finger as a pivot. Using a pin is easier but it's bad for the sheet and pock-marks the working surface of the board. Sight with both eyes open, facing the facts, not asquint. Some plane-tablers stand back a bit to examine the shot before drawing the ray. Some with a little practice learn how to stand sideways to the object and sight on it with the head bent to

one side. This puts you in a good position for drawing the line the moment you have made the sight.

That's the process of the plane table. Now for its application. Intersection, resection, radiation, traverse, and triangulation—all take place on this board with ease and swiftness. And in the combination of these few basic operations (for the most part already familiar and all simple) lies its versatility.

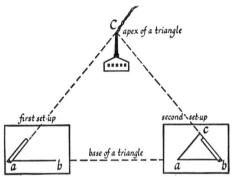

Take intersection. In the example opposite the purpose is to locate the chimney. (It might have been a mountain peak or just a reference point for lining up other topographic features —the principle is the same.) *A* and *B* are known points. When the mapper set up at *A* he oriented his table and fixed it tight. Then, sighting on *B*, he drew line *ab* an indefinite length. After sighting on *C*, he picked up and went over to *B*, counting his strides on the way, and marked *b* according to the map's scale.

When he set up at *B*, the first thing he did after orienting was to take a backsight on *A*. In fact, taking such a backsight *is* orientation. Plane-tablers always, after they have left the initial station, supplement their compass orientation by a good clean backsight and never consider themselves sitting pretty until they've done so.

The resection is the old story of "Where am I?" Here the mapper knew where the tall tree

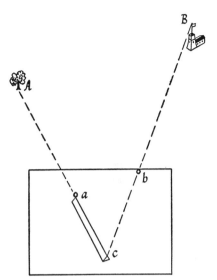

and the ranger station would go on his map, but he was standing on an old well cap, let's suppose, which he couldn't see from either of those places. If he could have seen it, he would have intersected it from those stations, as we saw the fellow do in our previous example. So he came over to the well cap and set up over it, oriented by compass, and sighted on *A* and *B*, drawing the rays back upon himself to cross at *C*. His position. That's all resection is: intersecting on yourself to mark down where you are.

PITCHER'S VIEWPOINT: THE RADIAL METHOD

Radiation on a plane table is the same as with a compass: stay in one place and aim the shots at various points around you. A whole map framework can be made by this kind of sighting alone.

The mapper places himself at the center of his field like a baseball pitcher on the mound. It must be a very definite point from which he can see all the outer points he wishes to get into the map, and they must be easy to stride to directly. For, after he has sighted upon them he must measure their distances. Then he scales these off on the rays. Connecting the distance marks with lines, he gets the shape and boundaries of the map. Because the radial method involves a great deal of walking, more than a pitcher may do in 9 innings, the field for mapping ought not to be much larger than a baseball field.

Perhaps a better analogy would be to say that in the radial method you work as though you were right on the North or South Pole on a fine balmy day, making a map. For all your reference lines are now polar coordinates.

Be sure to make the table fast to its orientation, checking with the compass ray as you move around the board, sighting. Instead of a center dot, a tiny hole pricked with a fine needle makes a good hub for this miniature "polar" map. Also, in all these plane-table operations remember the trick of keeping the map uncluttered: not drawing rays full length (as perforce must be done in these illustrations). Make only short, sharp slits. And on the objective only. None on the station point, which is a dot or needle prick and so is a plain enough mark to go by already, but which will be buried out of sight if pencil lines converge on it.

The radial method is useful in landscape-garden mapping. For the city man who needs a good airing and some weight taken off, it's an excellent combination of a desk job and outdoor exercise. And most pleasant when done in the center of a fine wide meadow in early spring.

MAPPING ON THE MOVE

Traversing with a plane table is faster work. Especially route mapping, when you'd have to walk the distances anyway to get somewhere, even if you weren't making a map. All there is to it is: orientation, backsight, foresight. And maybe an intersection or two. Some plane-tablers set up only at alternate stations if there is plenty of intervisibility and if the skipped station (some strong object, like a windmill) is at enough of an angle between the other two. Then by a foresight on it from the earlier station and a backsight on it from the later station you get an intersection. By running a careful, short route-traverse, taking features on *both* sides of the road, you can make a pretty interesting area map. The traverse line is the axis, so to speak, of a somewhat symmetrical map. One of the easiest and most gratifying practice jobs for the beginner to try.

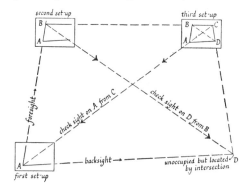

A closed traverse with a plane table is the same as that with only a compass, but more graphic and trustworthy. Note in this follow-

through illustration how the true shape of the area evolves on the board in but three steps. At *A* the plane-tabler, after orienting, sighted on *D* and *B*, getting two sides of the figure at his very first set-up! It's a good idea in plane-tabling to draw a bead on as many visible stations and strong features as you can from the station you occupy. These auxiliary rays not only help you keep a check on your work as you go along but they hook in a lot of detail for you as a bonus.

Here, then, is the entire control framework for a map (and perhaps much of the map itself); it's made with nothing but intersections.

Why didn't the mapper occupy *D*? He didn't have to. Or maybe, he couldn't. Perhaps it was a lighthouse a half mile or so out in the water. Of course if he wished to occupy it the advantage would be still better checking: backsights on the entire job.

Anyhow, there it is, the whole control framework done in the field. No reading and recording angles. No computing of the resulting triangles to draft them, because they virtually draft themselves directly upon the map. No notes and intermediate plottings to make mistakes in.

Distances? Well, if he counted his strides from *A* to *B* that's all the stride-counting he'd have to do for the entire framework. He'd then have the scale of the map and every other line of it would be in true and easily measurable proportion. Say, between the first two stations is 1,000 ft. (12,000 in.) and line *AB* is arbitrarily drawn 10 in. long. Then the RF is 1:1200. To find any other distance, say, *B-C*, all he needs to do is to multiply its plotted length in inches by 1200. Thus, in the midst of making the map, when it is but little more than begun, he can already use it to measure the country with.

There is even a quicker method of making a map framework with the plane table, with even less walking.

TRIANGULATION SAVES SHOE LEATHER

Triangulation is a difficult word for an easy job. Whenever we do an intersection, you may have noticed, we make a triangle. One triangle for each intersection. Well, if we did more than one intersection from the same base line we'd get more than one triangle on that base line, and that would be triangulation.

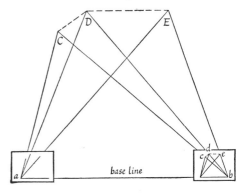

base line

The whole procedure becomes obvious with a moment's pondering of the illustration. Note that the mapper made the complete framework at only two stations, *A* and *B*. The only difference between this job of intersecting and the others we've watched him do is that here he intersected on more than one point. At *A*, instead of taking a sight on but one distant point he sighted on all the sharp distant points he could use for indicating the bounds of his area and his map thereof. The steeple of a church, maybe, or a radio antenna, or a powerhouse chimney. Notice also that when he finished the intersections at *B*, he got his triangles and all he had to do was connect their top points, apexes, with lines, and lo and behold he had on his plane table an exact replica in miniature of the entire field. The same shape. And to scale.

Triangulation is the mapper's choice in hilly

regions where walking is hard and sighting is easy. If your base line is a level stretch of good striding ground on an elevation and you can see from it all the other points which you'd like to get into your map but can't get to with your board, fine. Take it, and take it easy. Or if you find a good base-line possibility in a valley where you are surrounded by your mappable country, fine too.

Good triangulation can take place on *both* sides of a base line. The base line does not need always to be at the bottom of the map merely because it's the foundation or base of the map. It can be in the middle and act as spinal column, a main stem.

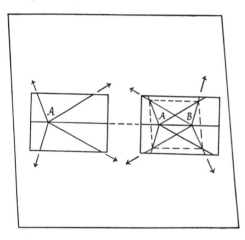

Here again, the picture of the mapping job itself explains everything plainer than words can. Again we see the map begun at one station *A* and completed at a second.

One thing to notice particularly is that the plane-tabler this time began by drawing the base line straight through the middle of his sheet. Forthright as that. And why not? Isn't the actual base line somewhere in the middle of the field? In fact, after he set up and oriented at *A*, he sighted on *B*, and so the very first ray he drew was his base line.

Thus, by only making intersections from a

base line you can lay out a complete map. And without measuring any distances at all. For one thing, you may not care especially about stating any actual distances on the map and will want to show only the general shape of the country and the correct locations of a number of places in it, their direction from one another. For another thing, the country might be so rugged that it is impossible as striding ground for the measuring of distances. Triangulation station *A* may be on one mountain peak, *B* on another. And the line between them

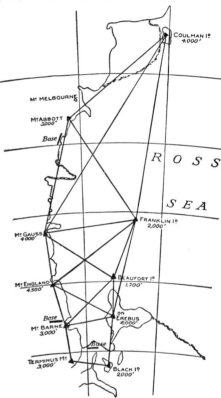

Triangulation scheme in the Antarctic by Debenham °

° From British Antarctic Expedition, 1910–13–Report on Maps and Surveys by Frank Debenham. Committee of the Captain Scott Antarctic Fund, London, 1923.

nothing but an airline. But it would still be a good base line.

With a very simple plane-table outfit and by this rough-and-ready method one person can map a considerable spread of country. Rough mapping, yes, but very tolerable—and practical, at that. He can extend his survey to take in still more country by going over to one of his intersected points and setting up at it, using the back ray between it and A (or B) as a kind of secondary base line for further triangulating. In fact, it is in this way that the great official surveys, especially the U.S.C.G.S., have spun networks of triangulation from coast to coast. (See illustrations, pp. 18 and 237.)

Should our lone mapper at any time during his survey come upon a nice piece of strideable ground which lies along one of his rays, and if he takes a notion to measure it, that's all the measuring he need do. It will scale off on the map he has drawn thus far.

By taking backsights on previous stations so that he will have three rays instead of only two going through each, he can improve the precision of his work. For the third ray is a means of checking his work. If it goes through the point where the other two rays intersect he will know he has done a good job.

CHECKS, BALANCES, AND PRECAUTIONS

Such a coincidence of three lines on a single point, though, is not likely to be frequent with a beginner, or even with an expert using this rudimentary equipment. But neither need the error be frequently very serious.

But what should "serious" mean to us? A good way to answer that is to look at the tiny triangle that the third ray makes where it crosses the other two. If it had crossed them at the point where they cross each other that would be a good fix and this small triangle would not be there. So this little by-product of error you can consider your triangle of doubt.°

Well, how big is it? If it scales so small in terms of actual distance on the ground, not enough to throw the map-user off so that he'd get lost, then you can assume that a point in the center of the tiny triangle will make a safe compromise position for all three lines to meet.

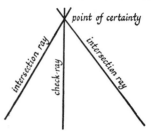

Sometimes, even though the pesky little triangle is not little enough to dismiss, the point involved is not important enough to count: it is not a place that the map-user is likely to

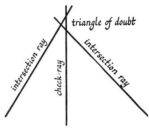

visit. Then rather than utterly disregard the uncertainty, a conscientious mapping would call for noting that fact. Some mappers make no bones about it. They classify locations as to order of accuracy. If a point is of first-order accuracy they place-mark it with a small, neat equilateral triangle. A point worthy of the

° This is not the "Triangle of Error" which occurs in resection from three points and involves a solution of greater difficulty to understand than would be suitable in this book. Should the beginner attempt a resection from three points with a plane table, to locate his position, or else to check it if it is a previously intersected one, he should be extremely careful of his orientation at every sighting. Then if he doesn't get a good fix, the tracing paper method, p. 72, will help him.

name of triangulation. Such points would be the *A* and *B* of their base line and important or outstanding places that pilots are likely to use to sight on for lining up with a course. The main corners of the map should also be first-class points if possible. If a point has been checked and found but slightly off so that it may be improved by adjustment, a tiny ring around it will show it's of second-order accuracy. If a point has not been checked, or if a checking indicated it as off, though not enough to spoil the map, the point is not honored with a mark but left with the rays confessing the error. If the mapper has a good idea of what the correct position is, he marks that with very lightly penciled rays, so as to improve the point later, either by going back over the work or by future intersections.

However, there is something curious about sight-rule errors as compared with those of the compass. If you make a mistake sighting with a compass in the first corner of a survey, that corner will be wrong both as a bearing and as a corner. It will throw the next corner off too, but not the *next* bearing. If you get that next bearing correct you will stop the error at that point, so that when you get to the third corner and take a correct bearing you will also have a correct corner. Not so with a sight rule. If you go wrong at any one corner you'll throw all the subsequent corners off, and with accumulative effect. Cartographers call this a "cumulative error" because it gets worse and worse.

Then why not use that compass as a stop-gap! Why stake everything on the sight rule? Here you're at the source of the worst errors in plane-tabling: *failure to keep oriented.*

The plane-tabler must watch and check his orientation constantly; before every new sight-ing and ray-drawing he must look at his compass line-up to see that the table hasn't been jarred or budged in the least. Then, before picking up and going to the next station, he reviews the intersections he made at the present station. A good way is to begin doing this by laying the sight rule along the first ray you drew at that station and seeing whether it still sights on the first object sighted at that station. If the table has accidentally moved any, this first sight will appear off. So re-orient the table dead on that first sight (which of course was a good one since it had been made directly after orientation) and then do the other rays over in reverse order—beginning with the last one you drew, until you come back to a good ray. Naturally, this will be the last good one before the table shifted.

If you have no compass, or suspect local magnetic disturbances, a good practice is to begin by taking some long direction-shots at a strong object or two far beyond the bounds of your map. Sharp summits are good for these direction rays. Two or three such rays will aid you also in accurately resecting yourself at outer stations and at points you may not have located by intersection.

Another precaution is at every station to sight all previous stations and locations. Back-sighting saves backtracking.

Errors often result from selecting ill-defined objects to sight on. These should be sharp and unmistakable, steadfast and unelusive. Mappers, for instance, get so that they hate tele-phone posts. You can't always be sure that a post is the same one you selected from a previous station, one post looking so much like another. Treetops wave in the wind, and rare is the lonesome pine whose shape is as clean cut as a spire. The shape of a house gable changes with your position. Hillocks, dunes, crags, crests, brows and the noses and cheeks of cliffs are deceptive.

To prevent the sight rule from slipping at the crucial moment, keep one or two fingers of the left hand on it, both while you are sighting and while you are drawing the ray. Sight-rule slips are perhaps the most frequent of all mishaps on a plane table.

Often a point important for the map has no sharp feature to sight on. The mapper then puts up a signal there of his own making. A bit of white paper on a stake or pinned to a post is good. In running a route traverse for building a road or trail you will find very few natural signals and will have to drive stakes, both to sight on and over which to place the table.

Let your principal triangulation stations be as far apart as visibility will permit. This long-sightedness will save much legwork.

Always be sure that the board is directly over the station point or mark. With scales as large as 1:600 (1 in. for 50 ft.) the plotted point should be directly over the station point.

Two interesting tripod facts are: Moving a leg in or out tilts and shifts the board in the same direction. But moving a leg sidewise tilts the board without shifting it.

If you use an alidade with peep sights or a telescope rising to some height above the table the tilt of the board is critical. But with our humble triangular sight rule, rising less than an inch above the table, there is not enough swing to matter. A board can be 15° off level before the worst resultant error in a bearing will amount to 1°. If a round pencil doesn't roll off the board it is level enough.

More important is the tilt of the pencil. If you use a conical point, tilt the pencil outward, away from the rule, so that the point is smack against the fiducial edge. This stunt alone may prevent a bad fix.

If the station of origin of the ray is a needle-point hole the fiducial edge should be so that it touches a pencil lead whose point is supposedly in that hole. Then the ray will emanate from that exact needle-point.

Don't expect good fixes if your rays converge on angles smaller than 30° so that you have a pike instead of a point, or if they meet at an angle of more than 150° so that you have a corner so round you can't see the corner. We might call these "illegible angles."

The most illegible and mischievous mark, though, to come off a pencil is that little circle which is a sign of a degree: °. It's all right for printers; but in our hands it is always trying to look like a zero, 0. Write "*deg.*" Figures to be extra careful of because they tend to look alike are 3 and 5, 1 and 7, 4 and 9.

Abbreviations and symbols are indispensable in either careful or hasty mapping. But be sure to label the points definitely, though. "Smith's h." is better than "house" and "elm" is better than "tree."

However, with all these precautions, one must good-naturedly expect a certain amount of error. Air layers of different temperature will bend the light rays between your eye and the object so that the sight rays will not come out absolutely true. Then, there is that very predictable margin for error due to the width of your pencil line, already spoken of earlier on the matter of scale. Say your average working line is 1/50 in. wide, and the map is to a scale of 1:3600 (1 in. for 300 ft.). That means your pencil line itself is equal to 6 ft. on the ground. So you must allow 6 ft. every time you draw a line.

Speaking of scales, this graphical triangulation which we have been mulling over is advisable on scales no smaller than 1:10,000. That's about 5 in. to the mile. And very nice. This affords a mapper with a 1/50-in. pencil-line about a 17 ft. margin of error.

Here also are 9 grief-saving "Reminders" selected from those which appear at the end of Swainson's *Topographic Manual:* °

"Orient on distant signals and resect on near-by ones.

"Keep points of dividers sharp and protect them when not in use by a small piece of rubber or cork.

"Keep pencil sharp and, when drawing lines, hold it close to edge of alidade at contact angle.

° See book-list, p. 258.

"See that alidade rule makes close contact with paper.

"Draw magnetic meridian on sheet.

"Keep sheet clean.

"Keep bottom of alidade clean.

"Do not rub alidade over sheet more than necessary. Lift it.

"Do not let body or arms rest on table."

However, lest so many detailed precautions seem to take the fun out of the game, let's reflect that if we added all of them up we'd perhaps find they are fewer than what a catcher or a second-baseman must keep in mind at almost any very active moment in the field.

Frank Debenham, who was the mapper and geologist on the heroic expedition of Captain Robert Falcon Scott to the South Pole, in 1912, says he used a plane table for most of the cartographic work. And not a very fancy one either: it was an ordinary drawing board, 13½ x 17 in. mounted on an old-fashioned camera tripod. For an alidade he used "a plain 15-in. wooden rule stiffened by a brass strip screwed to its lower surface, and the sights were fashioned out of two long brass hinges screwed to the rule and folding down when not in use. The foresight was at first fitted with a fine brass wire soldered to the hinge, but later this was replaced by fine thread which was easily renewed." [*]

This outfit served where a theodolite and sextant alone could not, what with all the note-taking and abstract reporting of detail these involve, while the plane table with its graphical method enabled Debenham to plot the detail at once on the map, there in the field, "as direct observation."

OTHER MEASUREMENTS

A resourceful beginner can extend the usefulness of these surveying principles by ap-

[*] In his *Report on Maps and Surveys*, p. 88.

plying his knowledge of ordinary schoolbook plane geometry.

We have already used the geometric principle that "in any triangle a line which is parallel to a side, divides the other two sides proportionately." Here is that principle applied to measuring the length of a pond:

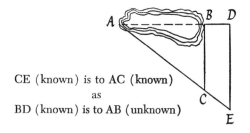

CE (known) is to AC (known)
as
BD (known) is to AB (unknown)

Here is the same principle expressed as "similar triangles" for measuring another inaccessible feature:

If CE is ½ EB
and DE is ½ EA
CD is ½ AB!

You can tell the length of the leg of one triangle by measuring the leg of its siamese twin, and thus find the width of a river:

AE is to EB as AC is to BD
AC = BD

If for any reason you cannot bisect the baseline, *AB*, conveniently, or if you cannot at that midpoint sight well on *C* and *D*, let sight line *CD* cut *AB* at some other point. The two triangles will not then be equal, but they will still be *similar*, and proportionate.

Cross-ruled paper is helpful in estimating the areas of most irregular shapes. Count the whole-squares enclosed and estimate the fractional squares. The area will be so many square units of whatever scale you are using.

Cross-section paper is a time-saver when plotting in the field. Plot directly on it. If the map can be plotted conveniently with the vertical rules running plumb north - and - south (magnetic or true) all the better.

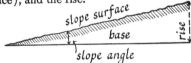

*area =
51 squares*

LEVELING

Thus far we have been taking only horizontal measurements. The wise self-teacher will confine himself for the first few maps to somewhat level terrain. He will not force discouragements upon himself by being unrealistically ambitious in tackling certain jobs prematurely. For instance, surveying for contour lines. That is an expert's job, and introduces more hard work into a map than amateurs like ourselves bargain for. Even drawing form lines, unless we have already had considerable experience in plane-surveying so that our eye has become skilled, is likely to spoil a map which was pretty good as far as it went. Often, it is sufficient for a map to indicate slope or drainage by simple arrows.

Let us, then, accept the fact that we may not be able to put the entire relief on our homemade maps, or to measure the altitudes of a mountain so great that even its distance from our observation point is too much for us. (The elevations of such peaks are likely as not already determined by professional surveys, as are many other elevations in the country we are mapping, if we but look for bench marks. The non-use of a bench mark by a mapper is the next thing to its misuse.)

Much of the hypsography which we shouldn't tackle, because we couldn't get away with it, we don't need even to attempt since it has already been done for us. Nevertheless, some certain slope, some particular hill which the professionals passed by or slighted on every map we can get hold of might mean a lot to the usefulness of our own map. We may need to make some of our own vertical measurements.

A user of the ground may not care so much about the elevation of the place as about its slope or some of its grades. (Surveyors speak of a "gradient.")

So that we may know what we are talking about, let's first label the elements of a slope. They are: the slope angle, the sloping (or ground) surface, the base (or horizontal distance), and the rise.

There are several ways of stating a slope. The one we think of first is the simplest and as good as any: the degrees in the angle. "That hill rises at an angle of 12° from the shore," we say.

Another way is to give the percent of the rise: how many units (feet or anything) does

the hill rise for every 100 units of level? If it rises 1 ft. for every 100 horizontal ft. buried at its base, the grade is 1%. If it rises 6½ ft. in every 100 ft., it is 6½% grade. "Looking up-hill we say it is a plus slope: "+6½%." Looking downhill, minus: "−6½%."

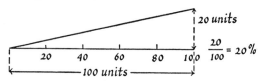

$$\frac{20}{100} = 20\%$$

Engineers, though, speaking of a railroad embankment, will say "it's 1 in 1½," or "*on*." That would be 1 unit rise on 1½ units of base. The illustration below, a slope of 1 on 5. "On" or "in" work all right up to and including 1 on 1, which of course is 45°. After that, the base becomes smaller than the rise; so state the base (horizontal) figure first, and say "*to*." "1 *to* 1½" means that there is 1 unit of level to 1½ of vertical. All that "on" or "in" or "to" means, you see, is a ratio. The ratio of two sides of a triangle.

Still another method is to give the relation in a fraction. Divide the rise by the base. A rise of 1 (or 1000) ft. on a 1½ (or 1500)-ft. base is a slope fraction of 2/3. (1 ÷ 1½ = 2/3). The illustration, above, showing a slope ratio of 1 on 5, expressed fractionally, would be a 1/5th slope.

With the exception of this latter method, which seems to be used less than the others, these ways of expressing gradient are compared in a ready-to-use table on p. 275.

Now for a way of measuring slopes. With all due respect to those who own, and know how to ascertain elevations with, an aneroid barometer and to surveyors and their levels, or clinometers, we can have plenty of fun and hypsography with a homemade slope board.

A slope board consists of three things: a drawing board (or thick piece of cardboard with a straight edge for sighting), a piece of fish line or fine linen cord for a plumb line, and a 2 or 3-oz. sinker for a bob.

The idea of this contraption is that the plumb line hangs across a scale which you have laid off on the board, and the figure which that string cuts on the scale is the amount of slope from where you stand if you sight the top edge of the board parallel with ground.

To assemble, bore a hole in the middle of the board near the upper (sighting) edge. Drop a perpendicular line from this edge down the middle of the board. At 10 inches

for percent of slope

down this line, lay off a line. The intersection of these two lines is zero on the scale. From here, in both directions make ticks 1/10 in. apart. Each of these ticks represents 1% of slope. Put the loose end of the string through the hole so that the bob can swing pendulum-wise and free slightly below the lower edge of the board.

If you'd rather have the board give the *degree* of slope, then instead of dropping a perpendicular and laying off another line at right angles to that, take a radius of 5.7 in. With the top hole (the point from which the

plumb cord will hang) as a center, draw an arc in what would be near the lower end of the board. Mark this arc off with ticks 1/10 in. apart. When the board is held so that its top edge is level the plumb line cuts across the arc at the point that should be marked 0°. Each tick away from this represents 1°.°

for degree of slope

Whether you have your slope board scored for percents or degrees, or ingeniously for both, it is now ready for business.

Sight along the upper edge of the board, making sure to shield the plumb line from the wind. Help bring the line to a stay by retarding its swing. As soon as it stops press it to the board with your thumb. Face the board up to read the result.

Now, to measure an actual slope. This landscape with figures reminds us that a man's eye is not in his toe but some 5 ft. (more or less) above that point.

This fellow got his girl to help him out. She being as tall as he, they could gaze into each other's eyes and work at the same time, effecting, as you see, a striking parallel. A line parallel to the sloping distance of the ground between them.

It's plain that the raised-up triangle is an identical twin of the down-to-earth one which

° To convert percent of grade to degrees of slope, multiply the percent figure by .573. Say, a road has a 10% grade. What's that in degrees? 10 × .573 = 5.73. The slope is 5.73° or 5° and about 44'.

is all but hidden from direct measurement. Hence, the angle at his foot must be the same as the angle at his eye, and he can read that angle off the board.

As for the two other angles, one of them, though buried in the hill, is surely enough a 90-degree angle, and since all three angles must add up to 180°, he can tell without bother of much geometry what is the degree of the angle at his lady's eye, and the one at her feet.

All he needs is one side of that triangle to know the whole of it. The slope side is the only tangible one, and he can measure it easily enough with a tape. Reducing this boy-meets-girl line to scale on a scratch-pad, and applying the respective angles, he gets a triangle which is a miniature replica of the one formed by the hill. It supplies him with the following useful facts: The amount of slope. The sloping distance between the foot of the hill and the top. The horizontal, or planimetric, distance between these two points. And the height of the hill—or of one point above another point on the hill.

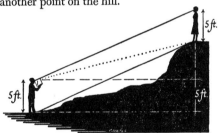

He may not have a tape, or the slope distance may be too great for taping. Nothing daunted, he strides a baseline athwart the foot of this slope and locates the point above by the method of intersection. Same as the man did back on p. 216, where the interference may have been a pond or swamp instead of an unstridable slope. Or he can make a plane-table intersection.

He may not have a helper. Then a stick

marked at about the height of his eyes, or a signal in a tree atop the slope will do, and he won't be the first mapper that ever toiled in solitude.

Let's suppose now that instead of sighting the slope-board at somebody or a stick, he sighted it directly at the ground where the helper would be standing.

Consider the dotted line which represents this sight in the illustration. It is obvious that now he is getting an angle different from the slope angle. But he is still getting a *right triangle*. What's more it has the same base as the upper triangle had in the former experiment. It also has a segment of the vertical side of the lower triangle. If he adds his own eye-height to *that* he'll have it all: the height of the hill. (See also table, p. 275, col. 2.)

RULE-OF-THUMB MAPS

If you have a knack at freehand drawing and understand some of the tricks of perspective that enter into landscape sketching, you will enjoy panoramic sketching, which is a very legitimate form of mapping.

As it is pictorial it is appealing, even to people who don't ordinarily warm up to maps. And as it shows the horizon, it is of military importance. A panoramic sketch can be drawn to such fair accuracy of scale as to designate targets.

Though the panoramic sketch is a picture, and though much mapping is done by photography, it has definite advantages over the photograph. You can omit what you don't need—whatever you deem not "map"—and can put in or give emphasis to features which the camera either loses or scants. For instance, distant hills. Cameras belittle these, while in a cartographical picture they should be exaggerated to be appreciable. A pencil can apportion this skyline strip across the picture, making the scale of the background larger than

that of foreground, as a camera can't. In making profiles of the relief, we saw the reason for exaggerating vertical scale, and essentially the same reason operates here in the hand of the landscape artist or mapper. Furthermore, you can label the features and places as in any map. A fair, even a rather bad, photograph of a spread of country can be transformed by the mapper's hand into a panoramic sketch; all it takes is perhaps an enlargement, a sheet of tracing paper, and some graphic skill. Heightening the contrasts between light and shadow will help things to "stand out" for purposes of quick indication as well as for pleasing effect.

Outdoors, hold your arms outstretched before you, and your two fists will mark off on the horizon a width of arc of, roughly, 15°. Another such rule of thumb is that on a sketch pad held about 20 in. from the eye, a horizontal inch subtends about 3° on the skyline. For this reason some map-sketchers fasten to the bottom of their sketch-pads a piece of string 20 in. long on the end of which is a knot they take in their teeth while holding the pad in the hand of their extended left arm. The pad is ruled with vertical lines 1 in. apart. So if the pad is, say, 10 in. wide it will span a sector of about 30° of landscape (3° between the ruled lines) as the sketcher sights over the top edge of the pad he holds out before him. The worth of these horizontal angles is that they help to make your picture a map by giving you the

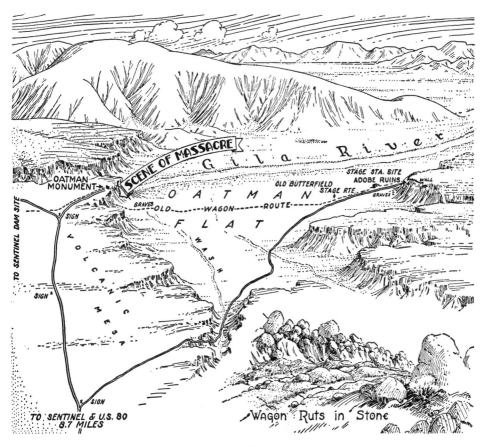

Site of Oatman massacre, in Arizona, 1852, sketched by Norton Allen from a high point on an overlooking mesa °

angular distance between the features before you. It is almost the same as if you used the method of radiation with a sight rule or compass. The middle ruling will be the zero line, and everything on that line from the top to the bottom of your sketch will be at an angle of 0° from you: i.e., right before you. Any object on the next ruling, to the right or left, will be at 3° from your station. It may be a hilltop in the background or a pond in the foreground, but if you sight it on that ruling, it is 3° from where you sit. You can do this also with mils

(see p. 272). If the vertical guide lines are ¾ in. apart and the pad is held 15 in. from your eye, the distance sighted between two rules will be 50 mils.

Another way is to use a pad, say, 6 x 12 in. A horizon line across the sheet and a vertical one down the middle becomes a control framework to start you off. The horizon line does not have to be the actual skyline: it can be the foot-line of a distant range of hills, a distant shoreline, or anything horizontally im-

° From *The Desert Magazine*, March, 1940.

portant enough to act as an axis and line of reference. To get the scale, hold a ruler out at arm's length, and thumb off on it as much of the scene before you as you wish to map. If you know the actual distance between two points you have sighted off, you'll have an approximate idea of the scale across the axis of your sketch. A handy ratio is to let ½ in. on the pad take what sighted ground is spanned by 1 in. of the ruler. Select detail strictly for the purpose of the map. Use conventional map symbols for trees, plowed fields, villages, etc., unless some particular feature, such as a monument or dam, is to be recognized by its highly individual form. Generalize the land forms to bring out their character rather than to evade it; i.e., get the forest instead of merely the trees.

COMBINED OPERATIONS

Because most of this has to be read before it is likely to be applied, much of it is perhaps oversimplified. Not that the application might prove difficult: but as a practical reader must know, words are a poor substitute for action.

Mapping, and especially plane-tabling, is a very personal, individual job. Not only every map, but every station will bring up its new peculiar problems along with its new slants and angles. Doubtless before you have made many maps you will have lighted upon, invented, contrived, and combined more tricks, stunts, cuts, dodges, devices, etc., than could be told in this chapter. It's this ever-renewing challenge and adventure which has led mappers to speak of the "charm" and "fascination" of plane-tabling.

Perhaps it is because mappers see nature at first-hand, in her limitless variety, that they are such resourceful fellows. They take all the breaks she gives them; then adapt themselves and instruments to what she denies them.

Their modest, rather drily written accounts of how they did this or that mapping job are full of instances of adaptability.

Before picking up at any station and proceeding to the next, the mapper looks around for possibly one more good intersection and maybe a few short radial sights on interesting topography. And even as he walks to his next set-up, if he doesn't have to count his strides, he sketches into his map a bit of the winding of that creek he can see from here. He must have a hand free for it, and usually packs himself so that he has. He may not be able in this map and with his equipment to survey a river or a railroad line or the way of a canal. But let any of these take a curve upon which he can from any good stance and station slit a ray in the form of a tangent to that curve, he will by the end of the survey have pinned down the meandering feature in a few critical places at least.

The survey figures in this chapter are only starters. Your very first map will very likely call for surprising variation. It's a good idea to resurrect the old plane geometry textbook of high school days and look through the triangles for any principles which might come handy in the field—or that might have saved you some stalling had you known them the last time you were out. Surveyor's manuals, especially the very old ones to be found in second-hand bookshops, have mapping sections which are mines of various plane-table figures for deft land measure. Such reading, though, is most rewarding after rather than before some fresh-minded work in the field.

Too much work may deaden a map, but a little play can put a world of life into it.

Anyone who seats himself on an elevation and combines mapping with landscape sketching is likely to have a pleasant time. Some people can't sit before a splendid view and not hanker to write a poem about it. Although there is little room on a sketch pad or plane

Physiographer's panoramic sketch map °

table for verses, there is also nothing in all nature to prevent a mapper from being also a poet. By dint of some unshowy beauty within himself the mapper often expresses some of that in the terrain outside.

This same esthetic responsiveness in him is what enlivens his technical abilities.

The beginner will expedite his work if he aims at making a good-looking map rather than a very accurate one. Henry Gannett, of the U.S.G.S., wrote in the beginning of its strict *Manual of Topographic Methods*, "The greatest accuracy attainable is not always desirable. . . . The education of the topographer therefore consists of two parts—the mathematical and the artistic."

Your present equipment and ability should dictate what kind of map to attempt, because the purpose of the map, let's repeat, determines just what the order of its precision should be.

You will increase the scope of your equipment and ability both if you will combine operations as soon as you feel like it. Within the same plane-table survey there will be times when the Distance Method or the Compass Method will expedite the work. This may mix orders of accuracy somewhat, but not all fea-

tures in the map are likely to be in the same order of importance anyway.

One of the most advisable combinations is that of survey and compilation. Using ready-made professional maps both out in the field and in the drafting room is not only legitimate but sagacious. And the beginner in plane-tabling will give himself the best start if he does his first work directly on the framework of a professional map. Usually he wishes to make his map in a larger scale than that of the base map. The thing to do then is to trace off an enlargement of the base map and transfer that to the plane-table sheet.

The last highly advisable combination here might be the first to work upon in actuality. That is combining your own survey with any already done. This entails no more than familiarity with station marks, township corners, and other points of official record.

Locating a bench mark provides the new map with a fundamental datum, a main elevation that has been officially determined. Finding a U.S.C.G.S. traverse will do likewise.

° Drawn by Griffith Taylor. From "British Columbia: A Study in Topographic Control," *Geographical Review*, Vol. 32, 1942, p. 391. Courtesy of American Geographical Society.

A Geodetic Survey triangulation mark pinpoints a place for which you can have the exact geographical location in degrees, minutes, and seconds if you will do as the inscription says: "For information write to the Director."

Not far from a station mark of a principal triangulation you will see some supplementary markers. One of these will give your survey a starting direction from that station and so is called an *AZIMUTH MARK*.

The others will be *REFERENCE MARKS*, which are so placed that in case the triangulation mark is destroyed, it can be re-established by reference from these points.

Sometimes reference marks define the true position of a boundary corner that may be under water or in a marsh or in a place where a permanent mark could not well be put.

In the B.L.M. surveys, these supplementing marks are called "witness corners," "reference monuments," or "witness points," according to the special service they do for the corner monument to which they belong.

You may have to depend on just such a corner monument. This may be a metal pipe securely buried, with an inscribed cap on top. Or it may be a similarly inscribed metal tablet fastened in a rock outcrop or imbedded in a heavy chunk of concrete. If a good-sized, healthy tree is standing where the monument should be, the tree itself may have been marked as a monument: on a tree with smooth, thin bark, light scribing, but on a tree with rough bark, a narrow blazing down to the smooth, scribable surface of the live wood.° By writing to the Director of the B.L.M., in Washington, or visiting the regional and local offices of the Bureau, you can get for a small charge copies of the approved field notes and of the plat for the particular monumented area with which you're concerned. In any case, an acquaintanceship with a professional surveyor in your vicinity will prove to be a boon.

If the U.S.C.G.S. has done any work in your state about which it has published an account, you will find the title and price in the *List of Publications of the Department of Commerce*. For example, suppose you need and obtain *First-Order Triangulation in Kansas*. In it you will find map sketches of the net-

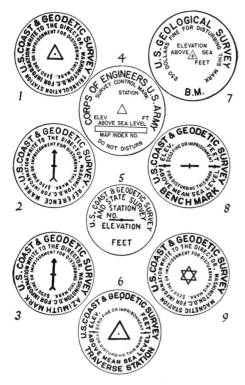

Standard marks: 1. triangulation station mark, 2. reference mark, 3. azimuth mark, 4. army survey mark, 5. state survey mark, 6. traverse station mark, 7. bench mark, 8. bench mark, 9. magnetic station mark

° For more detailed information about markers used in the U.S. public-land surveys, see the two B.L.M. publications, *Manual of Surveying Instructions* (Chaps. IV and V) and *Restoration of Lost or Obliterated Corners*, which is a pamphlet supplementary to that manual.

work and the whereabouts of triangulation stations described so that you will know just where to look for the one you wish: when it was put there, its latitude and longitude, and often its elevation.

The Geodesy Division of the U.S.G.S. has issued this request to people with a sense of democratic responsibility:

If there is construction going on in your area and you notice a survey mark which appears to be in the way, call it to the attention of the surveyor in charge to insure that he is aware of it.

If you see a survey mark which appears to be susceptible to damage of any kind, or which seems to be undergoing erosion or other "old-age ailments," flag it by driving stakes nearby and marking them with red ribbon, cloth, or plastic.

Publications of the U.S.G.S. is the catalogue to consult for any leveling, triangulation, or traverse literature issued by that bureau. Look under the heading of the name of your state.

The two illustrations here show a typical triangulation scheme and a farm survey based upon it. To anyone who hasn't read the first and the present chapters the first illustration may seem a bit puzzling, but practically everything in this sample section of triangulation and traverse will look familiar to anyone acquainted with those two surveying methods. The permanently marked main scheme stations are triangular symbols. From them are visible the supplementary points: spires, elevators, cupolas, etc. Note that the point de-

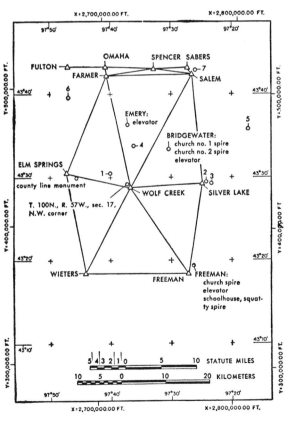

1 German Baptist church, spire (3 miles west of station Wolf Creek)

2 T. 100N., R. 55W., sec. 18, N.W. corner

3 Dolton highest red elevator

4 Church spire (on east end of ridge 3 miles S.W. of Emery)

5 CANISTOTA:
 red elevator
 cupola
 highest white spire
 high church spire

6 ALEXANDRIA:
 Baptist church spire
 courthouse dome
 elevator
 large building
 small, open belfry

7 T. 103N., R. 55W., sec. 21, N.W. corner

Typical section of triangulation and traverse °

° Courtesy of U.S.C.G.S.

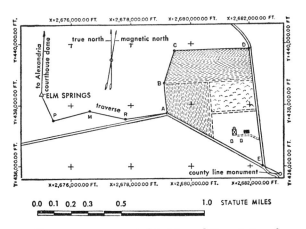

Farm survey connected to triangulation stations °

scribed in item 7 of the legend is a Public-Land Survey corner. Along the outside borders of the diagram are the *x* and *y* coordinates designating certain distances in feet from a point of origin in the general grid of the state-wide plane-coordinate system. This is therefore not a lone-wolf survey made as though the earth were flat and this an isolated piece of it. Along the inside border are the geographic coordinates in degrees and minutes. This piece of country, manifestly, is at latitude 43° N. and 97° west longitude. A unique point in the earth's surface, in the southeast corner of South Dakota. The tiny plus marks (+) are also unique points, for they are the 10-minute intersections of parallel and meridian.

Now, to come still closer to our objective, observe Elm Springs and the supplementary point, the County Line Monument. Between these two is the site of the next illustration.

This shows how a farm survey is tied in with that of the North American continent. The hitching post is Elm Springs. Here our surveyor began his traverse line, taping the distances, probably through flat country of not much inter-station visibility. And at each station he took down the azimuth of his fore-sight to the next station, until he got to the farm corner. Crooked as this traverse line may be it very securely connects that little farm with the earth's main reference lines. And its own lines, which we can suppose might have been mapped on a plane table, become thereby as geographic as any other written on the face of the earth.

Township plats make excellent base maps for the kind of surveys and cartography that an amateur may wish to do. An acquaintance with the peculiarities of land corners and an ability to identify them, though, might prove more or less necessary. But it is sure to prove interesting. What surveyors call a bearing tree ("BT") may or may not have fruit on it, but it is supposed to give you the bearing from a land corner. Trees on a survey line are sometimes blazed to indicate that they are on such a line. Two chops or notches indicate on which side of the tree the line runs. A good field man knows how to detect these blazes even when they are overgrown with bark.

One should not think that simply because a field is small it is insufficient for a map survey. A mapper will have plenty to do showing

° Courtesy of U.S.C.G.S.

Apples Field house
and
hay
Pasture
and
young orchard
Apples and vegetables
Chickens
Vegetables
Field house
Stones
Apples
and
hay
WASTE LAND
Wood pile
Apples
and
hay
LANE
Stones
Apples and hay
Pasture
Wheat
Apples
and
hay
Stones
ROAD
Vegetables
WAY
Apples and
vegetables
Apples and hay
Apples
and
hay
Apples and hay
Apples
and
vegetables
Apples
and
hay

CHARACTERISTIC FIELDS
0 3 6 9 12 METERS
Each field is a terrace. The stone walls
are one to three meters in height. The
stone piles represent excess stones
THE GEOGR REVIEW, APR., 1930

*Study-map by the geographer Roderick Peattie, showing
farm use of valley bottom in French Pyrenees* °

the distribution of native trees and shrubs within a square mile. A census map of bird residents in a 40-acre tract during one season will take a neat bit of surveying. And sketching land utilization as viewed from a near hilltop is something to write away from home about.

Do not be afraid that you have a subject too slight for large scale. Even a prairie-dog "town" is worth mapping. You may envy a professional his training and equipment but you can give him cause to envy your ingenuous opportunities, original interests, and mere sheer fun.

In mapping farms, ranches, and privately owned tracts, you will find a good source of survey information at the county clerk's office, in the registry of deeds. For the deed of a farm should specify its surveyed boundaries. Other good caches of cartographical material are the street department and the state highway commission.

See pp. 247–250 for a list of the various government mapping agencies whose surveys and base maps will spare you the more exacting and tedious work while enabling you to impart to your mapping the precision that you may not be equipped to render it by yourself. This will leave you free to enjoy doing the job and to produce something of the very agreeable character which you doubtless had in mind when you first thought of making a map.

° Courtesy of American Geographical Society.

9. Treasures, Tools and Materials: EQUIPMENT

AFTER WE HAVE developed an eye for maps our keenest enjoyment of them comes, perhaps, not from the general-purpose maps, which had formerly been the only ones with which we had been at ease, but from special-purpose maps. Particularly those that suit *our* purpose.

The same is true of collections. A general collection of maps—maps of any and every kind —must be the aim of public libraries because the public itself is miscellaneous. But if the individual map-maker or muser goes in for a general collection, he will soon founder.

That is not to say that every one of us who likes maps should not *have* maps of the world, of the oceans, the continents, and of our country and state. These are indispensable to any mentally awake world-citizen who may or may not consider himself a map-fan. The practical mapper will get together for himself a kind of working-atlas of general maps.

But *having* is not quite the same as *collecting* maps. A collection should have a purpose, a theme. If we go in for aimless, miscellaneous collecting, we shall feel our work scattered instead of collected. We shall soon tire of the whole business as a result of wanting the whole business. The theme should be one close to our actual interests and not one we select simply because we've been told to do so. To assume a collecting theme in the cold, half-hearted way that some people "adopt" a hobby is to miss the whole point of having one. Once, though,

you consult your own wishes, the collecting of maps becomes exciting.

You may soon find yourself feeling that of all things collectable, maps are perhaps the most deserving. Whoever makes a sensible collection, however modest it be, is doing a service to his fellowmen in preserving the products of culture. Among these, maps are some of the most valuable.

A map may be lettered in a language we do not know, yet we can still somehow understand the *map*: land forms speak more universally than do alphabetical forms. There is no such thing as an "outlandish" map of any place on this planet. Very old maps, like an attar, retain their recognizable essence through the ages. Man's written thoughts become altered and watered down through translation into later language forms, but in any map that he made we can still get a first-hand appreciation of his view of the world.

The difficulty about collecting very old maps, though, is their rarity. Some collectors make rarity their chief incentive. Many of these are the dog-in-a-manger type of collector, for often they have little intrinsic appreciation of what they hoard; their only pleasure is in having something nobody else may have, and their only profit is lucre.

You may not have a single rare or, as collectors say, "unique" map in your collection but your collection, as such, can be unique. Its future value may come to mean little in the

The Pleasant Isle of Aves. Fanciful map by the artist and printer Porter Garnett, made as a gift for a friend °

market place but much in some place of learning. A prudent collection is one thing that is *more* than equal to the sum of its parts.

If your interest prior to maps has been, say, birds, bird-migration maps may best suit you. If your interest has been in literature, art, or music, you need not stop with the few maps which show the birthplaces, etc. of celebrities. Collect large-scale maps of the region where your favorite poet, painter, or composer grew up so that you may see what places may have figured in his formative period; or the regions where he later lived so that you may see where he walked while meditating and planning certain of his creations.

Map-collecting can fit in and interlace with some other form of collecting, and with none

more congenially than with postage stamps. These bits of paper by their very function betoken geography. And sometimes they are themselves maps. The first stamp to have a map as its main design was a Colombia, 1887, issue for Panama. There is no telling how much this tiny map might have unintentionally had to do with awaking the world to the idea of a canal across the isthmus. In another instance, the omission of a line so small that if it had been a sliver in one's finger one would have scarcely felt it nevertheless nearly precipitated an international rumpus. The line was on a

° Drawn for a privately printed edition of Charles Kingsley's *The Last Buccaneer,* issued on the occasion of the fiftieth birthday, October 3, 1907, of the historian Henry Morse Stephens.

map, and the map was on a postage stamp. This was the Irish Free State issue of 1922, and the omitted line was the Ulster boundary! A Japanese, 1927, stamp has a map of the whole world on the Mollweide projection, with Nippon at the center. Stamp maps have the smallest scale to be found in all terrestrial cartography. Many of them show considerable skill, as in the Arctic maps on some stamp issues of the Soviet Union. Fascinating facts about "postal cartography" are to be found in a small book, *Maps in Miniature*, by Walter Klinefelter, Hawthorn House, Windham, Conn., 1936.

Before you have seen many maps you may become interested in the style of a particular cartographer, and there again is a collecting angle. If he is a newspaper or magazine cartographer you may soon have your hands full with examples, but that doesn't render him less worthy of being "collected." His repetitions of a map on various dates can be managed by jotting down the date and the newspoint of the map instead of clipping it.*

Occasionally a number of maps by a favorite come ready-collected in a single volume. Such "one-man shows" afford a sustained view of an individual style, in the same way as does a volume of stories, essays, or poems by a preferred author.

Maps for the blind warrant collecting. Prepared for finger reading only, they may present at first a "blank" look—like that of an embossed all-white paper napkin—but what matters is that they have a very instructive *feel*. Running our fingers over the serrated lines to feel the conformation of continents, for instance, our notion of them deepens a bit beyond what we get from solely visual maps. In these tactile maps, only the place names and the graphic-scale numerals are in the code known as braille;

all the other map features are expressed in those more or less familiar delineations and symbols which might be called the universal language of cartography.

A type of map which we may well regret that more people did not from the beginning collect and preserve is the automobile road map. In the United States, oil-company maps have attained a character worth more than the passing interest of yesteryear's motorist who valued a highway map only when he was in sore need of it, and then neglected it because he had got it free of charge. These maps are rich with local-history materials, for by seeing how the great highways either took in or by-passed certain villages, and how later, still more important highways made a different selection we can read the varying fortunes of certain places through a period. To the mapper, these road charts are useful because while other maps of the region may give horizontal distances as though the entire country were at a sea-level flatness, these give him the speedometer distances over roads. And a comparison of such information with that of the contours on a topographical map can be helpful to him in compiling his own.

Of all the purposes there may be for collecting maps, none are so down-to-earth as the aims of the practical map-user or maker. And whether or not you intend to make any maps yourself there is no scheme of collecting through which you will learn more about the ins and outs of medium and large scale maps than through starting out by collecting maps of your home region or the region you are every day becoming more intimately acquainted with. Let your region be the unifying theme of your collection; then save every different kind of map of it you can get hold of: geological, cadastral, historical, agricultural, etc. What kinds you can't find you may possibly make yourself.

* For a good historical survey of news maps in U.S., see "Journalistic Cartography" by Walter W. Ristow, *Surveying and Mapping*, Vol. 17, October–December 1957, pp. 369–390.

CARTOGRAPHICAL MATERIAL: GLOBES

Just as there is no all-purpose map, there is no all-purpose globe. The variety of general uses and special purposes for which globes are made is what strikes you when you look through a manufacturer's catalog or salesroom.

In the workroom of a distinguished American cartographer, an old 18-in. globe used to hang by a string from the ceiling. It was stained and a bit worn, like a carpenter's square, from much use. Many of the political boundaries on it were out of date, but that wasn't the function which this globe served. The parallels and meridians were correct, and the lands, seas, and other important physical features were correctly disposed on it with reference to those lines. That was all the cartographer needed.

Having a globe unattached enables you to turn it any way you wish and see all the aspects without standing on your head or wrying your neck as you would have to do with a ball fixed to an axis that is fixed to a stand. "Free" globes are available, along with "cradles" to set them in. Should you find a bargain in a second-hand globe attached to a stand, chances are you can unscrew it from the spindle and use as a cradle for it a salad bowl or chopping bowl in which you've laid some felt or soft cloth as a protective cushion. Or, suspend the ball by a cord from a wall-bracket.

On handmade globes, the gores are applied with great care. Such globes are more accurate than those made by machine, usually two hemispheres formed under pressure after maps have been glued to them. If you buy your globe from a manufacturer or a reputable map house, there will be no misrepresentation, but if you buy a second-hand globe, you can detect the difference by looking closely at the Equator. If the globe is machine made, you'll find there either a seam or an extra strip pasted over the seam to hide the failure of the two halves to jibe exactly. If it comes to a choice between a small hand-made globe and a larger globe that was made by a machine, choose the handmade one and use your magnifying glass.

Consider your frequent handling of the globe a legitimate kind of wear, the same as walking is for shoes. But keep it away from heaters and window sills, and never ask anybody to roll it across the table to you.

CARTOGRAPHICAL MATERIAL: ATLASES

Writers don't worry over the question as to what is the best anthology to own; neither do cartographers over what is the best atlas to have. In both cases there may be some individual opinions, valued in conversation rather than in practice. There are so many atlases and so many different kinds of them and so many more coming out to supersede the ones before that the only thing to do is to regard them either as friends and acquaintances you might wish to see again or as instances of little interest to you, rather than as possible commitments to a sort of monogamy. "I don't want any atlases, I already have one," would sound to map-makers and map-lovers almost as funny as the same notorious remark about books.

Some of the best and greatest atlases are like monuments, so big and costly that they are more apt to be shared in a large library by many users than to be owned by only one. Some of the finest and most important atlases are so special that if you're not pursuing the specialty of a certain atlas it may not be of

use to you more than once or twice in a lifetime. Nevertheless, if you're predisposed to think of the geographical significance of things—and a great many actively intelligent people are—there is no telling how many specialties in atlases, as in maps, you may require. In fact, even a branch library in a neighborhood of people whose intellects get up each morning with them has need for more than one atlas and dictionary and encyclopedia. The real problem is not atlases but attitudes.

Unless you have better than a nodding acquaintance with some of the many possible uses there are for atlases, you can scarcely foresee the many likely uses they might be to you, and you may too unprofitably spend time in libraries and money in book stores. To avoid doing this, such a reconnaissance of the atlas field as that made by Ena L. Yonge,° former map-curator of the American Geographical Society will prove to be helpful briefing.

One thing that you probably will not need in an atlas is what the popular atlases—both the condensed and the pretentious—persist in offering: gratuitous geographic text taking up space that could be better occupied by more maps, especially in larger scale. Publishers seem to believe that the atlas-buying public consists mostly of the people who have in their homes only three or four other books, none of which could be geographical. And yet in those atlases some or all of the maps may be quite good and perhaps have the latest indications of boundary changes, etc.

If you are drawing maps you may wish to see how other cartographers have handled

certain design problems that the subects you are dealing with have raised. To compare the different styles of representing the same areas for more or less similar purposes is fascinating and instructive. Then the old, seemingly out-of-date atlases you may have bought second-hand might serve as well as some of the latest, most expensive ones.

Not all atlases are issued in book form. The *Atlas of Canada*, to cite a fine example, comprises 110 sheets. It offers so many aspects of the country—geographical, ecological, historical, political, economic, etc.—that it is virtually a national encyclopedia in *map* form. Moreover, the sheets are available in a loose-leaf binder. There are also separate-sheet atlases devoted to a single subject, e.g., the A.G.S. *Atlas of Diseases*. The sheets of these atlases are usually issued individually, as they come from the press, so that you may in that way buy the entire set with "install-ment payments" or buy only the sheets you want.

CARTOGRAPHICAL MATERIAL: BASE MAPS

Good base maps are worth hunting up. They are a quarry to be sought in the most unsus-pected places, often hiding amongst much dry matter and dust in city halls, county offices, farm bureaus, real estate and insurance offices, railroad stations, and hotel travel-information desks. Even in your own home. An obsolete road map may provide you with data on for-gotten villages, vanished trolley lines, or the shape or extent of certain hills before the new roads graded them away, should you ever wish to make a map of the region as it was at a by-gone time.

There is no hunter's license among cartogra-phers, but there is an unwritten law: Take the

° In *The Geographical Review:* "National Atlases: A Summary," Vol. 47, October 1957, pp. 570–578; "Regional Atlases: A Summary Survey," Vol. 52, July 1962, pp. 407–432; "World and Thematic Atlases: A Summary Survey," Vol. 52, October 1962, pp. 583–596. *See also:* "Atlases Revisited," a review by R. E. Harrison *The Saturday Review*, Vol. 45, pp. 37–40, March 24, 1962.

data but not the chart. A mapper who can't use a base map without injuring it betrays himself as a bungler, for through the same fault he'll not be able to make his own map without spoiling it. A base map is something to be preserved, like a basic yardstick held inviolate at a government bureau of standards.

However, there are written laws about copyright. If you copy certain delineations in a map made by a private publisher he may sue you for plagiarism. His map originally may have been based on a government map, but—as he may well argue—that makes no difference: if you steal his adaptation you steal his property. You have the same right as he has to use the free base map. And he has no right to copy any part of *your* map without previous arrangements with you.

Road maps usually bear the copyright of a private map company even though they are given away. If you use one as a *base* map and your adaptation reaches the attention of the proprietor he may have a case against you. That is, if he can prove you actually lifted the lines, the draftsmanship, etc. off his map and represented them as your own. On the other hand, he published the *information* in that map for you to use: he can't expect every time you tell somebody that Bingville is 40 mi. from the county seat you will credit and pay him for the use of that information. It isn't his. He doesn't own the distance and direction from one place to another, the angle in a road, the bend of a river, or the elevations of places. He doesn't own the facts. All he owns is the means of communicating these facts: his particular design of map, with its more or less generalized interpretation of relief and shoreline, its expression of detail, the special symbols of his own invention, etc. But that's a lot, and it isn't always easy to distinguish between the mapping (which he owns) and the facts themselves (which belong to nature and the public). The dimensions of a city block are public data, but the arbitrary spacing between them to indicate streets on a map belongs to that map. Commercial map-making companies have gone through some tangled litigation on this subject. The business is complex. So these comments are not offered as jurisprudence, but merely as common prudence. The question comes down perhaps to this: am I appropriating some particular mapper's *work* or merely some general information? Am I taking somebody's art for my own use or am I using everybody's knowledge for my art?

When a government cartographer makes a map, he does so as both an employee of and a part of the public. You, being the public, made that map, in a sense, and it's yours to use as a base map.

The Geological Survey publishes regular base maps of the United States. The largest scale uses 1 in. for about 40 mi. Also base maps of the individual states in still larger scale: 1 in. for nearly 8 mi. These two issues contain water features, boundaries, railroads, cities, and counties. Our old friend, the topographical quadrangle—the first map a mapper would think of getting anyway and actually the fundamental household map almost wherever love of country begins at home—can serve as a base map but also is good to have on hand to supplement some other base map.

The Coast and Geodetic Survey publishes several base and outline maps on various projections.* These are mostly of the entire United States, and of still larger areas, such as the North Atlantic or Pacific, or the World; but if you have anything that big to say cartographically—as you might if you are making a mural—these, or the U.S.G.S. 40 mi. base mentioned above, or the U.S.N.H.O. World Charts, or the World Aeronautical Charts, are good foundations.

* This agency issues blank projection-nets, which may prove helpful for practice in drawing large areas according to certain important projections.

In Canada there are parallel opportunities for obtaining base maps. These comprise topographical quadrangles, aeronautical charts, electoral district maps, coast charts, harbor charts, charts of inland-waters, etc. The Township Plans afford 2 in. to the mile, and the Plans of Townsites as much as 20.4 in.!

Don't overlook your *local* government for base maps. Your county surveyor's office or some other office in the county courthouse may have what you need.

Be critical even of official maps. Look at the date. Distinguish between the date of the survey, of the revision, and of the reprinting. The fact that a map was reprinted this year doesn't mean it was *revised* this year and that everything in it has been brought up to date. Before compiling your own map, it might be wise to go out and check certain features you plan to include. For, since your base map was made, highways may have swerved away from settlements, which in turn may have disappeared; railroad tracks may have been taken away or some new spurs put in; local boundaries may have been changed, or ponds filled in.

CARTOGRAPHICAL MATERIAL: INDEX MAPS

Most map publishers and distributors issue catalogs or price lists. After a little experience —sometimes a bit shocking or expensive—we learn how to judge from the descriptions of the items whether they are the maps we want, that is, if what we are buying is a *single* map of a specific place, region, continent, or of the whole world. But many indispensable maps do not come singly: they are components of a larger map. For example, the International Map of the World, a map which when completed will consist of 1500 sheets. Although

a large built-up map like this will name each one of these sheets after the most important locality or physical feature contained in it, still that name may not be definite enough to tell us just what the particular sheet covers unless we have at hand a map on which we can see that particular section. We need a map in order to find a map!

Index map to the A.G.S. five-sheet Map of the Americas

These maps which enable us to locate the coverage of other maps serve the same purpose as does the index of a book, and so they are known as *INDEX MAPS.* Such an index is the familiar one of aeronautical charts issued by the U.S.C.G.S. Similarly, in ordering any of the topographical sheets of the U.S.G.S. you must first consult an index map of the

state or possession in which the quadrangle you wish to buy is situated.°

Most index maps are easy to obtain. Always request them before ordering any map of a series if you cannot definitely indicate the area you wish the map to include, or if you are likely to need several maps of the series. Mark on your index map each sheet as you aquire it, so that your collection will be self-inventorying. Every library, however modest its collection, should have a few important index maps handy. The map-collector needs them as hunting guides in mapdom, which is vaster than the world itself. And they're good for map-musing too; for example, the World Aeronautical Charts index shows sheet #1 in that series is for the North Pole. The sheets are numbered for the entire earth, and the last one is for the South Pole, sheet #1851.

GOVERNMENT MAPPING AGENCIES OF THE UNITED STATES

The names and classifications of government agencies do not always remain fixed but change with administrations and national requirements. Nor do the Federal mapping agencies continue to publish the same maps throughout the years. Some maps pass out of print, and new ones and new editions of old ones are ever coming in. A good way to keep up with these changes is to select the agencies whose scope seems likely to embrace your special cartographical needs, then every year or two request their latest price lists or catalogs.

° For index maps to the International Map: sheets of all areas, write to International Map Company (p. 252); Latin America, write to A.G.S.; along the Canadian Border, write to Canada (p. 249); parts of the United States, write to U.S.G.S.

Begin by sending to the Superintendent of Documents a post card requesting Price List 53-*Maps*. This will show you a selection of what maps, made by various agencies, were in stock at the time the List was got up. Some lists, such as PL 15-*Geology* and PL 70-*Census*, offer leads to maps and map-compilation materials, often precious odd little facts you'd wear yourself out hunting for elsewhere. These lists tell also whether a book or pamphlet advertised in them contains maps. Soon you'll find your eyes happily spotting the phrase "map(s) in pocket."

Many maps are made primarily or solely for the internal administration of some government division, and so are not always likely to appear in published lists. Some agencies and bureaus, whether or not they publish maps, have in their collections aerial photographs, photomaps, field sketches with notations, and as-yet unprinted maps; and often in cases of valid intent photostats of these will be made to order for people. During times of caution for national security, not only these things but also many actually printed maps and charts must be of course restricted.

If any question arises on this or on any other point having to do with Federal mapping agencies, send your query to the U.S.G.S. Map Information Office. They are the index to the whole magnificent job.

All addresses, unless otherwise noted, are: Washington 25, D.C.

DEPARTMENT OF AGRICULTURE PLs 25, 42, 48, 53, 68

Bureau of Agricultural Economics (statistical)

Forest Service (national forests)

Bureau of Plant Industry, Soils, and Agricultural Engineering PLs 46, 53 (soil, etc. in county and other small-area units; up to 1:24,000)

Production and Marketing Administration (aerial photos)

Rural Electrification Administration (lines and facilities)

Soil Conservation Service PLs 20, 46 (physical land conditions, up to 1:15, 840)

DEPARTMENT OF COMMERCE PL 53
Department of Commerce Publications (basic volume, 1790–1950; yearly *Supplements* thereafter; list of maps of Minor Civil Divisions in U.S.)

Bureau of the Census PLs 53, 60, 70 (states, with county names and boundaries; outline) *Congressional District Atlas of the United States*

Coast and Geodetic Survey PLs 25, 53
Aeronautical Charts: U.S., foreign areas as published by Air Force (airport obstruction, enroute intermediate altitude, enroute low altitude, instrument approach procedure, jet [long range, high altitude and speed] navigation, planning, position, radio facility). Auxiliary maps and charts—see *Nautical,* below
Nautical Chart Catalog: Atlantic, Gulf, Pacific Coasts; Alaska, Hawaiian Archipelego, Puerto Rico and the Virgin Islands, Samoa and Guam (coastal approach and coastwise with or without loran lines of position, intracoastal waterways, large inland waterways, smaller waterways, harbor, anchorage areas; small-craft charts of active boating areas). Auxiliary maps and charts: world, N. Atlantic, S. Atlantic, Alaska (outline); U.S. (outline, great circle, isogonic)

Bureau of Public Roads (send inquiries to state highway departments)

DEPARTMENT OF DEFENSE PLs 50, 53
Air Force
Aeronautical Chart and Information Center (buy through U.S.C.G.S. catalog, *Aeronautical Charts,* above)
Army: Corps of Engineers
Army Map Service. *Listing of Map Series Available for Public Sale* (world, western

hemisphere, Asia, Europe, foreign countries, U.S.A., the moon; strategic planning, road, railroad; outline, molded plastic relief). Also a graphic descriptive index for each series. U.S. Series of Topographic Maps, 1:250,000 (buy through U.S.G.S.)

Division Engineer (charts of Middle and Upper and Middle Mississippi R. and Illinois Waterway to L. Michigan) Corps of Engineers, U.S. Army, Chicago 5, Ill.

Division Engineer (charts of Ohio R.) Corps Engineers, U.S. Army, Cincinnati 1, Ohio

Division Engineer (charts of Missouri R.) Corps of Engineers, U.S. Army, Omaha 1, Neb.

Lake Survey. Catalog of charts (Great Lakes, each and parts of each; N.Y. State Canals; L. Champlain; St. Lawrence R. to Cornwall, Can.) Corps of Engineers, U.S. Army, 630 Federal Bldg., Detroit 26, Mich.

Mississippi River Commission (charts and maps of Lower Mississippi R., including Gulf of Mexico to Ohio R.; also St. Francis, White, Big Sunflower, Atchafalaya, and other rivers) Corps of Engineers, U.S. Army, Vicksburg, Miss.

Navy
Hydrographic Office PLs 48, 50. U.S.N.H.O. *Catalog* and/or *Circular* (world, oceans; nautical, aeronautical; star, magnetic, loran; position plotting, time zone, outline)

FEDERAL POWER COMMISSION (State, larger units; electricity, gas, water power)

DEPARTMENT OF THE INTERIOR PLs 15, 25, 42, 53

Fish and Wildlife Service PL 21

Geological Survey PLs 15, 42, 48, 53, 60.
Publications of the Geological Survey (U.S., each state, Puerto Rico, Antarctica, Saudi Arabia; physical divisions of U.S.; national parks and monuments; special city areas; special districts or regions; certain basins, mountains, rivers [plan and profile];

geologic, geophysical [aeromagnetic], hydrologic; land classification, mineral resources; planimetric, topographic, shaded relief; U.S. base, outline) State Index Maps. Status Index Maps (*Aerial Mosaics, Aerial Photography, Topographic Mapping*—status of, in U.S.) U.S. Series of Topographic Maps (as produced by A.M.S.; separate areas in state, listed on sheets of individual state index maps); moon. Map Information Office (up-to-date facts about surveys and cartographical productions by all Federal agencies)

Bureau of Indian Affairs PL 55

Bureau of Land Management PL 53 (public land states; grazing districts, Indian reservations, mineral resources utilization, national forests, national parks, other Federal reservations; large cadastral maps, township plats 1:31,680 to 1:7,920

Bureau of Mines PL 58

National Park Service PLs 35, 53

POST OFFICE DEPARTMENT Official Postal Maps pamphlet (post routes of States, Territories and possessions; county or local rural delivery)

DEPARTMENT OF STATE PL 65

CIVIL AERONAUTICS BOARD (airlines) 1825 Connecticut Ave., Washington, D.C.

FEDERAL POWER COMMISSION (state, larger units; electricity, gas)

GOVERNMENT PRINTING OFFICE Superintendent of Documents PLs (all) (maps by various but not all Federal agencies)

INTERNATIONAL BOUNDARY COMMISSION, U.S. AND CANADA (topographic 1:250,000 to 1:6,000)

LIBRARY OF CONGRESS PL 53 Map Division (photoduplication service

"at reasonable cost, subject to conditions of law, copyright, and deposit")

NATIONAL ARCHIVES AND RECORDS SERVICE Cartographic Records Branch (maps as records, recent and old, domestic and foreign; photoduplication service)

TENNESSEE VALLEY AUTHORITY PL 42 *Tennessee Valley Lakes* (recreation areas) New Sprankle Building, Knoxville, Tenn.

STATE AND COUNTY MAPPING OFFICES. The various states issue separate map productions by their bureaus of mines, geology, natural history, economics, highways, agriculture, conservation, water resources, etc. If not printed, many of the maps are available through photostat privileges, as will be found the case also with the large-scale maps in the offices of county surveyors and engineers.

GOVERNMENT MAPPING AGENCIES OF CANADA

Write to the Geographical Branch, Department of Mines and Technical Surveys, Ottawa, for the list of Dominion map publishing agencies, and for any specific geographic information. For index map to sheets along the Canadian border, of the International Map of the World, write to the Map Distribution Office, in the same Department.

The *Atlas of Canada* is obtainable in separate sheets or in a binding. Specify English or French edition. In the Land Use Series (separate sheets), the individual maps have wordings both in English and French.

The mapping offices of the various provinces issue maps produced by their Departments of Mines, Natural Resources, Highways, Municipal Affairs, etc. If not printed, many of the maps are available through photostat privileges, as are also large-scale maps and plans of townships and townsites.

EQUIPMENT

INSTITUTIONAL AGENCIES

American Automobile Association, 1712 G St., N.W., Washington 6, D.C. (Also various cooperating regional and state organizations.) Road maps and itinerary strips for members.

American Geographical Society, Broadway at 156th St., New York 32, N.Y. Request list of publications.

The American Museum of Natural History, Central Park West and 79th St., New York 24, N.Y. Request price list of maps.

The Geographical Press. See Private Agencies.

Howe Press for Perkins School for the Blind, 175 N. Beacon St., Watertown 72, Mass. Embossed maps for finger reading.

National Geographic Society, 1146 16th St., N.W., Washington 6, D.C. Request list of publications.

Sky Publishing Corporation, Harvard Observatory, Cambridge 38, Mass. Astronomical maps and coordinate sheets. Request list of publications.

The University of Chicago, Department of Geography, Chicago 37, Ill. Outline base maps: world, continents. Request price list.

PRIVATE AGENCIES

Government maps are primarily intended as instruments for the many services a nation and its subdivisions perform and also as accommodations to the public for availing itself of those services. Institutional maps are produced through a definite endeavor, usually scientific, sustained by an inspired association of people on their own initiative and with no aim at profits. Proprietary maps are those that people as customers ask for to suit their particular needs and tastes, and for which they are willing to pay a market price. Public needs and tastes vary with local attitudes, and businessmen watch them keenly. Keeping maps in schools is one of these needs, and most school maps are the productions of commercial publishers. Most are a collaboration between teachers and cartographers. Like school books, school maps have gone through culturally significant changes: from stern and stodgy to tawdry or over-glamorous aspect, then to judicious dramatization and pleasant clarity. You can now look into the catalog and stock of almost any educational map publisher and feel anew the fascination of geography.

Nearly all of the educational map publishers produce outline maps, molded plastic relief maps, and globes.

Rand-McNally's 75-in. "Geo-Physical" relief globe (mentioned in Chap. 5) is a proprietary production, and the National Geographic Society's 12-in. globe is an institutional one; but both of these are properly endeavors of the general publisher rather than of the educational publisher. School and "grown-up" maps, like juvenile and adult books, are not in mutually exclusive categories at all. A map made expressly for the elementary grades might prove eminently useful in some places of business, and another made for definite professional purposes might have plenty to say in a schoolroom. For example, there's a firm (Jeppesen) specializing in charts and flight information strictly for the aviation industry and the private pilot; yet as an aid to visual navigation, it makes a map that can be instructive to children in the same way as air travel can: a depiction that simulates not only the pronounced relief but also the natural colors of surface features in aerial perspective.

Thus, though we can't remind ourselves too often that every map must be limited in its duties, *we* are not necessarily limited by

our age or occupation in what we might gain from a map of any particular kind.

Although private cartography may use a great deal of government material, the government in time of war calls upon the expert services of the commercial houses. If you are looking for good maps of anywhere you must look everywhere. No single map producer is likely to have everything. Cartography intermingles the endeavors of public and private enterprise.

Along with the educator and the national defender, the business man is a big customer of the private agency. He needs maps to assist him in his transportation, marketing, and expediting problems: maps such as only other business men know how to provide him. Frequently he has his special maps made to his individual order or else he employs his own cartographers—as with railroad maps and oil maps. Real estate or insurance maps must be of large scale and have very specific information. Where property is worth thousands of dollars a front-foot, the map must be accurate down to a finer fraction of an inch than sometimes might be required of the more impressively scientific geological map. Fire and mortgage underwriters must have maps which show not only lot lines, street widths, and structures but the kind of material used in the walls, in the systems of wiring, and in the underground conduits.

Since competition is ever lively among the private publishers; new ingenuities continue to appear. Some of these may seem to be catchpenny, but whether or not they are, the activity is enlightening to watch. Many of the private firms have to meet the critical requirements of educational or governmental patrons, whether in special aerial surveys or in the drafting and printing of the actual maps.

Like one's own mapping, one's own map-collecting begins most sensibly at home. Your local stationery and technical supply stores,

and perhaps a dealer at your airport, may have stocks worth your acquaintance.

Some of the campanies listed below do not sell maps at retail but survey and draft for other firms or for institutions and government agencies. You may wish to know about them, though, so as to keep an eye on their productions. The firms for which no specialties are mentioned here, and whose titles do not designate a specialty, are likely to offer a wide variety of maps. If you live near any of the agencies, a visit may prove rewarding.

Aero Exploration Company, P. O. Box 7068, Tulsa 18, Okla. (photogrammetry)

Aero Service Corporation, 210 E. Courtland St., Philadelphia 20, Pa. (photogrammetry, molded plastic relief)

American Air Surveys, Inc., 907 Penn Ave., Pittsburgh 22, Pa. (topographic, tax)

American Map Company, 3 W. 61st St., New York 23, N.Y.

Amman Photogrammetric Engineers, Inc., 931 Broadway, San Antonio 5, Tex. (oil cadastral)

G. W. Bromley & Company, 325 Spring St., New York 13, N.Y. (real estate, city)

Chicago Aerial Survey, 10265 Franklin Ave., Franklin Park, Ill.

George F. Cram Company, P. O. Box 426, Indianapolis 6, Ind.

Dennoyer-Geppert Company, 5235 Ravenswood Ave., Chicago 40, Ill.

Fairchild Aerial Surveys, Inc., 224 E. 11th St., Los Angeles 15, Calif.

Falcon Air Maps Company, 540 E. McDowell Rd., Phoenix, Ariz.

Farquhar Transparent Globes, 3724 Irving St., Philadelphia 4, Pa. (terrestrial, celestial)

General Drafting Company, Inc., Canfield Rd., Convent Station, N.J. (road)

Geographia Map Company, 636 11th Ave., New York 36, N.Y.

The Geographical Press, a division of C. S. Hammond & Company (graphic depictions of surface features, geological)

H. M. Goushá Company, 2001 The Alameda, San Jose, Calif. (road)

Hagstrom Company, 311 Broadway, New York 7, N.Y.

C. S. Hammand & Company, 515 Valley St., Maplewood, N.J.

Hearne Brothers, First National Bank Building, Detroit 26, Mich. (wall; school, office)

Mark Hurd Aerial Survey, Inc., 345 Pennsylvania Ave., South, Minneapolis 26, Minn.

International Map Company, 140 Liberty St., New York 6, N.Y.

Jeppesen & Company, 8025 E. 40th Ave., Denver 8, Colo. (airway)

H. P. Kraus, 16 E. 46th St., New York 17, N.Y. (antiquarian)

Map Corporation of America, 316 Summer St., Boston 10, Mass. (city)

Midcontinent Map Company 114 W. 3d St., Tulsa 3, Okla. (oil, cadastral)

The National Survey, Chester, Vt.

A. J. Nystrom & Company, 3333 Elston Ave., Chicago 18, Ill.

Panoramic Studios, 179–189 W. Berks St., Philadelphia 22, Pa. (relief globes and models)

Erwin Raisz, 107 Washington Ave., Cambridge 40, Mass. (graphic depictions of surface features)

Rand McNally & Company, P. O. Box 7600, Chicago 80, Ill.

Replogle Globe Company, 1901 N. Narragansett Ave., Chicago 39, Ill.

Sanborn Map Company, 629 5th Ave., Pelham, N.Y. (insurance; atlases of urban areas)

Thomas Brothers, 550 Jackson St., San Francisco 11, Calif.

Weber Costello Company, 1212 McKinley St., Chicago Heights, Ill.

MAPS NEED CARE

It is often easier to use a map for all it is worth than to take care of it that well. One reason is that a good many of us have never learned a proper respect for *paper*. We have seen so much trash put on paper that we've come to think of it as being nearly trash itself. Even a document of honor is now and then dismissed as a "scrap of paper." We think of using paper as a wrapping to protect articles of value oftener than we think of it as meriting any special protection on its own account. Yet good rag paper has often outlasted pompous stone edifices and mighty things of iron. It has served as the material of the immortals, in literature, art, and science. And as much as steel or platinum it is the material of precision instruments, for maps are made of paper. Most maps.

Maps which must take heavy use, as in classrooms, are given extra strength with linen or muslin backing. One can learn how to glue paper maps to cloth at home; but it is a messy, risky process, involving a knowledge of the wetting and shrinking characteristics of different kinds of papers and cloths. You might practice on materials that you can afford to spoil, and when you have acquired the knack, you may find you'll have to spoil a good map or two before you can be sure of your ability. Leaving all this to experts is generally more economical.

Lack of proper space for storing maps is a sore problem, and unfortunately many of us who have a fondness for maps live in cramped apartments where we can scarcely take good care of ourselves. Maps lay before us the breadth of the world, but for them we have not even a few square feet of space to rest without injury. We roll them into tamales or fold and unfold them into tatters.

There are two good excuses for rolling a map. One of them is to put a map into a tube

for shipping, and the other is to store a map for a considerable period during which it will not be used. Rolling and unrolling maps every few days (except tough wall-maps on regular rollers) soon spoils them. They don't lie out flat, and so are punished for that with punches, slaps, and back-bendings. Usually, a few are rolled together, and as they are seldom the same size, the larger sheets get their edges kinked and torn while the smaller ones get lost inside the roll and mangled.

Folding-maps, however, like "folding-money" may imply usage. They have to be carried around in one's pocket. Surely, in time folding wears a map out too, but there's a difference between "using up" a map and ruining it through misuse. Much depends upon knowing how to fold a map.

The underlying principle of folding maps for regular use is to do so in such a way that you can open them readily to consult any portion with a minimum of handling. The first step toward this end is to get used to the idea of folding a map *face outward.*

This trick obviates unfolding the whole map whenever you wish to look at only one part of it, and makes it small enough to carry easily in a protective envelope or jacket. Nicely planned face-out folding also enables you to file most lightweight sheets so that their titles will show at the top.

The method illustrated here is the accordion fold. Four or six folds usually suffice.

There are many methods but this will work as a foundation for several of your own devising to suit the usage and the shape of your particular map. Unlike the chart demonstrated above many maps are not oblong but fairly square, and they would require more than one horizontal crease; but all of them should be accordionwise. Then do the vertical folding.

Many maps come ready-folded, and not always in a way that we would like or can understand. Once we get them unfolded it seems we can never fold them right again. An old bit of counsel is "let the map fold itself for you." Hold it suspended from one side while you let it drop slowly onto a table or into your other hand, and the chances are that it will find its own folding pattern.

Perhaps the most familiar example of a good map file is that issued by the National Geographic Society for its publications. These files are like books and therefore the maps they hold receive the good care that books are given on a shelf. The "book" contains heavy-paper pockets each bearing a number, and also a page with blank lines correspondingly numbered, so as to be a "table of contents."

But folding is not the last word in care. The pilots who so ingeniously fold their charts that each part unfolds in the order needed during flight, nevertheless before taking off lay out routes on a flat chart which has never been folded or wrinkled. Creases and dents interfere with protractor reading and with scaling. They can almost wreck the base map which you may sometime wish to use under a tracing sheet. The best way to keep maps is flat in large folders made of some tough but pliable cardboard, such as pressboard, manila tag, or index bristol. Sheets of this material, 20 × 24, and larger can be found in the stockroom of almost any job printer. Don't fold them, but

hinge two long sides together with binder's or other suitable cloth. One of these folders can hold from 30 to 50 maps.°

The next question is where in a two-by-four apartment is one to put such a folder. Standing it on edge, unless it is made of stiff chipboard, is unsafe. Libraries have broad shelves or cabinets with wide, shallow trays for these folders; but about the only equivalent horizontal expanse to be found in an urban hive is under a bed!

The map collector may have to reconcile himself to one or two folds in his larger maps and then stow them in a trunk tray or in a bureau drawer.

As soon as you have more than one folder or over 50 sheets, you will want a cataloging system of your own. That sounds pretentious, but a small card file will save you much time in looking for the very map you wish and will also save the maps. It is from just such useless handling (as when they stand in the way of other maps) that they reproachfully show the most wear and tear before you have got much good out of them.

Cataloging them in some plain order is easy and can be as agreeable an occupation as that of the philatelist who is forever arranging his pet stamps in an album.

Library experience seems to indicate that the handiest classification of maps is alphabetically by regions: "Arabia, Asia, Berlin, California," and on, to "Xingu, Yellow Sea, and Zanesville." That is, the part of the world which is the main subject of the map becomes the subject, or key-word of the index card, and so goes at the top of it. Following that come the specifications, and in your system these will fall in whatever order of importance best suits your purpose. This might be: Scale, Type of Map (whether topographical, pictorial,

° See the Library of Congress publication, *Maps—Their Care, Repair, and Preservation in Libraries,* for examples of various kinds of folders, jackets, and boxes as well as for many other practical suggestions.

etc.), Projection, Maker, Date, etc. Finally but prominently, what folder it is stowed away in and its number in that folder.

Librarians who have large open shelves label their folders at the folded edge, because that closed edge comes next to the outer edge of the shelf to spare the maps unnecessary exposure to dust. But when they have drawertrays, they keep the open edges of the folders forward and label them there, because that facilitates finding a map without overhandling. Accordingly, the nearest edge of the map sheet should be marked with its identification, in a corresponding corner. This should be the same place—say, the lower righthand corner—on every sheet in that file. Use a broad-leaded pencil or crayon to make the mark readily recognizable, but avoid pencils which are too soft and smudgy.

If your collection of topographic quadrangles is considerable they should have a folder or two of their own, arranged by states or provinces. Or, if they comprise but parts of one or two of these, the sheets will be most handily filed in groups of 5 or 9 according to how they adjoin when you assemble them to form a large map.

Index maps are often best separately catalogued and filed. But however you choose to care for them, make them work for you. Check on them the quadrangles for which you have sheets.

Maps enjoy wall space as much as paintings do. On a wall they don't have to serve as elbow rests for habitually recumbent people, but themselves stand primly facing the light.

An easy, uninjurious way to suspend a map on a wall temporarily is to make a simple holder of two or three spring ("bulldog" type) clips and a dowel rod, 3/16 in. diameter. Run the dowel through the cylindrical spring of each clip. The holder hangs either by the eye of the middle clip, on a hook, or by a string tied into the eyes of two clips. It will safely take three or four maps if they are

not more than 40 in. wide, a dowel being 36 in. long.

FURTHER READING

It has been the purpose of this book to give the reader a fair panorama of the subject, with the main features strong and with the details well marked. Some readers may feel they have had a sufficient view, while others may wish to go on and get more. They will find rich fields.

If this book has stimulated such venturesomeness and enabled the reader to comprehend better than he might have otherwise the books listed below, his inevitable respect for them will in part acknowledge the debt that this book owes.

Contrary to general impression, engineers and cartographers are usually good writers. A little dry, maybe, but not so unfeeling as their frugality of sentiment makes them appear. After reading them but a short while you'll discover that their habitual modesty (a few of them have absolutely none!) is holding them to understatement and you get to like it, for as with small scale you get a greater breadth of survey. And you'll begin to suspect that they are aching to tell you more than they'd better: about how it feels to be out on a lone reconnaissance at night time, cooking one's own chow while others hasten down distant highways homeward to warm suppers; how after a day of plane-tabling it feels to go on working so as to be on top of the next day's job; and how there's an aesthetic experience in watching a map "grow under one's hand" from a welter and a fracas of data and a white desert of paper into a valid article, as trim and pretty as a prize flower yet as precise and strong as a fine rifle.

Many of the books listed here are out of print, but some of the oldest of them may still be found in public libraries or picked up in secondhand book shops. Recency is little or no indication of their usefulness to the map amateur and the amateur mapper. For example, you are unlikely to find another such regale of wonderful old maps as are reproduced in the two large tomes by the great Swedish arctic explorer A. E. Nordenskiöld.

Some large concerns issue manuals which are prepared to go with their globes, but which are purchaseable separately. They contain practical explanations of globes and other maps, principally as handbooks for teachers, a feature which makes them that much the better for self-teachers.

The government manuals are inexpensive, and though more likely than other writings to be dry and over-condensed, are reliable. After using one of them for a while you become attached to it. Because of their unpredictable nature, prices are not shown here. The catalogs of the various mapping agencies mentioned on pages 247–250 contain the titles and prices of the manuals and papers recommended in our list. However, the manuals of the Army Department you may best inquire about either by visiting any of the larger retail map stores or by writing to the Superintendent of Documents, Washington, D. C.

Maps are not ends in themselves but instruments for use in the sciences. And if we wish to understand maps at their functional best, we should read the books in which maps are earnestly at work. Such as physical and economic geographies, geological and meteorological works, books of exploration, etc. Then indeed maps open up new worlds.

BOOKS ISSUED BY VARIOUS PUBLISHERS

ABC's of Photogrammetry: Part 1, Fundamentals, by G. T. McNeil; *Part 2, Tilt and Control Extension,* by R. O. Anderson. 2 vols. Washington, D.C.: G. T. McNeil, 1949.

American Society of Photogrammetry. *Manual of Photogrammetry*. Washington, D.C., 1952.

———. *Manual of Photographic Interpretation*. Washington, D. C., 1961.

AVERY, T. E. *Interpretation of Aerial Photographs*. Minneapolis: Burgess Publishing Company, 1962.

BAKER, W. H. *Elements of Photogrammetry*. New York: The Ronald Press Company, 1960.

BIRCH, T. W. *Maps Topographical and Statistical*. Oxford: Oxford University Press, 1949.

BISHOP, M. S. *Subsurface Mapping*. New York: John Wiley & Sons, 1960.

BOGGS, S. W., and D. C. LEWIS. *The Classification and Cataloging of Maps and Atlases*. New York: Special Libraries Association, 1945.

BRINTON, W. C. *Graphic Presentation*. New York: Brinton Associates, 1939.

BROWN, L. A. *Notes on the Care and Cataloguing of Old Maps*. Windham, Conn.: Hawthorn House, 1940.

———. *The Story of Maps*. Boston: Little, Brown & Co., 1949.

CHAMBERLIN, W. *The Round Earth on Flat Paper*. Washington, D.C.: National Geographic Society, 1950.

The Columbia-Lippincott Gazetteer of the World. New York: Columbia University Press, 1962.

COTTLER, J., and H. JAFFE. *Map Makers*. Boston: Little, Brown, & Co., 1938.

CRONE, G. R. *Maps and their Makers*. London: Hutchinson's University Library, 1953.

D'AGAPAYEFF, A., and E. C. R. HADFIELD. *Maps*. New York: Oxford University Press, 1942.

DEBENHAM, F. *Exercises in Cartography*. London and Glasgow: Blackie & Son, 1937.

———. *Map Making*. London and Glasgow: Blackie & Son, 1955.

DEIGHTON, H. *The Art of Lettering*. London: B. T. Batsford, 1953.

DOUGLAS, R. *Calligraphic Lettering*. New York: Watson-Guptill Publications, 1950.

FAIRBANK, A. J. *A Handwriting Manual*. Hollywood-by-the-Sea, Florida: Transatlantic Arts, 1954.

FIELD, R. M., and H. T. STETSON. *Map Reading and Avigation*. New York: D. Van Nostrand Company, 1942.

FILCHNER, W., et al. *Route Mapping and Position-Locating in Unexplored Regions*. New York: Academic Press, 1957.

FINCH, J. K. *Topographic Maps and Sketch Mapping*. New York: John Wiley & Sons, 1920.

FISHER, I., and O. M. MILLER. *World Maps and Globes*. New York: Essential Books, 1944.

FITE, E. D., and A. FREEMAN. *A Book of Old Maps*. Cambridge, Mass.: Harvard University Press, 1926.

FORDHAM, H. G. *Maps, Their History, Characteristics and Uses*. Cambridge: Cambridge University Press, 1943.

HALLERT, B. *Photogrammetry—Basic Principles and General Survey*. New York: McGraw-Hill Book Company, 1960.

HEWITT, G. *Lettering*. New York: John de Graff, 1954.

HINCKLEY, A. *Map Projections by Practical Construction*. London: George Philip & Son, 1942.

HINKS, A. R. *Map Projections*. Cambridge: Cambridge University Press, 1921.

———. *Maps and Survey*. Cambridge: Cambridge University Press, 1942.

HOFFMEISTER, H. A. *Construction of Map Projections*. Bloomington, Ill.: McKnight & McKnight, 1946.

JOHNSON, W. E. *Mathematical Geography*.

New York: American Book Company, 1907.

KJELLSTROM, B. *Be Expert with Maps and Compass.* New York: American Orienteering Service, 1955.

LOBECK, A. K. *Block Diagrams and Other Graphic Methods Used in Geology and Geography* (2d ed.). Amherst, Mass.: Emerson-Trussell Book Company, 1959.

LOBECK, A. K. and W. TELLINGTON. *Military Maps and Aerial Photographs.* New York: McGraw-Hill Book Company, 1944.

MAINWARING, J. *An Introduction to the Study of Map Projections.* London: Macmillan & Co., 1942.

MONKHOUSE, F. J. and H. R. WILKINSON. *Maps and Diagrams: Their Compilation and Construction.* London: Methuen & Co., 1952.

NORDENSKIÖLD, A. E. *Facsimile Atlas to Early History of Cartography.* Stockholm, 1889.

———. *Periplus.* Stockholm, 1897.

RAISZ, E. *General Cartography.* New York: McGraw-Hill Book Company, 1948.

———. *Mapping the World.* New York: Abelard-Schuman, 1956.

———. *Principles of Carthography.* New York: McGraw-Hill Book Company, 1962.

ROBINSON, A. H. *Elements of Cartography.* New York: John Wiley & Sons, 1960.

———. *The Look of Maps: An Examination of Cartographic Design.* Madison, Wis.: University of Wisconsin Press, 1952.

SCHWIDEFSKY, K. *Outline of Photogrammetry.* New York: Pitman Publishing Corporation, 1959.

SHARP, H. O. *Geodetic Control Surveys.* New York: John Wiley & Sons, 1943.

SKELTON, R. A. *Decorative Printed Maps of the 15th to 18th Centuries.* London and New York: Staples Press, 1952.

———. *Explorer's Maps; Chapters in Cartographic Record of Geographical Discovery.* New York: Praeger, 1958.

SLOANE, R. C., and J. M. MONTZ. *Elements of Topographic Drawing.* New York: McGraw-Hill Book Company, 1943.

SPURR, S. H. *Photogrammetry and Photo-interpretation, with a Section on Applications to Forestry.* New York: The Ronald Press Company, 1960.

STAMP, L. DUDLEY (ed.). *Glossary of Geographical Terms.* New York: John Wiley & Sons, 1961.

STEERS, J. A. *An Introduction to the Study of Map Projections.* London: London University Press, 1962.

STEVENSON, E. L. *Terrestrial and Celestial Globes.* 2 vols. New Haven: Yale University Press, 1921.

TOOLEY, R. V. *Maps and Map-makers.* London and New York: B. T. Batsford, 1962.

TROREY, L. G. *Handbook for Aerial Mapping and Photogrammetry.* Cambridge and New York: Cambridge University Press, 1952.

Webster's Geographical Dictionary, Springfield, Mass.: G. & C. Merriam Company, 1962.

WHITMORE, G. D. *Advanced Surveying and Mapping.* Scranton, Pa.: International Textbook Company, 1949.

WILLIAMS, R. L. *Statistical Symbols for Maps: Their Design and Relative Values.* New Haven: Yale University Map Laboratory, 1956.

WRIGHT, J. K., and E. T. PLATT. *Aids to Geographical Research.* New York: Columbia University Press, 1947.

GOVERNMENT PUBLICATIONS
UNITED NATIONS
DEPARTMENT OF SOCIAL AFFAIRS

Modern Cartography—Base Maps for World Needs. New York, 1949.

World Cartography, Vols. 1——. New York, 1951.

EQUIPMENT

Office of Geography

Gazetteers (official standard names approved by Board on Geographic Names, *q.v.;* Hawaiian Islands, Puerto Rico and other islands in Caribbean, South Atlantic, South Pacific, Southwest Pacific, Indian Ocean, Antarctica, and foreign countries): *see* PL 53.

Bureau of Land Management

Manual of Instructions for the Survey of the Public Lands of the United States. 1947.

Restoration of Lost or Obliterated Corners and Subdivision of Sections. 1955.

LIBRARY OF CONGRESS

Catalog of Copyright Entries; Series 3, Part 6: Maps and Atlases (listing of maps and atlases received during previous six-month period by Copyright Office for registration; no maps by Federal agencies). 1947.

Classification, Class G, Maps. 1946.

HILL, J. D., and R. S. LADD. *Treasure Maps in the Library of Congress.* 1955.

LeGEAR, C. E. *Maps—Their Care, Repair, and Preservation in Libraries.* 1956.

———. *United States Atlases: List of National, State, County, City, and Regional Atlases in the Library of Congress.* 2 vols. 1950–53.

PHILLIPS, P. L. *A List of Geographical Atlases in the Library of Congress.* 6 vols. 1909——.

RISTOW, W. W. *Aviation Cartography* (2d ed.). 1960.

———. *Marketing Maps of the United States.* 1958.

RISTOW, W. W., and C. E. LeGEAR. *A Guide to Historical Cartography—A Selected, Annotated List of References on the History of Maps and Map Making* (2d ed.). 1960.

BOARD ON GEOGRAPHIC NAMES ("to provide uniformity in geographic nomenclature and orthography throughout the Federal Government"): address, care of Geological Survey.

GOVERNMENT PUBLICATIONS
CANADA

The Geodetic Survey of Canada, Ottawa, issues publications concerning bench marks (elevation) and triangulation and traverse (latitude and longitude) as these matters apply to specific areas in Canada. They publish also field instructions and reports on geodetic operations.

PERIODICALS

Developments in the various sciences and in the cartography which interprets them are taking place so briskly that a good part of the mapping game consists in keeping up to date. As no book on sociology can substitute for a newspaper, no book on mapping can take the place of the current publications. Those listed here are not devoted entirely to maps, and some may appear for an issue or two without any maps or articles on survey or cartography.

All public libraries of any size have the *Reader's Guide to Periodical Literature* easily accessible in their reference department. This is the best informer as to who's talking about what in the better known magazines. The *Monthly Catalog* of U. S. Government publications lists many of the papers issued by the bureaus. The larger public libraries and the college libraries have or should have both this and *Current Geographical Publications*, the best informer the map enthusiast could ask for. This is published every month by the American Geographical Society. It lists not only the magazine articles but the latest books of geographic interest and maps, approximately 600 items in each issue.

EQUIPMENT

Annals of the Association of American Geographers. 1785 Massachusetts Ave., N.W., Washington 6, D.C. Quarterly

Braille Map Quarterly. Howe Press for Perkins School for the Blind, 175 N. Beacon St., Watertown 72, Mass.

The Canadian Surveyor. Canadian Institute of Surveying, Box 57, Westboro, Ont., Canada. Five times a year

Geographical Bulletin. Geographical Branch, Dept. of Mines and Technical Surveys, Ottawa, Ont., Canada. Bimonthly

The Geographical Journal. Royal Geographical Society, London, S.W. 7, England. Quarterly

The Geographical Magazine. Geographical Magazine, Ltd., Friars Bridge House, Queen Victoria St., London, E.C. 4, England. Monthly

Geographical Review. The American Geographical Society, Broadway at 156th St., New York 32, N.Y. Quarterly

Geography. G. Philip and Son, Ltd., 32 Fleet St., London, E.C. 4, England. Quarterly

International Yearbook of Cartography, Orell Füssli, Zurich, Switzerland; Rand-McNally, Chicago, Ill.

The Journal of Geography. Published by A. J. Nystrom and Company, 3333 Elston Ave., Chicago 18, Ill., for the National Council for Geographic Education. Monthly, except June, July, and August

The Military Engineer. Society of American Military Engineers, Mills Building, Washington 6, D.C. Bimonthly

The National Geographic Magazine. National Geographic Society, 1146 16th Street, N.W., Washington 6, D.C. Monthly

Our Public Lands. Bureau of Land Management. Superintendent of Documents, U.S. Government Printing Office, Washington 25, D.C. Quarterly

Photogrammetric Engineering. The American Society of Photogrammetry, 44 Leesburg Pike, Falls Church, Va. Five issues per year

The Professional Geographer. Association of American Geographers, 1785 Massachusetts Ave., N.W., Washington 6, D.C.

The Scottish Geographical Magazine. The Royal Scottish Geographical Society, Synod Hall, Castle Terrace, Edinburgh, Scotland. Three times a year

Special Libraries Association, Geography and Map Division, Bulletin. Map and Geography Library, University of Illinois, Urbana, Ill.

Surveying and Mapping. American Congress on Surveying and Mapping, 733 15th St., N.W. Washington 5, D.C. Quarterly

WORKING OUTFIT

Many aspiring hunters and anglers get their biggest bags and greatest pleasure in the sporting goods shop itself. The bright readymade articles fill them with dreams of success which are more vivid to them than what they usually get when facing the reality of field and stream. It is a common human failing to overburden oneself with equipment: having so much equipment that the mere care and carrying deprives one of the use of it. We all know that the lad with the bent pin for a fishhook somehow does things better. And this is no sentimental nostalgia for barefoot days. The fact is that as boys we saw our objectives more simply and singly.

It was for the fun of it. We couldn't buy many things; so we *did* them, or made them. Eagerly —for we couldn't abide to let the means in any way interfere with our ends.

This, then, might be called The Bent Pin School of Mapping. However, there are so many varieties of work that more items are listed here than any one amateur should desire to have at any one time.

MAGNETIC COMPASS

Selecting a good magnetic compass is difficult even if you can afford the expensive ones. You may determine the exact magnetic variation of the locality where you make the purchase, but the shop will very likely be in a steel structure surrounded by trolley lines and full of attractive metals. Even a professional compass made for surveying or navigating and costing more than we are likely to spend on all the mapping we shall ever do are at times faulty. But there are moderate-priced instruments that will prove fairly reliable if we ourselves are a bit faithful in now and then checking the compass, as we would a watch, with the correct reading at the locality, and in taking into account the exact difference. (See pp. 60–65.) There was a time, don't forget, when a ship's master considered a needle in a tub a very scientific instrument and felt safe with it out at sea.

Here, then, are some pointers which may prove helpful. Don't buy a toy, or jeweler's gadget, or combination compass-and-something-else. Let the full cost go into the compass and be your money's worth. Select a clear, legible card. A card with one system of marking on it—preferably the azimuthal—is better than one with a combination. Trying to make a quick, exact reading on a card cluttered with letters and numbers is more difficult than converting azimuths to points later at one's leisure.

A metal card is better than one which will not resist dampness and warping. Not only paper but celluloid may buckle. Of all card materials, aluminum or silvered metal hold color and shape best.

There are several kinds of needles. In lower-priced compasses the needles are usually flat. The north-seeking end is usually blued. These give good service, being light and responsive. Somewhat better are the bar needles. These are small steel bars pinched in the center to sit on the pivot point. The north-seeking end usually has a bit of wire wound around it or a pin inserted through it.

An excellent type of compass is one in which the dial and the needle are united, so that the dial does the floating and turning. As soon as it comes to rest it gives you not only magnetic north but also all the other directions. What's more, you can hold the box any way you like, and no matter how much you move about, the needle-card stays set in its magnetic orientation. In the ordinary type, with the needle separate from the card, which is at the bottom of the case, you have to turn the case to bring the north mark under the needle, each time you so **much as budge.**

There are **compasses fitted with a peep sight or some other sighting device. Among the best of these is one with a hinged eyepiece containing a lens to magnify the card so that you can read the azimuth at the same time as you are sighting your line on the distant object. It is known as the *lensatic compass*. As it is standard for military use, you will find a complete explanation of it in the Department of the Army Field Manual *Map Reading* (FM 21-26).**

A good way to test the action of a compass when you buy it (or later) is to lay it on the smooth, level top of the showcase, or of a table. Then very steadily rotate the case. If the card stays still while the case is turned, and does not tend to drag along with the turning motion, its action is all right.

Some low-priced compasses are fitted with detachable peep-sights in the form of cradles in which the compasses sit. Good too.

A safe place to buy a moderate-priced instrument is at the Boy Scout trading posts.

P. R. Jameson, in his brochure *The Compass the Signpost of the World*, published by the Taylor Instrument Companies, Rochester, N.

Y., suggests the following requirements of a pocket compass:

(a) Sensitiveness of action
(b) Accuracy of magnetic needle
(c) Jeweled center to needle
(d) Stop arrangement to check action
(e) Construction capable of repair when anything goes wrong with it
(f) Heavy tempered steel point for needle to operate upon.

A trough compass fitted into a plane table is of considerable convenience if there is a great deal of mapping to do. It is a long narrow box with a card having a short arc of scale at each end. When the long needle comes to rest with its points at the center of these scales, it is parallel with the sides of the box; and so the box being parallel with two sides of the board, the plane-tabler has a handy way of keeping oriented. If you have the knack for small, somewhat difficult fabrications and get hold of a copy of Debenham's *Map Making,* you will find in that engaging manual how to make your own trough compass at home, forging and magnetizing the needle yourself.

LEVELS, TAPES, AND OTHER MEASURERS

Hand sighting levels are useful in measuring small vertical distances; that is, differences in elevation. They are simple and not expensive. One manufacturer of them credits the instrument with being accurate to one-fifth of 1 degree.

For measuring short distances on the ground, tapes made of steel or of interwoven wire and thread are practical for surveys not requiring high professional precision. The steel tapes are more reliable than the other metallic kind. The former come in lengths of 100 ft. and 300 ft.; and the latter, usually 50 ft.

Hand sighting level °

The Department of the Army's *Elements of Surveying* (TM 5-232) is explicit about the fine points of careful taping. Here are some of the mistakes it warns against:

"Failure to hold the zero gradation of the tape over the point.

"Incorrectly transposing figures, such as recording 48.26 for 48.62.

"Reading the tape upside down and obtaining, for example, 98 for 86.

"Measuring from the wrong end of the tape and misreading tape lengths, for example 47 instead of 53.

"Reading the wrong foot mark, such as 68.32 for 67.32."

You probably have already seen or acquired one of the several different mechanical measurers of map distances. Their usefulness is primarily in reading, rather than in drawing, maps. But if you are doing any compiling, you will be reading some distances, and if these are linear but not straight, one of the tiny cyclometers might prove helpful both in copying and checking.

For doing the same kind of measuring on the ground itself, there are various makes of distance meters, sometimes called "perambulators," which are wheels that you push by a handle, like a roller toy. They register distances up to 10,000 ft. To buy one you may

° Courtesy of Swift Instruments, Inc.

have to choose between it and a good warm parka coat.

PAPER

Mapping paper should be smooth and tough. It should be able to take it. Its smoothness should not be one of artificial gloss but of hard finish. It should be erasable, but blotting paper is "erasable" too. Pencil marks should come off more or less easily but without damage to the surface. The surface of a map sheet is like the shell of a ship. It supports the whole load. Lastly, good mapping paper should shrink very little or none at all when exposed to dampness.

The kind of paper to use depends upon the kind of use. Let us first consider the final map.

The finest paper, which only the finest maps deserve, is handmade drawing paper. This stuff is made entirely of rag, unadulterated with any other kind of pulp, and is just as much to be admired as hand-loomed cloth. You can soil it and kink it, then douse it in a bath of clear water, and press it; it will come out as fresh and sweet and right-shaped as a good linen napkin. *Mappa!* (Indeed, maps are now being made on cloth kerchiefs so that they will remain as good as ever after having been with the owner through dirt and struggle and even shipwreck; and some of the first of these modern "mappas" were sent during the War to soldiers in Tunis, where the word itself got its start.)

There is some machine-made paper which is all-rag and almost also too good for us. As well as expensive. This is bristol board of the best obtainable quality. The best weights to use are medium and heavy. Two-ply is good for most work.

Then there are bristols and other papers which are partly of rag. You will find various kinds of medium and lower-priced sheets, as well as the finest, in the artist's and draftsman's supply shops; but a small job printing shop is also a good place to go to if you know what you want and the printer is neither too busy or ill-humored at the time to pull out a few sheets on which his profit is hardly ever worth the trouble. Such sheets would be any of his good ledgers, bonds, or heavy writing-papers. Tell him the size of your job and he'll find a size of sheet which will contain the map, or more than fit your board. If your mapping skill warrants only the most modest expenses for paper, ask for a middle grade bond of 24 lb. substance, but *smooth*, not cockle finish. Uniform texture always, whatever the grade.

For plotting preliminary maps, draftsmen use detail paper. This comes both in rolls and in cut sheets. The tints are cream and green, and many prefer the green. A smooth manila detail paper is excellent to work on with pencil. If it seems to resemble wrapping paper and leads to the use of such for practice maps, you may or may not have hit upon an economy. Uniformity of texture and clearness are qualities you must have in a paper though you may be only "practicing," and few wrapping papers have these qualities. A good part of early practicing may consist in learning how to draw a neat, steady, and well-defined pencil line, and a paper which thwarts this is no economy.

Plane-table paper should be especially tough. It may have to face bad weather. If the paper has a gloss, a sizing, or is of the "hot press" type the slick smoothness will not hold up well in the field. Some mappers like to have their plane-table sheets the least bit rough, arguing that this makes them easier to work on. They sometimes "season" the sheets before using them. This consists in subjecting the sheets to changing humidity for many weeks. Before this Spartan exposure the sheets are usually mounted on a cloth. Fresh sheets are liable to produce distortions, throwing a carefully worked out scale into havoc.

A good way to fasten the sheet to the board is to wrap it partly around the board, applying the tacks, glue, or adhesive tape to the back of the board. When the job is done, remove the sheet by slitting it off the board with a sharp knife. This keeps the board's working-surface free of tack holes.

Some of the mapper's uses for cross-section paper have been mentioned. At ordinary stationery stores the range of these will be very small, but at stationery stores serving a college trade (particularly the co-operatives within the campuses) and at the regular drawing-material shops will be found many of these time-saving papers. And we might use one or two of them without abandoning our "bent-pin" policy. These papers come ordinarily in two weights: drawing paper and tracing paper. Their quality is usually good enough for the final map. As has been said, the blue lines do not photograph; however, orange, green, red, or black inks are used for some rulings.

The chief factor in selecting a graph sheet is the number of lines to the inch. For this relates directly to the scale you are working with. If, for instance, you are working in terms of tenths, you will prefer a sheet having 10 lines to the inch, or, if this mesh is too small, 5 lines to the inch. Tenths will enable you readily to divide your mile into tenths, or decimals. It will work well for scales of 10 mi. or 100 mi. to the inch. Or with such representative fractions as 1:100, 1:1,000, and so on. The fifths will likewise aid in a scale involving fifths, fives, twenty-fives, fifties, etc. Once you have really got the idea of scaling, you will discover the folly of straitjacketing *every* job to fit the inch; you will be free to use the much more amenable and truly natural scale of the RF. Then you will have more choices of units to stand for a mile. You can choose 3.3 in. or 2.5 in., or whatever figure your RF boils down to.

There are, of course, millimeter rulings too,

with the centimeter, or half-centimeter lines heavy.

If you are working in a scale which calls for the more familiar division of halves, quarters, and eighths, you can get rulings 4 lines or 8 lines or even 16 lines to the inch. And if you are working in terms of feet or yards, 6 or 12 lines to the inch will prove helpful.

Cross section paper, 4 x 4 lines or 400 feet to the inch °

Cross section paper, 10 x 10 to the inch

Profile ruling, 4 x 20 to the inch

In all these figures above, the spacing applies to both the vertical and the horizontal lines, and so the proper designations would be: 10 x 10 to 1 in., 6 x 6 to 1 in., and so on. The reason for stressing this point is that you may not always wish to have the same number of lines both ways. When making a profile of a

° Illustrations courtesy of Keuffel & Esser Co., N. Y.

piece of ground, as has been shown in Chapter 5, we must often select a larger scale for the vertical measurements than that which is used for the horizontal, *i.e.*, the map's own scale of miles. Often, also, the vertical need be but a mite larger—not twice or thrice as large. Thus a typical profile paper comes ruled 4 x 20 to the inch. The twentieths afford you smaller steps for increasing the vertical scale, for if the paper were 4 x 4, you would be compelled to use a 100% increase at the very least; that is, 2 lines up for every 1 horizontal. Yet all your job would call for might be 80%, or a four-fifths, increase in the vertical scale. With a division of twentieths, then, your vertical scale is in readiness for the fractional increase.°

Thus, the beauty of these cross-section papers is that the drawing paper on which you work serves also as a ruler for you. Each sheet is itself a graduated scale.

In tracing-paper weight these sheets are useful for making transfers from a base map and at the same time to effect an enlargement or reduction of the original in fully controlled proportions.

As for unruled tracing papers, the cartographer likes a sheet which does not crepe or buckle but lies flat, which has a hard enough surface to take a well-handled 2H pencil, and which has uniform transparency. For doing a tracing directly on the sheet which must serve as the final map, a one-ply high grade bristol is the best. This requires doing the tracing over a plate of glass illuminated from beneath. Bonds, ledgers, and other writing-papers will also serve very well.

Tracing material comes also in the form of cloths and cellophane compositions. The latter has one surface slightly grained, so that it will take pencil or India ink.

° For making star maps, there is also a special rectangular coordinate paper, with a smaller interval between the horizontal ruling than between the vertical ruling.

PENCILS

The very finest pencils cost so little that the economical mapper should not hesitate to treat himself to the best. The difference in quality between the best and the lowest priced is so great that a cheap pencil soon seems intolerable. A good pencil graphite should have a uniform consistency of grind and packing throughout its length; otherwise it will not scribe a uniform line. The lead should have the same gauge throughout the bore, or it will not fit the bore and will break at various places within and slide out at unexpected times. A moderate hardness of the lead in a good pencil will have the strength or firmness of a degree harder pencil of inferior quality. And the *wood* —we may think that because we pare it away as waste, it is something that should not be very choice; but in all the range of uses for wood there are few which call for more selectivity than does the draftsman's lead pencil. It must be clear stock which does not split; strong enough to act as a protective shield for the graphite, yet soft enough to cut easily.

But the goodness of a pencil is wasted if it does not receive proper usage. Artists and draftsmen usually avoid mechanical sharpeners because these eat up a pencil too soon. Then there is the craftsman's pride in handling a knife well and sharpening one's own pencil. The sharper the knife the easier it is to guide without suddenly digging in too deep at places. So, just as one is wise to keep a knife handy to sharpen the pencil, one is wise to keep a stone at hand for sharpening the knife.

Once the pencil has been sharpened and the point dressed, the trick is to maintain that point. Just as we get into the good habit of seeing that a car is not in gear before we step on the starter we should habitually examine the condition of a pencil point before each use. The main object is to draw a true line;

this can't be done without constant attention to the point: trimming the lead rather than forever whittling at the wood. Use sandpaper of fine or medium grade. Or, better, a steel file. About ⅜ in. of lead should be exposed. After dressing the point on sandpaper, and polishing it on a scrap of drawing paper, wipe it off with a cloth so that no dust will fall off it and smudge the sheet. A slight repolishing after drawing a line or two will renew the point. In precise work with a hard pencil, the longer and thinner the lead the better you can see around it while drawing a line close by any minute detail. But do not taper the wood too slim, for it supports the lead. Whittle back not more than ¾ in., and even less on a soft pencil, which with its short, thick neck has to be somewhat square-shouldered for strength. Use a knife only on the wood of a pencil, never on the lead itself. Anything but an abrasive spoils the shape and balance of a graphite point.

Only a person who doesn't know what a pencil is all about will sharpen the wrong end of it. The end indicating the hardness of the pencil should be preserved.

There are three kinds of pencil points: The conical, for marking subdivisions and location-points, making symbols, numbers, freehand lines. The wedge, for line work against a straightedge, such as ruling rays or survey lines. The chisel, for use in compasses.

The greater the hardness of the pencil, the harder must be the surface of the paper and the higher its quality. More than that, the greater must be the skill of the hand. This is not to say that a novice can hide his inability in the velvet of a soft pencil, for there too the ill-trained hand may be revealed. Graphite in all its forms is surprisingly expressive. But when using a hard pencil the beginner tends to press too hard, so that he scores the paper instead of lightly marking it. The results are disastrous. The cut not only injures the surface permanently but makes a line whose edges are

so bad that the precise plotting of angles from it, or of distances upon it, becomes impossible. Inking in becomes like trying to ride a bicycle over plowed ground. The less hard grade of pencil submits more easily to erasure which is necessary often not only before the inking, as when blunders must be removed without injury to the paper surface, but also afterward, as when construction lines and other auxiliary

A. Chisel point, B. Wedge point, C. Conical point

marks are cleared away by erasing which must be so gentle that it will not scuff the inked features. As for the very hard pencil, its thin but firm line is not intended to serve as a mere preliminary to ink but to stand as the final, permanent work itself.

Until you have acquired the proper control and lightness of touch, you will find that the safest hardness to use should be no higher than 4H. In fact, H is hard enough for good, clean plane-table maps.

The range is from 6B, the softest, to 9H, the hardest.

ERASERS

The softer, the better. Avoid gritty "ink erasers." Save the surface. Artgum, "rubber dough," and "soap" erasers are the safest. Knead the dough and shape it to a point: you will be surprised what tight places it will get into to pick out fine lines. To erase ink lines, use a harder rubber (not coarser), or if you've a brain-surgeon's touch, a razorblade. Commercial artists do a great deal of deleting with a white paste known as reproduction white, or Chinese white. When whiting out a line, keep to the line as much as you can. The chief excuse for the use of the stuff is that it will not show up in a photograph or other reproduction; but if the original map is the only one you will have you will not wish to whitewash it. A neat patch of the same paper as used in the map can delete the fault and show a cleaner correction.

LETTERING PENS

There are many kinds of patent lettering pens on the market, some accompanied with advertisements which exaggerate the ease with which anybody can become a letterer overnight. The mapper may as well make up his mind at the outset that there is a difference between signcard writing and map lettering. But even though excellent lettering may be so difficult and rare that few of us who preach about it can show it in actual practice, still anyone who has a little natural graphic ability and the right kind of pen can very soon learn to do work with logic and good taste. And while the fine-pointed pen is what usually attracts the draftsman, it is the broad-pointed pen, known sometimes as a manuscript pen, which gives one's hand the right feel and swing for making letters. In many of the art supply shops which carry these are also some helpful manuals, usually put out by the pen manufacturers, and therefore low-priced. One

or another of the makes finds personal preference among beginners as well as among expert calligraphers. The brands differ in their cut, spring, feed, and, one might imagine, also in the "glide" on paper. They have variously devised reservoirs for holding a drop of ink, and one or two brands require a special holder. Each style comes in a range of widths: select the one which will give the width of line or weight of letter you wish, and the pen will give you exactly that width in its broadest stroke. Its thinnest stroke will be scarcely more than the thickness of the metal at the point. And your letters can have in them every gradation in between these two gauges. Pens too are precision instruments and require the amount of care that a scientific worker gives any article which has to do with measurement. Clean them thoroughly after each use, and before the ink dries on them. Alcohol is a good cleaner. Very few calligraphers dip these pens but fill them by using the quill or dropper which comes with a drawing-ink bottle.

Fountain pens with calligraphic nibs can expedite your practicing the formation of good-looking letters that will fit nicely into your maps. Also, they may help you in feeling confident for working in a relaxed, natural way. This feeling is a prime requirement for successful freehand lettering.*

Some professional cartographers use one or another of the mechanical devices for drawing letters. These save time for anybody who has to turn out maps fast enough to make money or who doesn't care whether his maps have appeal.

Letters with a stiff, machine-made look are more suitable for dry charts and graphs that try to have a technological deadpan aspect than for an equally serious map made by somebody who likes his calling.

* One of the many instructive points Arthur H. Robinson makes on this subject in *Elements of Cartography* ([2d ed.], New York, 1960) which has excellent chapters on designing and lettering a map.

Nowhere in the world is there any subject that requires a map to have its lettering stilted or stodgy or flimsy or prettified. On too many professional maps the lettering is dead wrong—made up of trite characters from the want-ad sections of newspapers or from the cut-and-dried typography of dismal textbooks.

Your unperfected but unpretentious style (frank penwork instead of imitation engraving) is certain to look more comely on a map than the perfected bad taste of an expert. Bad style in a map is as much an ineptitude as the bad drawing of rivers and coast lines.

Besides, a learner shouldn't mistake a shortcut to production for a shortcut to skill. Personal skill expedites in ways that nothing else can. This isn't to say there aren't some phases of map-making you'll find mechanical anyhow, e.g., line and dot patterns; and the sooner you use mechanical devices for such jobs, the more time you will have for your training in the skills you can enjoy possessing as strength for self-reliance. But select the essentials of your equipment to serve you as tools and materials rather than as dodges.

INKS

However modest you may be about the importance of your early jobs, use an opaque, waterproof, permanent black drawing ink if you care at all about keeping a map. Nothing is more pathetic than a map in which some conscientiousness was at work but one done with thin, anemic writing ink. The best drawing ink, like the best drawing pencil, is not costly, not enough above the price of the ordinary stuff that we should make our work suffer for the want of it. Good ink has much to do with the evenness and definition of lines, whether in ruling a coordinate, drawing a river, or making a letter.

MEASURING TOOLS AND DEVICES

A 6-inch triangular rule will serve as an alidade or sight-rule for a good deal of amateur work. Some mappers prefer a longer one, and there is something gained in having one to approximate the width of one's plane table.

Triangular rule with "engineer scale"

Whatever the length, having a rule marked in tenths will prove the real boon once you get used to it. This manner of division is sometimes what is meant by calling it an engineer's scale. And an important fact about it is that it *is* a scale as well as a sighting apparatus with a straight edge.

A brass-edged ruler is useful for drawing lines in ink, but if you are so fortunate as to have a good ruling pen, a T-square is better to use. The other reason for an extra ruler is to have an inch division into sixteenths and millimeters. For that matter, rulers showing sixty-fourths are easy to find at the supply shops and if made of celluloid are inexpensive. These need not be more than 6 in. long. Divisions down to hundredths come a little more costly, and you will find some 6-in. scales costing several dollars instead of only a few cents; but at any good mechanic's supply or high-class hardware store, 6-in. steel rulers graduated for sixty-fourths or hundredths are to be had for a half dollar, or less.

Coming back to the straight-edge function, be sure that when you buy rulers, T-squares, and triangles, to test the straightness of the edges, and that you do so again occasionally thereafter. The test consists simply in drawing with a well-sharpened pencil a line along the edge, then switching the rule end for end and trying to draw a second line upon the first. If the straightedge is a true one the lines will coincide and become a single line, but if there is a defect one line will bend away from the other somewhere between the contiguous ends.

A 30°-60°, transparent, right triangle will be useful. To test a right triangle, let it sit, with the right-angle down, against a straightedge. Draw a perpendicular along its vertical side. Now flop the triangle over as though it were hinged to that vertical side, and at the same point where you drew the line draw another perpendicular. The two lines will coincide and appear as one line if the triangle is true.

Protractors cost from a few cents to a few dollars each. Though the cheapest have probably not more inaccuracy than is inherent in the general conditions under which non-professional work is likely to be done, an inaccurate measuring tool is a bad psychological influence, for it suggests slovenly work and thereby brings about inaccuracies much more serious than may be found in its own construction. A tiny miss on a protractor can grow into a mighty arc of error. Transparency is a help. For map work, the familiar semicircle protractor is less accommodating than the full circle, sometimes called the "compass protractor," as it is marked like an azimuthal compass card for all 360 degrees. Some transparent 6-in. rules made by the draftsman's supply houses contain a protractor within their markings, and so are very handy for the mapper who must travel light. One of the best protractors for map work of moderate require-

ments is the kind that is printed on tracing paper, sometimes called "polar coordinate" paper. This is a big circular web, usually 10 in. in diameter, of radiating lines. Lay the paper over your job, wherever you wish to lay out an angle, and stick a needle point lightly through at the right points. The finest-sharpened pencil point can't beat this for precision.

A handy device for use on base and other maps is the "Natural Scale Indicator" prepared in the Department of State by S. W. Boggs.* It is simply a long strip of cardboard with the sides so graduated that you can read off a map's RF merely from the latitude parallels, or from the graphic scale of the map. Or, knowing only the RF, you can directly lay out a graphic scale in miles, feet, or kilometers.

A pricking needle is better than a 9H pencil for pointing. A fine needle inserted into the end of a pencil-like stick is an excellent homemade implement. Keep it shielded with a small cork, or with an old fountain-pen cap containing a bit of cork.

An ordinary pair of compasses will do, but even a good pair require a bit of skill in using. Guide the pivot point to the center point on

* Now published by C. S. Hammond & Co., New York City.

the sheet by steadying the shaft with the small finger of the left hand. Bear very lightly so as not to pock your sheet. The thumb and forefinger of the right hand now take hold of the top of the compasses, tilting a bit toward the line to be drawn. Then, with a single sure, clean sweep, draw the circle. To do this, roll the tip-handle between the thumb and forefinger. Unless you wish a heavier line do not try going over the circle again. The better compasses come in regular drawing-instrument sets, which for your purposes need not contain more than the compasses, a divider, and a ruling pen. Sometimes you can pick up a bargain in a pawnshop. Even so, the thrifty beginner can get along without this. Dividers are useful in laying off equal distances or in transferring them. The ruling pen is a double-bladed affair and comes in several types. In professional work it is the most frequently used instrument of the set, and quite a care, having to be cleaned repeatedly during use and kept sharpened and shaped by skilful oilstone work. But proper care will be found to repay the user many times over.

An accessory which the map-collector and maker will not find to be an unnecessary frill is a good pocket-magnifier. This need not be a

Pen pressed against T square too hard

Pen sloped away from T square

Pen too close to edge. Ink ran under

Ink on outside of blade, ran under

Pen blades not kept parallel to T square

T square (or triangle) slipped into wet line

Not enough ink to finish line

Avoidable troubles of the ruling pen

highpowered, expensive glass, but it should be one which is ground fairly true so as not to distort what you are trying to see through it. It should be not less than 1½ in. in diameter, so as to give you an appreciable field. It will come in handy not only in the reading of small-scaled maps but also in reading the fiftieths or sixty-fourths of an inch on your own scale.

Appendix

Useful Figures

APPENDIX

THE EARTH

DIMENSIONS

Equatorial diameter	7,926.677 st. mi.
Polar diameter (axis)	7,899.988 st. mi.
Difference in diameters	26.689 st. mi.

This difference is 1/297th of the greater diameter.

Mean diameter (for rough scaling)	ab. 500,000,000 in.
Equatorial circumference	24,902 st. mi.
Meridional circumference	24,860 st. mi.
Area	ab. 196,950,000 sq. mi.
land	ab. 57,470,000 sq. mi.
water	ab. 139,480,000 sq. mi.
Curvature of surface	ab. .7 ft. in 1 mi.
Difference between arc and chord length	.02 ft. in 11½ mi.

TERRESTRIAL ARCS

DEGREES

360° = a full circle
360° = 21,600′ = 1,296,000″
180° = a semi-circle
 90° = a quadrant
 60° = a sextant
 45° = an octant
 1° = 60 minutes
 60″ = 1 minute

RELATION OF ARCS TO TIME

In 24 hr. the earth turns 360°
In 1 hr. the earth turns 15°
In 4 min. the earth turns 1°
In 1 min. the earth turns 15′ *¼th of a degree*
In 1 sec. the earth turns 15″ *¼th of a minute*

LENGTHS OF ARCS IN SECONDS OF LONGITUDE

For the lengths (miles-per-degree) of east-west arcs at various latitudes, see the diagram on p. 51

An east-west second

at Lat.		at Lat.	
0 is 101.45 ft.		50 is 65.34 ft.	
5	101.07	55	58.32
10	99.92	60	50.85
15	98.02	65	42.99
20	95.37	70	34.80
25	92.	75	26.34
30	87.93	80	17.68
35	83.2	85	8.87
40	77.83	90	0.
45	71.86		

THE MILITARY MIL

$1 \text{ mil (as of an arc)} = \dfrac{1}{6400}$ of a circumference

$1 \text{ mil (as of a chord)} = \dfrac{1}{1000}$ of a radius

Explanation: If instead of dividing the circle into 360 equal parts, as for degrees, we divide it into 6400, we shall get the unit of angular measure known as the mil. The radius lines marking off one of those equal parts form an angle of 1 mil. They mark off on the circumference an arc of 1 mil. And the length of the chord subtending that arc is equal, practically, to 1/1000 of the radius. The word mil is derived directly from the Latin word for "thousand": mille.°

1 mil = ab. .056° or ab. 3′ 22.2″
17.8 mils (ab.) = 1°
1,000 mils (or a radius) = an arc of ab. 57° 17′ 44.8″

° A mil is the angle subtended by an arc of 1 unit on a radius of 1,000 units.

DISTANCE MEASURES

ENGLISH UNITS

1 rod (or pole)	= 16½ ft.
	= 5½ yd.
	= 1/320 st. mi.
1 furlong	= 660 ft.
	= 220 yd.
	= 40 rods
	= ⅛ st. mi.
1 statute mile	= 63,360 in.
	= 5,280 ft.
	= 1,760 yd.
	= 320 rods
	= 8 furlongs
1 league	= 15,840 ft.
	= 5,280 yd.
	= 3 st. mi.

SURVEYOR'S, OR GUNTER'S, CHAIN

Used in U. S. public-land surveys

1 link	= 7.92 in.
	= .66 ft.
100 links	= 1 chain
1 chain	= 66 ft.
	= .0125 st. mi.
80 chains	= 1 st. mi.

ENGINEER'S CHAIN

1 link	= 1 ft.
100 links	= 1 chain
1 chain	= 100 ft.
	.0180 st. mi.
52.80 chains	= 1 st. mi.
(52 ch. and 80 li.	= 1 st. mi.)

1 arpent = ab. 186.88 ft. or ab. 11.5 rods, i.e. the length of one side of a square arpent. *Parts of Canada.*

1 perch = 1 rod (or pole) = 5.5 yd. *Canada, England, and U. S.*

1 vara = 33.33 in. *Texas. In Spanish-America, the vara varies in length from 31.5 in., in Colombia, to 43.31 in., in Brazil, which is the same legalized value it has in Portugal.*

MARITIME UNITS

1 fathom	= 6 ft. = ab. 1/1,000 n. mi.
1 cable's length	= 720 ft. *U. S. Navy*
	= 120 fathoms *U. S. Navy*
	= 608 ft. *Brit. Navy*
	= ab. .10 n. mi. *Brit. Navy*
	= 600 ft. *occasionally*
	= 100 fathoms *occasionally*
1 nautical mile	= 6,076.1 ft. (*International*)
	= 1', or 1/60° of a great circle of the earth
	= 1/21,600 of a great circle of the earth
	= ab. 10 cables
	= 1.15 st. mi.
3 nautical miles	= 1 league *marine*
60 nautical miles	= 1°
66 nautical miles	= 76 st. mi. (= ab. 122 kilometers)
1 knot	= 1 n. mi. per hour
	= 1.15 st. mi. per hour (= 1.8532 kilometers per hour)

METRIC UNITS

Denomination	Value	Equivalent
1 millimeter	= 1/1000 m.	= .039 in.
	= 1/10 cm.	
1 centimeter	= 1/100 m.	= .393 in.
1 decimeter	= 1/10 m.	= 3.937 in.
	= 10 cm.	
1 meter (primary unit)	= 1,000 mm.	= 39.37 in.
	= 100 cm.	or, 3.28 ft.
		or, 1.09 yd.
		or, .00062 mi.
1 dekameter	= 10 m.	= 32.808 ft.
1 hektometer	= 100 m.	= 328.08 ft.
1 kilometer	= 1,000 m.	= 3,280.833 ft.
		or, 3,280 ft. 10 in.
		= .62137 st. mi.
		or, ab. ⅝ st. mi.
1 myriameter	= 10,000 m.	= 6.2137 st. mi.
	= 10 km.	
1 megameter	= 1,000,000 m.	= 621.37 st. mi.
	= 1,000 km.	

AREA MEASURES

Denomination	Value	Metric Equivalent
1 sq. inch		= 6.452 sq. cm.
1 sq. foot	= 144. sq. in.	= 929. sq. cm.
1 sq. yard	= 1,296. sq. in.	= .8361 sq. m.
	= 9 sq. ft.	
1 sq. rod, perch, or pole	= 272.25 sq. ft.	= 25.29 sq. m.
	= 30.25 sq. yd.	
1 acre	= 43,560. sq. ft.	= 4,047. sq. m.
	= 4,840. sq. yd.	= 40.4687 ares
	= 160. sq. rods	= .4047 hectares

A square field of 1 acre has each of its sides about 209 ft. long.

PUBLIC-LAND SYSTEMS, U.S. AND CANADA

1 township is 6 mi. × 6 mi.
1 township contains 36 sections
1 section = 1 sq. mi.
1 quarter section = 160 acres = ab. 65 hectares
1 quarter-quarter = 40 acres

ODD UNITS

1 rood = 40. sq. rods
= .25 acre

In Eng. and Scot. In the Union of So. Africa a rood is 17.07 sq. yd., or 14.28 sq. m.

1 arpent = .84 acre = 34.2 ares

Sometimes called the "French acre." Used in parts of Can. Appears, with variations of value, in old land deeds in parts of Ala., Fla., La., and Miss.

METRIC UNITS

Denomination	Value	Equivalent
1 centiare	= 1 sq. m.	= 1,550. sq. in.
		= 1.196 sq. yd.
1 are	= 100 sq. m.	= 119.6 sq. yd.
		= .0247 acre
1 hectare	= 10,000 sq. m.	= 2.471 acres
	= 100 ares	

The side of a square having 1 are of area measures about 33 ft.

CONVERSION FACTORS

To change one kind of measure into another only requires multiplying by the conversion factor. Suppose we are told that a certain distance is ten kilometers. How many miles is that? We first find out what the equivalent of one kilometer is in terms of miles. This is .6214 st. mi. That equivalent is also a conversion factor. So:

If 1 km. = .6214 st. mi.
10 km. = 10 × .6214 = 6.214 st. mi.

APPENDIX

As the meter is the primary, or basic, unit for the entire metric system, a table of conversion factors in meters and in feet will work for all the different units of the metrical system. For instance, a kilometer is 1000 meters. So, to multiply a meter by 1000, simply move the decimal point three places to the right:

$$1 \text{ m.} = 3.280833 \text{ ft.}$$
$$1 \text{ km.} = 3280.833 \text{ ft.}$$

The following condensed conversion table appears in various U.S.C.G.S. publications. It is intended for use in the field, where no computing machines are available, and where the mapper wishes to make conversions quickly, "avoiding some of the labor of hand multiplication." The simple example to illustrate the use of this table is converting 24.6 ft. to meters.

20 ft. = 6.096 m. *Get this by taking the factor which is the value in meters corresponding to 2 ft., then by moving the decimal point one place to the right.*

4 ft. = 1.219 m.

.6 ft. = .183 m. *Get this by taking the value for 6 ft. and moving decimal point one place to left, and then rounding off the number.*

Sum $\overline{24.6 \text{ ft.}} = \overline{7.498 \text{ m.}}$

Meters into feet		Feet into meters	
1	3.280833	1	.3048006
2	6.561667	2	.6096012
3	9.842500	3	.9144018
4	13.123333	4	1.2192024
5	16.404167	5	1.5240030
6	19.685000	6	1.8288037
7	22.965833	7	2.1336043
8	26.246667	8	2.4384049
9	29.527500	9	2.7432055
10	32.808333	10	3.0480061

DISTANCES, MISCELLANEOUS

To change	Multiply	By factor
Millimeters to inches:	millimeters	× .03937
Inches to millimeters:	inches	× 25.4
Meters to yards:	meters	× 1.094
Yards to meters:	yards	× .9144
Meters to statute mi.:	meters	× .000621
Miles to meters:	miles	× 1609.35
Meters to nautical mi.:	meters	× .000540
Nautical mi. to meters:	nautical mi.	× 1853.25
Kilometers to statute mi.:	kilometers	× .6214
Miles to kilometers:	miles	× 1.609
Nautical to statute mi.:	nautical mi.	× 1.151553
Statute to nautical mi.:	statute mi.	× .868393

AREAS

To change	Multiply	By factor
Sq. centimeters to sq. ins.:	sq. centimeters	× .1550
Sq. ins. to sq. centimeters:	sq. inches	× 6.452
Sq. meters to sq. feet:	sq. meters	× 10.764
Sq. feet to sq. meters:	sq. feet	× .0929
Sq. meters to sq. yards:	sq. meters	× 1.196
Sq. yards to sq. meters:	sq. yards	× .8361
Hectares to acres:	hectares	× 2.471
Acres to hectares:	acres	× .4047
Sq. kilometers to sq. miles°:	sq. kilometers	× .3861
Sq. miles to sq. kilometers:	sq. miles	× 2.59

° Statute miles.

ANGLES

Degrees to mils:	degrees	× 17.8
Mils to degrees:	mils	× .056°
Percent of grade to degrees:	percent	× .573

To change degrees to percent of grade see table "Methods of Expressing Gradients," p. 252.

° 1° = 17.8 mils approximately. .056° is 3′ 52″.

CIRCLES AND SPHERES

To find	Multiply	By factor
Circumference of circle	diameter	3.1416
Area of circle	diameter squared	0.7854
Side of square equal in area to that of given circle	diameter	0.8862
Area of sphere	diameter squared	3.1416

CONVERSION OF COMPASS POINTS TO DEGREES

		Angular measure				Angular measure	
North to East:		°	′	*South to West:*		°	′
North	0	0		South	16	180	
N. by E.	1	11	15	S. by W.	17	191	15
NNE.	2	22	30	SSW.	18	202	30
NE. by N.	3	33	45	SW. by S.	19	213	45
NE.	4	45		SW.	20	225	
NE. by E.	5	56	15	SW. by W.	21	236	15
ENE.	6	67	30	WSW.	22	247	30
E. by N.	7	78	45	W. by S.	23	258	45
East to South:				*West to North:*			
East	8	90	0	West	24	270	
E. by S.	9	101	15	W. by N.	25	281	15
ESE.	10	112	30	WNW.	26	292	30
SE. by E.	11	123	45	NW. by W.	27	303	45
SE.	12	135		NW.	28	315	
SE. by S.	13	146	15	NW. by N.	29	326	15
SSE.	14	157	30	NNW.	30	337	30
S. by E.	15	168	45	N. by W.	31	348	45
				North	32	360	

A quarter point is 2° 48′ 45″. The quarter points proceed thus:

North—N¼E—N½E—N¾E
N. by E.—N. by E¼E—N. by E½E

and so on, around the compass. For a complete table showing all the quarter points and their values in angular measure, see American Practical Navigator *by* Nathaniel Bowditch, U. S. Hydrographic Office.

METHODS OF EXPRESSING GRADIENTS [*]

Angle	Ft. per 100 ft. horiz. or	Vert. ft. to horiz. mi.	1 vertical on or in—	1 horizontal to—
Degrees			Horizontal	Vertical
¼	.44	23.	229	——
½	.87	46.1	115	——
¾	1.31	69.1	76	——
1	1.74	92.2	57	——
1¼	2.18	115.1	46	——
1½	2.62	138.3	38	——
1¾	3.06	161.2	33	——
2	3.49	184.4	29	——
2½	4.37	230.5	23	——
3	5.24	276.7	19	——
3½	6.12	322.9	16	——
4	6.99	369.2	14	——
4½	7.37	415.5	13	——
5	8.75	461.9	11.4	——
6	10.51	555	9.5	——
7	12.28	——	8.1	——
8	14.05	——	7.1	——
9	15.84	——	6.3	——
10	17.63	——	5.7	——
15	——	——	3.7	——
20	——	——	2.7	——
25	——	——	2.1	——
30	——	——	1.7	——
40	——	——	1.2	——
45	——	——	1	1
50	——	——	——	1.2
60	——	——	——	1.7
65	——	——	——	2.1
70	——	——	——	2.7
75	——	——	——	3.7
80	——	——	——	5.7
81	——	——	——	6.3
82	——	——	——	7.1
83	——	——	——	8.1
84	——	——	——	9.5
85	——	——	——	11.4
85½	——	——	——	13
86	——	——	——	14
86½	——	——	——	16
87	——	——	——	19
87½	——	——	——	23
88	——	——	——	29

[*] This table has been abstracted from TM 5-236 (December, 1955), Department of the Army.

Angle	Ft. per 100 ft. horiz. or	Vert. ft. to horiz. mi.	1 vertical on or in—	1 horizontal to—
Degrees			Horizontal	Vertical
88¼	——	——	——	33
88½	——	——	——	38
88¾	——	——	——	46
89	——	——	——	57
89¼	——	——	——	76
89½	——	——	——	115
89¾	——	——	——	229

DIFFERENCES IN ELEVATION FOR KNOWN SLOPE ANGLES AND DISTANCES

Slope angle	Sloping distances of—				
	50 ft.	100 ft.	200 ft.	300 ft.	400 ft.
1°	1 ft.	2 ft.	3 ft.	5 ft.	7 ft.
2	2	4	7	11	14
3	3	5	10	16	21
4	4	7	14	21	28
5	5	9	17	26	35
6	5	10	21	31	42
7	6	12	24	36	48
8	7	14	28	41	55
9	8	15	31	46	62
10	9	17	34	51	68
11	10	19	37	56	75
12	10	20	41	61	81
13	11	22	44	66	88
14	12	24	47	70	94
15	13	25	50	75	100
16	13	26	53	79	106
17	14	28	56	84	112
18	15	29	59	88	117
19	15	31	62	92	123
20	16	32	64	96	128
21	17	33	67	100	134
22	17	35	69	104	139
23	18	36	72	108	144
24	19	37	74	112	149
25	19	38	77	115	153
26	20	39	79	118	158
27	20	40	81	121	162
28	21	42	83	124	166
29	21	42	85	127	170
30	22	43	87	130	173

The altitude figures in this table are mostly approximations. For instance, the exact height above you of a point which is 50 ft. away on a slope of 1° would be .873 ft. But we may as well call that a foot. This table enables you to estimate differences in elevation to the nearest foot.

Example: Given a slope of 8° and an uphill distance of 150 ft., what is the rise in elevation?

Altitude at 100 ft. on 8° is 14 ft.
Altitude at 50 ft. on 8° is 7 ft.
So altitude at 150 ft. on 8° is 21 ft.

Another example: Slope angle 17°. Sloping distance 423 ft.

For 400 ft. put 112
For 20 ft. put 6 (20 being 1/10 of 200, take 1/10 of 56)

For 3 ft. put 1 (taking 1/100 of alti-
 tude at 300)
 ———
 119 ft.

MAP SCALE EQUIVALENTS

I

Representative fraction	Inches to mile	Statute miles to an inch	Feet to an inch	Kilometers to an inch
1:600	105.6	.0095	50.	.0153
1:1,200	52.8	.0189	100.	.0305
1:2,400	26.4	.0379	200.	.061
1:2,500	25.34	.0394	208.3	.0635
1:3,600	17.6	.0568	300.	.0914
1:4,800	13.2	.0758	400.	.1219
1:6,000	10.56	.0947	500.	.1524
1:7,200	8.8	.1136	600.	.1829
1:7,920	8.	.125 (i.e. 1/8 mi.)	660.	.2012
1:10,000	6.34	.1578	833.3	.254
1:10,560	6.	.167 (i.e. 1/6 mi.)	880.	.268
1:12,000	5.28	.1894	1,000.	.305
1:15,840	4.	.250 (i.e. 1/4 mi.)	1,320.	.402
1:20,000	3.17	.3156	1,666.	.508
1:21,120	3.	.3333 (i.e. 1/3 mi.)	1,760.	.536
1:25,000	2.53	.3945	2,083.	.635
1:31,680	2.	.5 (i.e. 1/2 mi.)	2,640.	.804
1:62,500	1.01	.986	5,208.	1.587
1:63,360	1.	1.	5,280.	1.609
1:100,000	.634	1.578	8,333.	2.54
1:125,000	.507	1.972	10,416.	3.175
1:316,800	.2	5.	26,400.	8.05
1:500,000	.1267	7.891	41,666.	12.7
1:1,000,000	.063	15.783	83,333.3	25.40

What To Do If A Scale Is Not Shown Here

Suppose the RF of a map is 1:225,000. How many miles to an inch is that? The answer comes easily by combining factors already in the table:

RF 1:100,000 = 1.578 miles to an inch
RF 1:125,000 = 1.972 miles to an inch
sum RF 1:225,000 3.550 miles to an inch

Another example: The scale of a map is 12 miles to an inch. What is the RF?
The RF of 1 mile to an inch is 1:63,360. So:

10 miles to an inch is 1:633,600
 2 miles to an inch is 1:126,720
12 miles to an inch is 1:760,320

II

With RF	1 statute mi. takes		
1:2,500	25.344 in.	or	64.37 cm.
1:5,000	12.672		32.19
1:10,000	6.336		16.09
1:15,000	4.224		10.73
1:20,000	3.168		8.05
1:30,000	2.112		5.36
1:40,000	1.584		4.02
1:50,000	1.267		3.22
1:60,000	1.056		2.68
1:80,000	.792		2.01
1:100,000	.634		1.61
1:120,000	.528		1.34
1:200,000	.317		.80
1:400,000	.158		.40
1:500,000	.127		.32
1:1,000,000	.063		.16
1:1,200,000	.053		.13

CORRECTION OF COMPASS BY OBSERVATION OF SUN

Add together the azimuths of the rising and the setting sun (or of the setting and the rising sun) as observed within the same day (or night) and at the same location. Find the difference between this sum and 360°. One half of that difference will equal the amount of local variation (declination) of the magnetic compass used.

Example:

Sun rises at mag. az. 65° (as taken with your compass)
Sun sets at mag. az. 305° (as taken with your compass)
 370°
 −360° (sum of true azimuths)
 10° ÷ 2 = 5°, the variation

If the sum of the taken azimuths is more than 360° (as in the example above) the declination is to the east; if less, it is to the west.

APPENDIX

MERIDIANS AND BASE LINES OF THE UNITED STATES RECTANGULAR SURVEYS*

Meridians	Governing surveys (wholly or in part) in States of—	Longitude of initial points west from Greenwich			Latitude of initial points		
		°	′	″	°	′	″
Black Hills............	South Dakota...............	104	03	16	43	59	44
Boise................	Idaho......................	116	23	35	43	22	21
Chickasaw...........	Mississippi.................	89	14	47	35	01	58
Choctaw.............	Mississippi.................	90	14	41	31	52	32
Cimarron.............	Oklahoma..................	103	00	07	36	30	05
Copper River.........	Alaska.....................	145	18	13	61	49	21
Fairbanks.............	Alaska.....................	147	38	26	64	51	50
Fifth Principal........	Arkansas, Iowa, Minnesota, Missouri, North Dakota, and South Dakota.	91	03	07	34	38	45
First Principal........	Ohio and Indiana............	84	48	11	40	59	22
Fourth Principal......	Illinois†....................	90	27	11	40	00	50
Fourth Principal......	Minnesota and Wisconsin.....	90	25	37	42	30	27
Gila and Salt River....	Arizona....................	112	18	19	33	22	38
Humbolt.............	California..................	124	07	10	40	25	02
Huntsville...........	Alabama and Mississippi......	86	34	16	34	59	27
Indian...............	Oklahoma..................	97	14	49	34	29	32
Louisiana.............	Louisiana..................	92	24	55	31	00	31
Michigan.............	Michigan and Ohio..........	84	21	53	42	25	28
Mount Diablo........	California and Nevada.......	121	54	47	37	52	54
Navajo..............	Arizona...................	108	31	59	35	44	56
New Mexico Principal..	Colorado and New Mexico.....	106	53	12	34	15	35
Principal.............	Montana...................	111	39	33	45	47	13
Salt Lake............	Utah......................	111	53	27	40	46	11
San Bernardino.......	California..................	116	55	17	34	07	20
Second Principal......	Illinois and Indiana..........	86	27	21	38	28	14
Seward..............	Alaska....................	149	21	24	60	07	36
Sixth Principal.......	Colorado, Kansas, Nebraska, South Dakota, and Wyoming.	97	22	08	40	00	07
St. Helena...........	Louisiana..................	91	09	36	30	59	56
St. Stephens..........	Alabama and Mississippi......	88	01	20	30	59	51
Tallahassee..........	Florida and Alabama.........	84	16	38	30	26	03
Third Principal.......	Illinois....................	89	08	54	38	28	27
Uintah..............	Utah......................	109	56	06	40	25	59
Ute.................	Colorado..................	108	31	59	39	06	23
Washington..........	Mississippi.................	91	09	36	30	59	56
Willamette...........	Oregon and Washington.......	122	44	34	45	31	11
Wind River..........	Wyoming..................	108	48	49	43	00	41

* Borrowed from the B.L.M.'s *Manual of Surveying Instructions*, 1947, p. 168.

† The numbers are carried to fractional township 29 north in Illinois, and are repeated in Wisconsin, beginning with the south boundary of the State; the range numbers are given in regular order.

Index

INDEX

PHOENIX BOOKS
in Science

PHOENIX SCIENCE SERIES

PHOENIX BOOKS
in Art, Music, Poetry, and Drama

PHOENIX BOOKS
in Education and Psychology

PHOENIX BOOKS
Reference